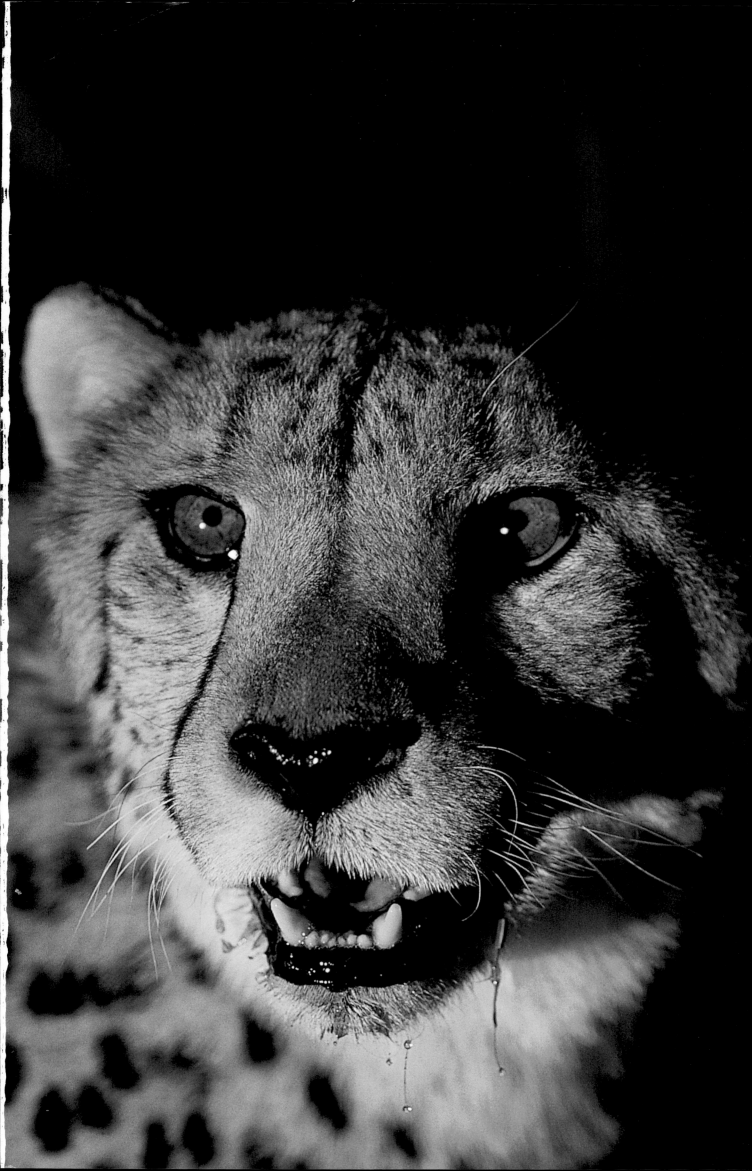

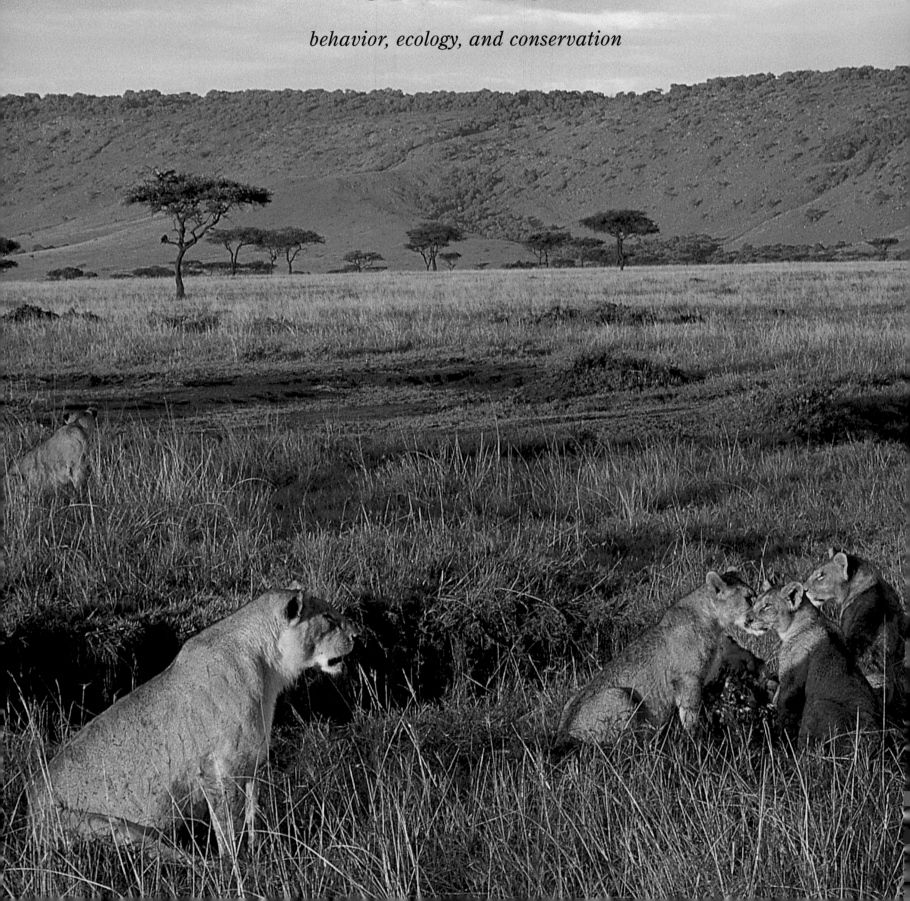

CATS
OF AFRICA
behavior, ecology, and conservation

TEXT BY

Luke Hunter

PHOTOGRAPHY BY

Gerald Hinde

For my lovely wife Pam and our children, Wayne, Kevin, Sharon, Gavin, and Ricky, with love.
In memory of a wonderful father, Pat, and with love to my mother May and brother Ron.

'The world and all that is in it belongs to the Lord;
The earth and all who live on it are His.' Psalm 24:1
GERALD HINDE

For my parents, Lois and Tim.
LUKE HUNTER

Printed in Singapore on acid-free paper by
Tien Wah Press (Pte) Ltd.

Published in the United Kingdom by
New Holland Publishers (UK) Ltd.

First published in the United States in 2006 by
the Johns Hopkins University Press

9 8 7 6 5 4 3 2 1

The Johns Hopkins University Press
2715 N. Charles Street
Baltimore, MD 21218-4363
www.press.jhu.edu

Library of Congress Control Number: 2006921514

ISBN 0-8018-8482-9

A catalog record for this book is available from
the British Library.

PHOTOGRAPHIC CREDITS
All photographs taken by Gerald Hinde
with the exception of the following:

BRUCE DAVIDSON/NATUREPL.COM/PHOTO
ACCESS: pages 35, 38
CAROL AMORE: page 27
DAVE HAMMAN/GALLO IMAGES: page 77
ERHARDT THIEL/IMAGES OF AFRICA: page 39
(Cape fur seal)
GERHARD DREYER/IMAGES OF AFRICA: page 39
(Cape clawless otter)
GUS VAN DYK: page 166
IR DOE/CACP/WCS/UNDP-GEF: page 158
JULIE MAHER: pages 38 (fossa), 39 (walrus,
harbour seal, red panda, striped skunk),
41 (bottom)
LUKE HUNTER: pages 38 (tiger, aardwolf,
large-spotted genet), 39 (wolf, bear, coati),
94 (bottom), 109, 114, 125 (top), 151 (top
and bottom), 157 (inset), 159, 167
NIGEL J DENNIS/GALLO IMAGES: 72
PHILIPP HENSCHEL: page 141
RICHARD DU TOIT: pages 52, 68, 70–71, 79, 92,
108, 120–121 (bottom)
TERRY WHITTAKER: pages 25, 111, 156 (inset)

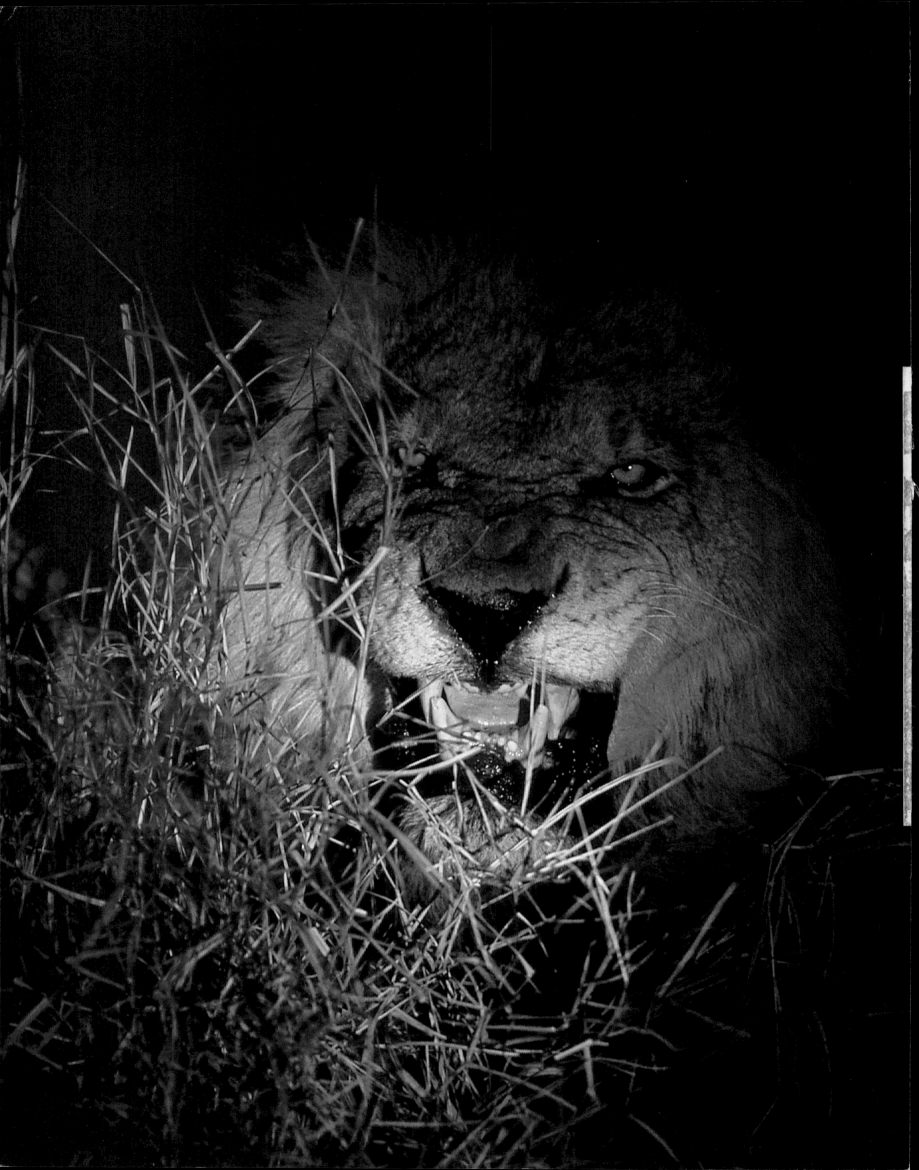

CONTENTS

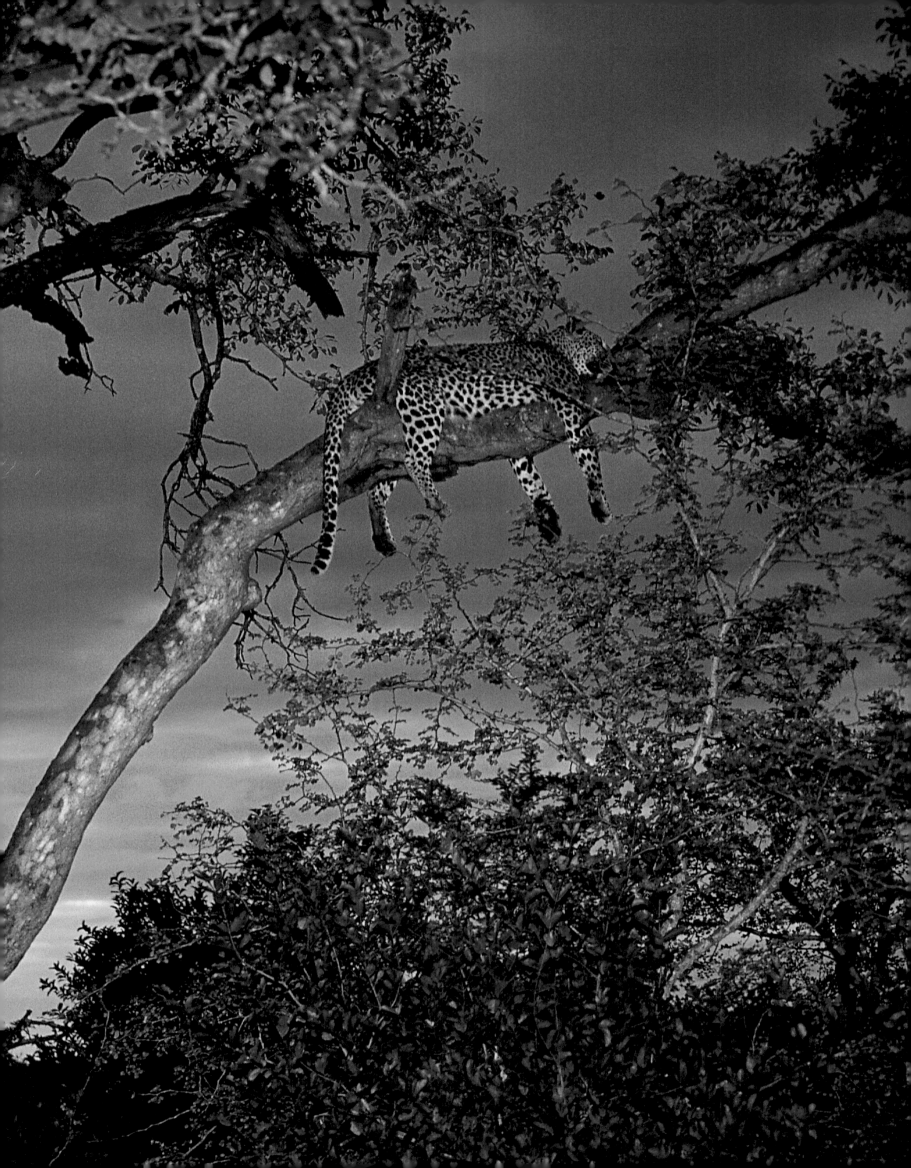

PHOTOGRAPHER'S ACKNOWLEDGEMENTS

'There is something about safari life that makes
you forget all your sorrows ... One feels really free
when one can go in whatever direction one pleases over
the plains, to get to the rivers and pitch one's camp.'

KAREN BLIXEN FROM *OUT OF AFRICA*

Were it not for the assistance of numerous people and organisations, this rather daunting project would not have been possible. Cats have always been my favourites and I enjoyed being constantly in their presence in some of the best viewing venues in Africa. I cannot offer enough praise about the quality of the places and the expertise and friendliness of the people wherever I went. I extend my thanks to them all, and my admiration for their contribution to conservation in Africa.

I am asked on a regular basis for recommendations as to the best places for game viewing. They are too numerous for me to mention them all, but below is a selection. Details of the destinations are brief and I recommend that readers check the web sites for more information.

I hesitate to mention names of people for fear of leaving anyone out. This book is not just the product of the immediate team, but the result of input and assistance from a wide range of people. A special thank you to all the staff at the places that I have been privileged enough to visit. Africa truly offers the best when it comes to destinations and friendly, efficient people in the tourism industry.

The staff at Johannesburg head office and at all the lodges of Conservation Corporation have always been friendly and professional and have contributed greatly towards this book. From my first contact with Yvonne and Peter Short, my subsequent meeting with Shayne Richardson and my numerous dealings with Suzanne Henderson, everyone was really wonderful. Along the way, Gavin Lautenbach (a senior ranger) helped initially at Phinda and then at Londolozi and whenever he could at other destinations. I owe him a special thank you for all his help and friendship. Conservation Corporation has numerous captivating destinations throughout Southern Africa and Zanzibar.

In Kenya and Tanzania the management and staff at the lodges were great, and the area and game viewing was astounding. This is a photographer's paradise and the annual migration adds another dimension to the drama on show. I especially enjoyed the cheetah viewing, with lions coming a close second. The open plains make photography a pleasure, and the colours and landscapes are captivating.

The Ngorongoro Crater Lodge offers views that are immensely wide and panoramic; the experience was quite surreal. The lion viewing on the crater floor was exceptional with good cheetah viewing, too. The crater floor met all my expectations, particularly with regard to game viewing. 'I stood on the edge of the world and saw my heart soar into its ancient sky.'

Cat viewing and photography is excellent at Londolozi Game Reserve in South Africa. In the early 1980s this was my first experience of a private game reserve. It remains one of the best places to see leopards and the other big cats.

Phinda Game Reserve is situated in lush northern KwaZulu-Natal in South Africa. The area comprises seven distinct habitats and an abundance of wildlife, including the big five. Cheetah viewing here is exceptional.

Ngala Game Reserve in South Africa hosts exclusive game lodges and walking safaris, and during my stays I had very good lion and leopard viewing, which offered excellent photographic opportunities.

Desert and Delta offered good photographic opportunities and friendly, efficient staff. A special thank you to Helga Hagner and Jonathan Gibson.

Overlooking the Chobe River in Northern Botswana, the Chobe Game Lodge is the only lodge situated within the Chobe Game Reserve in the Kasane area. The 48-room lodge offers luxury and comfort and great game viewing. Lions are well represented and very visible and the elephant viewing is excellent in the dry winter months. Game viewing is conducted on both land and water.

Camp Moremi is situated on the beautiful Xakanaxa Lagoon in the eastern Okavango Delta within the Moremi Game Reserve. The area supports abundant cats, including leopards, which are very visible and relaxed, and which make for good photography.

The Kwando Safari experience in Botswana is truly unforgettable and offers very good predator viewing – lion, leopard and wild dogs are well represented. The camps are intimate, private and exclusive. My times there were filled with a spirit of adventure and it was a uniquely African experience.

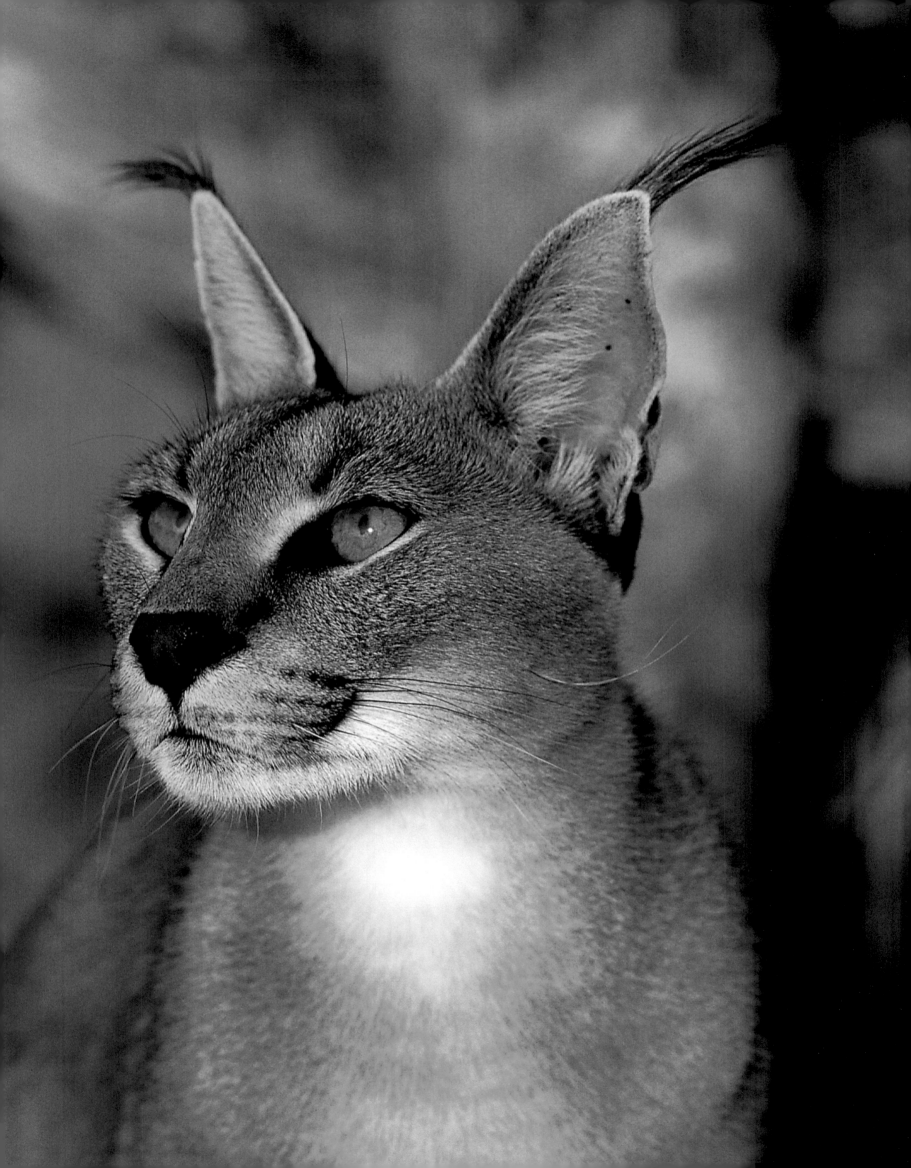

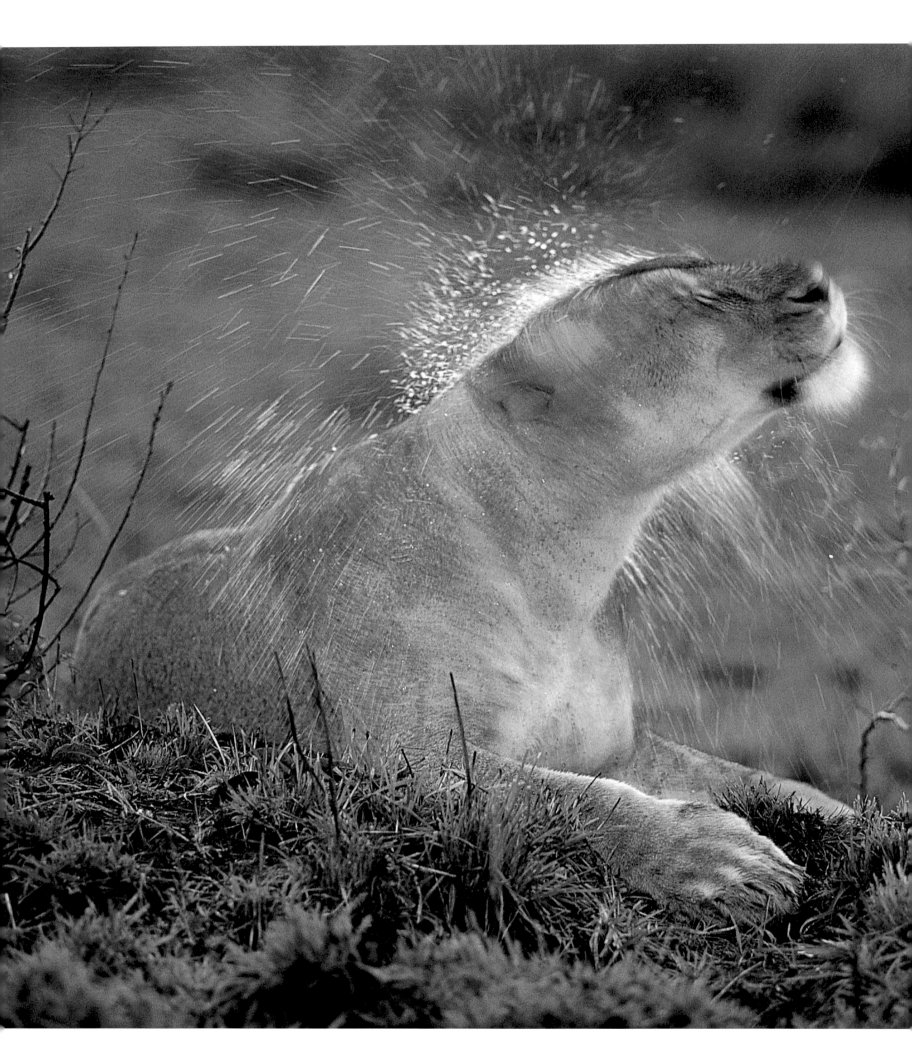

Hoedspruit Cheetah Project in South Africa made my job much easier with regard to the smaller cats such as caracal, serval, black-footed cat and African wildcat. The centre has established itself as one of the leading research and breeding facilities for endangered species in South Africa. A visit to this centre is highly recommended.

The Kruger National Park is probably one of the best known wildlife locations in the world today, where a great diversity of wildlife can be experienced. It was here that my interest in wildlife started when I was a small child, and I still rate it as a good wildlife destination and value for money. Malalane Lodge is situated on the southern border of the Park and this superb resort offers the thrill of exploring the African bushveld, combined with first-class luxury.

The luxurious Mala Mala Game Reserve in South Africa supports a great diversity of mammal species and is situated adjacent to the Kruger National Park. The reserve straddles the perennial Sand River and includes a variety of habitats that are home to a corresponding range of predators and prey. I owe much of my success in the wildlife photographic field to the opportunities offered to me by Mike and Norma Rattray, for which I am truly grateful.

Mokuti Lodge in Namibia, on the eastern border of Etosha National Park, offers superb accommodation. The eastern section of Etosha is my preferred location and offers exceptional game viewing in the dry months. In the mornings I drive from waterhole to waterhole to find lions either hunting or at play. The afternoons offer good elephant viewing.

I particularly want to thank Nick Seewer for allowing me the privilege of staying at the delightful Orient-Express destinations in Botswana. Also Karl Parkinson and Sandy Fowler for friendly and efficient service.

Step out of your luxury tent at the Khwai River Lodge in Botswana and gaze onto hippo, elephant and abundant wildlife. Bordering the Moremi Game Reserve, this area became the focus of my life for a full year when I produced a book called *Timeless Wilderness*, and developed a special affection for the area and its cat populations.

In a river channel parched by two decades of drought lies the Savute Elephant Camp. The area has one of the largest concentrations of resident elephant and offers good lion viewing. Twice a year (usually May and November) the zebra migration passes through Savute and it's a time of plenty for the predators. During the late 1980s and early 1990s I studied a pride of lions here, and made a documentary about them.

Okanjima Game Reserve lies nestled in the unspoilt beauty of the Omboroko Mountains in Namibia. Not only a luxury lodge, it is also home to the AfriCat Foundation, a non-profit organisation committed to long-term conservation of Namibia's large carnivores – especially cheetah and leopard. These cats are almost always seen and are relaxed, offering excellent photographic opportunities.

The Pilanesberg Game Reserve in South Africa is two and a half hours from Johannesburg by road, with the added attraction of Sun City nearby. Lions, cheetahs and rhinos (black and white) can be seen.

Wilderness Safaris offer a wide range of lodges in South Africa, Botswana, Namibia, Zimbabwe, Zambia, Malawi and Seychelles. They provide wonderful African safaris with great game viewing in unspoiled, natural habitats. I especially want to thank Colin Bell and Mike Myers for their personal help and friendliness during this project.

Hidden from the world and situated on Chief's Island within the Moremi Game Reserve is the secret paradise of Mombo Camp. Large concentrations of wildlife occur in the area and all the big cats are common. Each luxury tented room is raised off the ground, with breathtaking views over the plains.

Duba Plains is one of Okavango Delta's remote camps and is located in a private reserve famous for high concentrations of lions and huge herds of buffalo. A truly beautiful area with exceptionally good accommodation and game viewing.

The Waterberg, situated in the far north of South Africa, is really magnificent and one of the younger developing 'big five' areas. During my travels here, I photographed cats at Welgevonden, Entabeni and Shambala game reserves, all wonderful locations.

Quinton and Nicole Martins of the Cape Leopard Trust are doing a sterling job with the research and conservation of leopards in the Cape. I admire them for their tireless contribution to conservation.

Linda Tucker and Jason Turner are dedicated to the re-introduction of white lions to free-roaming conditions; it certainly is a landmark in conservation history. We will be watching anxiously for the day that Marah and her cubs are free and wild.

Thank you to Mike Bester at Bester's Zoo in Pretoria, South Africa for allowing me to photograph the sand cats.

Throughout my years of dealing with Struik Publishers I have met some wonderfully talented people, and I wish to thank Steve Connolly, Pippa Parker, Janice Evans and Helen de Villiers in Cape Town, and Deone Marsh and Janet Larsen in Johannesburg, for all their time, effort and friendship.

A special thanks to Richard du Toit, William Taylor, Royston Knowles, Brian Richards and Henk Maree for friendship and help along the way.

GERALD HINDE
Johannesburg, 2005

AUTHOR'S ACKNOWLEDGEMENTS

I am indebted to the many scientists and naturalists whose work on cats provided much of the material for my text. Although they are too numerous to list, the publications and observations of the following people were particularly important in writing the text; Mauricio Anton, Ted Bailey, Guy Balme, Hans Bauer, Koos Bothma, Tim Caro, Alain Dragesco-Joffe, Sarah Durant, Frauke Fischer, Laurence Frank, Paul Funston, Aadje Geertsema, Philipp Henschel, Lex Hes, David Jenny, Marcella Kelly, Jonathan Kingdon, Karen Laurenson, Laurie Marker, Gus Mills, Craig Packer, Gustav Peters, Netty Purchase, Justina Ray, George Schaller, John Seidensticker, Alex Sliwa, Flip Stander, Chris & Tilde Stuart, Mel & Fiona Sunquist, Alan Turner, Tim Wacher and Peyton West. Thanks also to John Newby and Amina Fellous for assistance with local names of wild cats in the Sahara; and to Chris Wozencraft and Don Wilson who allowed me to preview their revised classification of carnivores from *Mammal Species of the World*.

I am very grateful to the colleagues and friends who donated the use of their photographs to fill some critical gaps, in particular, thanks to Carol Amore, Julie Maher, Christian Sperka and Gus van Dyk. I am very grateful to Philipp Henschel (WCS) for the use of his unique golden cat photograph, and to Eve Gracie of Black Eagle Publications for ensuring it reached Cape Town. I am indebted to the Islamic Republic of Iran's Department of Environment and the CACP secretariat, particularly Dr Hadi Soleimanpour and Hooshang Ziaie, for permission to use the camera-trap image of the Asiatic cheetah in Iran.

My employer, the Wildlife Conservation Society provided substantial assistance while I was writing; in particular, thanks to Alan Rabinowitz for his encouragement in taking on the project and for support throughout; to Catherine Grippo for compiling reference material; and to Nicole Williams who assisted in the book's final stages. Justina Ray (WCS) provided excellent, up-to-date maps and permitted the use of her range loss analyses for the section on the status of cats. A special mention goes to Michael Cline, Tom Kaplan and Albert Hartog who provide exceptional support towards WCS's efforts to conserve wild cats in Africa and elsewhere. Special thanks also to Christian Sperka and Jim Dines for their generosity in support of cat conservation.

As always, the Struik-New Holland team was a pleasure to work with; thanks to Pippa Parker for inviting me to write this book and for keeping the entire process on track and to Janice Evans for working under pressure to do the wonderful design. I am in awe of Helen de Villiers' meticulous and extremely rapid editorial work, which did not falter in the midst of a personal tragedy. I am indebted to Lynda Ingham-Brown, Gill Gordon and especially to Monica Meehan for bringing this edition to fruition. Thanks also to the meticulous editorial staff of John Hopkins University Press, especially to Vincent Burke, whose oversight helped to tighten the text considerably. I am grateful to two anonymous reviewers for important suggestions, particularly for the sections on taxonomy, phylogeny and conservation. Tim Hunter proofread the entire text, saving me from a number of errors and making many valuable suggestions; the end result is significantly improved as a result.

Above all, my wife Sophie continues to tolerate my spending weekends and nights writing while providing invaluable comments on the text. This book would not have happened without her.

LUKE HUNTER
New York, 2006

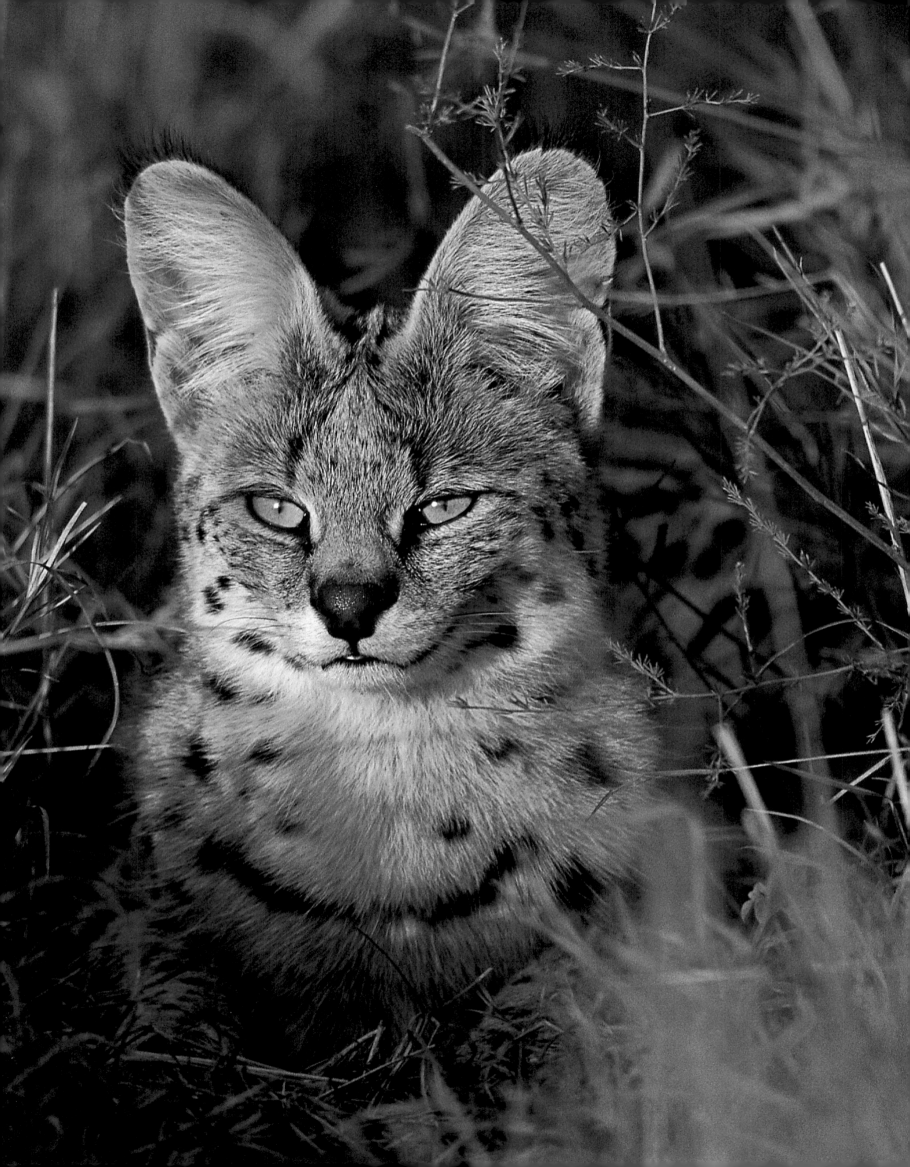

INTRODUCTION

The house cat is one of the most successful mammals on Earth. Absent only from a few offshore islands and Antarctica, its global population now numbers in the billions; in some countries, there are more cats than people. Its success embodies the adaptability, tenacity and, prior to modern human influence, the evolutionary triumph of the cat family. Excluding the domestic cat, felids are found on all continents except Antarctica and Australia. Wild cats also occur on any large island with a land bridge to the mainland in their recent geological past. The only large land masses that wild cats have never colonised have been separated from a natural source of cats for millions of years, among them Madagascar, Irian Jaya-Papua New Guinea, New Zealand and Iceland. Others such as Ireland and the major islands of Japan had cats in recent prehistory but no longer have them today.

The centre of felid evolution (see Chapter 1) and still the richest place on Earth for the family is Eurasia. Twenty-one species* of cats occur in Asia, with two extending their distribution into Western Europe. A twenty-second species, the critically endangered Iberian lynx, now numbering fewer than 200 adults, is found only in Spain and perhaps Portugal. North America has the fewest cats with five resident species, though jaguars occurred there up until the mid-1900s, and recent photographs from the south-west United States might represent incipient recolonisation from northern Mexico. That leaves Latin America, which is home to 12 species, and Africa, which has 10.

Wherever they occur, wild cats are notoriously secretive. Except for a handful of sites in Asia where tigers, leopards and Asiatic lions tolerate the presence of wildlife-watching tourists, Africa is the only place on Earth where sightings of wild cats are a reliable occurrence. In the protected areas of East and southern Africa's savanna woodlands, it is possible to see more species of felids in a week than a lifetime of searching will produce in the forests of Asia or tropical America. Millions of people are drawn to Africa every year to see the wild cats. Most are virtually guaranteed to see lions and many will enjoy exceptional views of cheetahs and leopards.

However, few travellers realise that, alongside the big three, Africa is home to a further seven species of cats. Rarely observed and little understood, most have never been the focus of dedicated scientific research. Of these seven, three are marginally better known; the caracal, widespread and resilient but exposed to intense persecution from farmers and herders; the serval, one of three cat species endemic to Africa; and the African wildcat, progenitor of the house cat and now threatened by hybridisation with its domestic descendant.

Few people have seen the remaining four. Restricted to the arid areas of southern Africa, and the smallest cat on the continent, the black-footed cat would be a complete enigma but for one excellent, intensive study in South Africa. Science is unable to make even this modest claim for the remaining three species, the African golden cat, the jungle cat and the sand cat. The little we know of them derives largely from examining dead animals and their scats. In the case of the jungle cat and the sand cat, most of the material hails from Asia where they also occur; we continue to be largely ignorant of their behaviour, ecology and status in Africa. The African golden cat occurs only in the equatorial forests of Central and West Africa where it remains one of the least investigated cats on the planet.

This book deals with all of them. Inevitably, the bias is towards the large, well-studied species where decades of research and observation has produced hundreds of scientific papers and reports. However, we have also compiled all that is known about the lesser species, including observations from their Asian range or from captivity to fill in some gaps. We hope to provide a comprehensive overview of the cat family in Africa – from the famous and popular African parks with their celebrated, safari-friendly felids, to the few remaining places on the continent uninhabited by people, where a wild cat may spend its entire life without feeling the effects of human presence.

Unfortunately, such wilderness is now exceptional. Africa has the fastest growing human population of any continent and the pressure on its wild places and natural resources is intense. The loss of habitat and prey to an ever-expanding agricultural frontier is reducing the space available to all carnivores in Africa, with the cat family the most severely affected. As occasional predators of livestock and poultry (and, in the case of lions and leopards, of people), cats suffer still more concentrated persecution that has driven calamitous range loss outside protected areas and, with escalating frequency, inside them.

None of Africa's cats is facing immediate extinction. But all of them have disappeared from large tracts they once inhabited and every species has relict populations whose loss is inevitable. The challenges facing cats in Africa are profound. Only one, the ubiquitous domestic cat, does not require dedicated conservation activity to ensure its survival for the next century. More than at any time in history, the fate of Africa's wild cats is in our hands.

* In this book, we have adopted the taxonomy established by the standard reference for mammals, Wilson & Reeder (2005). See Chapter 1 for details.

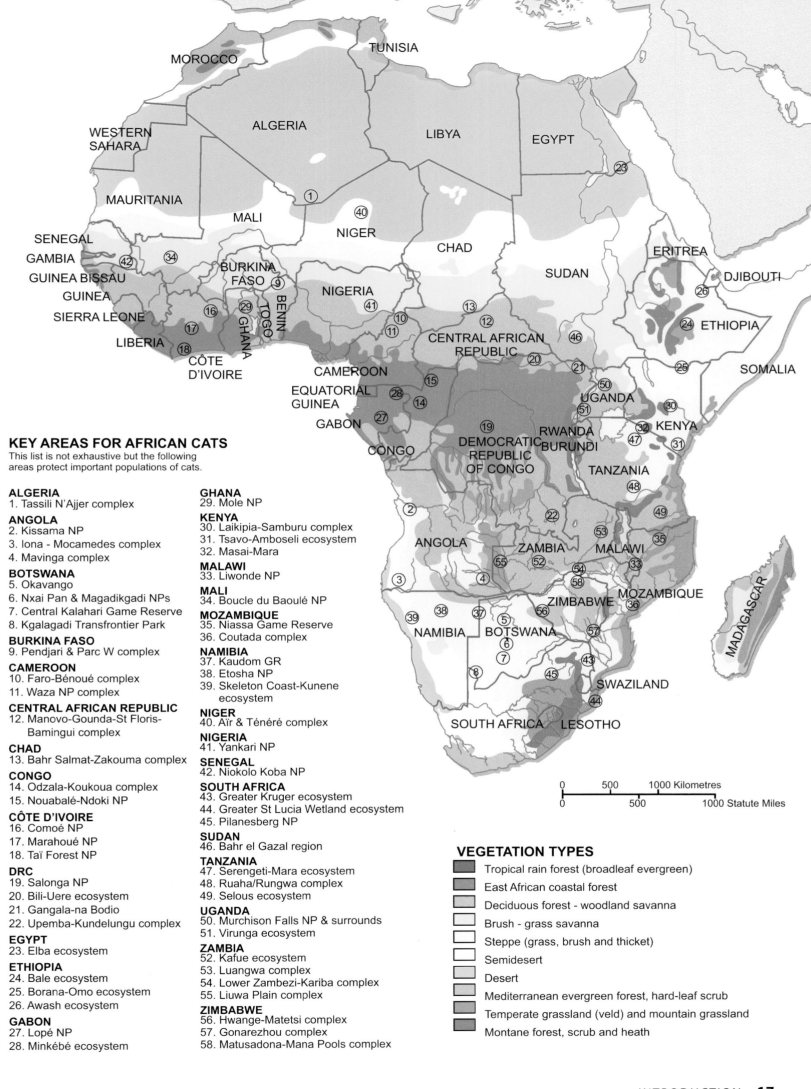

KEY AREAS FOR AFRICAN CATS

This list is not exhaustive but the following areas protect important populations of cats.

ALGERIA
1. Tassili N'Ajjer complex

ANGOLA
2. Kissama NP
3. Iona - Mocamedes complex
4. Mavinga complex

BOTSWANA
5. Okavango
6. Nxai Pan & Magadikgadi NPs
7. Central Kalahari Game Reserve
8. Kgalagadi Transfrontier Park

BURKINA FASO
9. Pendjari & Parc W complex

CAMEROON
10. Faro-Bénoué complex
11. Waza NP complex

CENTRAL AFRICAN REPUBLIC
12. Manovo-Gounda-St Floris-Bamingui complex

CHAD
13. Bahr Salmat-Zakouma complex

CONGO
14. Odzala-Koukoua complex
15. Nouabalé-Ndoki NP

CÔTE D'IVOIRE
16. Comoé NP
17. Marahoué NP
18. Taï Forest NP

DRC
19. Salonga NP
20. Bili-Uere ecosystem
21. Gangala-na Bodio
22. Upemba-Kundelungu complex

EGYPT
23. Elba ecosystem

ETHIOPIA
24. Bale ecosystem
25. Borana-Omo ecosystem
26. Awash ecosystem

GABON
27. Lopé NP
28. Minkébé ecosystem

GHANA
29. Mole NP

KENYA
30. Laikipia-Samburu complex
31. Tsavo-Amboseli ecosystem
32. Masai-Mara

MALAWI
33. Liwonde NP

MALI
34. Boucle du Baoulé NP

MOZAMBIQUE
35. Niassa Game Reserve
36. Coutada complex

NAMIBIA
37. Kaudom GR
38. Etosha NP
39. Skeleton Coast-Kunene ecosystem

NIGER
40. Aïr & Ténéré complex

NIGERIA
41. Yankari NP

SENEGAL
42. Niokolo Koba NP

SOUTH AFRICA
43. Greater Kruger ecosystem
44. Greater St Lucia Wetland ecosystem
45. Pilanesberg NP

SUDAN
46. Bahr el Gazal region

TANZANIA
47. Serengeti-Mara ecosystem
48. Ruaha/Rungwa complex
49. Selous ecosystem

UGANDA
50. Murchison Falls NP & surrounds
51. Virunga ecosystem

ZAMBIA
52. Kafue ecosystem
53. Luangwa complex
54. Lower Zambezi-Kariba complex
55. Liuwa Plain complex

ZIMBABWE
56. Hwange-Matetsi complex
57. Gonarezhou complex
58. Matusadona-Mana Pools complex

VEGETATION TYPES

- Tropical rain forest (broadleaf evergreen)
- East African coastal forest
- Deciduous forest - woodland savanna
- Brush - grass savanna
- Steppe (grass, brush and thicket)
- Semidesert
- Desert
- Mediterranean evergreen forest, hard-leaf scrub
- Temperate grassland (veld) and mountain grassland
- Montane forest, scrub and heath

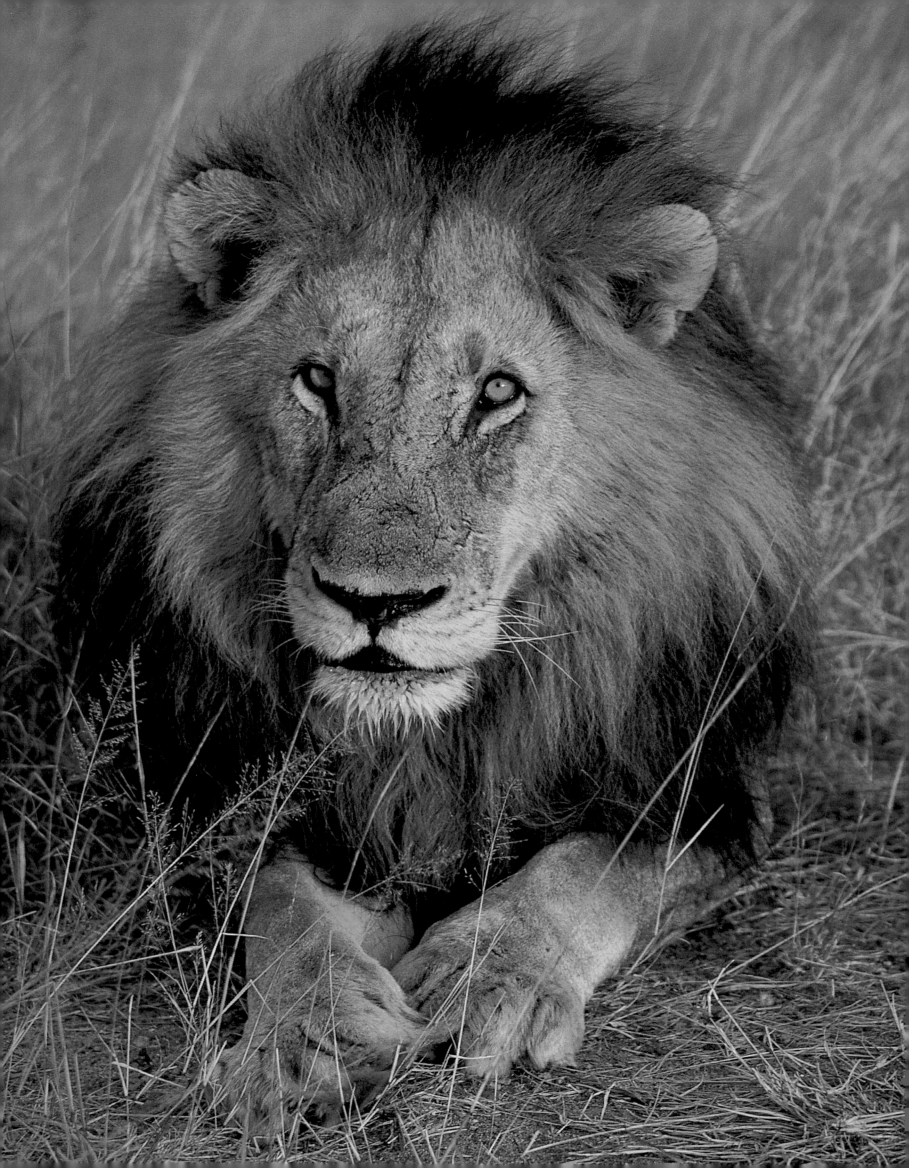

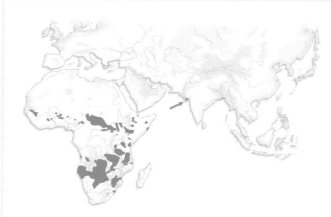

Lion
Panthera leo

Size
The second largest cat species and largest African carnivore. The most sexually dimorphic African felid. **Females:** up to 160 kg, average 120–130 kg; 110 cm at shoulder, total length up to 275 cm. **Males:** up to 260 kg, average 180–190 kg; 120 cm at shoulder, total length up to 330 cm.

Longevity
Males usually no more than 12 years. Females usually 13–15 years, occasionally up to 18 through the support of the pride. In captivity, lions live to 30 years.

Habitat associations
Broad habitat tolerance; optimum habitat is open woodland and thick scrub-grassland mosaics. Inhabits very arid areas such as the Kalahari Desert and Kunene region in north-west Namibia but absent from driest areas. Recorded up to 4 240 m in Ethiopia's Bale Mountains (transient), and formerly occurred in the Atlas Mountains of North Africa. Naturally absent only from tropical rainforest and the interior of major deserts. Outside Africa, restricted to a single population (estimated around 300) in India's Gir Forest.

Feeding ecology
A generalist that kills essentially everything it encounters, but diet is dominated by locally abundant medium to large herbivores, 60–320 kg: wildebeest, zebra and buffalo in much of East and southern Africa, nyala, wildebeest and warthog in northern KwaZulu-Natal (South Africa), and springbok in Etosha National Park (Namibia). Gemsbok, impala, kob, kudu and waterbuck also regionally important. Only adult elephants are invulnerable to lion predation. Occasionally kills people. Readily scavenges and frequently appropriates the kills of other predators.

Social organisation
The only communal living cat. Prides consist of up to 20 (but usually 4–11) related females and 1–9 males (but usually 2–5). Pride size including large cubs exceptionally reaches 45–50 (Masai Mara, Kenya). Female membership of the pride is stable but all pride members are together only rarely; small sub-groups spend considerable time apart within the home range. Male coalitions usually comprise related males, but around a third of Serengeti coalitions have at least one unrelated member. Serengeti pride home range size averages 65 km^2 (woodlands) to 184 km^2 (grasslands); largest recorded range size is 3 438 km^2 from Kunene (Namibia).

Reproduction
Gestation 98–115 days (mean 110 days). Litter size up to 7 cubs, usually 2–4. Lionesses can conceive around 30–36 months, age at first breeding usually 42–48 months. Males are sexually mature at 26 months, but rarely acquire breeding opportunities until about age 5. Oestrus lasts 4 days on average with 14–21 day cycles. Average inter-litter interval 20–24 months. No specific birth season. Cubs capable of hunting independently at around 16–18 months but females usually stay with the pride; males leave between 25–48 months.

Threats and status
Conservation-dependent. Incompatible with human activities particularly keeping livestock; persecuted relentlessly by livestock owners, and official destruction of 'problem' animals is widespread. Vulnerable to poisoned baits due to their willingness to scavenge. Becoming increasingly rare outside protected areas and ultimately may persist only in reserves. Genetic impoverishment of small and isolated populations possibly leads to declines and vulnerability to disease. Listed as CITES Appendix II permitting 'controlled trade' mainly of hunting trophies and some live animals. Trophy hunting permitted in 13 range states, chiefly Botswana, Namibia, South Africa, Tanzania, Zimbabwe and Zambia. On average, around 680 trophies exported annually. CITES Appendix II (in Africa), IUCN Red List Vulnerable (2002).

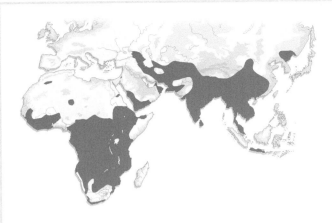

Leopard
Panthera pardus

Size
Very wide variation across its range, probably related to differences in climatic conditions and productivity of different habitats. Savanna and woodland leopards are generally largest, while mountain and desert animals tend to be smaller.
Females: 17–58 kg; 57–64 cm at shoulder, total length 1.7–1.9 m.
Males: up to 91 kg, average 31–65 kg; 60–80 cm at shoulder, total length 1.6–2.3 m.

Longevity
Up to 23 years in captivity but typically 10–12 in the wild. Oldest wild female on record died at 17 (Londolozi Game Reserve, South Africa).

Habitat associations
Very wide habitat tolerance; the only African cat occupying both rainforest and desert. Reaches highest densities in mesic woodland, grassland savanna and forest but also widespread in mountain habitats, scrub, semi-desert and desert. Absent from the open interiors of true desert but inhabits watercourses and rocky massifs in very arid areas. Tolerates some habitat conversion and persists in reduced densities close to large human populations. Recorded exceptionally up to 5 638 m (Mt Kilimanjaro). Widespread outside Africa throughout tropical and temperate Asia.

Feeding ecology
Extremely catholic diet; at least 100 species recorded in sub-Saharan Africa ranging from arthropods to adult male elands, but preferred prey is medium-sized ungulates weighing 20–80 kg. Capable of 'prey-switching' when medium-sized ungulates are unavailable; for example, to small antelopes and/or hyraxes in north-eastern Namibia,

Western Cape (South Africa), Matopos Hills (Zimbabwe) and Mount Kenya (Kenya). Primates are prominent in rainforest leopard diet. Occasionally preys upon people and readily takes livestock, particularly where natural prey is depleted. A consummate stalk and ambush hunter, approaching prey as closely as possible for a final rush from as close as 4–5 m. Capable of explosive speed for a short distance but rarely pursues prey further than 50 m if the initial rush fails. Foraging is mainly nocturnal/crepuscular; most daylight hunts are unsuccessful. Capable of hoisting kills up to 125 kg into trees. Typically plucks fur prior to feeding, usually starting at underbelly or hind legs. Occasionally cannibalistic, and scavenges.

Social organisation
Solitary and territorial, adults defend core area against same-sex conspecifics but tolerate considerable range overlap at range edges. Males interact with 'their' females and cubs often but never as long-term associations. Territory size varies from 5.6 km^2 (female, Kenya) to 2 750.1 km^2 (male, Kalahari). Mean range size for mesic woodlands, savannas and rainforest averages 16–25 km^2 for females and 52–136 km^2 for males. Ranges are much larger in arid habitats; average in northern Namibia is 188.4 km^2 (females) and 451.2 km^2 (males); southern Kalahari, 488.7 km^2 (females) and 2 321.5 km^2 (males).

Reproduction
Gestation 90–105 days, litters normally 1–3 cubs, up to 6 recorded in captivity. Both sexes sexually mature at 24–28 months; age at first breeding, females 30–36 months, males 42–48 months. Oestrus lasts 7–14 days and occurs in approximately 45 day cycles. No specific birth season. Cubs independent at around 12 months, inter-litter interval 16–36 months. Both sexes breed until age 19 in captivity but do not survive to that age in the wild.

Threats and status
Habitat destruction and modification by humans is the main factor causing decline of leopards. Despite great resilience to human activity, direct persecution in areas of livestock farming may result in leopard densities as low as 0.01 per cent of that in protected areas. Thousands of leopards are killed continent-wide as 'problem' animals where they conflict with livestock farming. In intact rainforest, the chief threat is probably competition with human hunters for prey. Killed opportunistically for skins and claws, especially in West and Central Africa. Listed as CITES Appendix I, allowing 11 African countries to export sport hunting trophies, live animals and a small number of skins sold commercially: 2005 total quota 2 570. CITES Appendix I, IUCN Red List Least Concern (2002).

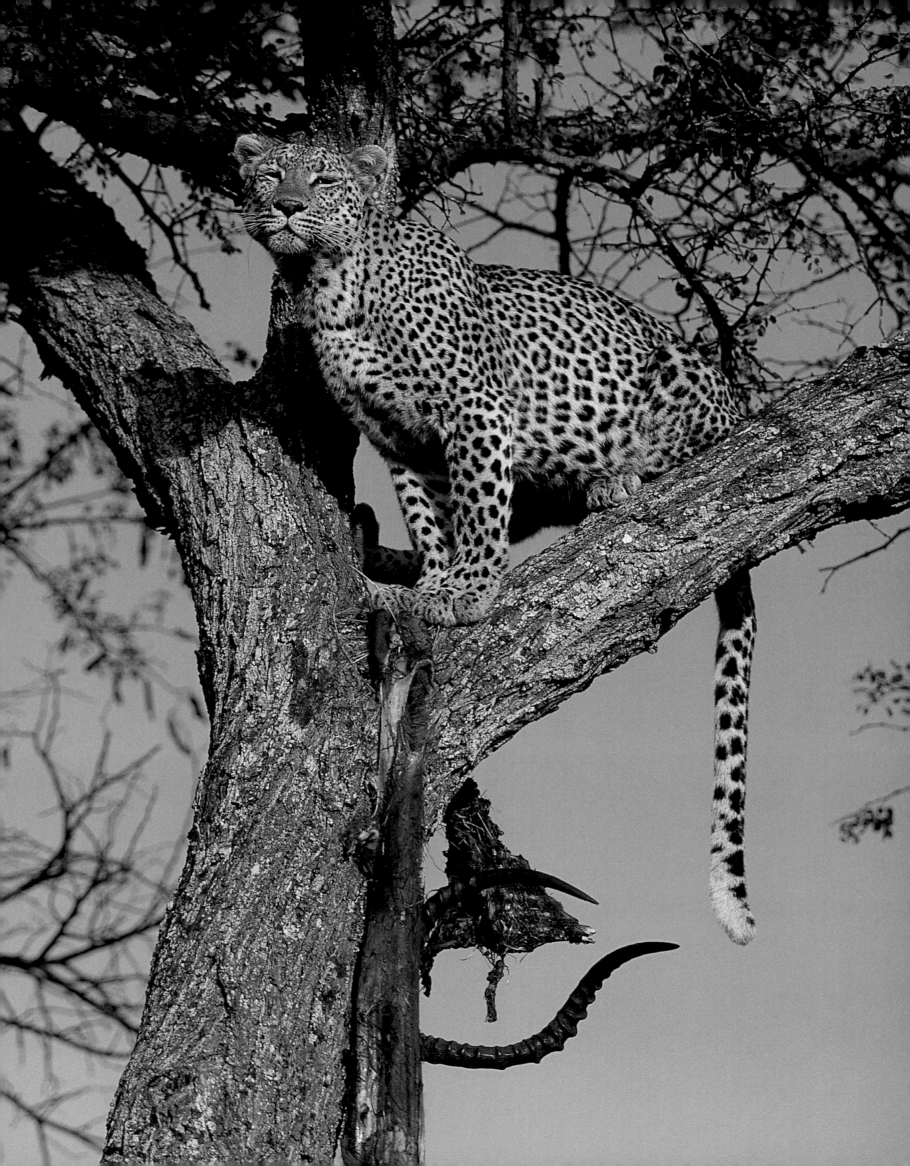

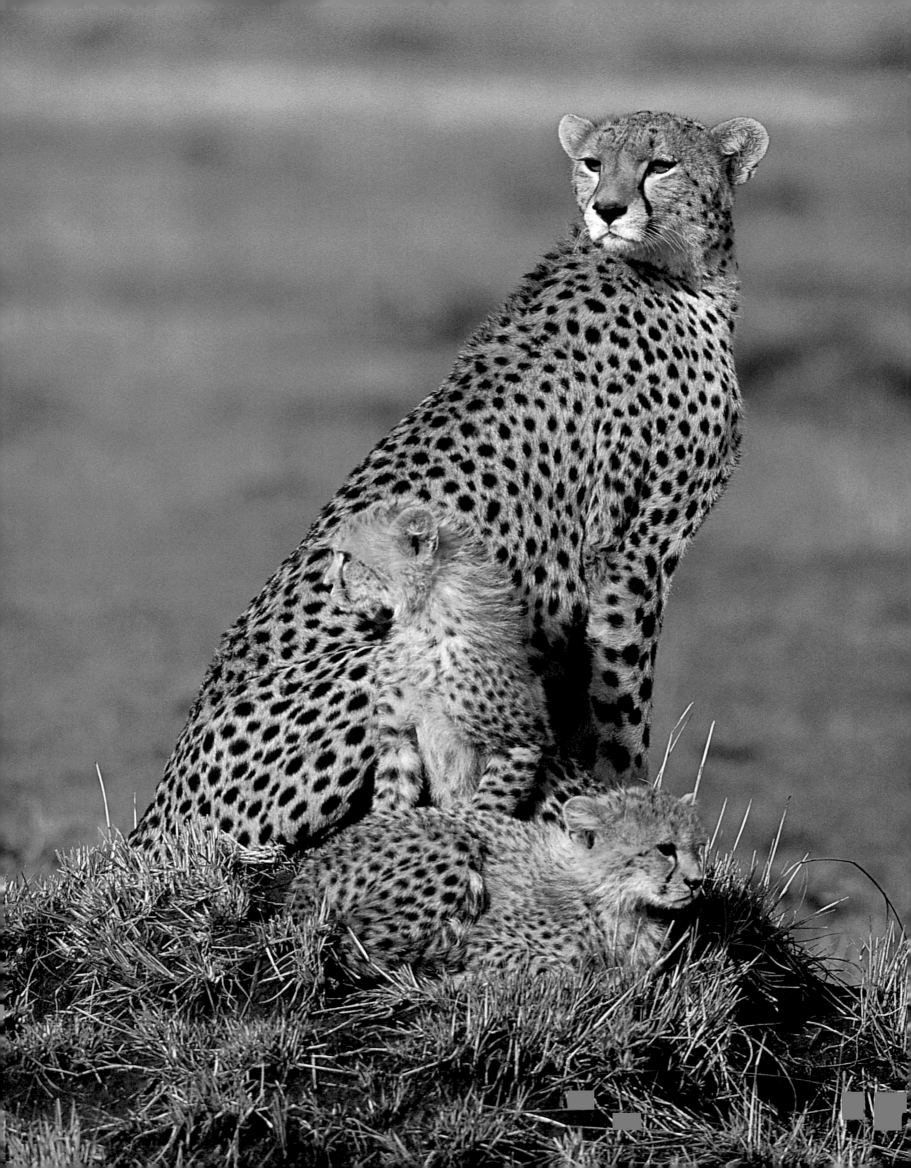

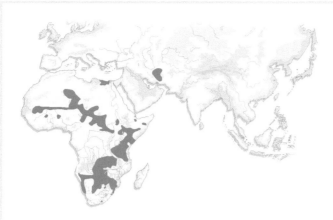

Cheetah

Acinonyx jubatus

Size
Females: 21–63 kg; 67–84 cm at shoulder,
174–236* cm nose to tail.
Males: 29–65 kg; 74–94 cm at shoulder,
172–224 cm nose to tail.
*Generally females are smaller and lighter than males but
sexual dimorphism is less pronounced than in other large
cats and sexes overlap somewhat in length.

Longevity
Up to 17 years in captivity; Serengeti females
average 6.2 years (maximum 13.5), males 5.3 years
(maximum 9.3).

Habitat associations
Favours woodland savanna mosaics and open grassland.
Occurs in arid areas including the Kalahari, Namib and
Sahara, and recorded up to 1 500 m in the mountains of
Ethiopia. Sparsely distributed in more humid miombo
woodland of central southern Africa and absent from
equatorial forest of Central and West Africa. Outside
Africa, restricted to single population estimated at
50–60 adults in central Iran.

Feeding ecology
A specialist on small and medium-sized antelopes 20–60 kg
such as impala and gazelles but male coalitions are
capable of taking large prey such as adult wildebeest,
gemsbok and hartebeest. Preferred prey species include
Thomson's gazelle (Serengeti-Mara Ecosystem), impala
(Kruger National Park, South Africa), nyala (northern
KwaZulu-Natal, South Africa), springbok (Kalahari, South
Africa), kudu and eland calves (Namibia) and puku (Kafue,
Zambia). Hares constitute important prey to Serengeti and
Namibian cheetahs, and perhaps to marginal populations,
for example, in Sahara and Egypt. Top recorded speed is
105 km/h but is probably able to reach 115–120 km/h
at least briefly. Occasionally cannibalistic and rarely
scavenges. Primarily diurnal, probably to increase visibility
for high speed chases and to offset competition with
nocturnal competitors such as lions and hyaenas.

Social organisation
Females solitary and non-territorial; occupy very large
home ranges averaging 800 km^2 (Serengeti) and 1 227 km^2
(Namibia). Males form coalitions of 2–4 and establish
territories where possible, average size 37.4 km^2 in the
Serengeti, 630.1 km^2 in Namibia. Male coalitions are
usually more successful than loners at territorial defence,
single males are more likely to be nomadic. Non-resident
males ('floaters') have larger home ranges, average 777 km^2
in the Serengeti, 1 083 km^2 in Namibia. Lifetime home
ranges for Namibian cheetahs vary from 553.9 km^2–7 063.3
km^2 for females, and 119.6 km^2 to 4 347.6 km^2 for males.

Reproduction
Gestation: 90–98 days, litters average 3–4, exceptionally
up to 9. Females can conceive from 24 months and first
give birth on average at 2.4 years (Serengeti); males
produce sperm from 12 months though rarely secure
access to females before their third year. Oestrus lasts
7–14 days, with 10–21 day cycles (average 12 days).
Breeds year round, though birth peaks have been reported
in East Africa in the rainy season (Nov–May). Cubs gain
independence from the mother at 12–20 months (average
18 months), inter-litter interval 20 months (Serengeti).

Threats and status
In terms of numbers, Africa's most endangered large cat
and extinct in Asia except for relict Iranian population.
Persecuted in much of its range over conflict with live-
stock farming, despite the fact that it causes relatively
minor damage. From 1980–1991, an estimated 10 000
cheetahs were removed from the wild Namibian
population, most by killing on livestock farms as well
as live captures for zoos. Also profoundly affected by
degradation of habitat and reduction of prey species in
pastoral areas. Eradication of prey particularly significant
in North Africa and the Sahel where recreational hunting
of desert antelopes is widespread, and cheetahs naturally
occur in low densities. Hunting for skins may be a threat
in areas where the cheetah is naturally rare, particularly
north-east Africa and Sahel regions. Listed as CITES
Appendix I, allowing four African countries to export sport
hunting trophies, live animals and a small number of skins
sold commercially: 2005 total quota 239. Trophy hunting
permitted in Botswana, Namibia and Zimbabwe. CITES
Appendix I, IUCN Red List Vulnerable (2002).

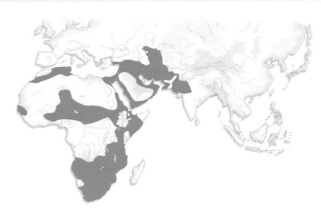

Caracal
Felis caracal

Size
The largest of Africa's smaller cats.
Females: up to 16 kg, average 8–10 kg;
total length 100–120 cm.
Males: up to 20 kg, average 10–14 kg;
total length 100–130 cm.

Longevity
Unknown from the wild; up to 19 years in captivity.

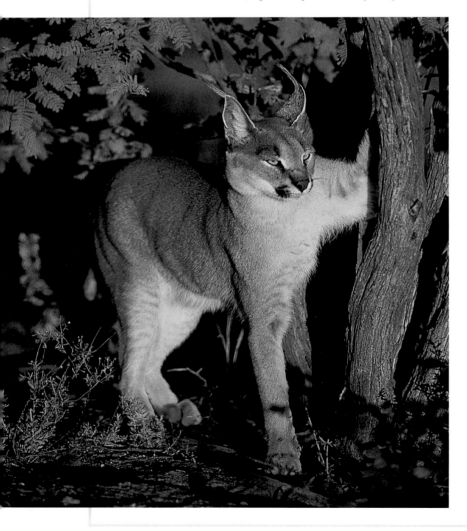

Habitat associations
Broad habitat tolerance, present in all habitat types except equatorial forest and deep interior of the Sahara. Prefers dry lowland habitats, including woodland savannas, grasslands, coastal scrub and semi-arid woodlands; most abundant in dry savannas of southern Africa. Recorded from evergreen and montane forest, and ranges up to 2 500 m (exceptionally 3 300 m). Widespread outside Africa throughout tropical and temperate Asia.

Feeding ecology
Versatile generalists, preying upon a wide variety of mainly vertebrate prey. Diet dominated by prey weighing less than 5 kg, especially small rodents, hyraxes, springhares, hares and birds, but capable of killing larger prey including adult bushbuck, grey rhebok, springbok and adult female impala. Capable of catching birds on the wing with extraordinary agility but not a bird specialist as popularly believed; in all studies, birds are secondary in importance to small mammals. Reptiles comprise 12–17 per cent of diet (West Coast National Park, South Africa); invertebrates and fish occasionally consumed. Scavenges. Sometimes recorded hoisting kills into trees (Kalahari).

Social organisation
Solitary and probably territorial with small female ranges and large male ranges. Sexes maintain home ranges which likely have exclusive core areas but overlap considerably at edges. Female territories in Eastern and Western Cape (South Africa), range between 3.9–26.7 km^2; males 5.1– 65 km^2. Mean range size of three males on north-central Namibian farmlands was 312.6 km^2, and a single Kalahari adult male had a range of 308.4 km^2 with a core area of 93.2 km^2.

Reproduction
Gestation 68–81 days, litters average 2–3, exceptionally up to 6. Females sexually mature at 14–16 months, males 12.5–15 months. Oestrus lasts 1–3 days, with 14-day cycles. Breeding weakly seasonal; birth peaks reported in South Africa Oct–Feb, and East Africa Nov–May. Kittens independent at 9–10 months.

Threats and status
Common in protected areas in East and southern Africa. Resilient to persecution on livestock land in East and southern Africa where they are difficult to extirpate despite intense persecution by farmers and official control efforts. Habitat degradation, loss of prey and human hunting are significant threats in Central, West, North and north-east Africa where caracals are naturally rare. Threatened over much of northern Africa and increasingly hunted for bush meat in West Africa. CITES Appendix II (in Africa), IUCN Red List Least Concern (2002).

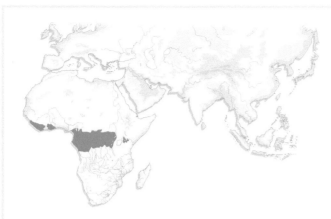

African golden cat
Profelis aurata

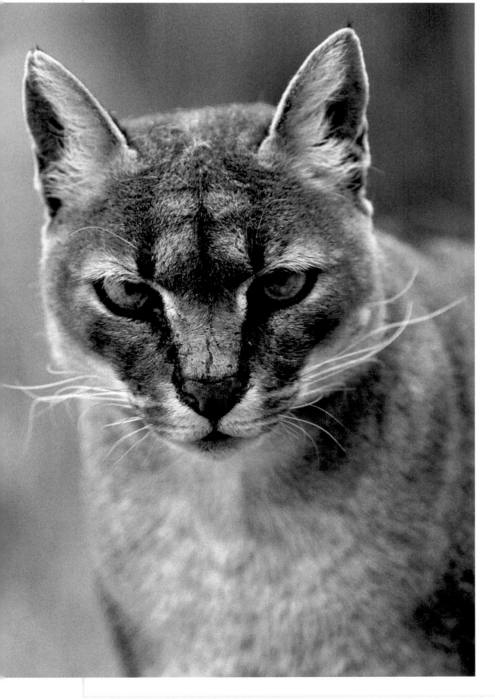

Size
Females: 5.5–8.2 kg, average 7 kg; total length 85–104 cm.
Males: 8–16 kg, average 11 kg; total length 90–125 cm.

Longevity
Unknown from the wild, up to 12 years in captivity.

Habitat associations
Endemic to Africa. Forest-dependent. Very strongly associated with moist forests, favouring undisturbed equatorial forest. Also recorded from wooded savanna, gallery forest and coastal forest. In East Africa, known from moist montane forests, bamboo forest and humid, lowland forest. Does well in abandoned logged areas, probably because of dense secondary undergrowth and elevated rodent densities. Recorded up to 3 600 m.

Feeding ecology
A wide variety of mostly mammalian prey with shrews, rodents and small forest duikers being most important; mean prey weight from Ituri forest, DR Congo was 1.4 kg. Forest primates also important but possibly scavenged from the remains of eagle kills on the forest floor. Scavenges from carcasses killed in wire snares.

Social organisation
Solitary but otherwise unstudied and very poorly known. Probably has a territorial system similar to other solitary cats, with core areas defended against same-sex adults and overlap at edges.

Reproduction
Gestation 75 days, litter size 1 or 2. Kittens weaned around 6 weeks. Female sexually mature at 11 months (captivity), male 18 months (captivity).

Threats and status
Thought to be naturally rare though no accurate data are available. Loss of habitat is the greatest threat. Marked range loss at the edges of forested equatorial Africa. West and East African moist forests are heavily degraded with large areas of former golden cat habitat converted to savanna. Bush meat hunting in West and Central Africa heavily impacts prey species, possibly driving declines of golden cats. Killed fairly frequently for bush meat and fetish markets which may further impact the species. CITES Appendix II, IUCN Red List Vulnerable (2002).

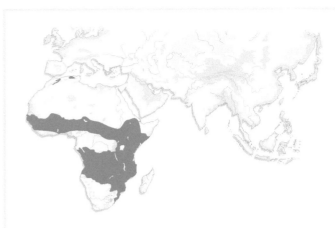

Serval

Leptailurus serval

Size
Females: up to 12.5 kg, average 8.5–11 kg; total length 93–123 cm.
Males: up to 18 kg, average 11–13 kg; total length 96–125 cm.

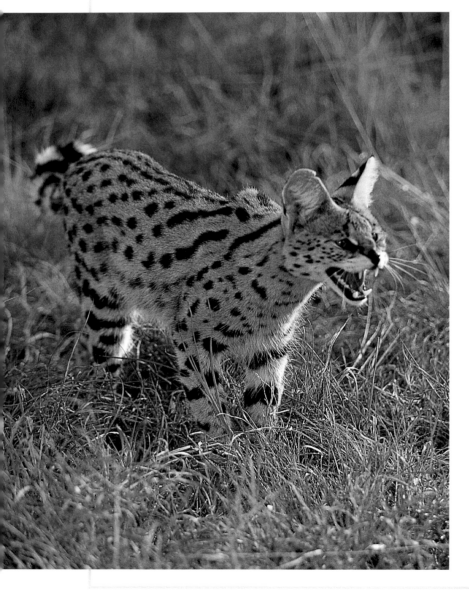

Longevity
Poorly known for wild animals; oldest recorded is 11 years (female); up to 20 in captivity.

Habitat associations
Endemic to Africa. Strongly associated with permanent water sources and requires cover such as tall grass, reeds and brush. Reaches highest densities in savanna woodlands, grasslands and forest, always in association with wetlands, flood plains and rivers. Also found in alpine grasslands (to altitudes of 3 800 m in Kenya), moorland (to at least 3 850 m near Mt Kilimanjaro) and high-altitude bamboo forests. Tolerates agricultural areas provided cover and water are present.

Feeding ecology
Specialist on small mammals, with rodents and shrews accounting for 80–93.5 per cent of diet in published studies; appear to attain high densities only where small rodents are abundant. Birds are the next most important prey item, mostly small species but occasionally up to size of flamingos and storks. Also takes hares, small antelopes, reptiles and arthropods. Scavenging is rare.

Social organisation
Solitary and territorial though tolerance of same-sex adults appears to be quite high and aggressive confrontations are uncommon. Home ranges overlap and individuals avoid one another. Female ranges smaller than male ranges. Range size is poorly known; 15.8–19.8 km^2 for two adult females and 31.5 km^2 for a male in KwaZulu-Natal, South Africa.

Reproduction
Gestation 65–75 days, litters average 2–3, exceptionally up to 6. Females sexually mature at 15–16 months (captivity), males 17–26 months (captivity). Oestrus lasts 1–4 days, with frequent cycles. Breeding appears to be seasonal, associated with rodent eruptions; Nov–Mar (southern Africa); Aug–Nov (Ngorongoro Crater). Kittens independent at 6–8 months.

Threats and status
Partially conservation dependent due to narrow habitat preference and widespread degradation of habitat. Loss of habitat is the main threat, but able to tolerate agriculture with sufficient cover, water and enlightened management. Degradation of grasslands by artificial burning regimes and overgrazing by livestock leading to lowered densities of small mammal prey is a further threat. Popular in local fur trade in north-east Africa and countries of the West African Sahel belt. Skins are traded domestically in large quantities in Senegal, Gambia and Benin. CITES Appendix II, IUCN Red List Vulnerable (2002).

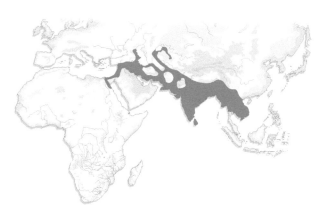

Jungle cat

(also called swamp cat, reed cat)

Felis chaus

Size
Females: up to 8.9 kg, average 6 kg; total length 85–128 cm.
Males: up to 13.2 kg, average 9 kg; total length 118–138 cm.

Longevity
Unknown from the wild, up to 20 years in captivity.

Habitat associations
At the extreme edge of its range in Africa; restricted to Egypt along the Nile valley, oases in the Western Desert and the western Mediterranean coast. Generally associated with reeds and long grasses in swamps, flood plains, wetlands, rivers and ponds, and in dense coastal vegetation. Also found in cultivated, marshy areas including sugar cane fields and bean crops. Avoids open areas. Extralimitally (south and central Asia), occurs in dry grasslands, tropical deciduous forest and evergreen forest. Widespread outside Africa throughout tropical and temperate Asia.

Feeding ecology
Primarily small rodents weighing under a kilogram, followed by birds. Also hares, fish, snakes, lizards and amphibians. Reputedly takes juvenile antelopes and wild pigs in Asia, not recorded in Africa. Stock-killing is very rare; a credible record exists of a near-adult sheep killed in Egypt.

Social organisation
Solitary but otherwise poorly known. In Israel, larger male home ranges overlap several smaller female ranges. Characteristically feline scent-marking and vocalisation suggest maintenance of exclusive core areas similar to most cats.

Reproduction
Gestation 63–66 days, litters average 2–3, exceptionally up to 6. Females sexually mature at 11 months (captivity), males 12–18 months (captivity). Breeding appears to be seasonal in Egypt; kittens are born mid-Dec to April. Kittens independent at 8–9 months old.

Threats and status
African population at limits of species distribution and threatened by habitat loss and human persecution. Destruction and development of wetland habitats is a particular threat in arid areas (including Egypt). Responds well to cultivation and artificial wetlands, provided cover is available. Widespread and common in much of south Asia. CITES Appendix II, IUCN Red List Least Concern (2002).

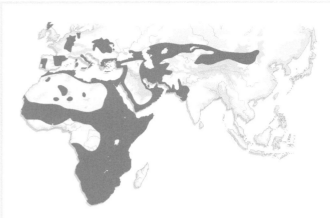

African wildcat
Felis silvestris

Size
Females: up to 5.5 kg, average 3.7–4.2 kg; total length 76–92 cm.
Males: up to 6.4 kg, average 4.9–5.1 kg; total length 85–100 cm.

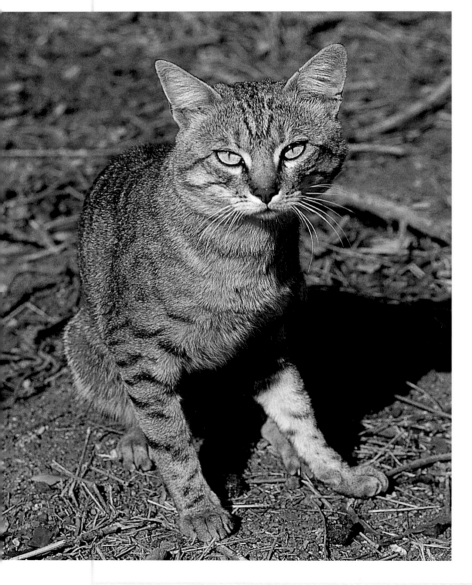

Longevity
Unknown from the wild, up to 15 years in captivity.

Habitat associations
Very broad habitat tolerance, absent only from closed equatorial forest. Probably reaches highest densities in mesic woodland savannas but also common in semi-arid desert and grassland such as the Kalahari and Sahel. Appears absent from open interior of deserts but occurs in very arid areas in association with watercourses or rocky massifs. Recorded up to 3 000 m. Tolerant of agriculture where cover is present. Species occurs widely outside Africa, in western Europe (including Great Britain), the Middle East and much of termperate and sub-tropical Asia as far east as Mongolia and China.

Feeding ecology
Small mammals especially rodents which comprise 71–82 per cent of diet in published studies (southern Africa). Birds are second in importance to small mammals. Also takes hares, rabbits, springhares and occasionally small antelope including young of gazelles; upper weight limit of prey is around 4 kg. Arthropods (especially locusts and grasshoppers) and reptiles also taken; able to switch to less preferred prey during rodent shortages. Occasionally preys upon very young domestic goat and sheep lambs; juveniles older than a week are rarely killed.

Social organisation
Solitary and thought to be highly territorial based on very frequent urine-marking by both sexes. Only published home range size is 4.3 km^2 for a Kenyan male.

Reproduction
Gestation 56–65 days, litters number 2–5, average 3. Weaned at around 8 weeks (captivity). Both sexes sexually mature at 11–12 months (captivity). Oestrus lasts 2–8 days. Captive females have produced two litters in a year. Kittens independent at 6 months, probably remain in the mother's home range until about 12 months. Breeding appears to be seasonal; birth peaks Sep–Mar (southern and East Africa), Jan–Mar (Sahara and North Africa).

Threats and status
Common and widespread but genetic integrity threatened by hybridisation with domestic cat which now occurs over most of its African range. Hybrids are prevalent anywhere near human settlements and pure wildcats are increasingly restricted to the most remote areas of the continent. Wildcats are also heavily persecuted in small-livestock areas in southern and East Africa. CITES Appendix II, IUCN Red List Least Concern (2002).

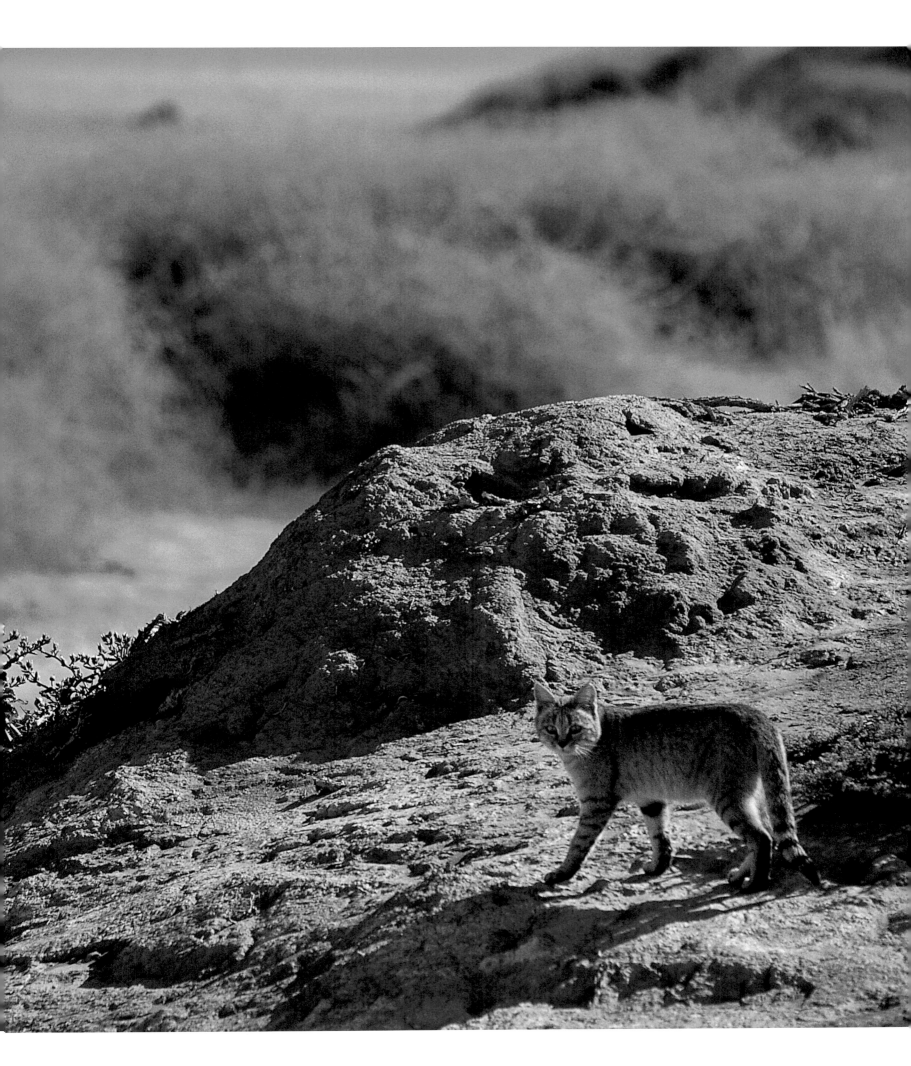

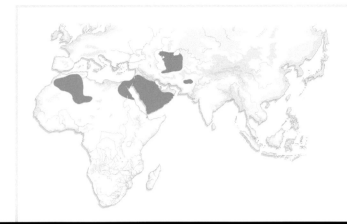

Sand cat
Felis margarita

Size
Females: 1.3–3.1 kg; total length 63–79 cm.
Males: 2–3.4 kg; total length 66–80 cm.

Longevity
Unknown from the wild, up to 14 years in captivity.

Habitat associations
A desert specialist, capable of inhabiting true desert with annual rainfall as low as 20 mm. Found in a variety of sandy and stony desert habitats, including stable dune areas, shifting dunes, wadis and in foothills of desert mountain ranges. Absent from heavily vegetated desert valleys. Found in grassed and shrub-covered steppes in central Asia.

Feeding ecology
Mainly small desert rodents especially gerbils, spiny mice, jirds and jerboas. Also young hares, small birds, reptiles (especially snakes) and invertebrates. Independent of drinking water.

Social organisation
Solitary. Unknown if territorial, possibly only weakly so if arid habitats determine low densities and large ranges. Three male ranges in Israel overlapped extensively. Only published range size is a male 16 km^2 (Israel).

Reproduction
Gestation 59–67 days. Litter size 2–8, average 3. Weaned around 5 weeks, sexually mature 9–14 months. Oestrus lasts 5–6 days, with 46 day cycles (captivity). Breeding is seasonal in the Sahara; mating Nov–Feb, kittens born Jan–April. Kittens are possibly independent very young; one record exists of 4–5 months.

Threats and status
Naturally probably occurs in low densities but their preferred habitat is so remote that they are somewhat insulated from human activities (at least in Africa). Expansion of cultivation projects into desert areas constitutes a threat, combined with associated feral animals, particularly domestic cats and dogs which may kill sand cats. They are sometimes caught around human habitations in traps set for jackals and foxes. CITES Appendix II, IUCN Red List Near Threatened (2002).

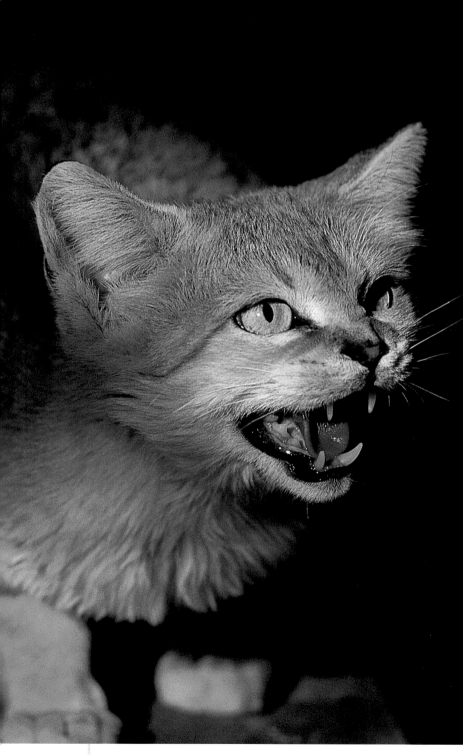

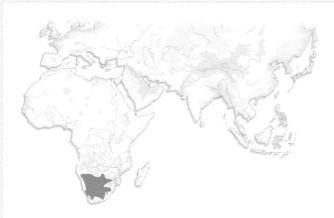

Black-footed cat
Felis nigripes

Size
Females: 1–1.7 kg, total length 50–57 cm.
Males: 1.5–2.5 kg, total length 55–69 cm.

Longevity
Up to 16 years in captivity, probably less than
half this in the wild.

Habitat associations
Endemic to southern Africa. Strongly associated with
open, short grass habitat, open savannas and Karoo scrub
and semi-desert. Requires some cover and absent from the
open, arid interior of the Kalahari and Namib deserts.

Feeding ecology
Primarily small rodents less than 100 g, followed by small
birds. Also reptiles, amphibians, birds' eggs and inverte-
brates. Largest prey on record is Cape hare; unsuccessful
attempts recorded on resting juvenile springboks.
Independent of drinking water.

Social organisation
Solitary and territorial; urine-mark and vocalise
frequently, and range overlap within sexes is limited.
Female ranges average 8.5 km^2 and male ranges average
16.1 km^2. Individual male ranges encompass up to
4 female ranges. Males guard oestrous females and
fight intruding males.

Reproduction
Gestation 68–81 days, litters average 2–3, exceptionally
up to 6. Females sexually mature at 7 months, males
9 months (captivity). Oestrus lasts 36 hours, with 54-day
cycles. Kittens independent at 3–4 months, and up to 2 litters
may be produced in a year. Breeding in South Africa appears
seasonal; birth peaks occur in spring and summer,
coinciding with rains and food availability.

Threats and status
Probably naturally uncommon to rare. Threats include
expansion of agriculture into semi-arid areas, and human
activities that impact rodent and insect populations,
including overgrazing, burning and use of insecticides.
Killed during control activities with use of poisoned baits,
coyote-getters, leg-hold traps and night-shooting. CITES
Appendix II, IUCN Red List Vulnerable (2002).

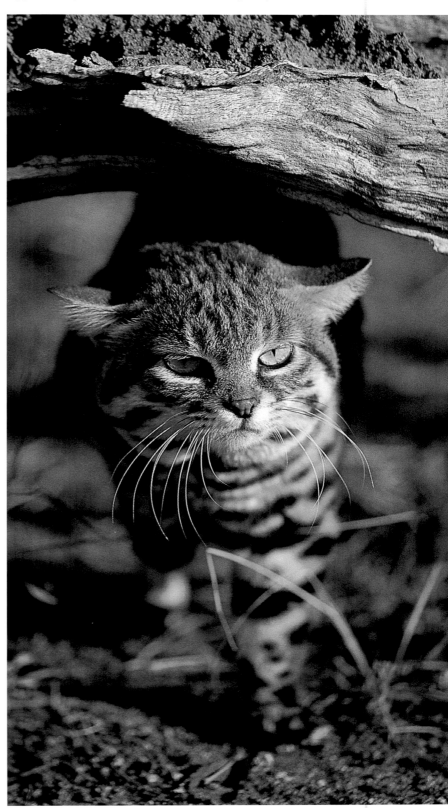

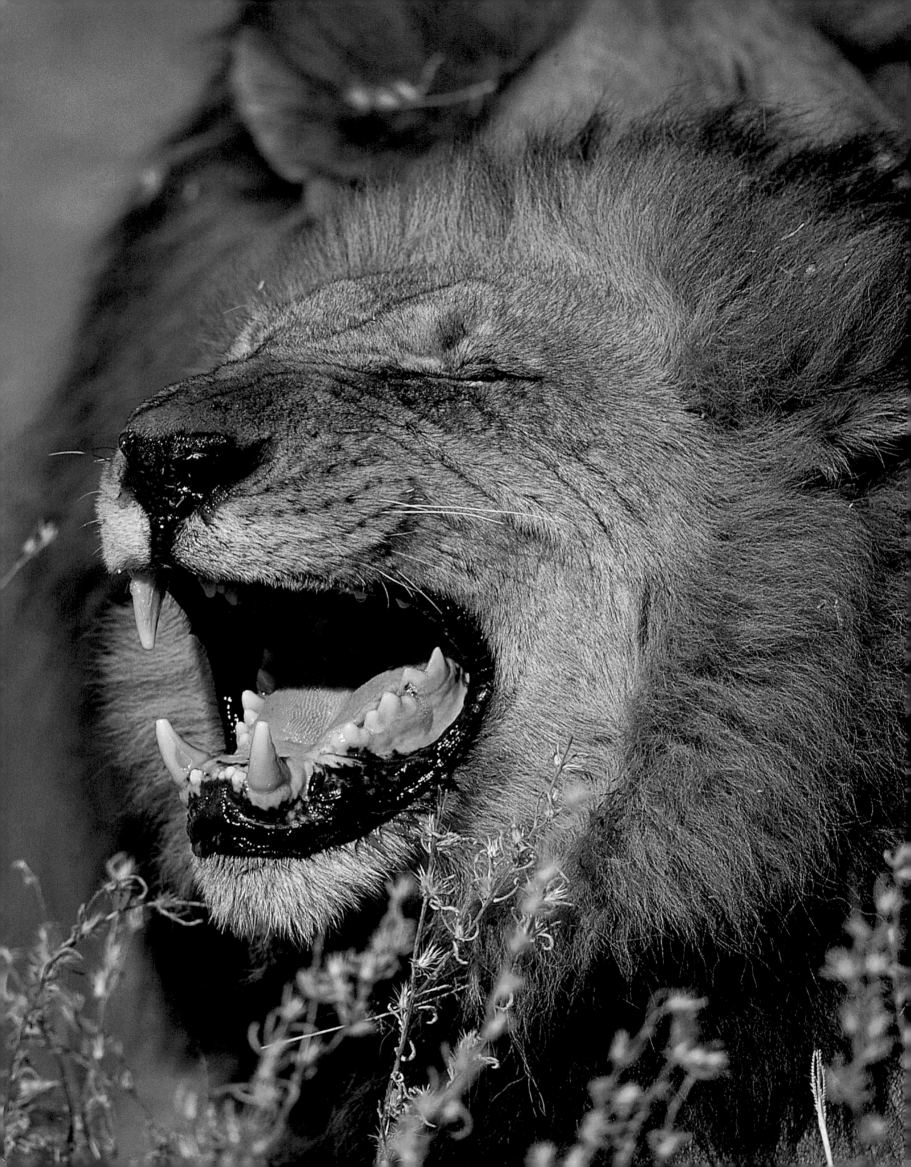

1

THE FELINE DESIGN

evolution, anatomy
and action

The key to carnivory

All cats are carnivores – they eat meat – but the label signifies far more than their diet. Any animal that eats meat can be described as carnivorous (even some plants are carnivorous), but to a biologist, this does not make it a carnivore. That designation belongs solely to the members of the order Carnivora. There are approximately 5 416 recent mammals, which are classified into 29 different orders based on their evolutionary relationships. Our own, the order Primates, includes some 376 species ranging from bushbabies to humans and, although many primates eat meat, this does not warrant their being classified as carnivores. The order Carnivora comprises the true carnivores, some 286 mainly predatory species which, despite astonishing variation in size and shape, are united by their shared evolutionary origins. The smallest carnivore in the world, the tiny least weasel of North America and Eurasia, is slender enough to squeeze through a wedding ring and weighs 10,000 times less than the largest terrestrial species, the polar bear. The carnivores make up one of the largest mammalian orders, are found on every major landmass, including Antarctica, and occur from the hyper-arid interior of the Sahara to the polar snows of the Arctic.

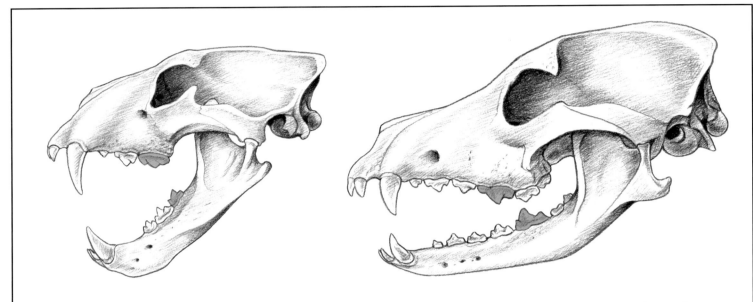

Skull of leopard (LEFT) and dog (RIGHT), with the carnassials indicated (in orange). The shortened felid jaw accommodates only specialised meat-eating teeth, whereas the dog retains a more diverse dentition with a full battery of premolars in front of the carnassials and two pairs of crushing molars behind the carnassials.

What makes them all carnivores? The answer lies in their unique cheek teeth, a modification of the mammalian molar (technically, the last upper pre-molar and the first lower molar) into a pair of flattened cutting shears called the carnassials. Like the blades of scissors, the carnassials slide closely past one another, slicing off chunks of meat as efficiently as a knife. To taxonomists, the scientists who classify species, the carnassials provide an unmistakable diagnostic attribute of the true carnivore. A number of modern species such as giant pandas, sea otters and aardwolves lack obvious carnassials (explained below) but their ancestors possessed them, as do some of their living relatives; they are clearly carnivores, even if some of them no longer eat meat. As we will see in this chapter, the carnassial not only connects all carnivores to one another but, far more importantly, it allowed them to become the dominant group of predatory mammals on the planet.

The carnivore carnassial made its appearance in a rather inconspicuous group of small predators called the miacids. First recorded from the fossil record of the northern hemisphere around 60 million years ago, miacids were slender, small-bodied forest dwellers with skeletons very similar to those of modern genets. They had supple spines, long tails, retractile claws and a somewhat opposable first digit on the front foot, a set of characters well suited to the dense forests that dominated the Earth at the time. They were equipped for an arboreal lifestyle and were able to hunt in the tree-tops, though most likely they also spent considerable time foraging on the ground. Miacid teeth were very similar to those of the modern African palm civet and, like the civet, miacids were generalists. Their carnassials efficiently processed small vertebrate prey such as small mammals, birds and reptiles, but their dentition had not progressed so far along

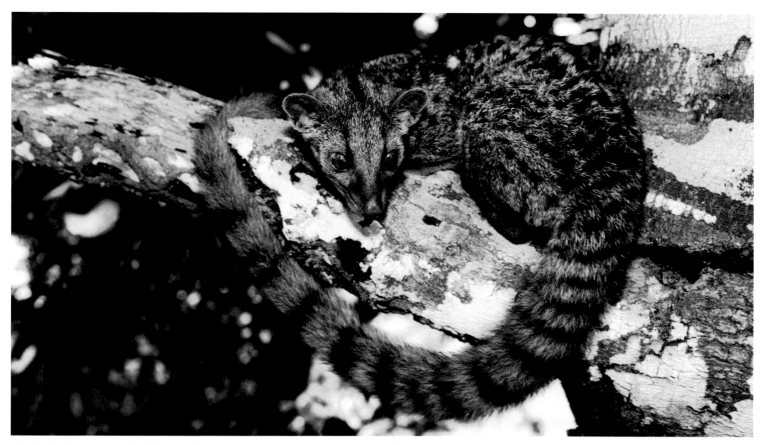

A 'primitive' carnivore, the African palm civet. Here, primitive does not imply inferiority but rather indicates that the civet has retained many features of anatomy and ecology that arose early in carnivore evolution. Their persistence demonstrates that, in fact, such features are well suited for survival.

the carnivoran specialisation that they could not also cope with a more omnivorous selection that included invertebrates, eggs, fruit, nectar and seeds.

In fact, while the emergence of the carnassial would be fundamental to the predatory success of the carnivores, most species – fossil and living – actually consume a varied diet like that of their miacid ancestors. This dietary spread reflects an evolutionary plasticity thought to be the reason the carnivores have proliferated while other mammals that followed a predatory path declined and, in most cases, died out. Again, the key lies in their carnassial dentition, yet numerous other mammalian groups have evolved a similar battery of meat-shearing teeth. Why is the carnassial so special?

The carnassial not only connects all carnivores to one another but, far more importantly, it allowed them to become the dominant group of predatory mammals on the planet.

Reconstruction of a miacid, the earliest carnivore type. Miacids were similar in anatomy and lifestyle to primitive carnivores living today, such as the African palm civet and probably shared a similar diet of small vertebrate prey, invertebrates, eggs and some plant matter.

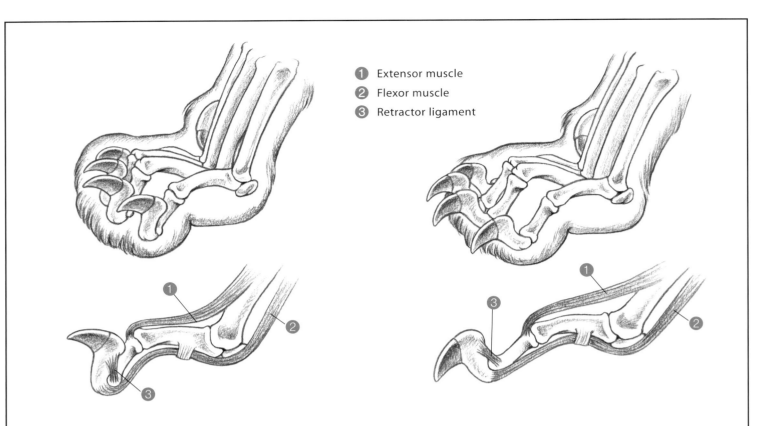

1 Extensor muscle
2 Flexor muscle
3 Retractor ligament

ABOVE AND BELOW: Retractile claws. Retraction is actually the relaxed condition (as in this sleeping lioness' foot, BELOW LEFT), in which the elastic retractor ligament automatically withdraws the claw when it's not in use. To extend the claws, the flexor muscles contract powerfully against the action of this ligament and contraction of the extensor muscles holds the digit firmly in the extended position. The action is more accurately termed protractile, meaning actively extended. Cheetahs (BELOW RIGHT) retain the ability to protract their claws but it is poorly developed and they lack the protective claw sheaths seen in other cats, so their claws protrude conspicuously even when relaxed.

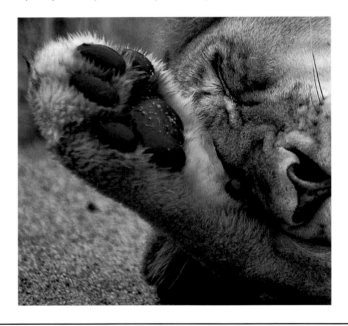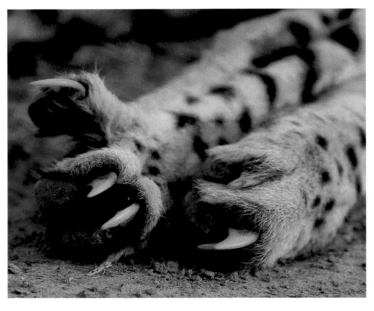

Evolutionary biologists think it has to do with the position of the shearing teeth. In true carnivores, the carnassials are located in the middle of the tooth row, in front of the rear crushing teeth, the posterior molars. In other mammals that experimented with carnivory as a way of life, it was these rear molars that were modified into the flattened slicing form suitable for dealing with meat.

The advantage for the carnivores was adaptability. With the carnassials responsible for shearing, the rear molars were free to follow various evolutionary routes closed to those predators that used them for processing meat. The molars of carnivores could become more robust, with reduced shearing edges and greater crushing surfaces, enabling bones, insects, seeds, fruit and plant matter to be exploited. The result, a dual-purpose

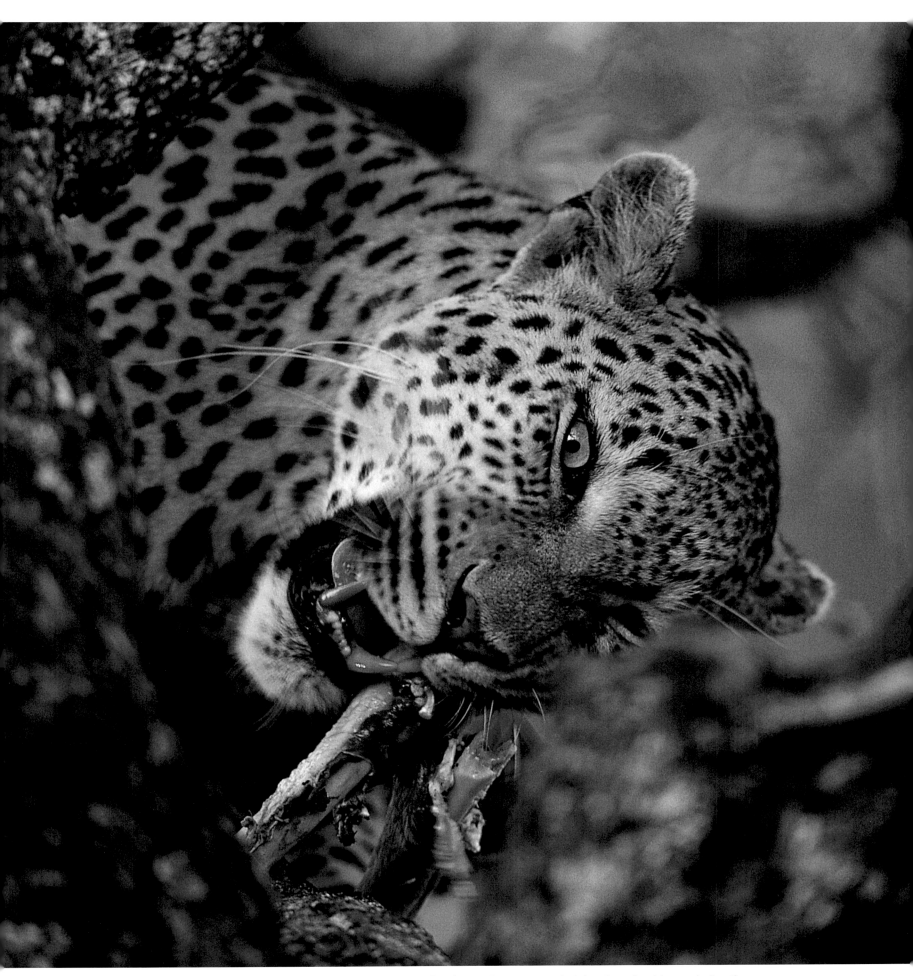

A feeding leopard displays the action of the carnassials. When eating, cats turn their heads to the side, employing the carnassials in a slicing action that shears off chunks of meat to be swallowed with little additional chewing.

dentition that both shears and crushes (using the carnassials and molars respectively), is typified in dogs; in fact most modern carnivores have elements of both. From this arrangement, the transition to an even more herbivorous diet is possible: the carnassials themselves gradually become less blade-like and more like molars, well equipped to deal with tough vegetation. In a handful of species, such as the giant panda and red panda (which actually belong to different carnivore families; see box below), the carnassial shear has been lost entirely and they are completely herbivorous.

In the alternative evolutionary route, the rear molars undergo gradual reduction until there is little crushing ability and the dentition is dominated by the carnassials (teeth that can handle only meat). This hyper-carnivorous type is most developed in the cats (but is not exclusive to them); modern cats have lost their rear molars or retain them only as residual useless pegs.

Carnivore families

All modern carnivores trace their origins back to the miacids, with the carnassial specialisation an unambiguous and unbroken connection. Today's 286 species of carnivores are classified into 15 families. Each family comprises a group of species more closely related to one another than to the members of the other families which, in most cases, is obvious; all cats belong to one family, the dogs to another and so on. The 15 families are further grouped into two major divisions (known as suborders) reflecting a major separation that occurred early in miacid evolution.

The dog sub-order (Caniformia) is made up of dogs, bears, raccoons, red pandas, weasels, skunks, seals, sea lions, and walruses, and the cat sub-order (Feliformia) comprises cats, hyaenas, genets, African palm civets, Malagasy civets, and mongooses. This illustrates, for example, that despite their dog-like appearance, hyaenas are actually more closely related to cats than to the canids.

The classification of carnivores is still hotly debated. Seals, sea lions and walruses are sometimes accorded their own full order, the Pinnipedia, though they clearly belong on the Caniformia branch of carnivore evolution. A few carnivore families are contentious; walruses are sometimes grouped with fur seals, and some recently reclassified families (such as red pandas and African palm civets) are not yet accepted by all authorities*. Even the number of species remains unclear, with the cat family a case in point. Depending on the authority, there are between 36 and 40 cats; see the cat phylogeny chart on page 44 for details.

* The classification presented here follows the standard reference for mammals, Wilson & Reeder (2005).

FELIFORMIA

Family Felidae – cats, 40 species; size: rusty-spotted cat and black-footed cat (1–2.5 kg*) to tiger (258 kg).

Family Herpestidae – mongooses, 33 species; size: dwarf mongoose (320 grams) to white-tailed mongoose (5.2 kg).

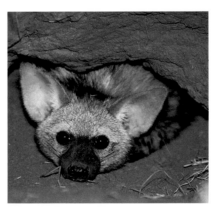

Family Hyaenidae – hyaenas, 4 species; size: aardwolf (8–10 kg) to spotted hyaena (82.5 kg).

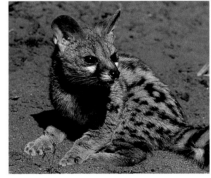

Family Viverridae – genets and civets, 35 species; size: spotted linsang (600 grams) to binturong (19 kg).

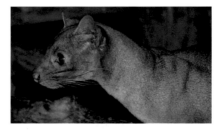

Family Eupleridae – Malagasy civets and mongooses, 8 species; size: broad-striped mongoose (500–600 grams) to fossa (20 kg).

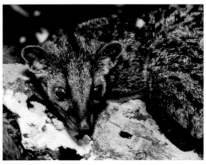

Family Nandiniidae – African palm civet, 1 species; size: 5 kg.

The flexibility of the carnassial-molar combination was the evolutionary catalyst enabling the carnivores to rise to dominance over other, early mammals that had committed their rear molars to carnivory. Ironically, it was the carnivores' ability to exploit food sources other than meat that probably catapulted them ahead in the evolutionary race and indeed, the more generalist, dual-purpose dentition as seen in dogs has always been the most widespread combination in carnivore evolution.

The hyper-carnivorous specialisation in the cats makes them the most predatory of carnivore families (see Chapter 2) and, as we will see later, perhaps the most vulnerable to extinction.

BELOW: TOP ROW, LEFT TO RIGHT: tiger, dwarf mongoose, gray wolf, white-nosed coati, Cape fur seal. MIDDLE ROW, LEFT TO RIGHT: aardwolf, large-spotted genet, walrus, brown bear, Cape clawless otter. BOTTOM ROW, LEFT TO RIGHT: fossa, African palm civet, harbour seal, red panda, striped skunk.

CANIFORMIA

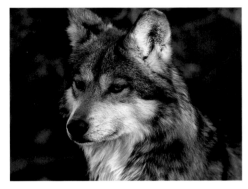

Family Canidae – dogs, 35 species; size: fennec fox (1 kg) to gray wolf (75 kg).

Family Procynonidae – raccoons and coatis, 14 species; size: ringtail (0.8–1 kg) to common raccoon (15 kg).

Family Otariidae – sea lions and fur seals, 16 species; size: Galapagos fur seal (75 kg) to Steller sea lion (566 kg).

Family Odobenidae – walruses, 1 species, size: (1 210 kg).

Family Ursidae – bears (including giant panda), 8 species; size: sun bear (65 kg) to polar bear (500 kg).

Family Mustelidae – weasels, martens, badgers and otters, 59 species; size: least weasel (30–70 grams) to sea otter (45 kg).

Family Phocidae – true seals, 19 species; size: Caspian seal (50–60 kg) to southern elephant seal (3 700 kg).

Family Ailuridae – red panda, 1 species; size: 6 kg.

Family Mephitidae – skunks, 12 species; size: spotted skunk (1 kg) to hog-nosed skunk (4.5 kg).

* Weights represent upper range of wild, adult males, except for spotted hyaenas in which females are larger.

The dawn of the cats

The exact origin of the cats from their miacid ancestors is obscured by millions of years without fossils. Nonetheless, we can be fairly certain that while carnivores arose about 60 million years ago, cats have been on the scene for only about half as long. Miacids had been following a variety of evolutionary routes that would ultimately lead to all modern families of carnivores for at least 30 million years before a species appeared that was clearly a cat. It was called *Proailurus*, the 'dawn cat'. The oldest fossils of *Proailurus* come from modern-day Eurasia which, together with a handful of European miacids that are clearly the ancestors of the cat sub-order Feliformia, places the origin of the cats firmly in the Old World.

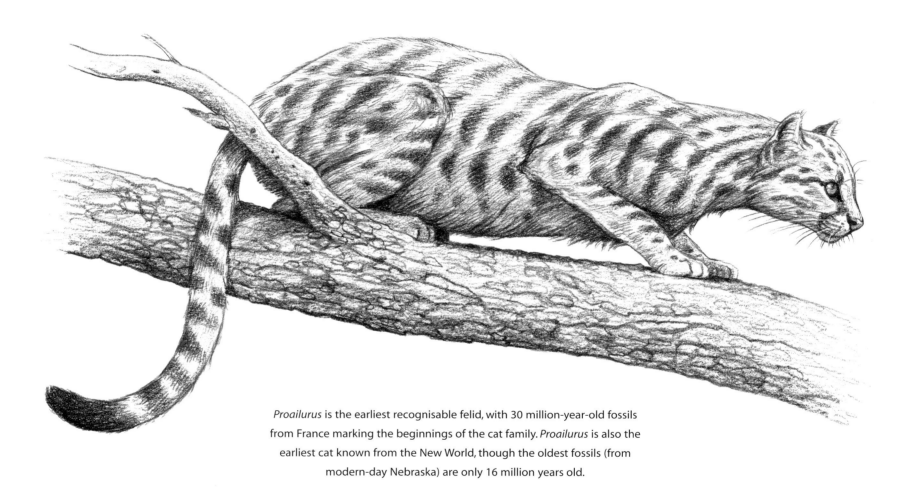

Proailurus is the earliest recognisable felid, with 30 million-year-old fossils from France marking the beginnings of the cat family. *Proailurus* is also the earliest cat known from the New World, though the oldest fossils (from modern-day Nebraska) are only 16 million years old.

The robustly built dawn cat was about the size of a male caracal but it had some features unlike any modern felid. Chief among them, *Proailurus* had more teeth; although its carnassials were characteristically feline, the dawn cat had not yet lost the rear molars of its miacid ancestors. Similarly, the dawn cat's body plan falls somewhere between miacids and cats, with a suite of adaptations suggesting it was more arboreal than most felids: supple ankles and wrists capable of wide rotation to grasp branches, a sinuous, elongated back suited for vertical as well as horizontal movement, and a stance that used the heels as well as the toes, increasing the area of the foot in contact with branches. Although there is no cat alive today with the same combination of features, the closest modern analogue is a distant cat relative, the fossa. Largest of the viverrid family

and restricted to Madagascar, the fossa looks feline enough to have originally been classified as a cat. Fossas hunt on the ground but are equally adept at climbing and leaping from branch to branch in pursuit of tree-living prey such as lemurs. *Proailurus* probably did likewise, pursuing a lifestyle more arboreal than that of any cat today.

Following the appearance of the dawn cat, there is little in the fossil record for 10 million years to suggest that cats would prosper. In fact, although *Proailurus* persisted for at least 14 million years, there are so few felid fossils towards the end of the dawn cat's reign that palaeontologists refer to this period as the 'cat gap' (between 23 and 17 million years ago). Filling the vacuum, other carnivore families fielded their own experiments in hyper-carnivory. Dogs, bears and hyaenas as well

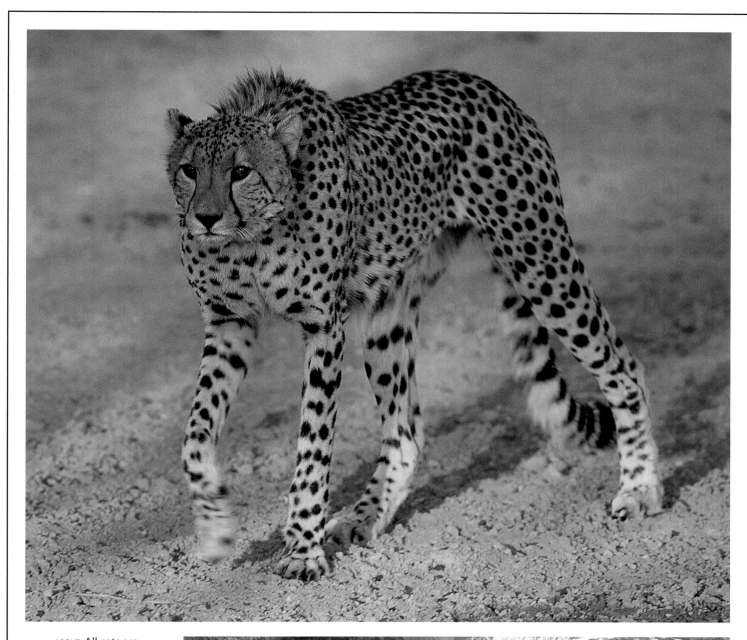

ABOVE: All cats are digitigrade, meaning they walk on their toes. In comparison, plantigrade carnivores such as this brown bear (RIGHT) walk using the entire foot – similar to the way humans place their feet.

as two extinct carnivore families, the nimravids or paleo-cats (family Nimravidae) and the bear-dogs (family Amphicyonidae), all evolved cat-like forms to occupy the vacant felid niche. The turning point for the cats came about with the appearance of a new genus of felids, *Pseudaelurus*.

Pseudaelurus (a misnomer meaning 'false cat') is probably descended directly from the dawn cat but had lost some of its progenitor's more ancient features. Like modern cats, *Pseudaelurus*' rear molars were greatly reduced and it walked on its toes (digitigrade), perhaps slightly less so than most modern species but just enough for a palaeontologist to discern the difference. It still had the dawn cat's elongated spine but otherwise, it would have been very reminiscent of a small leopard.

The emergence of *Pseudaelurus* heralded a new era in the evolution of the cats. From the mid-Miocene around 17 million years ago, the numbers of felid species appearing in the fossil record increased rapidly. At the same time, the number of cat-like species from other carnivore families declined. It is not clear why the true cats suddenly became so good at being cats, but they evidently out-shone all other families in the competition for hyper-carnivory. Almost certainly, global climate change contributed to their success. The world had been undergoing a gradual cooling and drying for millions of years at the time *Pseudaelurus* arrived, so that the humid, dense forests during the time of *Proailurus* were giving way to open savanna woodlands and plains. Ungulates, primates, rodents and birds emerged from the forests, evolving into a multitude of new forms to exploit the abundant grasses, seeds

African sabre-tooths

Based on the relative numbers of fossils, sabre-toothed cats dominated conical-toothed species in Africa for over 15 million years. At least eight species of large sabre-tooths are known from Africa, ranging in size from slightly smaller than a leopard to as large as a male lion. One of the most specialised was *Megantereon*, about the size of a large, powerfully built leopard. *Megantereon* had proportionally the longest canines of any African sabre-tooth and is thought to have killed its prey with a canine shear bite – inflicting a deep, massive wound to the throat or abdomen to sever vital blood vessels. Ungulates were probably held with the bite until they succumbed to blood loss or suffocation (much as modern big cats kill their prey), but the technique might also have been effective against juvenile mega-vertebrates such as elephants, rhinos and their extinct relatives. By speedily inflicting a devastating shear bite and retreating in the face of irate parental defence, *Megantereon* could simply wait until the injured calf died of blood loss before moving in to claim its meal. *Megantereon* and at least two other species of African sabre-tooths occurred alongside modern cheetahs, leopards and lions for two million years before dying out around 1.5 million years ago.

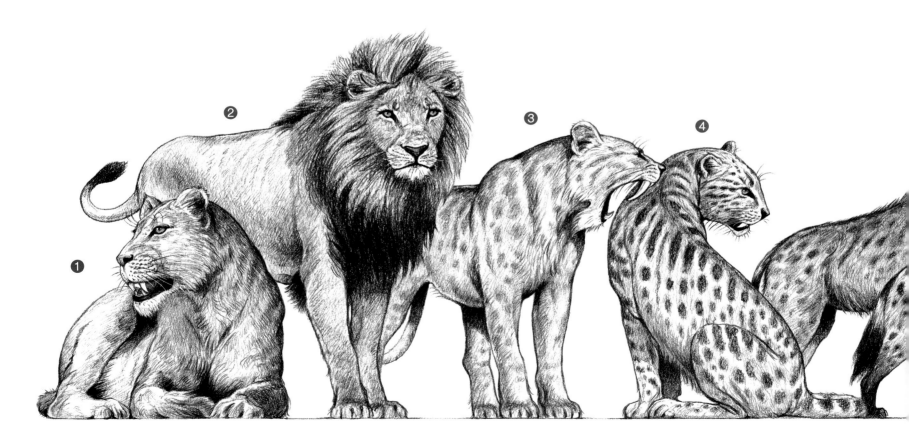

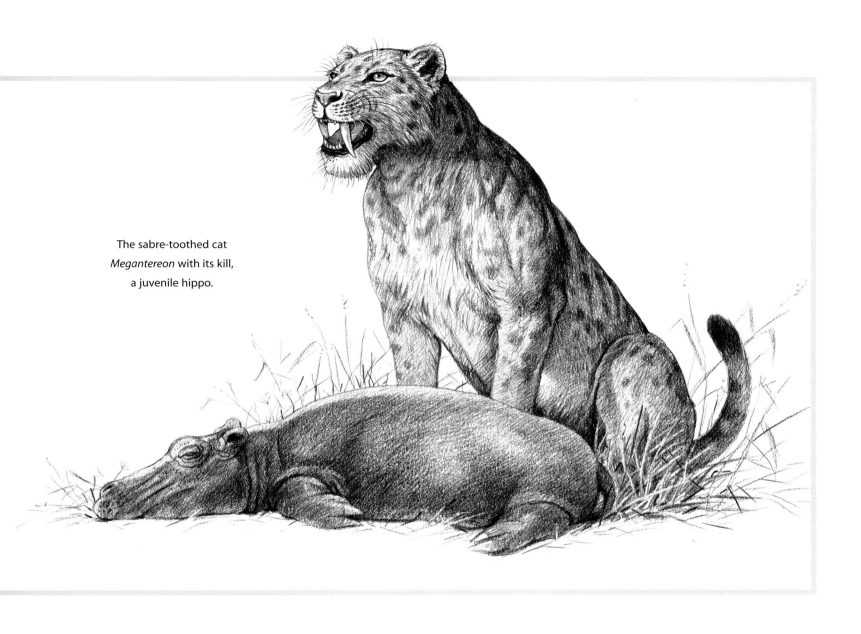

The sabre-toothed cat
Megantereon with its kill,
a juvenile hippo.

The African large carnivore guild around three million years ago. Living species: lion ②, spotted hyaena ⑥, leopard ⑦, cheetah ⑧ and striped hyaena ⑨. Note – the modern African wild dog and brown hyaena did not appear on the scene until more recently. Extinct species: the sabre-toothed cats *Homotherium* ①, *Megantereon* ③, *Dinofelis* ④, the giant hyaena *Pachycrocuta* ⑤ and the hunting hyaena *Chasmaportethes* ⑩.

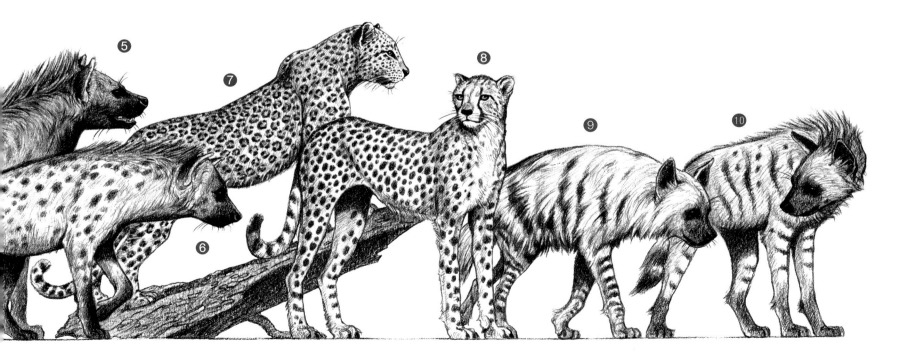

The phylogeny of the cats

Living cats comprise eight distinct lineages which began separating from their shared *Pseudaelurus* ancestors around 11–12 million years ago, but the finer classification of the cat family is still disputed. Most biologists agree on a minimum of 36 species but three forms are controversial. Based on significant morphological differences in skulls, teeth and pelage (coats), the South American colocolo is now classified as three species, although limited genetic analysis suggests they represent sub-species. Similarly, an isolated island population of the Asian leopard cat, the Iriomote cat, displays some unique characteristics but also great similarities to its mainland progenitor; in taxonomic terms, it is tentatively regarded as a species *incertae sedis*; 'of uncertain position'.

Finally, taxonomists argue over the domestic cat and its wild forebear, the wildcat. Selective breeding of the house cat has spawned sufficient morphological disparities to classify it separately although genetic data (and the fact that domestic and wild forms interbreed to produce fertile offspring) suggest it is still the same species as the wildcat.

The debates reveal the problems in classifying species. Speciation takes place very gradually over millennia in which behavioural or ecological factors eventually give rise to reproductive separation. Ultimately, geographic isolation among the various populations of the colocolo group, or between Iriomote and leopard cats will probably result in clear differentiation – morphological and genetic – resolving the dispute for future taxonomists. In the meantime, new and improved analytical techniques – particularly concerning molecular differences – help to continually refine the classification of cats.

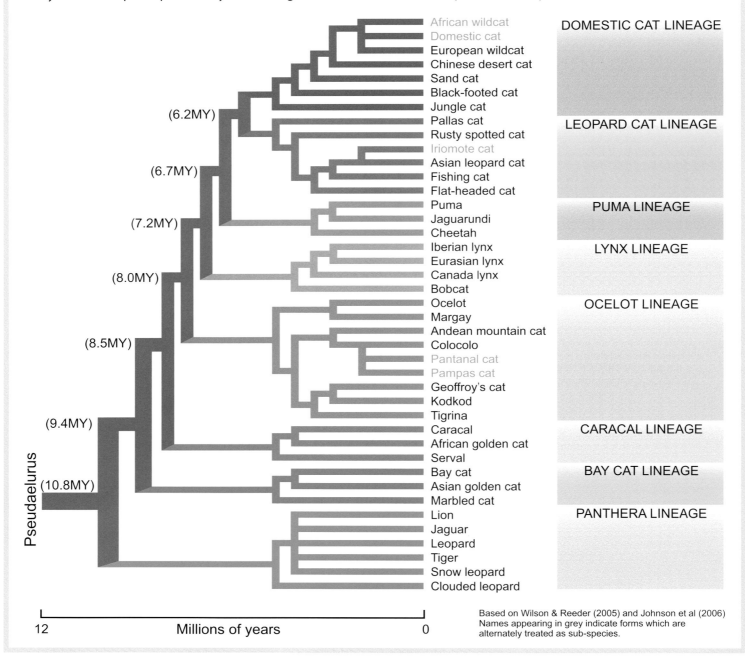

Based on Wilson & Reeder (2005) and Johnson et al (2006)
Names appearing in grey indicate forms which are
alternately treated as sub-species.

and tubers that arose in open habitats. *Pseudaelurus* followed them and, as its prey species evolved larger body size and greater speed to evade predators in open habitats, so too did *Pseudaelurus*. By around 15 million years ago, *Pseudaelurus* had evolved into a number of species with a global distribution.

The rapid radiation of *Pseudaelurus* laid the evolutionary foundations that would lead to all true cats, including every species living today and many extinct ones. *Pseudaelurus* was also responsible for seeding Africa with felids, with the earliest evidence of cats on the continent coming from modern-day Libya. As everywhere, the fossil record of cats in Africa is patchy, but it is clear that, until very recently, it was dominated by the sabre-tooths (see text box 'African sabre-tooths', pages 42–43). Sabre-toothed cats belong with all modern species in the family Felidae, but they represent an ancient lineage which diverged from the evolutionary route that would lead to today's cats. Both lineages arose from a shared *Pseudaelurus* ancestor about 15 million years ago, but only one of them developed the spectacularly elongated canine teeth known as sabres. The sabre-tooth lineage spawned a host of remarkable species, which are grouped together in their own felid sub-family, the Machairodontinae. The other group retained the conical tooth shape of its *Pseudaelurus* forebears, leading eventually to all modern cats (sub-family Felinae).

Compared to their sabre-toothed cousins, fossil evidence of the conical-toothed cats in Africa is sparse and we know very little about the immediate ancestry of today's African cats. Surprisingly, given that large species usually leave more fossils, Africa's three largest cats – the lion, leopard and cheetah – are the most mysterious. There are no obvious ancestors in the fossil record, until all three species appear at the same time in Tanzanian deposits that date back around 3.5 million years. Some older fragments may represent earlier appearances or possibly even evidence of their immediate ancestors, but none of the material is intact enough to be sure. Except for their ancient beginnings, we do not know how Africa's cats arose.

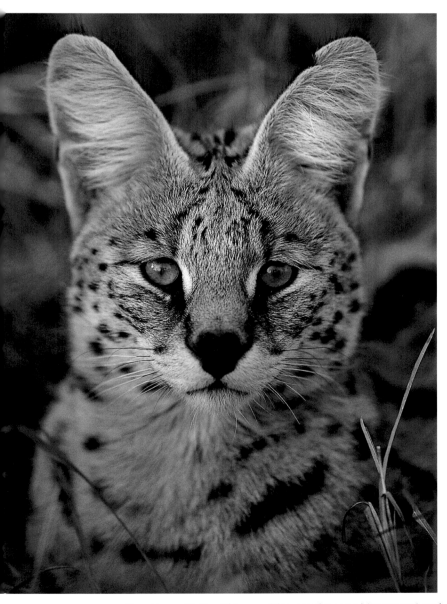 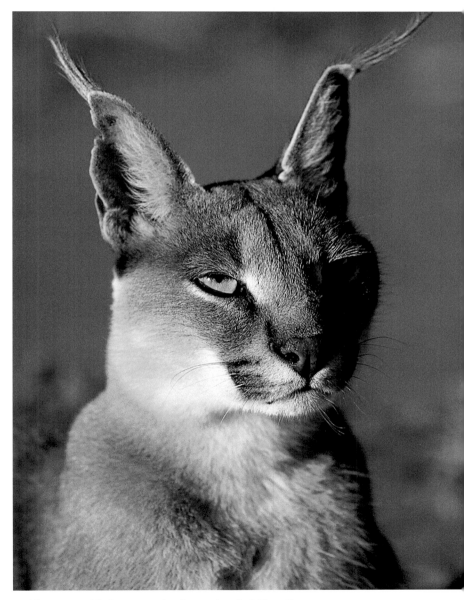

Together with the African golden cat, the serval (ABOVE LEFT) and caracal (ABOVE RIGHT) belong together in a uniquely African lineage descended from a common progenitor that arrived from Eurasia some 8.5–5.6 million years ago.

Physical adaptations: being a cat

As the most carnivorous of carnivores, cats are supremely well adapted to procuring their meals. Compared to abundant, accessible foods such as insects, grass or leaves, meat is scarce; so cats have to be well equipped to locate their prey without being detected themselves. Once found, the potential meal is usually highly mobile, armed with teeth, horns or antlers to defend itself; and it is often much larger than its hunter. Cats must capture and overpower their prey quickly and efficiently to avoid going hungry or, in the worst scenarios, incurring potentially fatal injuries from formidable prey. The physical challenge of being a cat is answered by a suite of anatomical and morphological specialisations that makes them the most exquisite of stealth hunters.

The framework: skeleton and skull

Africa's cats are remarkably varied. They range from the tiny black-footed cat, with a top weight of 2.5 kg, to the lion, 100 times as heavy. They can be tall and slender like the cheetah and serval, small and squat like the sand cat, or athletically robust like the leopard and golden cat. They vary in size, colour, build and even the relative length of their tails; sinuously long and 'typically' feline in most species, but oddly truncated in jungle cats, servals and caracals.

In spite of their apparent differences though, all cats are built along very similar lines. Discounting size, the skeletons of cats are surprisingly uniform, with the differences between lion and black-footed cat, or sand cat and cheetah, representing minor variations on a successful theme. Regardless of species, the feline skeleton delivers speed to run down prey and strength to subdue it. However, this presents an immediate biomechanical impasse, as adaptations for speed tend to counter those for strength. The feline design is an efficient compromise between the two, meaning that most cat species tend to be very fast and very strong for short bursts, but lack endurance in either. Cats are built for explosive effort. They cannot run down prey over long distances as can members of the dog family, nor can they spend hours excavating it, as do bears or badgers.

Compared to many mammals, cats have long, slender and relatively light legs, an adaptation for speed; long, lightweight legs translate to longer strides, increasing the ground covered for any given step. Like other cursorial carnivores such as hyaenas and dogs, the main bones of the felid limb are long and the bones of the foot (collectively called metapodials) are greatly elongated. As discussed earlier, all modern cats are digitigrade, which further increases the length of the limbs; to provide stability in this stance, the metapodials are fused together in a rigid assemblage. As one would expect, the cheetah shows the greatest sophistication of these refinements. It is the only cat in which

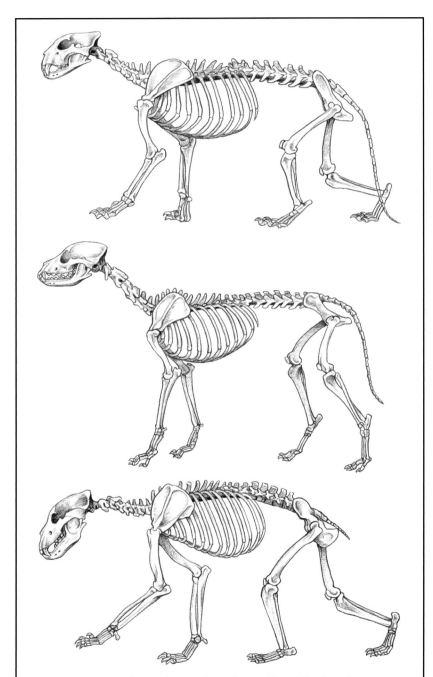

TOP TO BOTTOM: The skeletons of cat, dog and bear. With long limbs, digitigrade stance and a relatively stiff spine, the dog is lightly built for endurance running. The bear's heavy limbs and robust build reveal a combination of great strength and endurance but poor speed. The cat skeleton is the efficient middle ground, with adaptations for explosive bursts of both speed and strength but lacking in endurance.

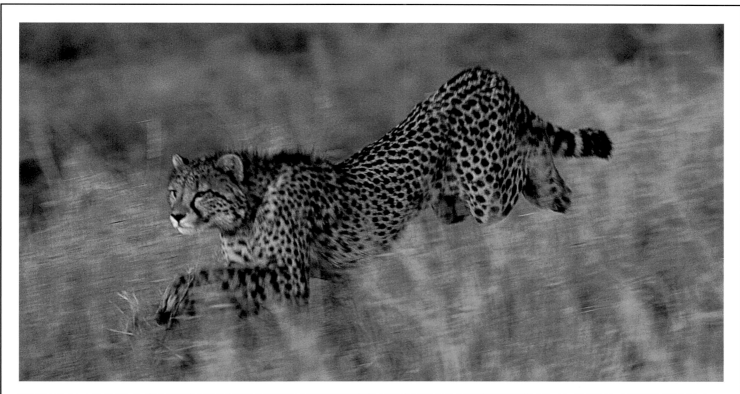

Although similar in size, cheetahs (TOP) and leopards (ABOVE) have strikingly contrasting builds, reflecting adaptations geared towards speed and power respectively. Cheetahs have longer, slimmer legs, a longer tail for balance, and a longer, flexible spine to furnish a speed that exceeds 100 km/h. The leopard's shorter, less flexible but more powerfully built limbs and spine limit its top speed to around 60 km/h but deliver far greater strength for tackling larger prey and climbing.

the main bones of the front leg, the humerus and radius, are the same length; a leopard's radius is about 85 per cent the length of its humerus, furnishing it with considerably greater strength but a shorter stride than the cheetah.

All cats have lost the clavicle (collarbone) or retain it as a vestigial 'floating' bone, so that the front limbs hang free in sturdy, muscular slings supported from the spine and ribs, able to pivot unhindered on the scapulae (shoulder blades). This permits a greatly increased range of movement in the front legs, which different cats put to different use; in cursorial species like the cheetah, greater movement enhances the length of the stride, whereas for more arboreal species such as the leopard, it allows greater mobility for vertical movement. The *shape* of the scapula – elongate in the cheetah, broad and shallow in the leopard – reflects how their different lifestyles put the front limbs to use.

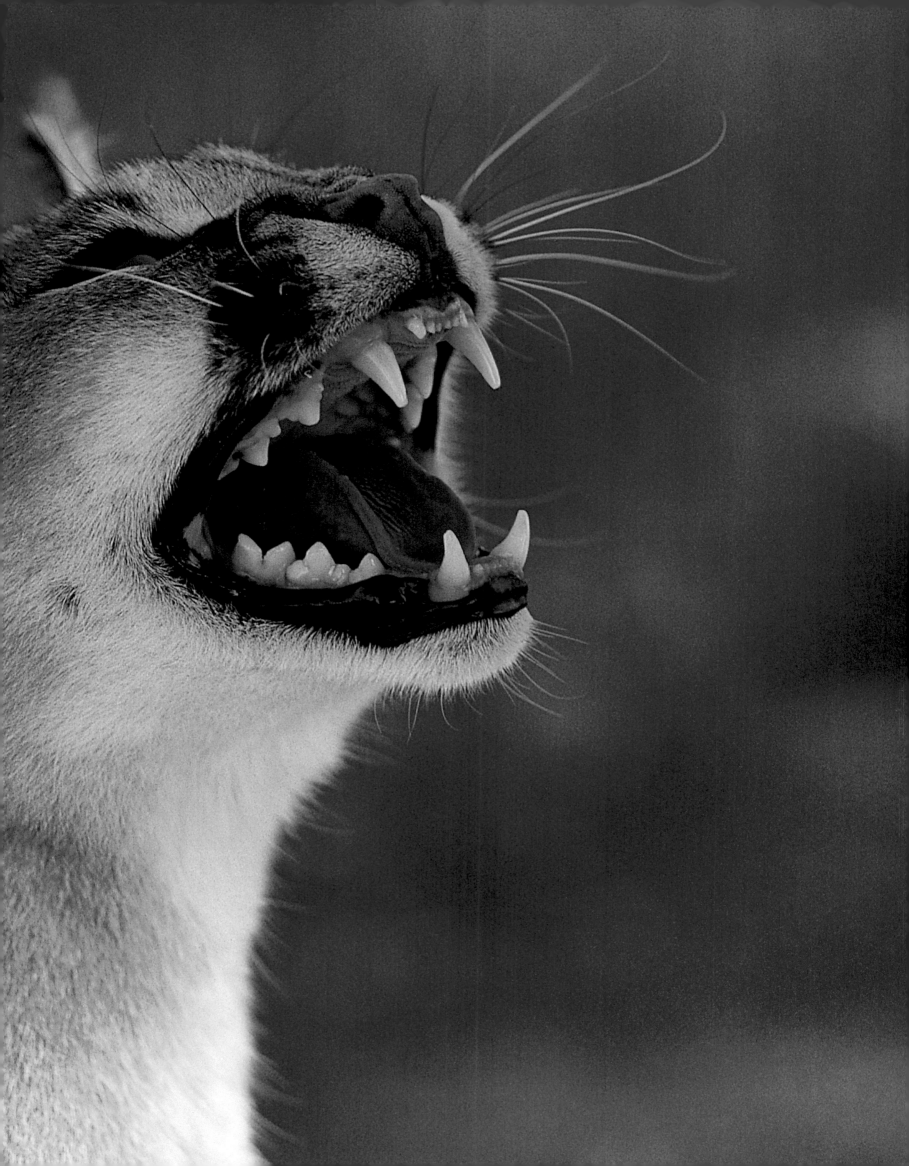

The feline spine displays variation along a similar scale. Small cats have a long, flexible spine, helping to augment their stride length while running on the ground but also increasing their ability to climb and negotiate obstacles vertically. Here the cheetah resembles small cats, with proportionally a longer and more supple spine than any cat larger than a male caracal, though of course it is for speed, not tree climbing, in the cheetah. In this, they differ from all other large cats, which have undergone a gradual shortening and stiffening of the spine from their distant *Pseudaelurus* roots. This is primarily to support larger body weights but it also serves to yield spectacular strength. The *Panthera* cats (represented in Africa by the lion and leopard) have the shortest, stoutest backs of all the felids. In the leopard, the spine has retained some flexibility reflecting its more arboreal habits, while the lion's massively robust spine delivers Herculean leverage for wrestling large prey to the ground.

As anyone who has seen their pet cat yawn can testify, the skull of the cats carries its own suite of adaptations for killing. Cats have shortened faces compared to most carnivores, a consequence of their reduced tooth count. The shortened mandible (lower jaw) enhances the action of the temporalis muscle which closes the jaw, increasing the force of the killing bite. However, as the size of the cat increases, the relative space on the braincase for anchoring this muscle declines. Proportionally, large-bodied cats have smaller brains than small cats, meaning that, as the jaw increases in size to cope with larger prey, the braincase remains relatively small. To provide space for muscle attachments, large cats have evolved a great flange of bone on top of the skull called the sagittal crest. The larger the cat, the larger the crest and, in fact, it differs between the sexes in the same species. Male leopards have considerably more prominent sagittal crests than females, leading some authors to speculate that males have markedly different diets.

Despite its greater size, the cheetah's skull resembles that of the small cats, a consequence of its high-speed lifestyle. The skull is relatively small with a foreshortened face and jaw to reduce weight, and a poorly developed sagittal crest. It also has proportionally the smallest canines of all large cats, creating space for enlarged nasal passages that allow the cheetah to inhale great gulps of air through the nose while maintaining a suffocating throat-hold on its prey. The cheetah's diminutive skull and jaws work well to subdue medium-sized prey with slim necks (as in their main prey, antelopes) but do not have the structure and strength to overcome larger species. With only slightly larger body size, the leopard's solidly built skull helps it to hold and dispatch prey over four times the size of the top weight manageable by the slight cheetah. A similar relationship exists between the skulls of the caracal and serval. Although similar in size, the serval's skull is far more lightly built, reflecting a diet dominated by small rodents and birds. The caracal's heavily constructed skull can deal with prey up to the size of a female impala.

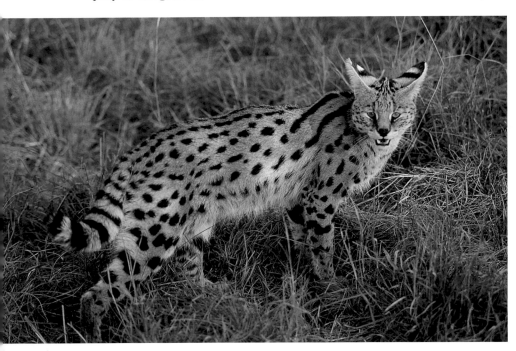

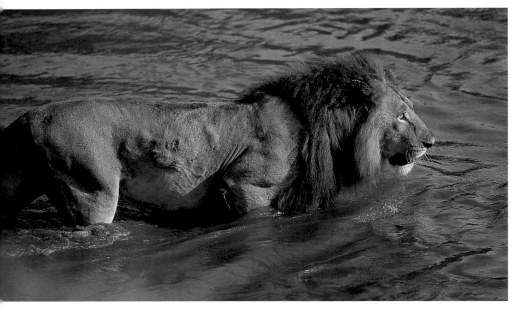

LEFT As typified in the robust back of the male lion (LEFT), large cats have proportionally shorter and stiffer spines than small cats such as the serval (LEFT, ABOVE). The modifications in large cats arise from a shortening and thickening of each vertebra, not from a reduction in their number.

PREVIOUS PAGE The caracal's stoutly built skull and robust dentition are adaptations for taking prey that is large relative to its size. Unique among African felids, the conspicuous ear tufts are thought to enhance facial expressions used for communicating with other members of the species.

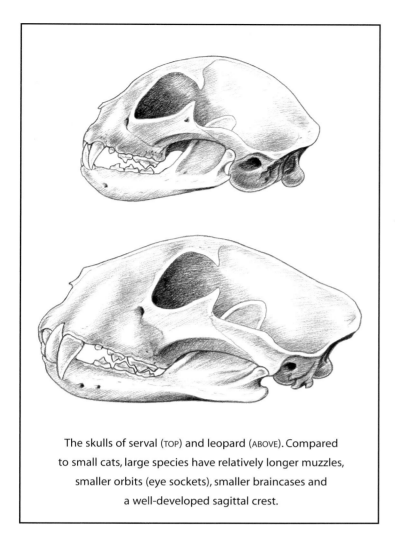

The skulls of serval (TOP) and leopard (ABOVE). Compared to small cats, large species have relatively longer muzzles, smaller orbits (eye sockets), smaller braincases and a well-developed sagittal crest.

We have already seen the importance of the carnassial teeth in the life of cats, but the kill is dependent upon the canines. Compared to the long, elliptical canines of the sabre-tooths, the broad, conical shape of the canines in living cats reinforces them against the risk of breakage during the deep, forceful killing bite. Most cats kill large prey by a suffocating bite at the throat but occasionally use a stabbing bite to the skull or into the nape, dislocating the cervical vertebrae and piercing the spinal cord. The latter technique is used frequently by small cats killing relatively small prey, and indeed the canines of small cats are well innervated – able to 'feel' the gaps between vertebrae to line up for the puncturing bite (this may also be true of large cats but further investigation is required). The clash of canines against bone in such a bite would probably have shattered the elongated canines of the sabre-tooths, but the stout canines of modern cats can usually withstand the impact. Intriguingly, there is a living cat that may be an exception to the rule. The clouded leopard of Asia has proportionally the longest canines of any felid, and possibly represents the nascent emergence of a sabre-toothed form among modern cats. The species is so little known that biologists have yet to discover how it kills, but its canines are long and just flattened enough to suggest that they would risk breakage in any bite that struck bone.

Compared to other large cats, the cheetah's skull is small, with proportionally shorter jaws and a smaller sagittal crest to reduce weight for the high-speed sprint. Cheetahs also have relatively small canines, creating space for enlarged nasal passages to improve the intake of oxygen while maintaining a suffocating throat-hold on the prey.

The senses

The world of the cat is one of sight and sound. Although felids have a relatively highly developed sense of smell (detailed on page 55), they rely chiefly upon superb vision and hearing to do their hunting. Cats are opportunists and kill at any time of day, but, except for the diurnal cheetah, hunting is mostly a crepuscular (dawn and dusk) or nocturnal activity. To accommodate all possible lighting conditions, cats' eyes have a sophisticated muscular mechanism for controlling the pupils. Unlike human eyes, where these muscles (called the ciliary muscles) are arranged around the pupil like the spokes of a wheel, allowing limited control, the ciliary muscles of a cat's eyes are drawn across each other like a braid. The ability is greatest in small cats, which are generally more nocturnal than large species, and are able to reduce their pupils to a characteristically feline vertical slit as protection against intense light

No animal can see in total darkness, but domestic cats can see in light one-seventh as dim as the absolute limit of human night vision.

during the day. Large cats have the same mechanism but it is somewhat less developed, probably reflecting their more round-the-clock habits and resulting in pupils that are oval shaped.

Once light reaches the eye, cats have an extraordinary ability to utilise it. A reflective sheet of cells called the *tapetum lucidum* redirects unabsorbed light into the retina for a second chance at imaging (resulting in the characteristic 'eye-shine' of nocturnal species). Cats have as many as 15 layers of mirrored cells stacked in their tapetum, reflecting up to 130 times as much light as that bounced around inside the human eye. Beyond the ability to capture light, night vision needs rhodopsin or 'visual purple', a light-sensitive pigment assembled from two fundamental building blocks, vitamin A and beta-carotene. However, unlike many mammals, cats cannot synthesise their own vitamin A nor can they access the main source of beta-carotene, plants. Ironically, their prey

ABOVE AND OPPOSITE: Light reflected from the *tapetum lucidum* enhances the nocturnal vision of cats, and also gives rise to 'eye-shine'.
Of all African cats, the nocturnal vision of cheetahs is probably the least developed, a reflection of its mostly diurnal habits.
Even so, cheetahs see far more efficiently in darkness than humans, and occasionally hunt when there is sufficient moonlight.

Cats' ears (CLOCKWISE, FROM TOP LEFT): Caracal, sand cat, lion and serval. Small felids have proportionally larger ears than big cats, reflecting their greater reliance on searching out small, cryptic prey such as rodents hidden in grass. Hair lining the inside leading edge of the ear helps to keep out dust and dirt.

provides the solution. Herbivores are able to process the compounds and store them in the liver, lungs and fat. In doing so, prey unintentionally equips predator with an accessible source of both, ensuring that cats can see in the dark. Indeed, domestic cats deficient in vitamin A suffer night blindness. No animal can see in total darkness, but domestic cats can see in light one-seventh as dim as the absolute limit of human night vision.

The cat's visual prowess is rounded off by its ability to judge distance and detail. Feline binocular vision is the most highly developed of all the Carnivora and, among mammals, is second only to that of primates. To improve detail over distance, nerve cells are clustered in the centre of the eye but, rather than as a central spot of improved vision (such as in human eyes), the nerves are arranged in a band. The result is known as a 'visual streak', a strip of highly acute vision that increases the ability of cats to discern their prey in the horizontal plane. Among cats that have been tested, the visual streak is most concentrated in the diurnally hunting cheetah, which can spot a moving gazelle on the horizon at two kilometres.

All cats have superb vision but some species rely more heavily than others on their hearing to hunt. Small cats are particularly well adapted to hearing high-pitched sounds, up to two octaves higher than the upper limit detectable by humans. It enables cats to hear with ease the vocalisations of their rodent prey, which typically fall between 20–50 kHz; the limit of human hearing is 20 kHz, so we are deaf to such ultrasonic 'squeaks'. Sensitivity to high-pitched noise is only half the challenge, though; such sounds are also extremely soft. To overcome this, rodent-hunting cats have very large external ears (called the pinna) to enhance sound gathering. Relative to body size, the serval has the largest pinna of any felid, assisting it to hear the sounds of rodents moving through grass and even detect their

ultrasonic calls from subterranean burrows. Desert-dwelling sand cats also have large pinnae to listen for rodents, and have a further refinement that seems to be specific to arid habitats: sand cats have a very enlarged bulla, the bony chamber which houses the fragile ear bones in all mammals. An oversized bulla is thought to reduce air resistance inside the ear, enhancing sensitivity to both high and low frequency sounds in an environment that is spectacularly quiet. Somewhat enlarged bullae are also found in the black-footed cat, a denizen of semi-arid habitats.

Secondary to sight and hearing, cats employ two further senses to survive: touch and smell. The whiskers, or vibrissae, of cats are richly served by nerves, intensifying their sensitivity to stimulation and enabling them to negotiate their world in complete darkness. When moving at night, a cat fans its muzzle whiskers forwards in order to feel its way, assisted by clusters of vibrissae on the eyebrows, cheeks and throat. Cats

even have vibrissae on the wrists to help them place their feet when stalking prey without looking down. Although less noticeable than vibrissae, a second type of long, tactile hairs called tylotriches are scattered thinly over the entire body hidden among the 'ordinary' fur. Working in unison with hearing, a cat's full-body tactile precision enables it to hunt in complete darkness. Domestic cats experimentally blindfolded were easily able to negotiate a large room and find, catch and kill mice with a precise bite to the neck.

Of all the senses, smell plays the least part in the cat's effort to feed itself (but is very important in felid social life, see Chapters 3 and 4). Nonetheless, cats have a sense of smell estimated to be 30 times finer than that of humans. A leopard easily follows the scent trail of a dragged carcass for up to two kilometres and, although the ability has never been fully assessed, cats clearly find some meals by smelling them from afar.

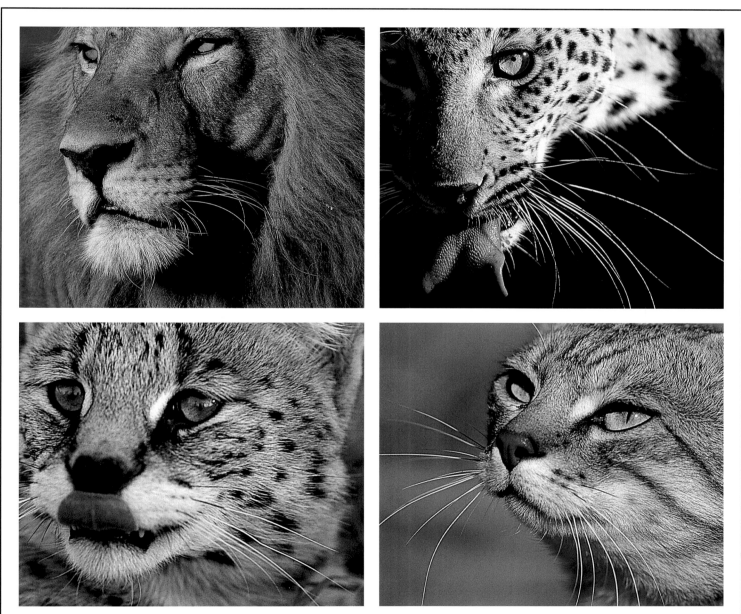

Cats' whiskers (CLOCKWISE, FROM TOP LEFT): lion, leopard, African wildcat and serval. The vibrissae (whiskers) of all cats are well served by nerves and muscles. Cats are able to extend their whiskers forwards to feel their surroundings or for the accurate placement of a killing bite.

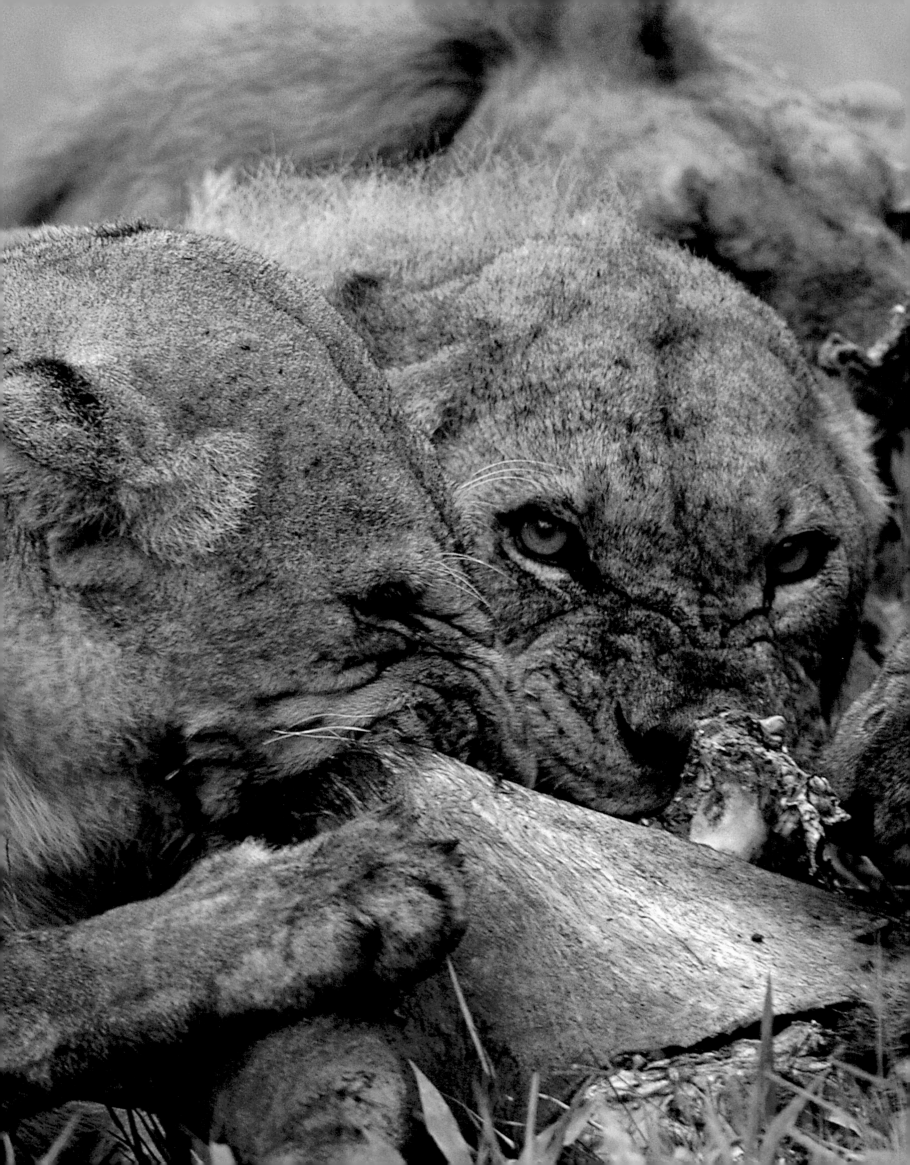

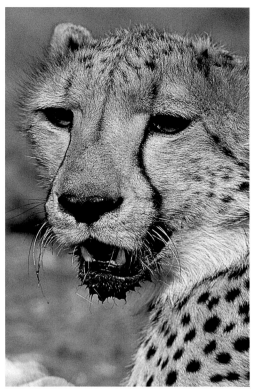

PREDATION

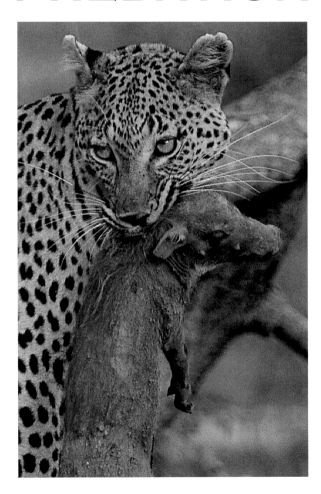

hunting, killing
and feeding

Hunting strategies

All cats are opportunists, meaning that they kill what they can, when they can. Evolution has engineered cats to seize any opportunity to kill, regardless of whether hunger is the motivation. It means that, on occasion, cats kill more than is required merely to satisfy their energetic needs. I once watched three lions that had been feeding on a freshly killed wildebeest lie in wait as a second wildebeest and later a zebra wandered heedless into their midst. Both were killed by the lions within metres of the original carcass and left virtually untouched. Similarly, many a farmer who has suffered the loss of a dozen penned goats to a caracal or leopard despises the killer for being 'wasteful'. But to the cat, the drive to kill is overwhelming. A wild cat never knows when it will next eat, so being constantly primed to kill makes sound evolutionary sense. Any individual cat not so utterly compelled to kill might hesitate when it really mattered, and wind up starving to death.

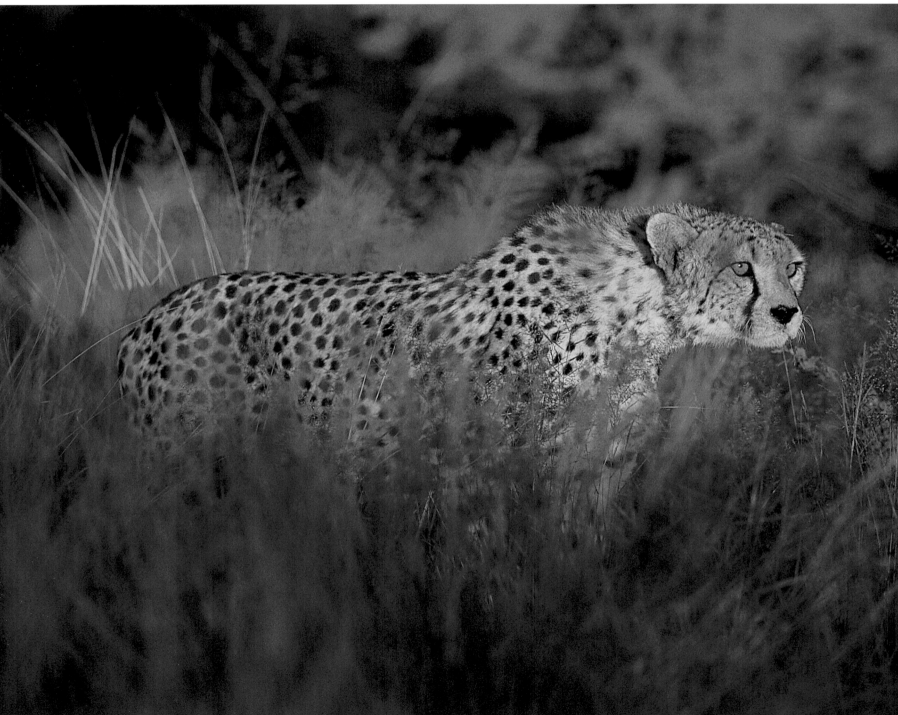

The cheetah is only marginally faster than its preferred prey – some gazelle species reach 90 km/h – so a successful hunt usually requires a typically feline stalk to narrow the distance. In most hunts, cheetahs carefully approach their prey to within 50–70 metres before commencing the chase.

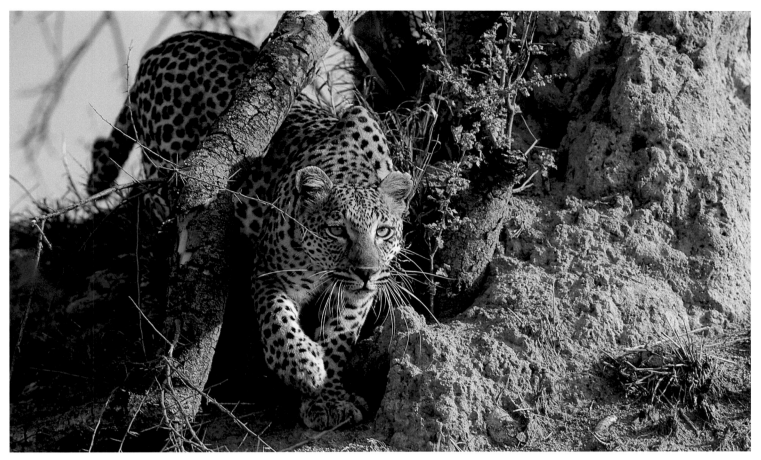

The majority of the leopard's kills are made when the cat is less than five metres from its target. To bring itself so close, the leopard exercises boundless patience and a superb ability to exploit all available cover.

For all that, though, the opportunity to kill more than they need rarely arises for cats in the wild; surplus killing is restricted largely to artificial circumstances such as when livestock is corralled or trapped against fences. Normally, a cat's meals result from a determined and sometimes exhausting hunting effort driven by the immediate need to feed itself or its cubs. To do so, cats employ a surprising variety of strategies, but the mainstay for all species is a dogged search ending with a stalk.

Finding prey – the search – has the appearance of being a haphazard process in which a cat wanders through its home range until it encounters a target. In essence, this is what every hunting cat does, but despite appearances, it is far from random. Cats are intimately familiar with their surroundings. They clearly carry in their heads a sophisticated blueprint showing the locations of rest sites, places to lay an ambush, waterholes, paths and trails, open areas, observation points, and so on. Acquiring this knowledge presumably takes some time, partly the reason why newly independent, adolescent cats often do not survive (see Chapter 4). To an adult cat, though, experience has taught it where the chances of finding something to eat are high, and it is those places where hunting effort is focused. So, a female leopard setting out on a hunt heads towards the transition between woodlands and open areas, which she knows are favoured by impalas. To reach her destination she moves onto game paths, helping to increase her

view ahead, knowing that her quarry also uses them. As she walks, she scans continuously, looking for the flicker of an antelope tail or ear in the distance, and listening for tell-tale vocalisations or rustling vegetation. From time to time along her route, she seeks out high points, climbing kopjes, termite mounds or trees to increase her field of view. She also detours to check possible rest sites for smaller quarry, assiduously investigating small bushes and thickets of grass where hares or young antelope might be hiding. And she stops at the entrance of warthog burrows, listening and even smelling to determine if there's an occupant.

Systematically scouring her range like this, the leopard is assured of finding a meal sooner or later. Often, like all cats, she stumbles upon prey before she has the chance to stalk it. Although such spur-of-the-moment hunts generally make a minor contribution to the kill tallies of most cat species, they may have a surprisingly high success rate. Paul Funston showed that lions in the Kruger National Park bushveld were more likely to make a kill when they chased prey immediately upon detecting it, rather than by stalking. Further, such spontaneous hunts often require less effort. Once, while following a female cheetah walking slowly through metre-high grass, I saw her chance upon a resting reedbuck which the cheetah caught where it lay. If not for the single, strangled bleat of the doomed reedbuck, I would have supposed the cheetah had flopped down to rest.

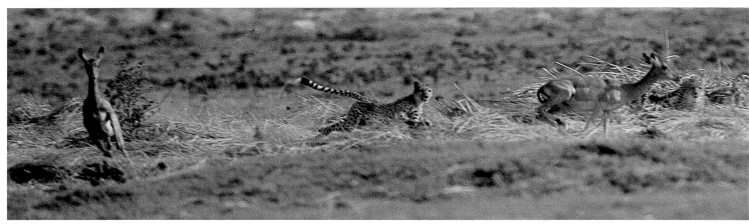

Melting into cover and freezing to avoid discovery when the prey looks up, a stalking

cat inexorably closes the gap until it can unleash the final, explosive attack.

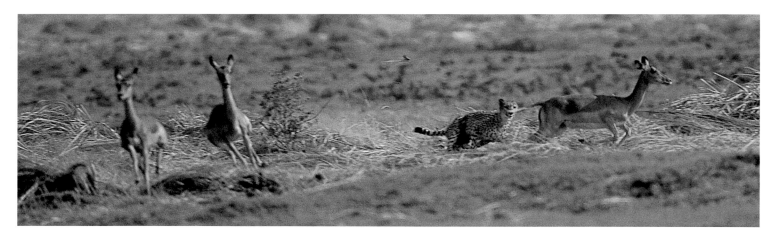

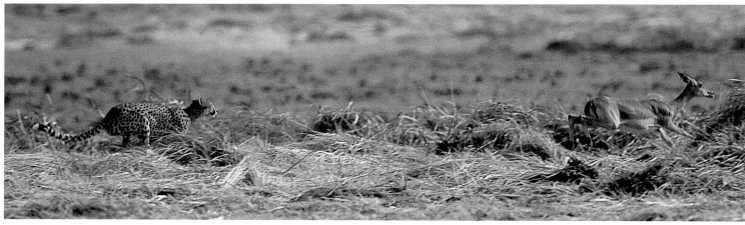

More often, though, a hunting cat detects an opportunity ahead of time and initiates its exquisite approach. Cats are unmatched among predators in their ability to cover ground undetected, bringing them within metres of highly strung quarry whose survival depends on being constantly alert. Melting into cover and freezing to avoid discovery when the prey looks up, a stalking cat inexorably closes the gap until it can unleash the final, explosive attack. In the open, semi-arid terrain of north-eastern Namibia, researcher Phillip Stander measured 94 stalks by leopards, which covered distances ranging up to 218 metres. On average, the final rush was launched when the leopard was less than five metres from the prey, and was never greater than 15 metres. The distance is very similar for lions, at least for prey species with explosively fast acceleration. Lions hunting Thomson's gazelles in the Ngorongoro Crater usually succeed when they launch their attack from 7.6 metres or less; they consistently fail when the distance exceeds 15 metres. For larger, heavier targets with slower acceleration, the minimum distance increases. In the Serengeti, George Schaller noted that rushes from an average distance of 30 metres often produced a kill when hunting large prey such as wildebeest.

The cheetah exploits the advantage of speed to its evolutionary limit but, unlike the lion, its acceleration is on a par with the swiftest of prey, reaching 75 kilometres per hour in the first two seconds of a chase. The cheetah is the only felid to run down its quarry with a high-speed pursuit, covering up to 500 metres, and it launches its final rush from a much greater distance than any other cat. When hunting adult gazelles in the Serengeti, the distance is around 70 metres but it may be as distant as 300 metres. Importantly, though, and contrary to popular belief, the cheetah usually precedes its chase with a typically feline stalk. Although less prolonged than the painstaking belly-crawling advance of other cats, the cheetah's approach is just as strategic. Exploiting all available cover that sometimes includes tourist vehicles, and dropping flat to the ground or freezing whenever the prey looks up, cheetahs narrow the distance to the prey in fairly typical feline form. Indeed, faced with almost completely bare ground, cheetahs in the Sahara flatten themselves on the sand and freeze, slinking forwards only when their gazelle quarry is grazing. The final distance to the prey resulting from such meticulous stalks is typically about 30 metres.

Variations of the search-and-stalk theme constitute the chief hunting technique for all cats. Despite its tiny stature, the black-footed cat is a predatory powerhouse with at least three distinct tactics. Like all felids, it methodically quarters its range in the search for prey. True of all smaller cats that have been properly observed, the black-footed cat takes particular care with the search-and-stalk method, snaking carefully between tufts of grass and scrub, its head moving from side to side as it watches and listens intently. Servals are similarly meticulous but they search from above, raised on stilt-like legs which, relative to body size, are the longest of all cats. Elevated above the long grasses, servals move slowly and tread softly, pausing for

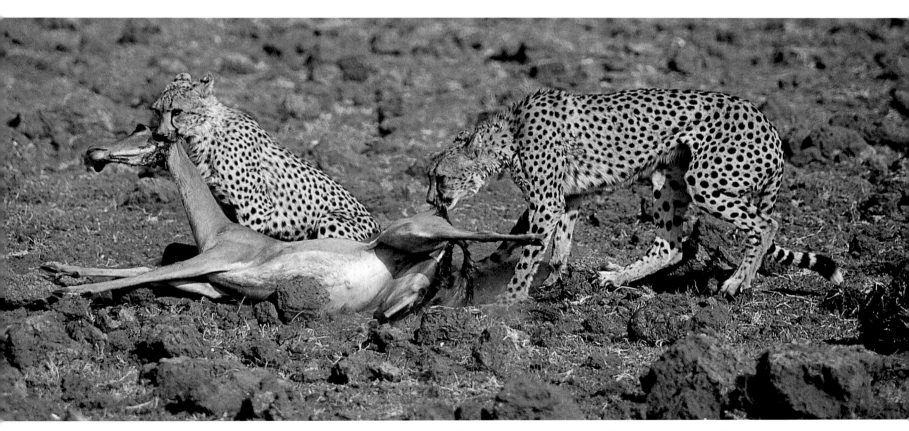

OPPOSITE AND ABOVE: Although it's atypical, cheetahs occasionally lie in wait to ambush prey. This impala kill was made by one of the cheetahs hiding in a reed bed at the edge of an open area until the impalas wandered into striking distance.

The serval is able to execute leaps over four metres long and up to three metres high. If the initial attack fails, servals often pursue fleeing rodents by a series of bounding zig-zagging pounces that attempt to pin down the quarry.

up to 15 minutes at a time to listen with their oversized ears for concealed rodents, birds and frogs. Also long-legged and favouring similarly well-watered, high grass habitats, jungle cats probably hunt in careful, serval-like fashion but there are few observations to confirm this.

The black-footed cat's second strategy is more reminiscent of foraging jackals or weasels. Known as 'fast-hunting', the cat moves in a swift zig-zagging jog, trotting at a steady 1–2 kilometres per hour, hoping to surprise and flush prey, particularly birds. Equipped with characteristically feline reflexes, black-footed cats execute gymnastic leaps up to 1.4 metres high – almost three times their own length – to snag birds as they burst from hiding. Caracals and African wildcats also fast-hunt, sometimes with similarly acrobatic results, though only a handful of observations exist, all from arid, scrubby habitats similar to the black-footed cat's; perhaps open country scattered with many potential hiding places for small prey favours the method (or possibly it simply increases the opportunities for biologists to observe it).

In a final alternative approach, known as the stationary or sit-and-wait strategy, cats exercise consummate feline patience waiting at strategic sites for prey to appear. Sitting in wait like this, black-footed cats lie perfectly immobile for up to two hours at the entrance of rodent burrows until the occupant emerges. The leopard's version of the technique may be the species' most common strategy in equatorial Africa, where dense habitat hinders visibility and limits the use of long stalks and chases. Leopards in the Democratic Republic of Congo's (DRC) Ituri Forest wait at fruiting trees, which attract duikers and red river hogs; based on signs at freshly killed carcasses, they ambush their prey from a few metres away. In the only comprehensive observations made of a hunting rainforest leopard, biologist David Jenny watched a female hide herself on 91 occasions in dense vegetation near troops of forest monkeys, and wait for them. Monkeys came to within 50 metres of the leopard in 60 per cent of her hiding bouts, though the technique yielded only one successful attack (a sooty mangabey). Importantly, though, most of Jenny's observations took place during the day when leopards typically have lowered hunting success; furthermore, his presence may have affected the outcome.

Servals also adopt the sit-and-wait strategy, relying chiefly on their exceptional hearing to detect targets. In the Ngorongoro Crater, they listen patiently for rodents in the clumped tussocks of kasangani grass, and elsewhere servals have been seen finding common mole rats underground by sound; on locating their quarry, they scratch away the entrance mounds to reveal the shallow dead-end burrows with the occupant inside. For deep-burrowing species of mole rats, servals in eastern DRC were seen to dig lightly at the plugged entrances to entice the fastidious owner to the surface for repairs. Revealingly, the serval's attempts at digging are never very strenuous and no cat species is especially efficient at excavating subterranean prey (see Chapter 1). On occasion, lions and leopards spend hours extracting warthogs from shallow burrows, but perhaps the most fossorial (adapted for burrowing) member of the family in Africa is the sand cat. Often considered the northern analogue of the black-footed cat, the sand cat's diet is also dominated by small desert rodents, and it probably has a similarly diverse range of strategies to catch them. So few people have seen sand cats hunting in the wild that the extent of their hunting repertoire is unknown, but among local people they are celebrated for a skill not yet seen in black-footed cats – speedily burrowing into soft sand in pursuit of desert rodents. Indeed, sand cats are so proficient at the technique that the Touareg people of Niger refer to the sand cat as 'the cat that digs holes'.

Co-operative hunting in cats

Except for mothers accompanied by large cubs, lions and cheetahs are the only cats that hunt in social groups. For both species, group hunting improves success; Kruger National Park lion singletons and pairs have a 21 per cent success rate when hunting, compared to 35–39 per cent enjoyed by trios and quartets. Looking at it slightly differently, Serengeti male cheetahs belonging to a trio eat slightly more each day than do single cheetahs. But do such benefits result simply because a target is less likely to elude three cheetahs than one, or because hunting cats actually co-ordinate their efforts? Evidence for co-operation by cheetahs is slim: one cheetah sometimes distracts adult herbivores attempting to defend their youngsters while his partner makes the kill, and adolescent cheetahs hunting with siblings appear to be braver when tackling larger prey (resulting in more kills) than when they hunt alone, but true co-ordination is exceptional.

However, the evidence for co-operation among lions is more persuasive. In Etosha National Park, lionesses apparently adopt different roles to enhance their success. 'Wings' circle the prey on long stalks and usually initiate the attack, while 'centres' mostly stay put and wait for the wings to drive prey towards them. Each individual lioness adopts the same role – wing or centre, but rarely both – in all hunts, and the most successful hunts are those where each lioness is in her preferred position. The Etosha study is the only one to date demonstrating such precision, perhaps a result of the very open habitat which makes opportunistic ambushes unlikely.

Without assistance, this lone lioness in Etosha National Park has no chance of pulling down an adult giraffe,
but the collective might of the pride enables a group of lions to tackle very large prey successfully.

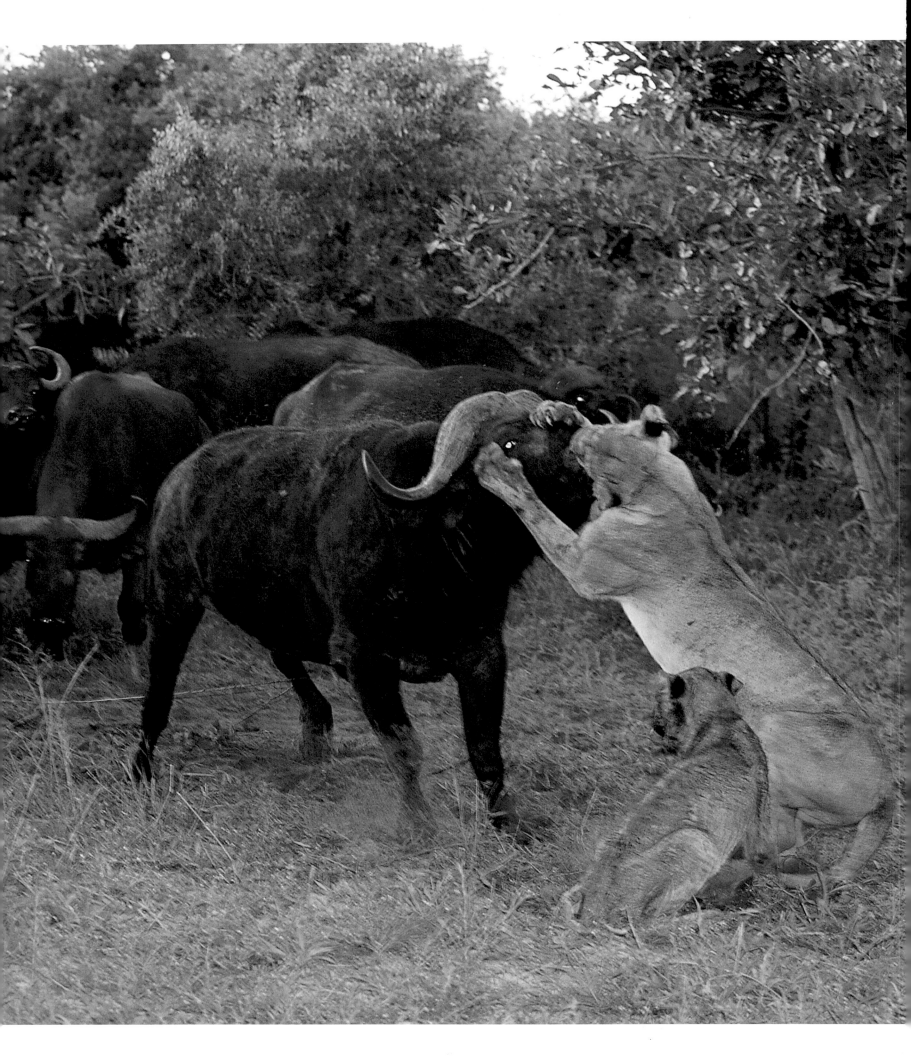

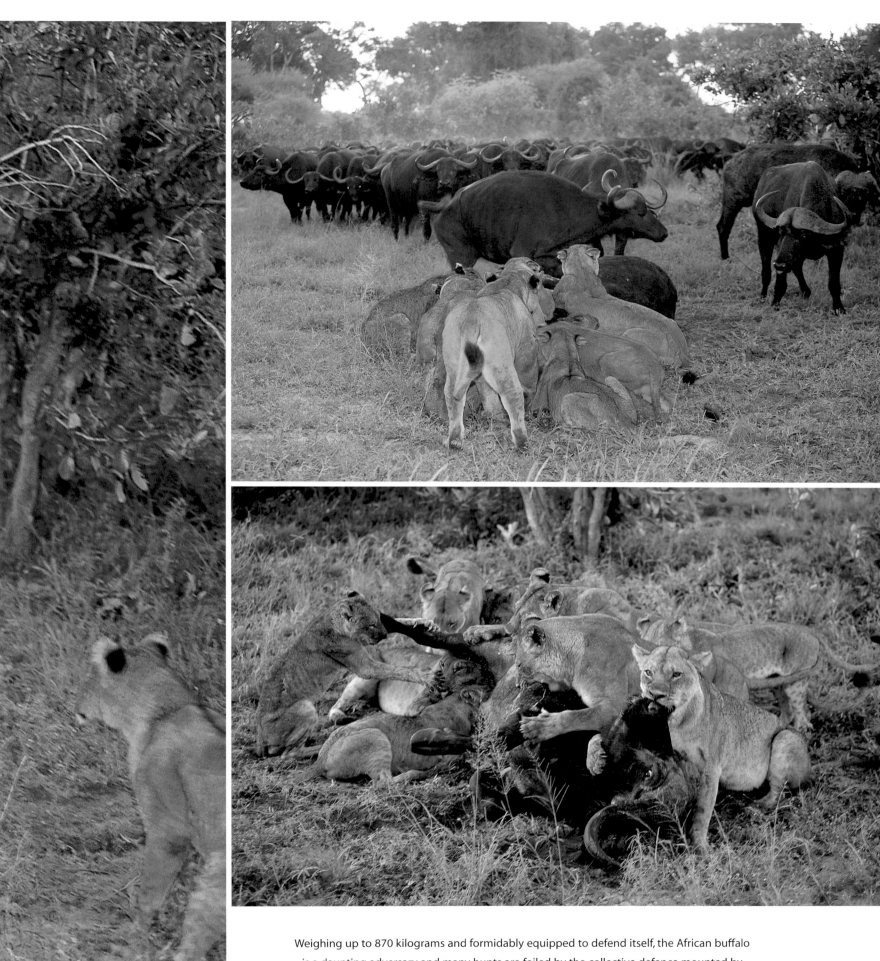

Weighing up to 870 kilograms and formidably equipped to defend itself, the African buffalo is a daunting adversary and many hunts are foiled by the collective defence mounted by the herd. The lion is the only predator capable of preying regularly upon adults, but even so, buffaloes are responsible for more lion casualties than any other prey species.

Prey: the eating habits of cats

Cats make their living by killing. As discussed in Chapter 1, the members of the cat family are the most predatory of all mammalian carnivores, requiring a diet derived almost entirely from other animals. Virtually all land vertebrates (and many invertebrates) in Africa are fair game to the cat family and, even if a particular species has not appeared on a published list, chances are that a cat has killed it. The way of the cat is to kill anything it can physically overpower, and indeed the family is notable among solitary carnivores for consistently taking species as large as or larger than themselves. Moreover, as seen in the previous section, cats employ a wide variety of techniques which not only enhance their chances of finding prey but also increase the selection of prey types available to them.

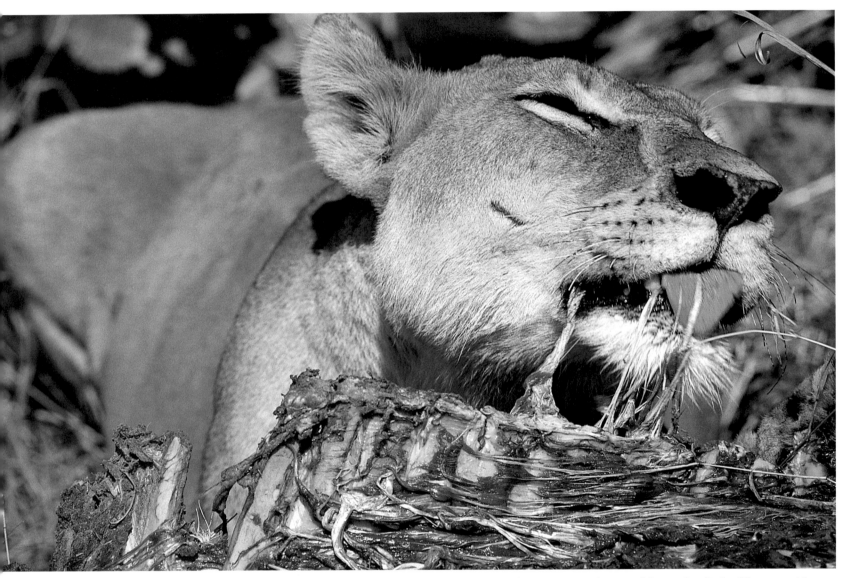

All cats have tiny backwards-facing barbs called papillae that cover the surface of the tongue and are used for rasping flesh off bones and for grooming. Unexpectedly, each lineage of cats (see the phylogeny chart on page 44) has its own unique pattern of papillae on the tongue.

For all that, though, cats are quite discerning about what they hunt. Although a leopard resting at a Kalahari waterhole will expertly snatch sandgrouse as they alight to drink, leopards are too large to live off sandgrouse alone. Cats need to invest their effort in hunting prey that provides enough of a pay-off to balance the energetic costs of finding and killing it. The result is a pattern in which, while cats opportunistically kill anything they can, a far narrower selection of prey comprises the bulk of their diet.

The big cats: big game hunters

Africa's three large cats depend upon large meals. Lions, leopards and cheetahs are alike in requiring medium- to large-bodied mammals as their mainstay, even if their tastes sometimes appear far more varied. A supreme opportunist that kills virtually everything it encounters, the lion is recorded eating a suite of prey that ranges from dung beetles to adolescent elephants. It eats a wide selection of birds, including ostriches,

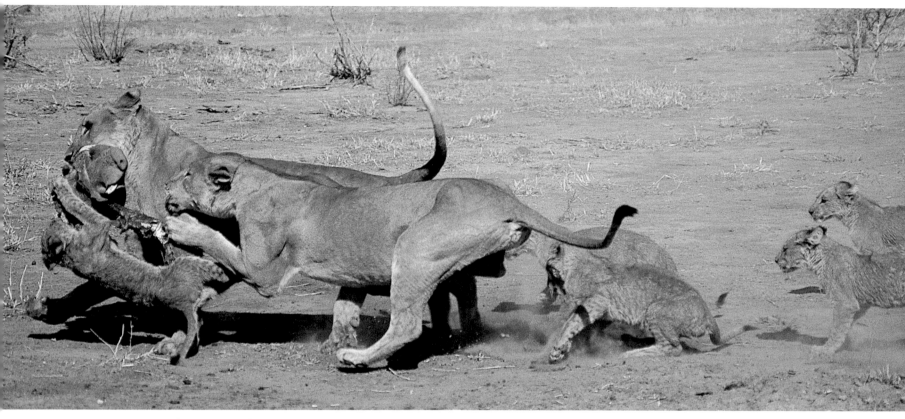

Two lionesses and their cubs compete for warthog remains during the dry season in Savute, Botswana. During extreme shortages of prey, young cubs sometimes starve or are mortally injured while competing for their share.

bustards, guinea fowl, francolins, plovers and birds' eggs, while reptiles on the menu include terrapins, tortoises, African rock pythons, Nile monitors and crocodiles. Lions scavenge from whale carcasses washed ashore on Namibia's Skeleton Coast, consume tsamma melons in the Kalahari and are not averse to eating each other. Yet, catholic tastes notwithstanding, the lion must deal with two key biological constraints at mealtimes: a very large body size and large family groups. An individual lion is too large to survive on small prey or those that are rarely encountered, which includes all of those listed above. Furthermore, as the most social of all felids, they require a prey base sufficient to feed many mouths at once.

The solution for lions lies in hoofed prey. Wherever they occur, lions concentrate on the most abundant, large ungulates available, with wildebeest topping the list for many lion populations. In the southern Kalahari, wildebeest (at 37 per cent), gemsbok and springbok make up slightly more than 82 per cent of lion kills. Of more than 12 300 lion kills recorded by rangers in the Kruger National Park between 1933 and 1966, wildebeest comprised 2 906 of them, almost a quarter. Six species – wildebeest, impala, zebra, kudu, waterbuck and buffalo – accounted for more than 90 per cent of Kruger National Park lion kills. A similar pattern occurs in the Serengeti, where

Cat family members are the most predatory of all mammalian carnivores, requiring a diet derived almost entirely from other animals.

seven ungulates ranging in size from Thomson's gazelles to buffaloes make up 90 per cent of kills. Wildebeest again head the count, though only for the open plains during the wet season when they are abundant. During the dry season, when wildebeest are scarce on the plains, lions switch to warthogs and Thomson's gazelles. In contrast, lions inhabiting the Serengeti woodlands and their edge habitats are able to exploit resident species that are abundant year-round. To woodland and edge lions, warthogs and buffalo are the most important prey species throughout the year. It is not yet clear where the lower threshold of lion prey size lies but prides in Namibia's Etosha National Park might subsist at the limit. Watching 920 hunts, Phillip Stander found that 73 per cent of lion kills were of springboks. At under 50 kilograms, this is the smallest preferred prey size recorded for any lion population.

A solitary hunter and about a third the size of a lion, the leopard is freed of some of the larger cat's limitations when it comes to feeding itself. Leopards have the most diverse diet of all African cats with at least 100 species recorded from sub-Saharan Africa alone. The leopard's smaller body size allows it to switch to prey that could not possibly sustain a lion. In north-eastern Namibia where prey is thin on the ground, most kills weigh less than 20 kilograms, with common duikers and steenboks dominating. Rock

Weeding out the vulnerable

A common refrain holds that cats are more likely to prey upon vulnerable individuals and thus help weed out the infirm and weak from a prey population. The problem with the idea is that the felid method of hunting does not particularly lend itself to identifying vulnerable animals. Long distance coursing, as used by African wild dogs or spotted hyaenas, is far more efficient for singling out an individual in trouble than the cat's close-in stalk-and-rush strategy. The high-speed pursuit used by cheetahs might provide an opportunity to isolate unhealthy prey, and cheetahs occasionally appear to 'test' a herd by running openly into its midst. Serengeti cheetahs are more likely to run down the least vigilant gazelles which, in some cases at least, are males that are unwary because they are exhausted or injured by the rut. Equally, though, there are many cases of apparently healthy animals being targeted simply for not remaining alert. It remains the case that, in careful studies of felid-prey interactions, the evidence for cats selecting the infirm is weak.

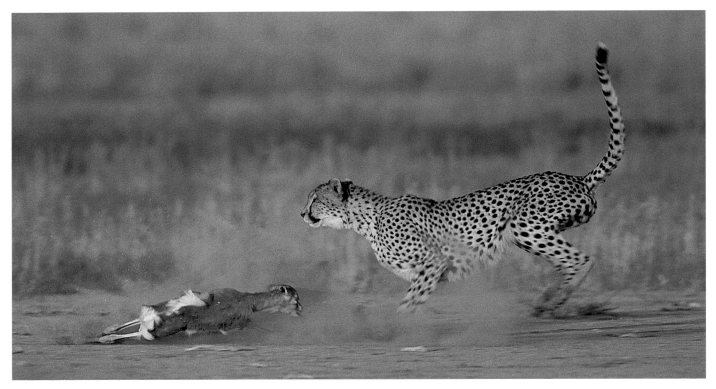

hyraxes are the most common prey item in many areas where the antelope biomass is low, among them Mount Kenya's alpine zone, Zimbabwe's Matopos Hills and the Cederberg range in the south-western Cape. Leopards eat frogs, locusts, scorpions, termites, crabs, fish, birds, reptiles and their eggs, indeed, virtually anything living. The known inventory does not include prey of the critically endangered leopards of North Africa which have never been studied but which exist with (and presumably eat) a number of species that do not occur south of the Sahara, among them red deer, barbary sheep, Cuvier's gazelles and red foxes. A thorough study of these leopards would doubtless swell the list even further.

Importantly, though, just as with the lion, leopards subsist primarily on antelopes. In savanna ecosystems where the leopard has been well studied, the same pattern of concentrating

Leopards have the most diverse diet of all African cats with at least 100 species recorded from sub-Saharan Africa alone.

on the most abundant ungulates manifests itself, if scaled slightly downwards. This translates to the leopard specialising in antelopes in the 20–80 kilogram range. In the southern part of the Kruger National Park, the most common antelope in this size class, the impala, makes up almost 88 per cent of their kills. In the Serengeti, preferred prey is the Thomson's gazelle whereas in Zambia's Kafue National Park, reedbuck, young waterbuck and puku are most often taken. In the moist savannas of West Africa, antelopes contribute between 53 and 67 per cent of the meat that leopards consume. Surprisingly, though, together with the kob and the western hartebeest, the most important prey species to these leopards is the greater cane rat. In one site, Côte d'Ivoire's Marahoué National Park, Frauke Fischer and her colleagues calculated that the large rodent is the local leopard's number one species.

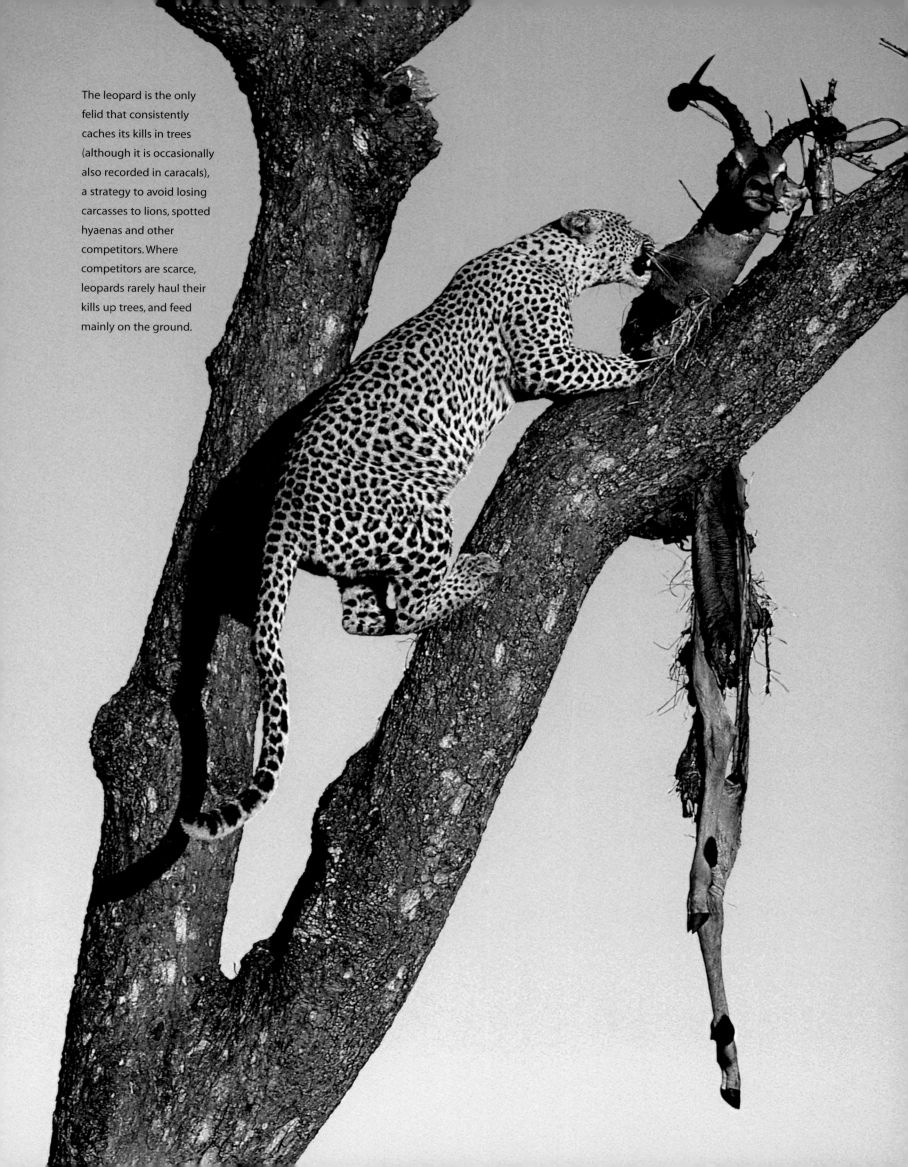

The leopard is the only felid that consistently caches its kills in trees (although it is occasionally also recorded in caracals), a strategy to avoid losing carcasses to lions, spotted hyaenas and other competitors. Where competitors are scarce, leopards rarely haul their kills up trees, and feed mainly on the ground.

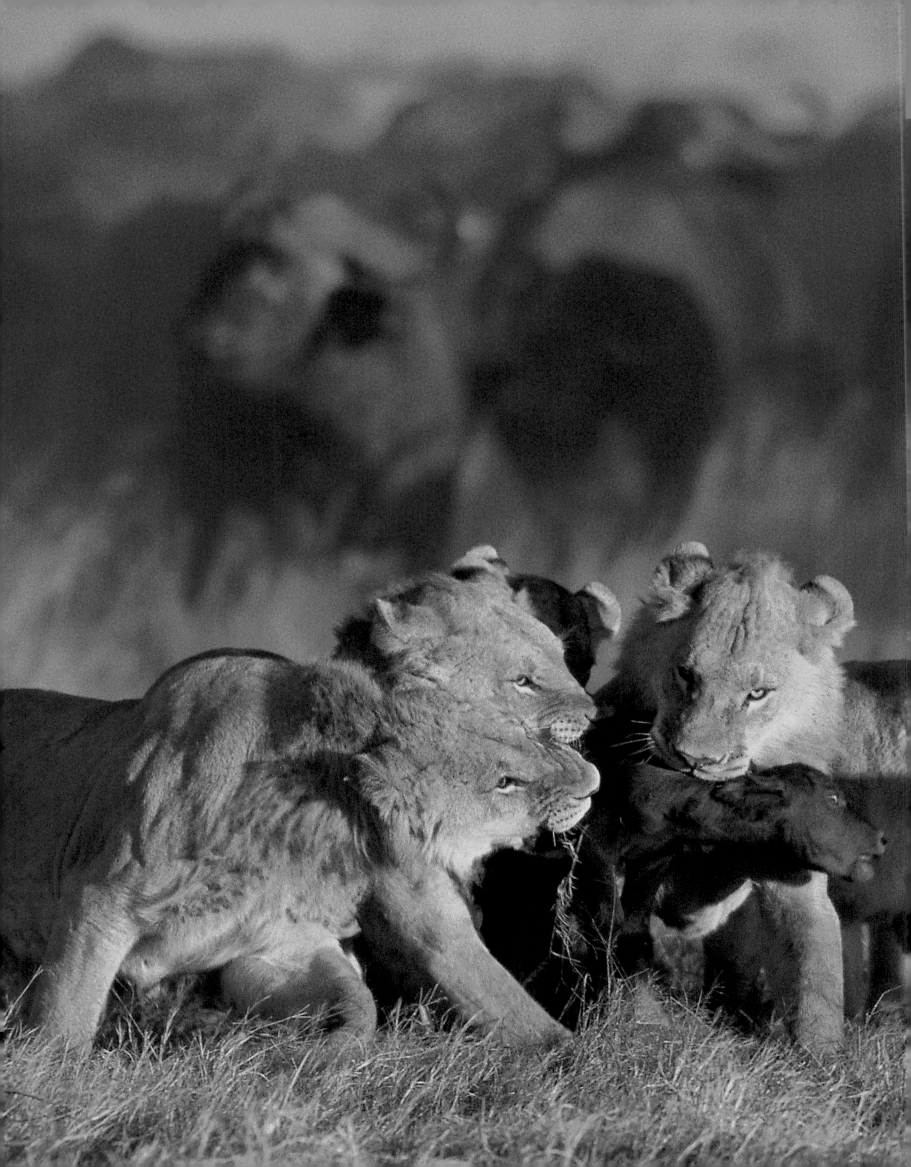

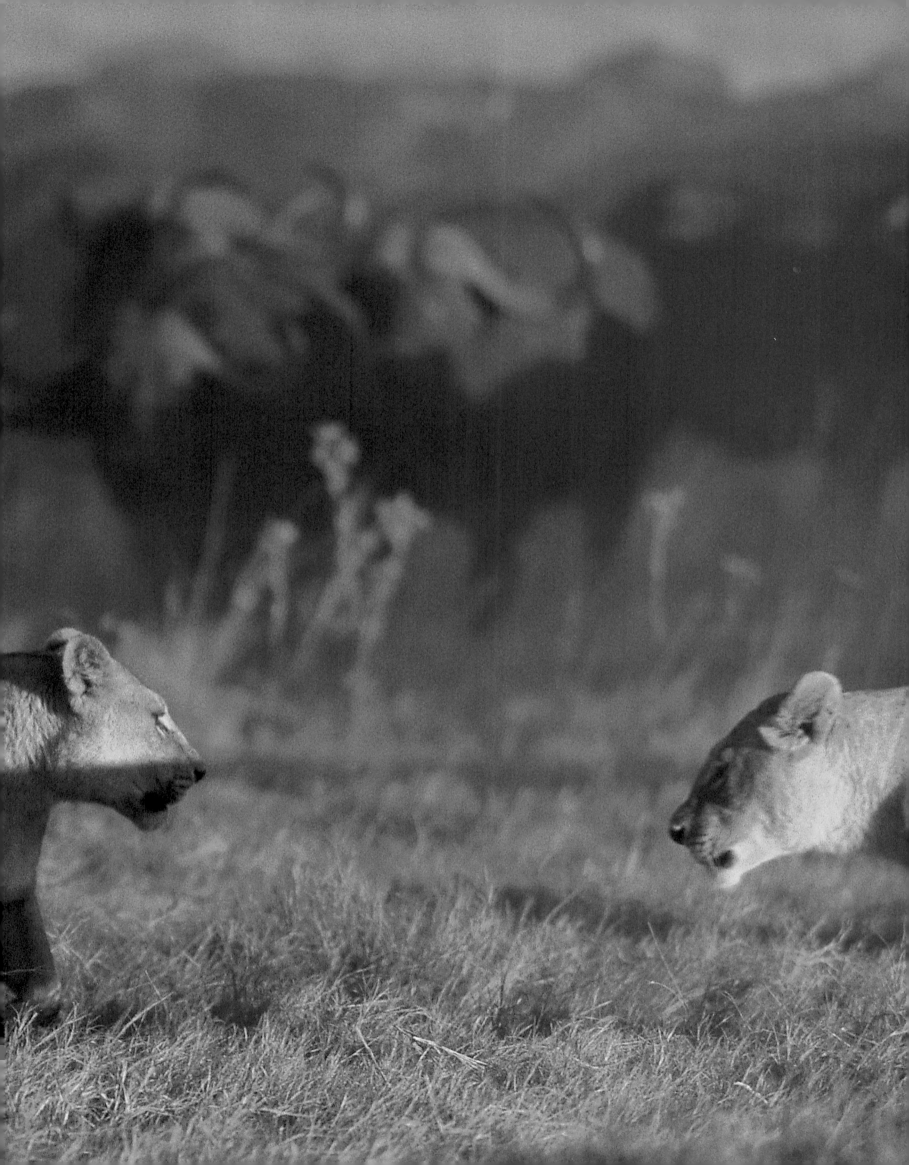

Leopards inhabiting rainforest have fewer ungulates from which to choose, both in terms of diversity and density. Nonetheless, red river hogs and forest duikers are their most important prey species with water chevrotains, forest buffaloes, okapis and sitatungas occasionally killed. Primates are the next most important group to forest leopards, with 11 different species recorded from studies in Côte d'Ivoire, DRC and the Central African Republic. Various arboreal species of colobus and mangabey monkeys are most important, but even the great apes are not invulnerable. In the Taï Forest of Côte d'Ivoire, leopard predation is the main cause of chimpanzee deaths, and indeed leopards and lions are the only carnivores able to kill adult chimps (lions rarely kill chimps, mainly because they mostly occupy different habitats, but four confirmed cases are known from when a pride passed through Tanzania's Mahale National Park in 1989). Researchers in the

Taï Forest documented at least 17 cases where leopards killed and ate chimps during a 12-year study. Leopards have also been recorded killing lowland gorillas, and, recently, researcher Danielle D'Amour working in DRC's Salonga National Park recorded bonobos as leopard prey for the first time.

Of the three big cats, the cheetah takes the narrowest range of prey. Of 325 cheetah kills I recorded in South Africa's Phinda Game Reserve, 322 were ungulates ranging in size from steenboks and red duikers to young giraffes and sub-adult wildebeest (the three outstanding kills were one adult ostrich and two cases of cannibalism). Three species of antelope – nyala, impala and common reedbuck – comprised over 80 per cent of kills. The same specialised pattern repeats itself throughout Africa. Springboks make up almost nine out of ten cheetah kills in the Kalahari Desert, while two-thirds of all cheetah kills on Tanzania's short grass plains are Thomson's

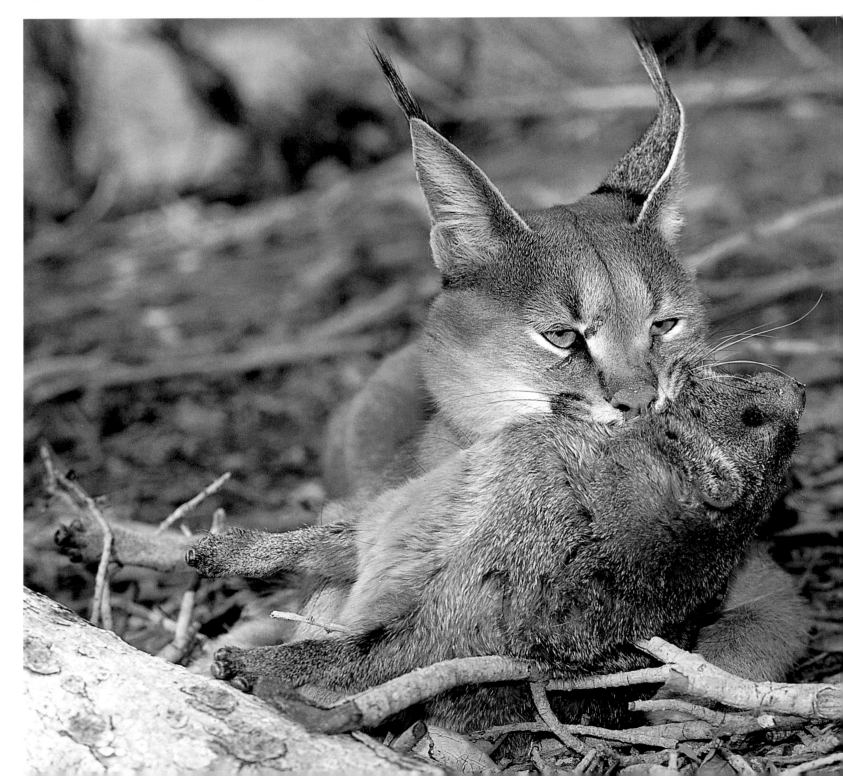

Able to tackle antelopes up to three times their weight, the caracal's menu includes mountain reebucks, springboks, female impalas and young greater kudus.

gazelles. In the great swathe of woodland savanna habitat stretching along Africa's east coast, from South Africa to southern Kenya, cheetahs focus on impalas. Exceptional prey recorded for cheetahs includes bustards, guinea fowl, cane rats, mole rats, one record of a baboon and, very rarely, other carnivores including caracals, jackals, bat-eared foxes and Cape foxes. Taken collectively, this mixed bag of unusual kills never comprises more than five per cent of the cheetah's diet.

Medium-sized cats: robust rabbit-traps

Leaving the three larger felids, there is a conspicuous drop in the size class of cats. After the similarly-sized cheetah and leopard, we see a gap to the next largest cats spanning around 25 kilograms. The caracal, African golden cat and serval share similar body sizes and weights, but while the serval's lanky proportions reflect a specialisation on rodents (see page 76), the caracal and golden cat are built to handle larger quarry. The robust caracal is renowned for its ability to kill outsized prey. Able to tackle antelopes up to three times their weight, the caracal's menu includes mountain reedbucks, springboks, female impalas and young greater kudus. In the Kalahari, Gus Mills saw a caracal on a freshly killed adult ostrich which he estimated at 100 kilograms – at least five times the weight of the cat. Such large kills represent the upper threshold of the caracal's predatory prowess, though, and more typically, they focus on smaller mammals. Caracals are surprisingly under-studied given their wide range and comparative abundance, and detailed information on their feeding ecology is available only from South Africa. There, rock hyraxes, hares, duikers, steenboks and small rodents make up the bulk of their kills. Birds are often regarded as a caracal favourite but, in fact, most studies show they represent a minor percentage of prey. On South Africa's west coast, small birds reach a peak in caracal diet, perhaps because of the low densities of larger mammal prey. On average, birds constitute slightly more than 23 per cent of caracal diet in the West Coast National Park, and they comprise more than half their kills in months when migrant birds swell the numbers.

The little knowledge about the African golden cat's diet comes almost exclusively from analysing their scats. A chance observation from Kenya's Kimikia River near the Aberdare National Park of a golden cat killing a Syke's monkey is one of the few eyewitness accounts available. It confirms that golden cats prey upon forest primates, although, in the only detailed studies from DRC's Ituri forest and Dzangha-Sangha in the Central African Republic, primates occurred in only five per cent of scats. Golden cats feed proportionally more on small rodents, squirrels and forest duikers, and they thrive where the understorey is most dense, sheltering high densities of these species. They are also thought to benefit from occasional scavenging of larger prey. Local people in Ituri report that golden cats feed upon large duikers killed in snares and they probably also scavenge the remains of crowned eagle kills and fallen monkeys on the forest floor. Like most cats, an opportunistic balance of hunting and scavenging probably satisfies the golden cat's daily needs, but until a determined researcher sets out to observe this elusive species more thoroughly, the finer details of its feeding ecology will remain a mystery.

PREVIOUS SPREAD: Separated from the safety of the herd, this young buffalo calf is doomed. Large buffalo herds usually stand their ground when threatened by lions, and the key to a successful hunt is to panic the herd into stampeding so that an individual can be targeted.

LEFT: A caracal suffocates a rock hyrax. Daytime kills like this occur fairly often where caracals are protected, but elsewhere they hunt primarily at night.

FOLLOWING SPREAD: A mother cheetah with large cubs feeds on a Thomson's gazelle, Masai Mara National Reserve, Kenya. Unlike lions, cheetahs show little aggression over carcasses and compete chiefly by bolting food as quickly as possible.

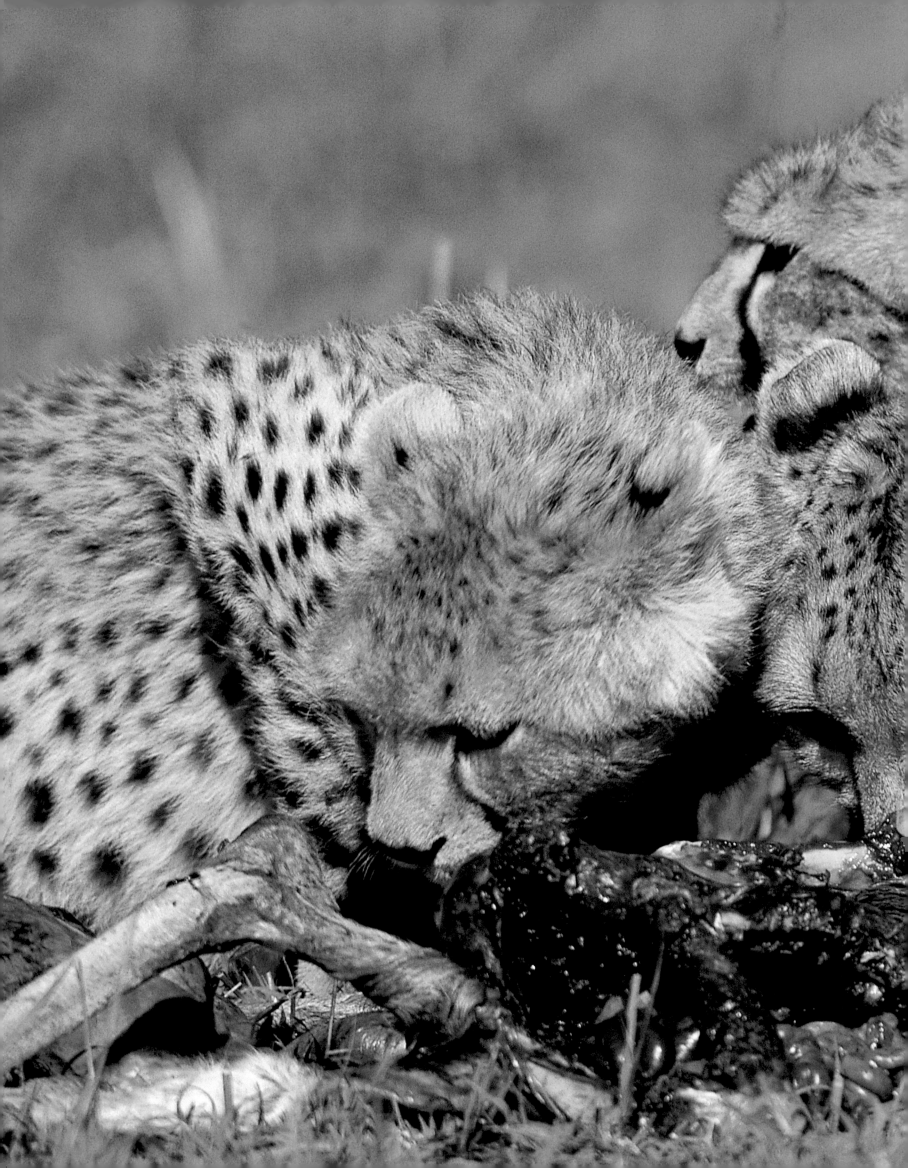

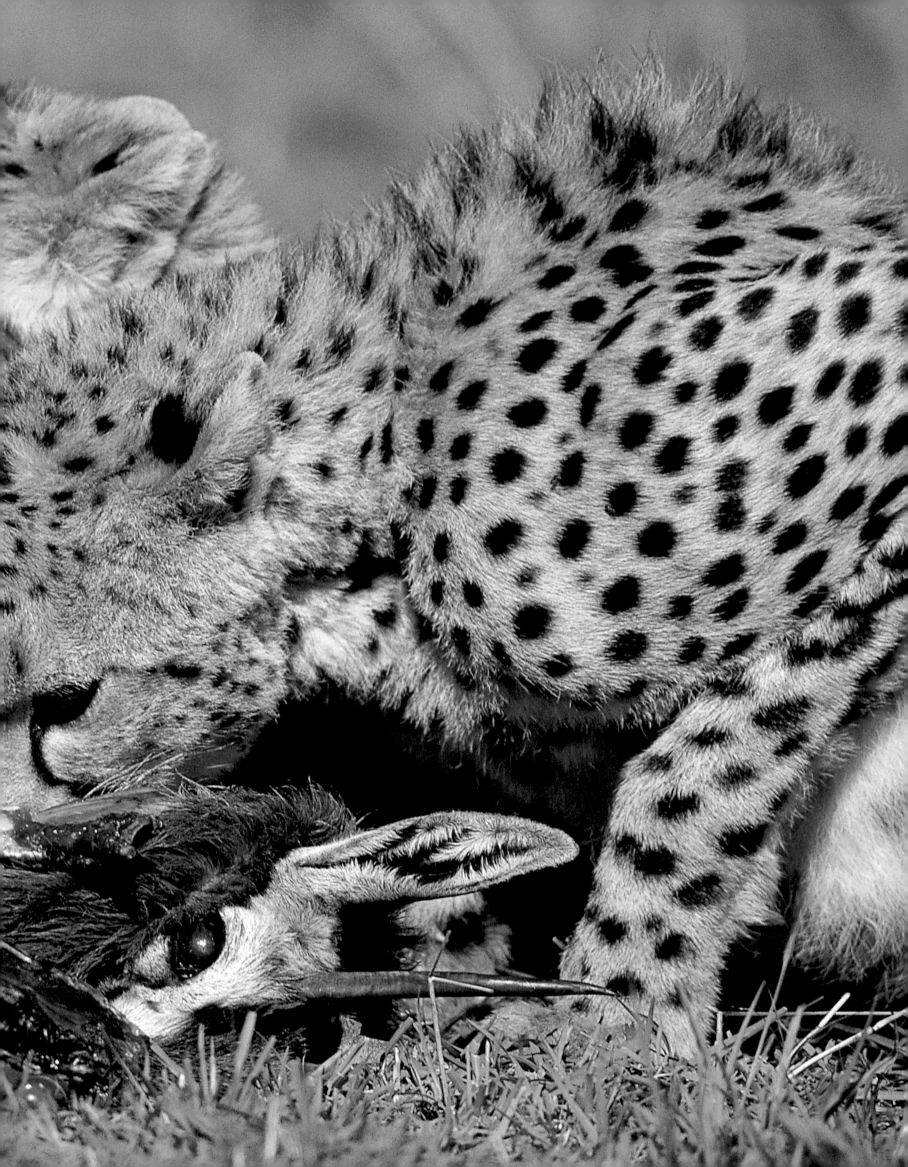

An adult serval kills around 4 000 small rodents each year, providing significant benefits to crop farmers. Under enlightened management, servals can thrive in agricultural areas but they are still widely persecuted in the mistaken belief that they are important predators of livestock.

Small cats: rodent-killers

Ranging in size from the 18 kilogram serval down to the 2.5-kilogram black-footed cat (both figures represent top weights), all five remaining species of African cats specialise in eating rodents. The diet of servals, which are common to Uganda's Bwindi Impenetrable National Park, Tanzania's Ngorongoro Crater, Zimbabwean farmlands and the foothills of South Africa's Drakensberg mountains, comprises at least 80 per cent small mammals such as Nile rats, vlei rats, various mice species and shrews. Small grassland birds like queleas, bishops and flufftails are collectively the next most common class of prey; cats slap them from mid-air or dispatch them by clapping their front paws together. They occasionally take swifter prey like hares and springhares, but servals are poorly built for pursuit and are easily outpaced by speedy quarry if the first pounce misses. Despite its long legs, the serval is designed for jumping rather than sprinting; its height is more the result of highly elongated foot bones – the metapodials – rather than lengthened limb bones. Indeed, it is more accurate to say the serval has long feet, rather than long legs and, unlike the cheetah's compact metapodials and stretched limb bones (a combination for speed), the serval's long legs deliver relatively sluggish speed but a prodigious ability to leap. The seasonal arrival in East Africa of huge flocks of migratory Abdim's storks around

October each year puts the serval's aerial skills on spectacular show. Sighting a stork, the serval adopts a classically feline stalk to come up close. A short, explosive sprint ends in a skywards leap up to three metres high, snagging the heavy bird during its clumsy take-off. Lesser flamingos, korhaans, guinea fowl and francolins are also taken by these caracal-like acrobatics.

The jungle cat shares the serval's adaptations for hunting in waterlogged, long-grass habitats. Although not as marked as in the serval, the jungle cat's long legs raise it above sodden ground and its large ears help to pinpoint prey concealed in reeds and rank grass. As with the serval, small rodents make up the bulk of the jungle cat's diet, and they also take waterfowl, small birds, hares and insects. Interestingly, although their physical specialisations for a wetland existence are less refined than the serval's, jungle cats show a stronger affiliation for water itself and are capable swimmers. They have been recorded swimming across stretches of open water up to 1.5 kilometres wide and readily plunge beneath the water's surface to catch fish and frogs. The stomach of one jungle cat examined near Alexandria in Egypt was full of fish and nothing else.

It is hardly surprising that the wild relative of the domestic cat is a mouse hunter. A range of figures from around southern Africa shows that the African wildcat's diet is dominated by various wild mice and rat species. Wildcats also hunt Cape hares,

rabbits and springhares, and are capable of killing very young antelope lambs, but they rarely kill anything exceeding four kilograms. Birds up to the size of korhaans, reptiles, amphibians and insects are also eaten, particularly during rodent shortages; wildcats readily switch prey when mice are thin on the ground and are able to survive for long stretches on less preferred quarry. During a drought in Botswana in which rodent numbers plummeted, wildcats subsisted solely on arthropods such as crickets and grasshoppers supplemented with small birds and, unexpectedly, the fruit of the jackalberry tree.

German biologist Alex Sliwa can be thanked for furnishing a spectacularly comprehensive insight into the eating habits of the black-footed cat. He witnessed more than 2 000 captures of prey made by this tiny felid in South Africa's arid Kimberley region. The large-eared mouse tops its list, and small rodents, shrews and 21 different birds make up the bulk of black-footed cat kills. Sliwa observed successful kills up to the size of Cape hares and recorded scavenging on dead springboks, though hunting attempts made on living lambs always failed when the lambs stood up. Possibly unique to small cats is the black-footed cat's habit of caching unfinished prey in shallow aardvark digs, concealing it with a covering of soil and grass. Surprisingly, the cat continues hunting even when many kills have been stockpiled. With winter night-time temperatures dropping below -8 °C and an elevated metabolic rate requiring constant fueling, continual hunting maintains the cat's immediate energetic needs while also establishing a network of caches to ensure a meal later if prey becomes difficult to find.

Sand cats are hunters of small desert rodents, particularly gerbils and jerboas, but there are few detailed accounts from Africa. The best indication of their diet comes from the former USSR where the species was killed in large numbers for its long, silky winter coat. Soviet biologists recorded the unfortunate cats' final meal and showed that, along with a rodent staple, common prey includes desert larks, sandgrouse, partridges, followed by hares, snakes, lizards, scorpions and insects. African sand cats probably have a very similar diet. The Toubou nomads of Niger regard the sand cat as a snake specialist and excellent records exist of their killing horned and sand vipers in the Sahara. Against such lethal adversaries, the cat employs a succession of rapid-fire blows to the snake's head until it tires and lowers its defence. The coup-de-grâce comes to the exhausted snake by the agile cat pinning down its head with a paw and biting the skull or neck. In the only published account of such an encounter, the cat devoured an entire sand viper after killing it, consuming venom glands, fangs and all without harm.

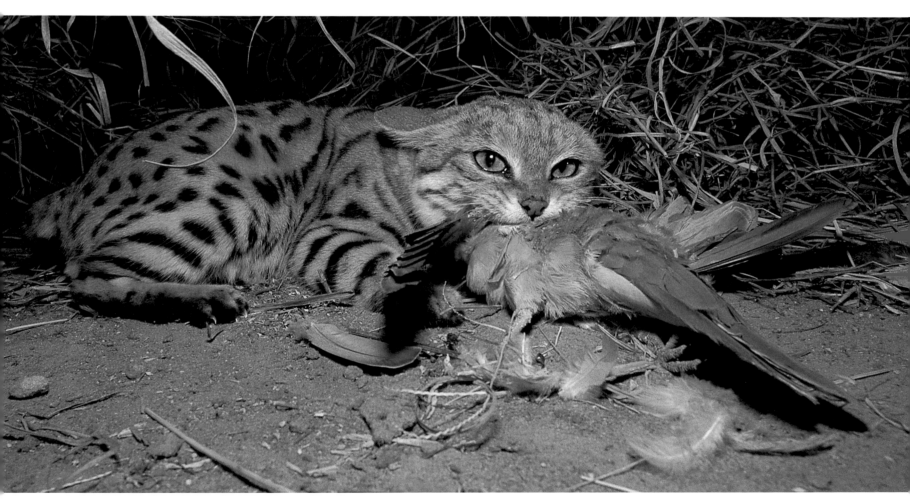

A black-footed cat with its kill, a Cape turtle-dove. In the only comprehensive study of black-footed cats, conducted near Kimberley, South Africa, 21 species of birds made up a quarter of all kills by mass.

Statistics of the hunt: how well, how far, how often?

Discussions about the hunting success of carnivores and the effort it requires are plagued by problems of measurement and definition. A sand cat waiting at the entrance of a rodent burrow and lions chasing a herd of 1 000 buffalo for over a kilometre have the same goal in mind – to eat – but they represent vastly different expenditure of effort. Similarly, how does one measure the intent to hunt? Both the leopard that happens upon a newborn impala lamb, killing it where it lies, and a caracal that wrestles a young greater kudu to the ground, taking 45 minutes to kill it, have successfully hunted – but are they comparable events?

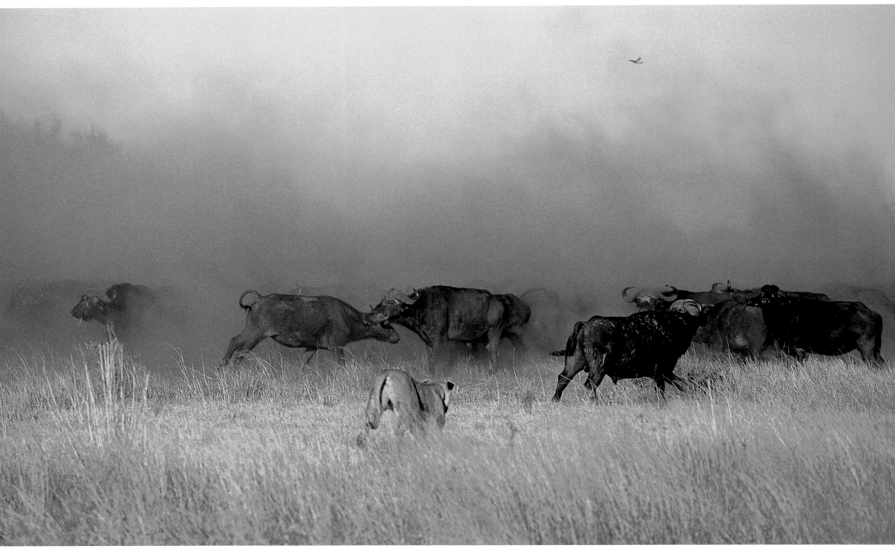

A lioness 'tests' a 1 000-strong buffalo herd in northern Botswana. Contrary to popular belief, there's little evidence for lions selecting weak or vulnerable individuals but the strategy of running into herds probably improves chances of a kill by separating a target from the dangerous, defensive mass of the herd.

Perhaps the most meaningful answer is that cats are as proficient as they need to be. To most adult cats, starvation is a rare threat, which means that they are at least efficient enough to survive. For females raising cubs, the stakes are higher and, under conditions of extreme food shortages, cubs may be abandoned (see Chapter 4). However, excluding these relatively rare events, cats are clearly proficient at balancing effort with intake. How they do so varies surprisingly among species.

Among the most impressive figures, the black-footed cat boasts some extraordinary statistics. Of the many hundreds of kills seen by Alex Sliwa, about 60 per cent of them produced a kill, one of the highest success rates for any cat. Black-footed cats typically make between 10 and 14 kills a night, averaging a kill every 50 minutes and eating between 250 to 450 grams – 20 to 30 per cent of their body weight. They cover up to 16 kilometres during a single night's foraging, though Sliwa is careful

to point out that he measured the distance by following behind cats in his vehicle; the real distance covered by the endlessly weaving hunter could be twice as much.

Servals in Ngorongoro Crater average a success rate of 49 per cent. They are most efficient hunting insects (54 per cent), least so while hunting small birds (23 per cent), with their mainstay, rodents, coming in at the average (49 per cent). Well protected and free of human persecution, Ngorongoro servals show a prevalence for diurnal activity and have greater returns from daylight hunting. They average one kill per hour during the day, compared to a kill every two hours at night. Looking at it another way, Ngorongoro servals make three kills per kilometre walked during the day compared to an average of 1.9 kills per kilometre at night. Hunting servals cover around 4.5 kilometres every 24 hours, occasionally walking as far as 10 kilometres. Servals kill an astonishing number of small animals every year: Aadje Geertsema watched 12 Ngorongoro servals for four years and calculated that each killed 3 950 rodents, 130 birds and 260 snakes annually.

At first glance, the figures for large cats seem somewhat less impressive. However, it is important to bear in mind that large felids hunt large, sometimes dangerous species that provide a greater return. Leopards in north-east Namibia walk up to 33 kilometres in 24 hours and average a kill once every 2.7 hunts, a success rate of 38 per cent. Tracking Kalahari leopards, Koos Bothma showed lower rates: females with cubs were most successful (27.9 per cent) compared to females without cubs (14.5 per cent) and males (13.6 per cent). Annually, Kalahari leopards average 111 kills for males to 243 kills for females, the higher figure for females reflecting more, smaller kills. Leopards in the Kruger National Park make fewer kills of larger prey, equating to one adult impala per week.

As the only intensely social felid, lions might be expected to show elevated rates of success. Although group hunting does increase success (see text box 'Co-operative hunting in cats', page 63), their overall success rate is comparable to other large cats. An average across numerous studies gives an overall rate of around 26 per cent, ranging from 15 per cent to 38.5 per cent. Etosha lions have the lowest success rate, perhaps because they inhabit such open habitat. Surprisingly, males and females are often equally successful hunters. From 679 attempted hunts seen by Paul Funston and Gus Mills in southern Kruger National Park, females succeeded around 27 per cent of the time compared to 30 per cent for males (the difference is negligible when the appropriate statistical tests are applied). Hunting success was least for medium-sized prey such as wildebeest, kudus and zebras (20 per cent) and climbed to more than 50 per cent for buffaloes.

To most adult cats, starvation is a rare threat, which means that they are at least efficient enough to survive.

With about a third of their chases ending in a kill, cheetahs have a success rate slightly higher than lions. On the open grasslands of the Serengeti where Thomson's gazelles comprise the cheetah's preferred prey, estimates of hunting success vary from 29 to 54 per cent (emphasising the problems in comparing measurements made by different researchers). When hunting very young gazelles, the figures show far less ambiguity: 100 per cent of hunts on newborn gazelles witnessed by Schaller resulted in a kill, while a comprehensive set of observations made by Tim Caro revealed a 92 per cent success rate for female cheetahs and 86 per cent for males. Although baby gazelles are extremely swift, they simply cannot match the cheetah's extraordinary speed, reliably timed at 105 kilometres per hour. Hares are also easily killed, 87 and 93 per cent of the time when hunted by females and males respectively. Caro further showed that hunting ability improves with age and, as detailed later in this book, that survival is not easy for young cats.

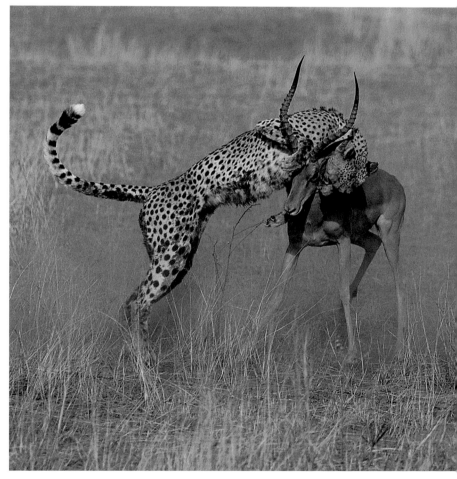

Tackling large, well-armed prey carries significant risks to cats, particularly when a prolonged struggle results, such as between this cheetah and impala. Although it does not occur often, species recorded killing cheetahs include gemsbok, blue wildebeest, warthog and domestic cattle.

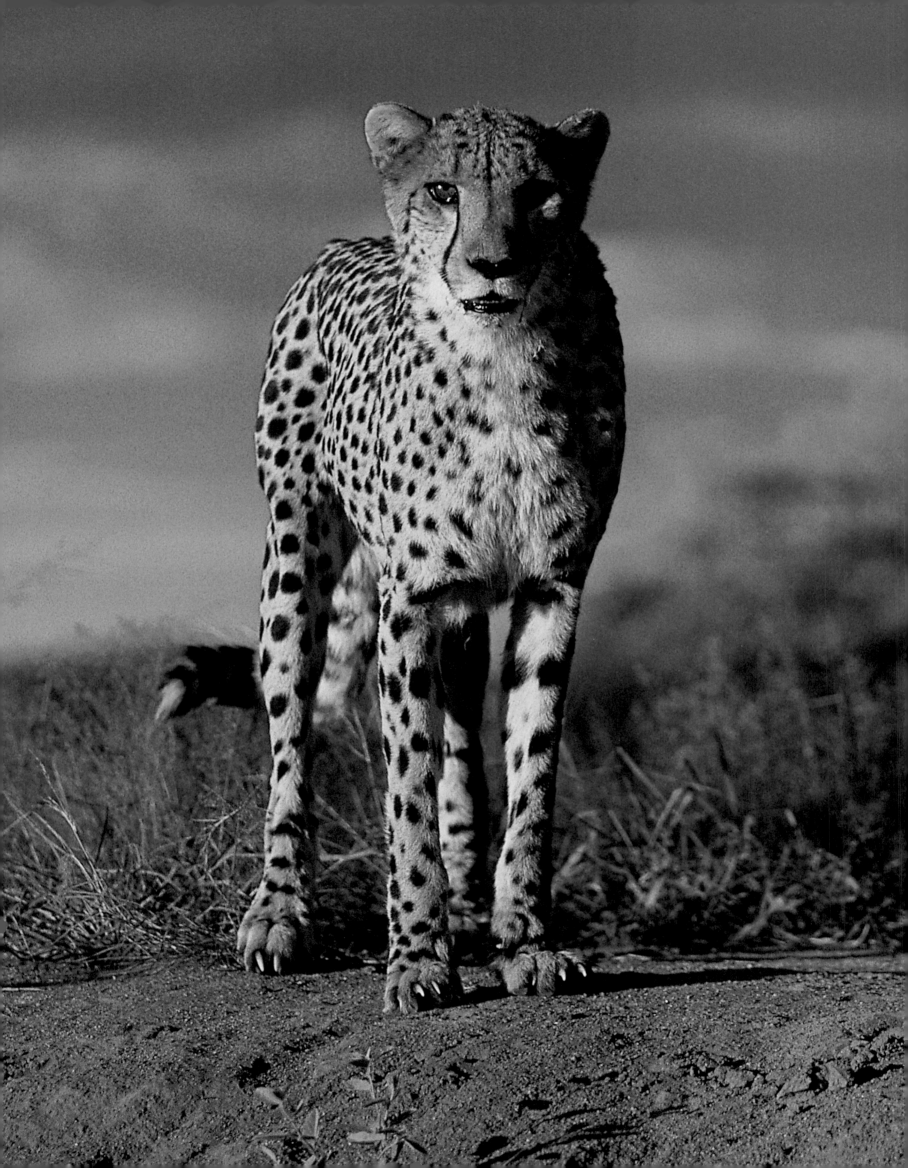

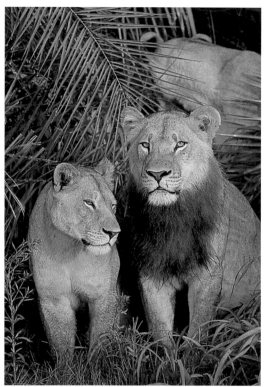

SOLITARY
AND
SOCIABLE

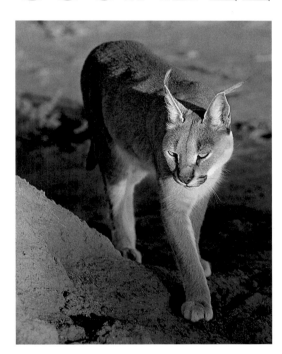

social systems,
land use and
communication

Social behaviour

Most cats are loners. With the exception of lions, male cheetahs and feral domestic cats (discussed in this chapter), felids do not form complex, life-long social groups. In this, they resemble most species in the order Carnivora; indeed, only around 15 per cent of carnivores form social groups that endure beyond the fleeting courtship required to perpetuate the species. Of the 110 species residing on the cat branch of carnivores, the Feliformia, at least 90 are fundamentally solitary as adults (or thought to be, in the case of some poorly known species). In addition to those cats listed above, only a handful of highly communal mongooses such as suricates, dwarf mongooses and cusimanses, and three clan-living hyaena species (brown, striped and spotted) form enduring social groups. A few other species – the aardwolf and possibly some mongooses from Madagascar – associate in pairs or extended family groups but, in as much as is known of them, only during the discreet breeding season where males temporarily remain with females to assist raising the young.

The adults of most cat species live alone but this does not mean they are antisocial.

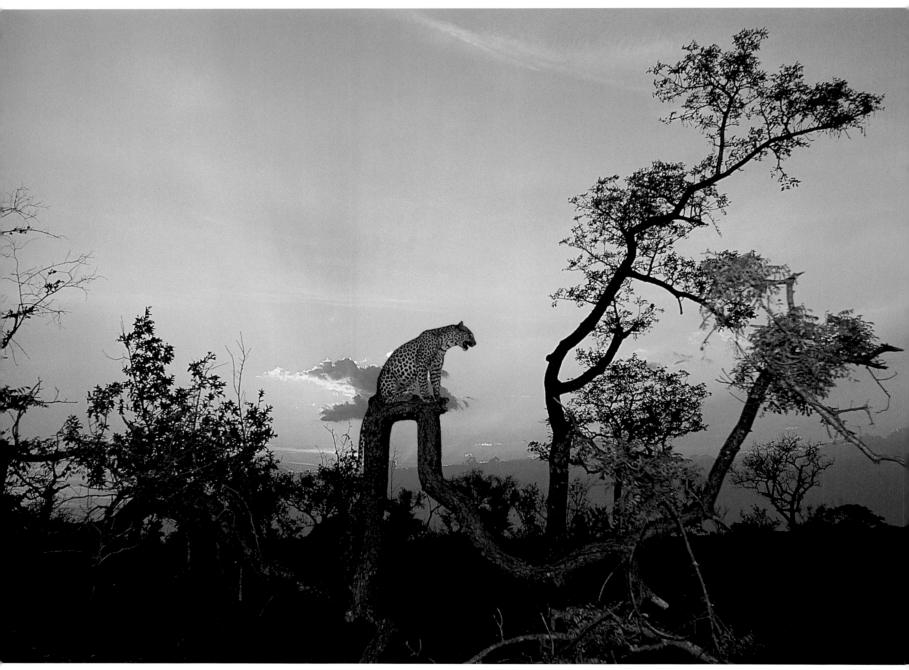

The leopard is the archetypal solitary cat, spending the majority of its time alone. Even so, leopards are far from being antisocial and maintain constant contact with other members of their species.

Cohorts of cats

In discussing the sociality of cats, biologists use a number of generally familiar terms that have specific meanings in this context. A 'cohort' is simply a group of animals of the same age class. The *adult* cohort is made up of animals capable of reproducing, and the most meaningful population estimates are given as the number of adults. *Sub-adults or adolescents* are young adults capable of surviving on their own. They hunt independently from the mother and, in most species, no longer associate with her at all, though lioness sub-adults usually remain with the pride into adulthood, and sub-adult males linger with their mothers for longer than other cat species before dispersing. Sub-adult cats are too young to reproduce, either because they are not yet sexually mature or they cannot compete with adult cats for access to mates. *Cubs or kittens* are dependent on their mother and are usually divided into two cohorts. Large cubs have been weaned and travel with the mother as she moves and hunts. Although they are highly mobile and begin making their own small kills during this stage, large cubs are still dependent upon the mother for survival. Small cubs are wholly reliant on the mother for food, shelter and protection. They are left on their own for long periods while the mother forages and she brings food (as milk or meat) to them, or she retrieves them from the den and escorts them to kills when they are slightly older. Naturally, the transition between cohorts can be quite prolonged – for example, from large cub to sub-adult – so it is not always clear where an individual belongs but, transitions aside, each cohort represents a discrete stage in the life of a cat.

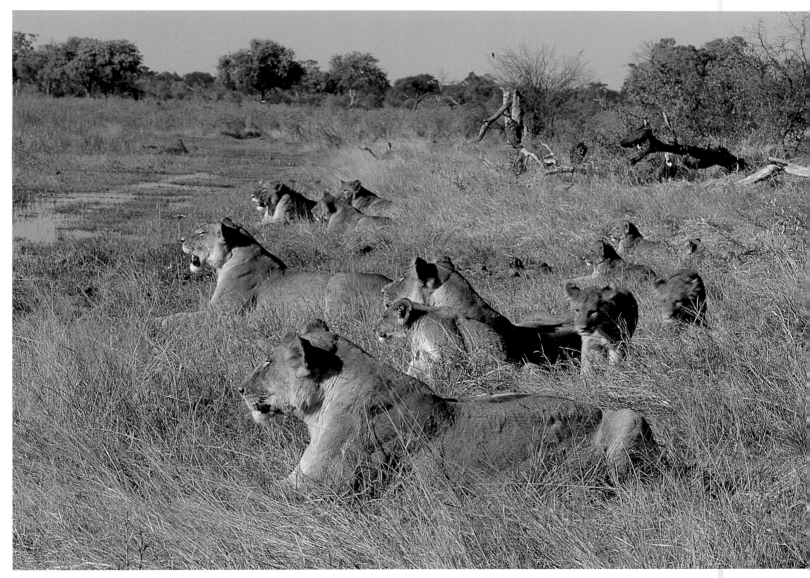

A pride of lions, Khwai River, Moremi Game Reserve, Botswana. This pride has representatives from three cohorts – adults, old cubs (at rear) and young cubs (right) – but a single pride may contain individuals belonging to all cohorts at the same time.

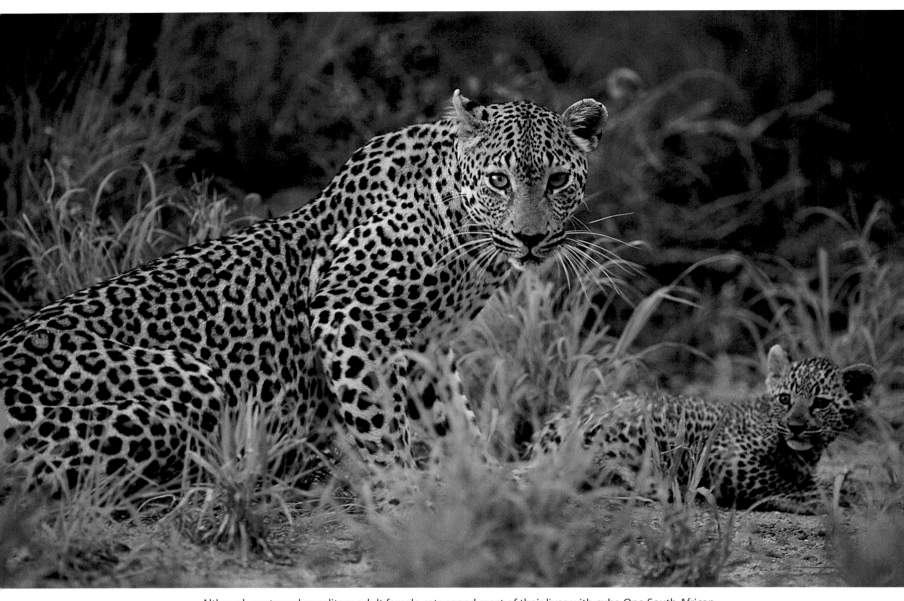

Although portrayed as solitary, adult female cats spend most of their lives with cubs. One South African leopard intensively monitored for 12 years had dependent cubs for almost 80 per cent of her adult life.

Outside the sub-order, there are more examples of sociality among carnivores, but only one terrestrial family, the Canidae, is dominated by group-living species. Large canids such as African wild dogs, Ethiopian wolves, Asiatic dholes and grey wolves have sophisticated and intensely gregarious, large family groups. Smaller species like coyotes, jackals and various fox species adopt a variety of fluid social arrangements usually based on an enduring pair bond between an adult female and male accompanied by 'helpers', the grown pups of previous litters. The other caniform families are made up mostly of solitary species. Although exceptions exist – the raccoon and weasel families each include a handful of group-living species among their ranks, and some bear species come together in large, temporary aggregations outside the breeding season – most other caniform carnivores also follow the cat model in living alone.

It is important to clarify what it means when a cat is described as solitary. The adults of most cat species live alone but this does not mean they are antisocial. Males and females come together to mate and usually stay together for as long as the female is receptive. Typically, such associations last less than a week but they may occur surprisingly often (detailed in Chapter 4). Revealingly, though, mating is merely the most obvious association in a world full of constant, if fleeting, social contact. Guy Balme has spent thousands of hours in the humid woodlands of KwaZulu-Natal watching leopards, long considered a strictly solitary species, and he has witnessed many interactions between females and males that have nothing to do with sex. Male leopards are tolerant even of cubs they have sired (or believe they have; see Chapter 4) and sometimes 'visit' their females and cubs in amicable associations for as long as 24 hours. Additionally, for most of their adult life, all female cats are accompanied by the cubs of successive litters, so while it is true that most felids do not form the lasting, intricate social bonds of a hyaena clan or a wolf pack, cats do not exist in a social vacuum.

But why are permanent social groups so unusual in cats? Surely teaming up and living together holds obvious advantages? A group of cats would outperform a singleton at many crucial survival tasks, for example, killing large prey, defending territory and protecting cubs. In fact, while these advantages *are* realised in a few circumstances, living in groups carries substantial costs which, for most cats, exceed the benefits. The main determinant is probably food. The advantages of communal hunting do not necessarily translate into more meat for each cat. Surprisingly perhaps, the gains from being able to tackle larger prey or the increased success rate of group hunts (Chapter 2) are quickly eclipsed by the collective demands of feeding multiple mouths. Numerous studies have demonstrated that the most efficient group size for lionesses to maximise their food intake is very small – usually one or two – and competition among the members of a pride at kills can be intense. (The reasons lions form groups are more complex and are discussed later this section.) Such demands are presumably so great that, for most felids, they outweigh even the potential gains sociality yields in defending cubs and territory or other possible benefits.

This is less unexpected when one considers how exceptionally well equipped the individual cat is to operate alone. As discussed earlier, all cat species are striking in their ability to kill very large prey (relative to their size) on their own. Morphologically and behaviourally, the cat is a supreme solo hunter. Enormously powerful musculature, hair-trigger reflexes, retractile claws and supple wrists furnish a cat with tremendous control when catching and handling prey; when combined with the delivery of a precisely oriented killing bite by truncated, powerful jaws, a lone lion can overpower an eland, a leopard can kill a zebra or a caracal can take down an impala. By contrast, African wild dogs or spotted hyaenas rely on relatively more robust and less flexible builds to tire prey over long distances, and work in a group that overcomes the limitations of the individual in killing large quarry. A lone wild dog is not physically constructed to wrestle a wildebeest to the ground but a few dogs can dispatch one at least as efficiently as a big cat. So, even though leopards, golden cats or jungle cats might derive some modest benefit from teamwork, each is proficient enough at surviving alone not to resort to this and, indeed, cannot afford to in view of the additional costs incurred.

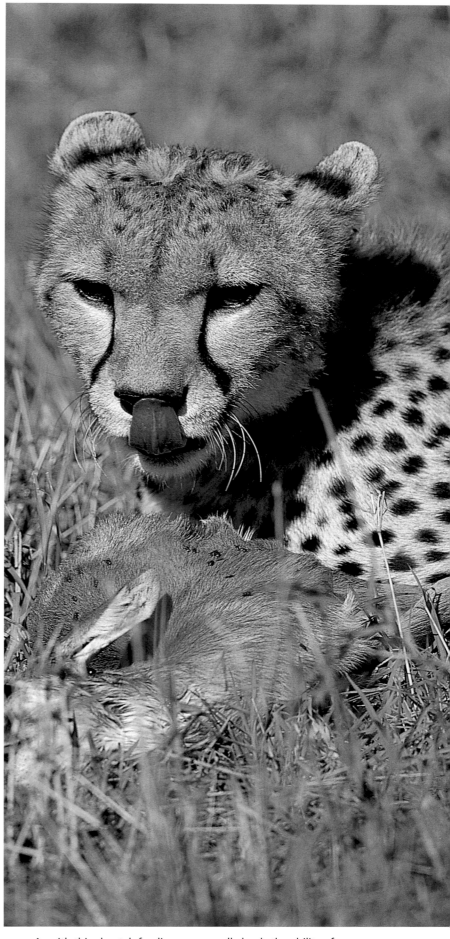

As with this cheetah feeding on a gazelle lamb, the ability of most cats effectively to meet their needs by hunting a variety of prey types and sizes is part of the reason they do not form groups.

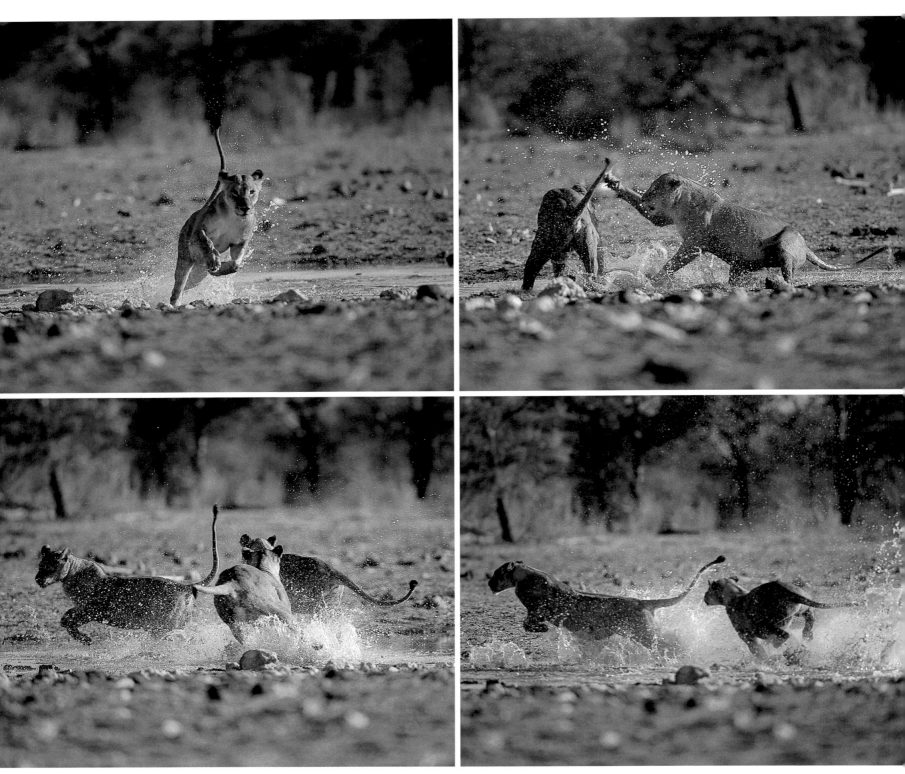

Lionesses at play in Namibia's Etosha National Park. Play among adults is assumed to strengthen bonds within the pride, though the idea has never been properly tested; doubtless, lions (and other cats) also play simply because they enjoy it.

Lionesses: matrilines and sisterhoods

There are, of course, exceptions to the rule. Most prominent among them, the lion's social system is founded on a sisterhood of related females. Lionesses born into the pride usually stay with the group for life, forging a stable social nucleus numbering up to 20 related lionesses from as many as five generations. Within this matrilineal society, lionesses demonstrate co-operative behaviours unique to wild cats, giving birth synchronously and communally raising the cubs (see Chapter 4).

Why, of all wild cats, are lionesses the only ones to live in prides?

Part of the answer is because they can. Africa's extraordinary richness and density of large herbivore species provides enough of a resource base to support the formation of groups in large cats. Yet, that it is possible does not necessarily mean it is the best strategy; as mentioned earlier, in terms of the amount each individual eats, lions would probably be better off alone or in pairs. Group living seems particularly difficult to reconcile given that an individual lion is capable of killing all but the

A pride of leopards?

At first glance, the same suite of conditions that biologists believe promoted sociality in lionesses (see main text) also applies to other large cats that share lion habitat – leopards and cheetahs. Both species are found in open habitats and both can kill large prey. Yet the females of these species are always solitary; why is it that there is no such thing as a pride of leopards or cheetahs? A closer look at their ecology reveals that both species are different enough from lions for sociality simply not to make sense. While both species are capable of making large kills, they normally prey upon animals their own size or smaller. Leopards haul their kills away from competitors or prefer denser woodland areas within the savanna mosaic, while cheetah females rarely make kills so large that they cannot drag them into cover and finish them off in a day; although both lose kills to competitors, neither has the lioness' persistent problem of defending very large, very obvious carcasses. The risk of infanticide is probably also less; it occurs in leopards but likely at lower rates than in lions, and it may not occur at all in cheetahs (see Chapter 4). For the females of both species, there is simply no compelling need powerful enough to overcome the costs of communal living and, like all other female cats, remaining solitary is still the most effective survival strategy.

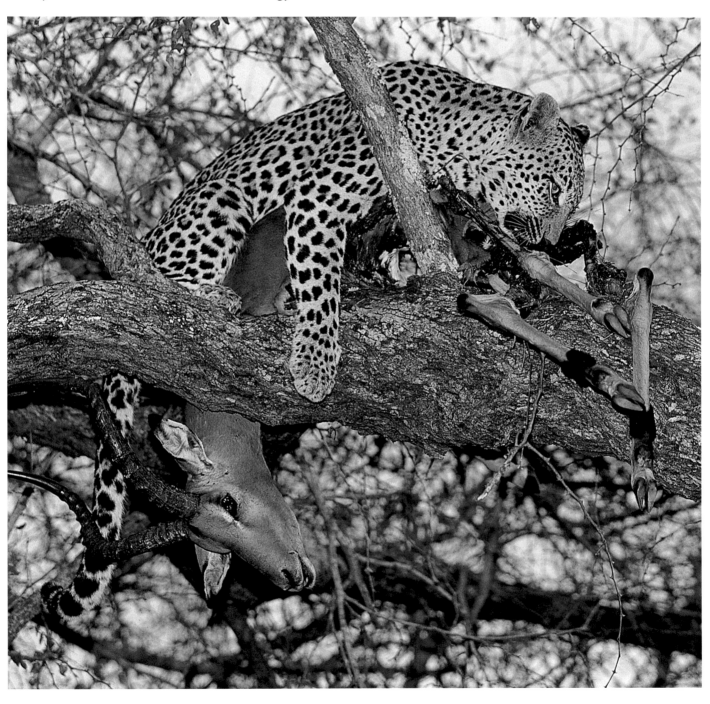

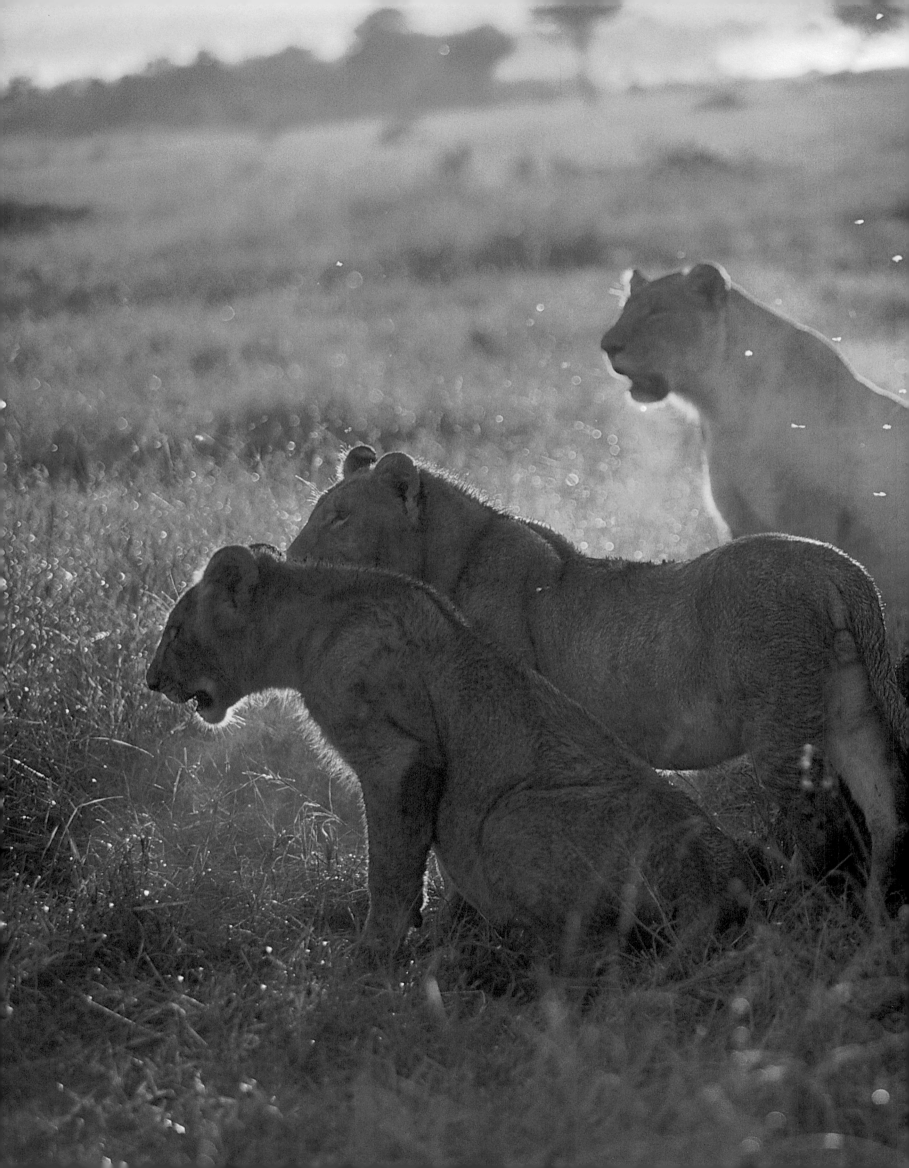

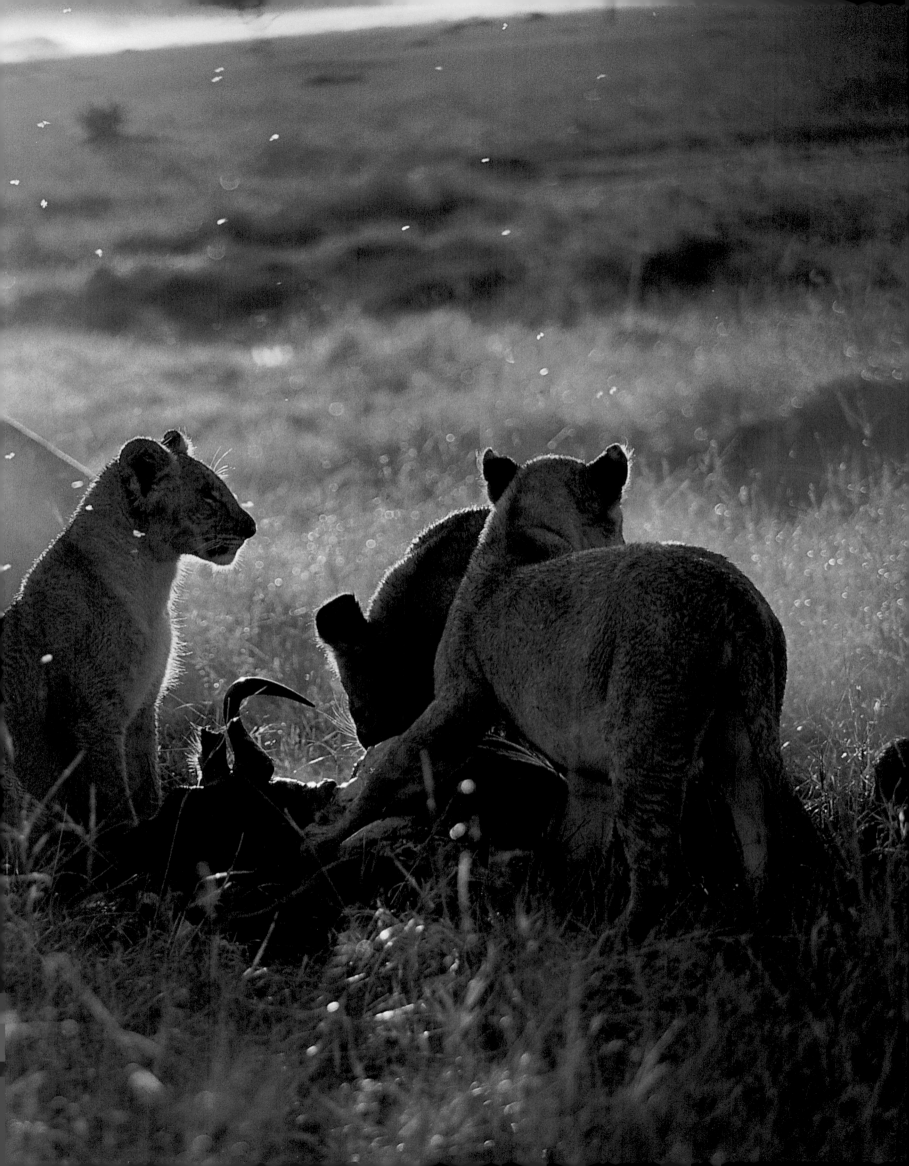

very largest prey species. In fact, this provides a further piece of the solution. In open habitats where visibility is great, a large kill is a liability; it is impossible to finish off quickly, difficult to hide and is visible to competitors from afar. A single lion can be displaced from a large kill by competing carnivores superior in numbers or size (and recall from Chapter 1 that lions evolved in a rich carnivore guild with almost twice as many species as today, including all modern species as well as three large sabre-toothed cats, and at least two extinct large hyaena species). When the odds of losing a kill are very high, better to share it with relatives who will help to defend it and, by reducing their losses to kleptoparasites, perhaps even increase their chances of surviving and raising cubs related to the hunter.

Indeed, enhancing the survival of cubs was probably just as important as retaining kills in driving the development of the pride. Groups of females represent an extremely attractive resource to males and, just as with large kills, are likely to attract a great deal of attention in open habitat. As incipient sociality grew among the ancestral female lion on the open woodlands of East Africa, so too did the risk of infanticide, the killing of their cubs by intruding, unrelated males (detailed in Chapter 4). Banding together held the further advantage that females could better defend their cubs from foreign males. Although a single lioness would have little hope against a male lion, even a pair of lionesses is capable of formidable opposition that can deter an infanticidal male. Serengeti researcher Craig Packer has even recorded single adult males killed by groups of lionesses in defence of their cubs.

So, in summary, the open woodlands where (presumably) lion sociality arose not only supported enough large prey to enable lionesses to be social, but essentially mandated it. The evolution of the pride appears to be the lion's answer to surviving in an acutely competitive environment where the stakes were cubs and kills. Their enhanced defence was enough of a factor to outweigh the disadvantages that continue to promote a solitary lifestyle in most other cats (including those that live in similar open habitats where one might expect sociality to emerge; see text box 'A pride of leopards?', page 87).

Fascinatingly, the only other cats known to form female groups are semi-wild domestic cats living under analogous circumstances. Females living in colonies around docks, boatyards and farms often enjoy access to rich patches of food in the shape of handouts or dumps of fish and animal offal, essentially the scaled-down equivalent of large carcasses. Reaching high densities under such artificial provisioning, female cats are exposed to the same evolutionary forces that promote sociality in lionesses, and their social response is almost identical. They form tight-knit matrilines of related

The evolution of the pride is the lion's answer to surviving in an acutely competitive environment.

females that enjoy enhanced access to food, synchronise their oestrous periods, den together, suckle one another's kittens and jointly defend their litters from infanticidal males. Revealingly, such conditions do not occur in the wild for the domestic cat's progenitor, the African wildcat, and female wildcats adhere to the solitary female model.

Male coalitions

But what about the males? Only two species of cats, the lion and cheetah, form enduring alliances between males, which are called coalitions. In both species, coalitions are typically made up of males with close genetic ties. This is especially so for cheetahs, where coalition members are usually brothers belonging to the same litter. Related males from a litter usually stay together when they disperse from the mother (see Chapter 4), leading to most coalitions numbering two or three, and never more than five. Given that a number of litters usually grow up together in a lion pride, membership of lion coalitions is somewhat broader than in cheetahs, and coalitions are larger. As many as nine (but usually two to five) brothers, cousins, half-brothers and so on contribute to their make-up.

Although most coalitions consist of related individuals, it depends on the size of the group. If a male has few or no male relatives, he is more likely to seek out partnerships with unrelated companions. Among the lions of the Serengeti National Park, coalitions of four or more males are always related. By contrast, over 60 per cent of male pairs consist of unrelated individuals and half of all trios consist of a related pair accompanied by an unrelated male. Similarly, as many as 30 per cent of all Serengeti cheetah coalitions contain at least one unrelated member. Most mixed coalitions are pairs of unrelated loners that have teamed up, but single males sometimes join a related pair and occasionally a singleton is accepted by a trio of brothers. Clearly, the reasons for forming groups are compelling for the males of both species. Not surprisingly, it is all about defending territory and the females that go with it, as will be seen in the next section.

PREVIOUS SPREAD: These lions in Kenya's Masai Mara National Reserve enjoy good hunting year round. In the wet season, lions have access to high densities of non-migratory prey species such as buffaloes, warthogs, topis and hartebeest. With the seasonal arrival of over a million wildebeest and zebras in July–October, they switch their diet to concentrate almost exclusively on the migrants.

OPPOSITE: Given that a single lion holds little hope of gaining territory, the pressure on loners to form coalitions is intense. In the Serengeti-Mara ecosystem, duos of unrelated males are more common than related pairs.

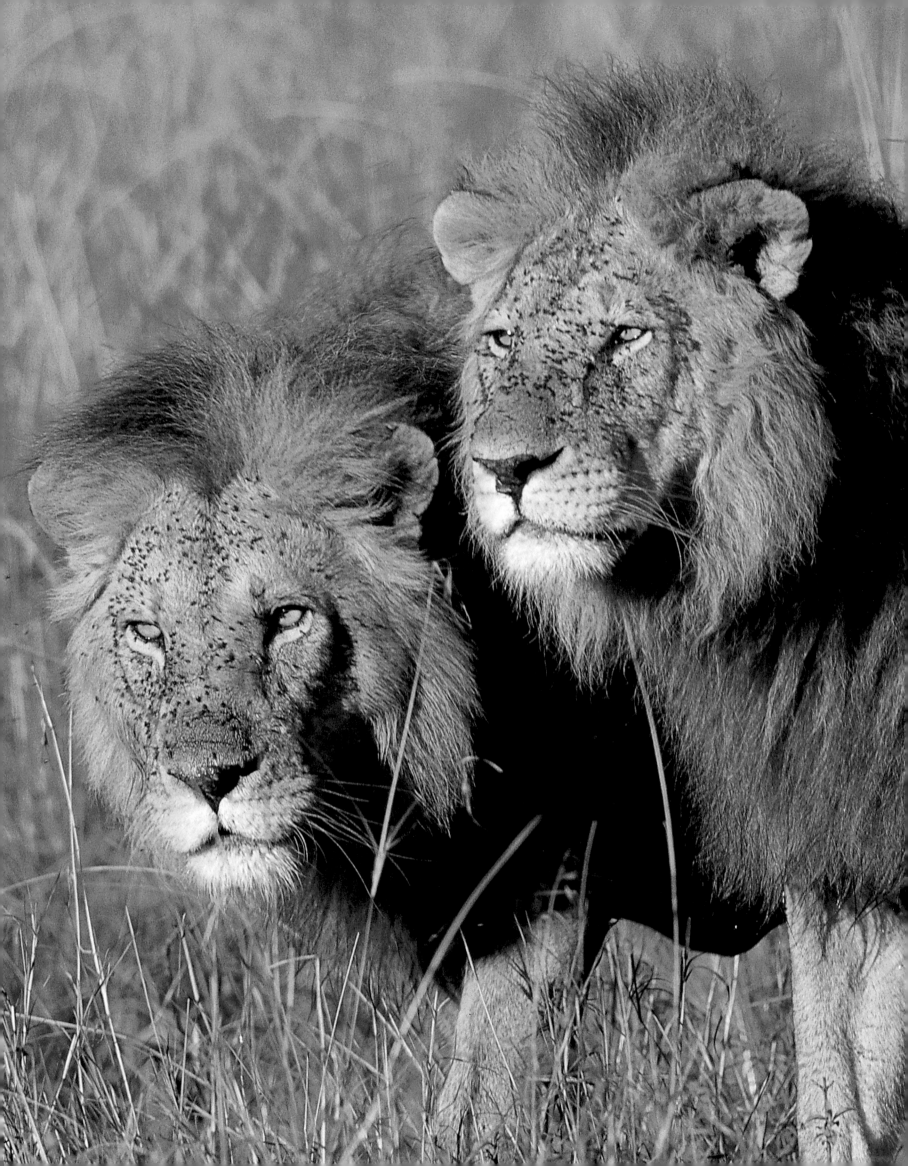

Land use: home ranges, territories and time-share

All cats, females and males, need to secure sufficient resources for two basic requirements: survival and repro-duction. Important resources for cats include a wide variety of features in the landscape – water, cover, den sites, refuges from competitors and predators, observation points, game trails and so on – but underpinning all is the availability of food. Female cats display the most straightforward manifestation of addressing this need. Carnivore biologist John Seidensticker fittingly describes adult females as 'contractionists': females occupy the minimum area required to provide for themselves and their cubs. While access to water and den sites is crucial for female cats of most species, their spacing patterns are dictated primarily by qualities of their prey: its size, movements, distribution in the landscape and how quickly and frequently it is replenished.

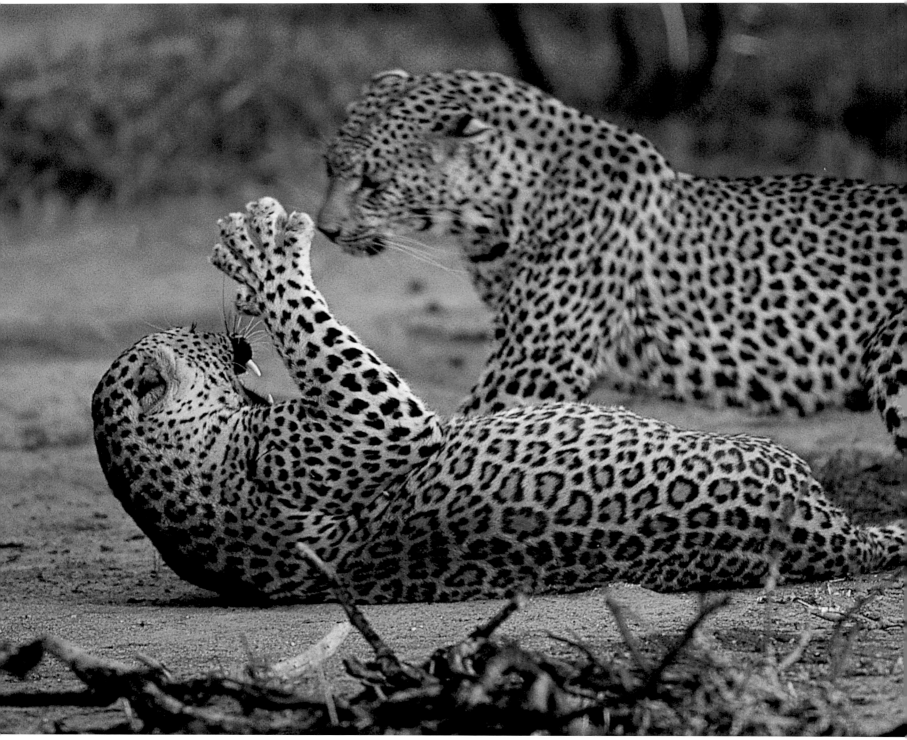

Territory holders exert considerable effort in curtailing intrusions, primarily by announcing their presence to avoid conflicts but, occasionally, clashes over turf can be fatal.

In general, where prey is plentiful, distributed evenly and is stable (meaning that populations fluctuate little), females are able to establish small, exclusive home ranges that overlap little with other female ranges. Where prey is meagre, unevenly distributed or undergoes large fluctuations due to seasonal change or migratory movements, female ranges are more likely to be larger and less exclusive, with more overlap. Depending on prevailing conditions, females of the same species may display both tendencies, or rather, a continuum of tendencies in which these are merely the two extremes. So, for example, the average range size of female leopards in the well-watered, game-rich woodlands of central Kenya is only around 17 square kilometres but climbs to 188 square kilometres in arid northern Namibia where prey is sparse. Overlap in the ranges between unrelated females in the Kenyan study was almost non-existent whereas it averaged 42 per cent for females in Namibia.

If food dictates how females organise themselves, the spatial patterns of males are shaped by another primal need – reproduction. Males are most interested in increasing their access to as many females as possible so they tend to be 'expansionists'; they expand the area they use beyond that set by their feeding needs in order to maximise the number of females they encounter. So male spacing patterns are determined chiefly by those of the females. Where females maintain small, densely packed ranges, males are able to establish ranges that encompass a number of female areas and that overlap little with other males. Where females occupy large ranges and live at low densities, male ranges are likely to be much larger and less exclusive. Returning to the leopard example, central Kenyan males have ranges averaging 37 square kilometres with little range overlap, compared to ranges of 451 square kilometres with 26 per cent overlap for Namibian males.

Whatever the resource, food or females, all cats attempt to defend them from conspecifics (with the exception of female cheetahs – see below). Until now, the discussion here has focused on 'home ranges' which simply refers to the area containing all the resources that a cat needs to survive and reproduce. However, as we have seen with the comparison between Kenyan and Namibian leopards, cats attempt to maintain exclusive use of their home ranges where conditions permit; in other words, they are territorial. Where possible, most cat species defend their home range from members of their own sex and their range is more accurately described as a 'territory'. Territory holders exert considerable effort in curtailing intrusions, primarily by announcing their presence to avoid conflicts (see the next section) but, occasionally, clashes over turf can be fatal. Males of the three big cats – lions, leopards and cheetahs – are known sometimes to kill unrelated intruders in fights, and similarly, fatal fights are known among lionesses and female leopards. Other than among female cheetahs, it is likely that such clashes occur from time to time in all African cats but, so far, few have been observed among the smaller species.

Two female leopards in a clash over territory, Sabi Sands Game Reserve, South Africa. Although fatal fights between female cats of the same species occur less often than among males, it is recorded occasionally in lionesses and leopards.

The critical advantage in being a territory holder is reproductive. For female cats, reproductive success is closely linked with access to food. The more reliable a food source or the more easily it can be secured, the greater the likelihood that a female cat will raise her cubs to independence. The point of female territoriality is to reduce competition for food and so improve the chances that her cubs survive. Precisely the same principle applies for males, though, of course, the resource for which they are competing is the female. Improving reproductive success for males means mating with as many females as possible while also eliminating competition from other males. So the upper limit of a male's territory is defined by the area he can effectively defend from competitors.

As discussed in the previous section, male cheetahs and male lions are unique among cats in achieving this by force of numbers. The stronger the coalition, the more effective the defence of an area and its females. If a single male is to have any chance of breeding, he needs to win a territory, a near hopeless task on his own if the competition is in pairs and trios. Among Serengeti cheetahs, for example, coalitions are about six times more likely than a loner to acquire a territory.

For singleton lions or cheetahs, teaming up with unrelated males is the answer, though it carries the cost of sharing females with an unrelated companion. The consequence is that some of 'your' cubs will not be related to you. If, however, your male relatives are your companions, you will be related to all of the cubs sired, even if you yourself never have a chance to mate. Indeed, in larger lion coalitions comprised only of relatives, some males never successfully breed. They act essentially as non-breeding helpers to their breeding brothers and cousins,

boosting the ability of the coalition to defend females and increasing their own genetic output via nieces and nephews. So, for a male lion or cheetah, the best strategy is to team up with male relatives. Only when they have few male relatives or, especially, none at all, do they form alliances elsewhere. Surprisingly perhaps, in both lions and cheetahs the degree of co-operation between coalition partners is not affected by their relatedness. Whether brothers or entirely unrelated, their bonds are extremely close and their behaviour towards one another is virtually indistinguishable.

For all the apparent 'rules' of spacing among cats, males or females, absolute exclusivity is almost certainly an elusive prize. The conditions that foster small, exclusive ranges are uncommon and even where they exist, it appears that most cats tolerate at least some sharing. Except for the very smallest ranges – those of central Kenyan leopards, perhaps – it is essentially impossible for a cat to maintain absolute control over its range. Even the most dominant individual cannot be everywhere at once and besides, it is likely to be surrounded by closely matched rivals that are best avoided, even if they occasionally overstep the territorial boundary.

An adult male leopard, killed by a rival male with a single, devastating bite to the neck, Phinda Game Reserve, South Africa. Few male cats (of all species) reach old age. Most will perish as a result of violent clashes with conspecifics, other carnivores or people.

Coalitions of cheetahs are more likely than loners to acquire a territory but, surprisingly, there is little evidence for longer tenure. Among Serengeti males, singletons that managed to establish a territory occupied them for the same period as coalitions, about four years.

Shared land tenure

The resulting dynamic pattern of land use is better described as 'shared land tenure'. In this system, the core area of the territory is typically inviolate and always used by one resident alone, but occupancy of the peripheries is more fluid. Neighbours share the edges but actively avoid one another in the overlapping areas in a time-share system based on the 'dear enemy' relationship: that is, it is better to tolerate limited overlap from a known rival who also 'agrees' to tolerance rather than attempt to overthrow it, risking both severe injury and its replacement by a more powerful, less tolerant newcomer. Maintaining the status quo means that a resident avoids a particular portion of overlapping turf if its neighbour is there. A week or a month later, the situation may be reversed.

Most cats are not yet sufficiently studied to know the degree to which the land tenure system applies but in the 'classically' territorial leopard, intensive study is revealing that overlap between neighbours is usually considerable. In northern KwaZulu-Natal's Phinda-Mkhuze ecosystem, Guy Balme and I have radio-collared every adult male in our study area to determine the degree of time-share (we know when we have successfully caught all the leopards present by remote cameratrapping). Despite the area supporting abundant resident prey, therefore lending itself to small exclusive ranges, none of the 14 males collared to date maintains an exclusive territory. In fact, in the most extreme case, one adult male has his entire territory within the boundaries of another. Such overlap is not unique to males. Indeed, female leopards are more likely than males to share resources with neighbouring females (in part, because they are more likely to be related; see Chapter 4) but, like males, never at the same time. Different females occasionally even use the same kopjes, caves or bushes to bear their cubs, though never simultaneously. In the game-rich southern Kruger National Park, female leopards share an average of 18 per cent of their ranges, and similarly, two radio-collared females in the rainforest of Côte d'Ivoire's Taï National Park shared about one-sixth of their ranges. And we have already

In the 'shared land tenure' system, the core area of the territory is typically inviolate and always used by one resident alone, but occupancy of the peripheries is more fluid.

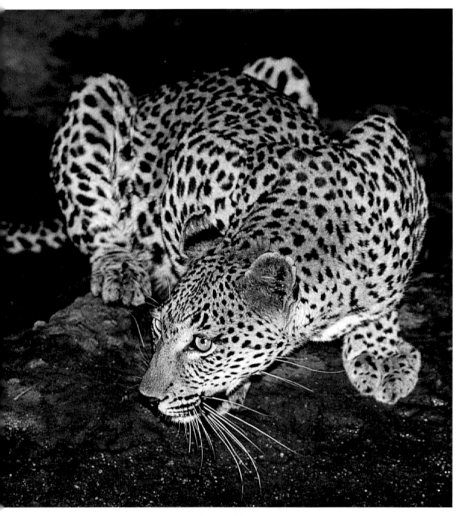

Female leopards (and probably those of most solitary felids) retain their territories for life. It is still unclear how female cats accommodate territorial overlap from successive grown daughters throughout their reproductive lives; presumably, a threshold is reached in which some daughters are forced further afield.

seen how overlap increases where resources are more thinly spread, as for female leopards in Namibia.

It is likely that the shared land tenure model applies to most solitary cats, at least to some degree. Three adult male black-footed cats in Sliwa's study had territories that overlapped by 12 to 14 per cent, while resident females overlapped by an average of 40.4 per cent. Similarly, three male caracals living on farms in central Namibia overlapped by an average of 19 per cent. In Israel, three radio-collared male sand cats with overlapping territories took turns using the same dens and burrows.

Of all wild cats, overlap is greatest among female cheetahs. In fact, cheetahs are exceptional among the Felidae in that the females do not establish a territory. Female cheetahs roam over vast areas which are never actively defended except for rare aggression towards other females if they venture near very young cubs in the den. Female cheetahs display the most extreme version of the time-share model, and do not maintain even an exclusive core region as do other female cats. In the Serengeti, up to 20 females use the same area and clashes between them are essentially non-existent. Female cheetahs go out of their way to avoid other females they see in the distance or simply ignore them. The home ranges of female cheetahs can be huge. On the Serengeti short-grass plains, ranges are rarely smaller than 395 square kilometres and sometimes exceed 1 200 square kilometres. In Namibia, female home ranges are even larger: eight females radio-tracked by Laurie Marker in central Namibia covered areas ranging from 554 square kilometres to an astonishing 7 063 square kilometres. The average range size for Marker's Namibian females was over 2 100 square kilometres.

The vast ranges of female cheetahs pose a problem for the males. As we have seen, male cheetahs *do* attempt to establish a territory but their females do not play by the normal felid rules. Female ranges are too large for male cheetahs to encompass and defend, as occurs among the males of all other species from black-footed cats to lions. Instead, male cheetahs exploit the extensive overlap between female ranges and adopt a unique variation on the male territorial strategy. Rather than attempting to defend entire female ranges, they focus on the most productive areas within them. Males create small, defendable territories around female 'hotspots', discrete areas rich in resources – prey, den sites and water – that attract female cheetahs. Females spend more time in the hotspots than outside them, so the best located territories may see a succession of females as they pass through the area.

There is one final twist in the social life of the cheetahs: the non-resident male or 'floater'. Floaters do not hold a territory and wander over large ranges, similar in size to those of females. Young males or old ones expelled from their territories have no choice but to float, but some coalitions of prime males appear to adopt this lifestyle by choice. In terms of the reproductive benefits, floaters might encounter as many or possibly even more females by searching for them over large areas, rather than staying put on a small territory and waiting for females to visit it. The genetic studies have not yet been undertaken to say which strategy yields the greater rewards in terms of the number of cubs sired, but perhaps both are equally effective. The cheetah's flexible social system illustrates that no rule is set in stone. The social systems of all cats demonstrate considerable elasticity and, as science continues to investigate them, more variation will doubtless be discovered.

The lion's mane

Unique among cats, the mane of the male lion has been thought to have three possible functions. First, to act as body armour, protecting the vulnerable neck and throat against attacks from other males; second, to make the bearer appear more intimidating to a rival; and third, to attract lionesses. These theories were put to the test by Serengeti researchers Peyton West and Craig Packer. They found no evidence that the mane provided a shield against attacks; fighting males do not preferentially attack the neck and shoulders, and wounds there were no more or less harmful than wounds elsewhere on the body. Besides, all large cats are armed for lethal attacks but only lions have manes. However, West and Packer's results lend support to the second and third theories. Using two life-size lion dummies with interchangeable manes, they tested the reactions of males and females to various combinations – dark manes versus light, and long ones versus short. They found that lionesses always preferred dark manes regardless of length, while males avoided dark manes and, to a lesser degree, also avoided long manes.

We know that dark-maned lions are older and have higher levels of testosterone, making them more aggressive fighters and dominant on kills; they are also better nourished. Short manes indicate youth and poor health (injured or poorly fed males often lose some mane) while light-coloured manes point to lower testosterone, hinting at a reduced ability to fight or compete. In other words, by assessing mane colour, lionesses select mature, healthy, aggressive individuals that will excel in defending the pride against incursions from other males. Males, on the other hand, *avoid* those individuals because they are the most formidable opponents in a fight. The lion's group-living behaviour is probably the reason it is the only felid possessing a mane. Living in close contact with many conspecifics provides constant opportunities for lions to assess one another. In such a rich – and risky – social environment, the mane is an invaluable signal by which other lions, female and male alike, make their decisions about which males to approach and which to avoid.

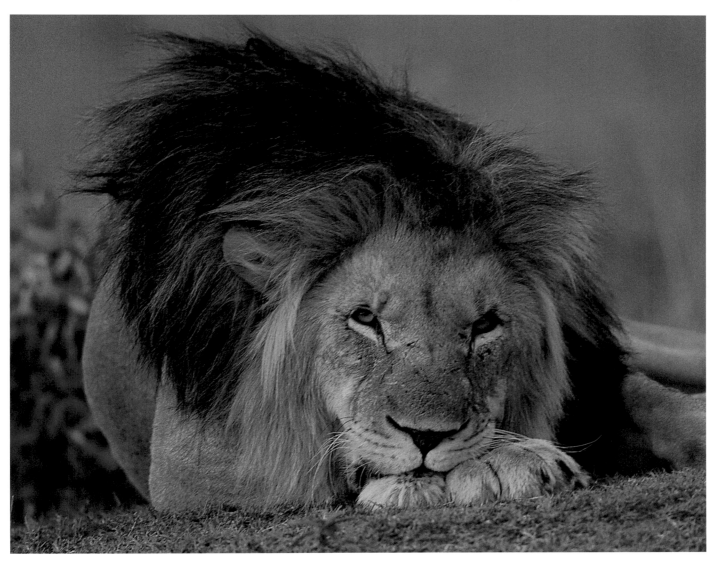

Territorial maintenance: communication among cats

To maintain spacing between one another, cats engage in a variety of territorial behaviours which advertise the presence of a resident. In the cat's world, such advertisements play a dual role, depending on the audience. To a familiar conspecific or a potential mate, they help maintain friendly contact, and ensure that males and females locate each other during the relatively brief opportunities when the latter are receptive (see Chapter 4). To a rival, though, the same behaviours act as a warning, proclaiming ownership of an area. Cats are so well equipped to inflict serious injury that it is better for all parties to avoid unexpected encounters. They do so by maintaining a constant network of communication based on scent marks and long-distance vocalisations.

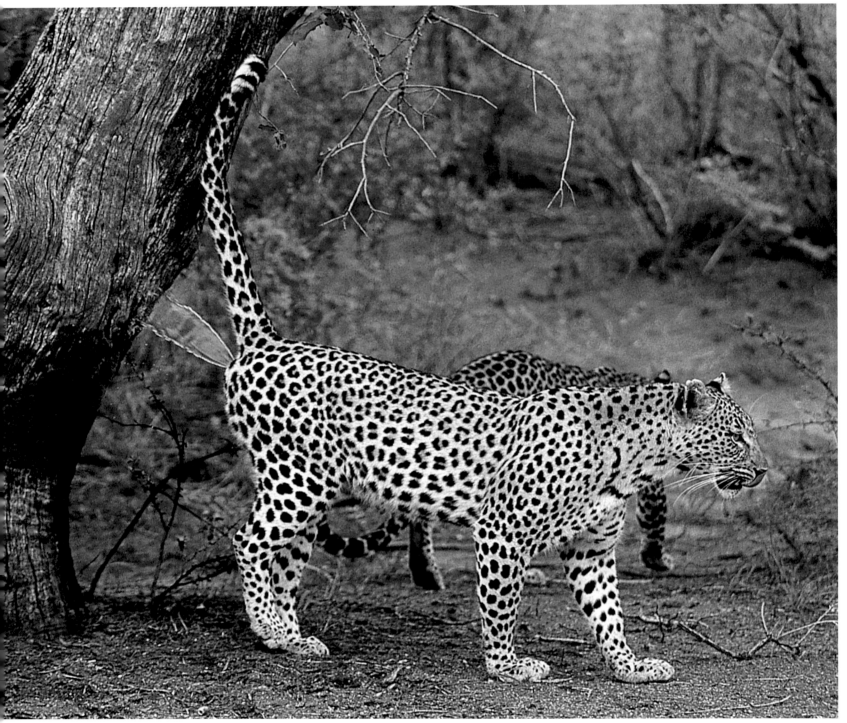

An adult female leopard urine-marks her range, proclaiming territorial rights. As her large cub (in the background) approaches independence, her scent marks will change subtly to herald her return to oestrus.

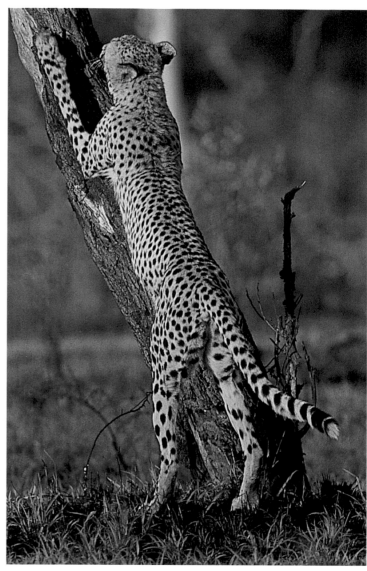

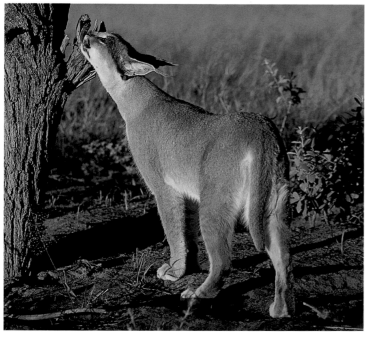

Cats marking their territory: deposits from scent glands on the cheeks, chin and between the toes enhance the territorial and reproductive messages left by spraying and defecation.

Territory holders tirelessly mark their range with urine and faeces. The rates of such marking can be prodigious. In only 65 minutes of following a territorial male leopard, during which time the cat was never out of sight, Guy Balme observed 17 sprays, six scrapes and five territorial calls. Male servals in Ngorongoro Crater spray at an average rate of 46 times an hour or about 40 times for every kilometre walked. Male black-footed cats normally scent mark around 10 to 12 times an hour but, like all cats, they escalate the rate enormously at critical times; one of Alex Sliwa's radio-collared males marked 585 times in one night on detecting a sexually receptive female in the area. Doubtless, his efforts helped the pair locate each other (they were together and mating the next night), but such assiduous marking also serves unambiguously to announce his interest to potential rivals. Female cats of all

Territory owners repeatedly freshen scent marks to ensure that their declaration of ownership persists.

species typically mark at lower rates than males – for example, 20 times per hour and 15 times per kilometre for female servals – but they intensify their efforts when in oestrus.

Cats also mark with saliva and deposits from glands on the cheeks and chin, which is why they rub their faces against key features like trees, stumps and rocks, often drooling in the process. Glands between the toes and at the base of the tail further contribute to their unique olfactory signature, and residents draw attention to their signposts by raking the ground with the hind feet, creating a territorial 'scrape' and by clawing trees with the front feet (which probably also maintains the condition of claws). Scent marks are deposited most often at the boundaries of territories and on conspicuous points throughout, including well travelled paths, large trees, bushes and termite mounds. Faced with a shortage of prominent sites, desert-living sand

Both lionesses and male lions roar, but the male's roar is louder, deeper and more prolonged than the female's. Experienced human listeners easily discern the difference, so presumably lions can and, indeed, lions are able to recognise familiar individuals by their call.

cats create their own: they scrape together a small pile of sand, and deposit faeces and urine prominently on top of the mound. Biologists are only now developing methods to translate the messages contained in scent marks, but it is clear they reveal substantial information about the owner to conspecifics: identity, sex, age, reproductive condition, ownership of an area and possibly even an update on health. Territory owners repeatedly freshen scent marks to ensure that their declaration of ownership persists; cats can assess the age of a mark and, although it has not been well studied in African species, scent marks appear to be effective for up to four weeks, after which they are ignored.

Reinforcing the message of their scent marks, most cats have long-range calls. Perhaps the best known is the lion's roar. Carrying for at least eight kilometres to human listeners and clearly more to leonine ones, roaring helps members of the same pride maintain contact and find one another. Without question, the roar also plays a critical role in communicating with strangers. Craig Packer and his colleagues investigated the response of Serengeti lions in an elegant series of play-back experiments, in which tape-recorded roars were played through loudspeakers to prides. When the roars of familiar lions were played, the response of listening lions was ambivalent; they sometimes called back or headed towards the calls but often they did not bother. However, when the tape played unfamiliar lions, the response was far less ambiguous. In response to calls by their *own* sex, both lionesses and male lions immediately began roaring and rushed to repel the 'intruders'. Intriguingly, though, lions are more likely to respond aggressively when they have numerical and geographic superiority. Lionesses assess how many adversaries are calling (in this study, Packer's females discriminated between one versus three rivals calling), and are more likely to engage lone aggressors. Similarly, males weigh up numbers at territorial boundaries but largely ignore them deep inside their territories; regardless of numbers, resident males rush aggressively to engage rivals if they have the temerity to roar in the central area of a coalition's range.

Science knows less about the role of territorial calling in other cats, though basic similarities are probably common to most species. The rasping long-distance call of resident

leopards (often called sawing or coughing) can be heard by humans from three kilometres away, and Kruger National Park researcher Ted Bailey was able to distinguish the leopards of his study by their calls, so doubtless leopards can too. Similar to roaring in lions, rasping takes place mainly at night, with surges at dawn and dusk reflecting peaks in activity and movement. Among the smaller felids, the equivalent call is probably the loud, repetitive meowing familiar to anyone living near stray domestic cats. The same call is known from golden cats, caracals, wildcats, servals and black-footed cats, though detailed observations from wild individuals are lacking for all but the last one. The black-footed cat's startlingly loud, deep meow is repeated up to ten times in quick succession and is mostly heard uttered by males. As for other cats, the calls probably help to maintain spacing between rivals, but importantly, they are most often heard during the mating season when males are looking for females (see Chapter 4). Most unusual of all, sand cats are reputed to utter a piercing, long-range call that sounds like the bark of a small dog. Male sand cats in Israel were seen to head to the tops of hills to repeat this strange call, presumably in an effort to boost their broadcast.

Cheetahs are notable among cats for apparently lacking a territorial call intended to warn off rivals. Although male territory holders are as diligent as any male cat in marking their turf, they do not proclaim its occupation by calling. Cheetahs do have a resonant long-range call known as yipping, but its primary function is to unite the members of a social group during rare separations. The balance of the feline vocal repertoire is used mainly for close and medium-range contact between conspecifics and other species (see text box 'Felid vocalisations' below).

Felid vocalisations

At least 14 different types of vocalisations have been described for cats, though no species has them all, and a number of call types have low, intermediate and high intensity variations that sound like quite unrelated calls to the human listener.

Common to all species of cats are *hissing*, *spitting*, *snarling* and *growling*, used in aggressive or defensive encounters. All cats also share what is termed the *main call*, although the sound varies greatly among species. In smaller cats, the main call has two major manifestations: *mewing* for close-range, friendly encounters, and the loud *meow* and its variants for long-distance communication. The lion is the only cat that lacks a pure main call (the meow) but employs a variation known as the *main-call-with-grunt-element*, which sounds like a soft moan and is used to call over medium distances. The main-call-with-grunt is also used by leopards, tigers and jaguars. Lions, leopards and jaguars are also the only cats that can *roar* and

grunt, which is their version of the mew. In lions, the grunt is the 'au-uhh' sound used to call cubs or pride members.

Unique to the *Panthera* cats and their relatives, the clouded leopard and snow leopard, are the unusual, close-range, friendly calls known as *prusten* and *puffing*, which are made by rapidly blowing air through the nostrils and lips. Prusten sounds like a horse's snort with a soft vocal murmur, and is not known from any African cat. The equivalent call, puffing (or chuffing), lacks the murmur and is recorded only in lions and leopards; it sounds like a bout of soft, stifled sneezing.

Functionally equivalent to prusten and puffing, *gurgling* is used by all other cat species in friendly encounters, during courtship and mating, or to appease strange conspecifics. Gurgling varies enormously among and within species, but it generally sounds like a burbling noise, cooing or a prolonged chirrup; the cheetah's *churr* call is a high-intensity example of the gurgle.

Only seven species of cats – including caracals, African golden cats and probably servals – are known to *wah-wah*, used when two animals approach one another. And, finally, *purring* is known from many species of cats, although none of the big cats is able to purr.

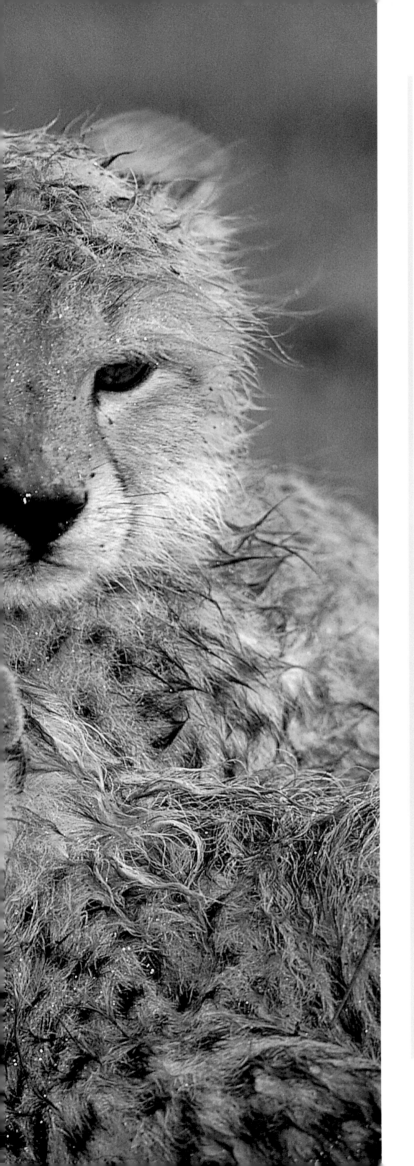

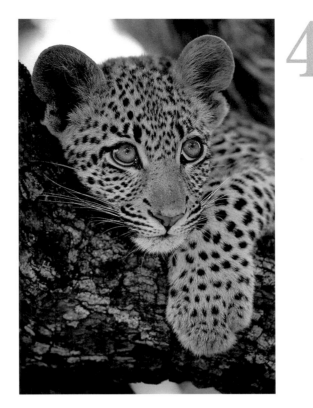

4

POPULATIONS

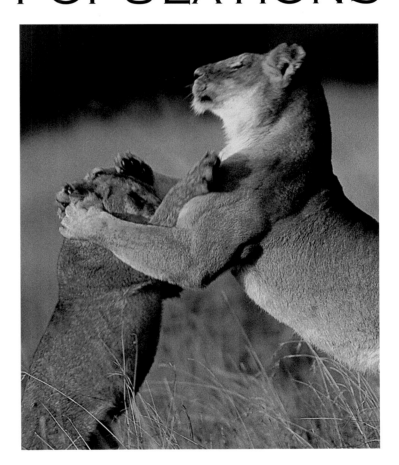

reproduction,
mortality
and survival

Finding mates and courtship

Like every living organism, the cat's fundamental biological imperative is to reproduce. As discussed in the previous two chapters, cats address the daily challenge of surviving by securing a range and the resources it contains. But, ultimately, the rich repertoire of hunting and territorial behaviour that allows a cat to make it from one day to the next is also geared towards ensuring reproductive success over the course of its lifetime. That success, or 'biological fitness', is measured by the ability of an individual to leave surviving, viable progeny.

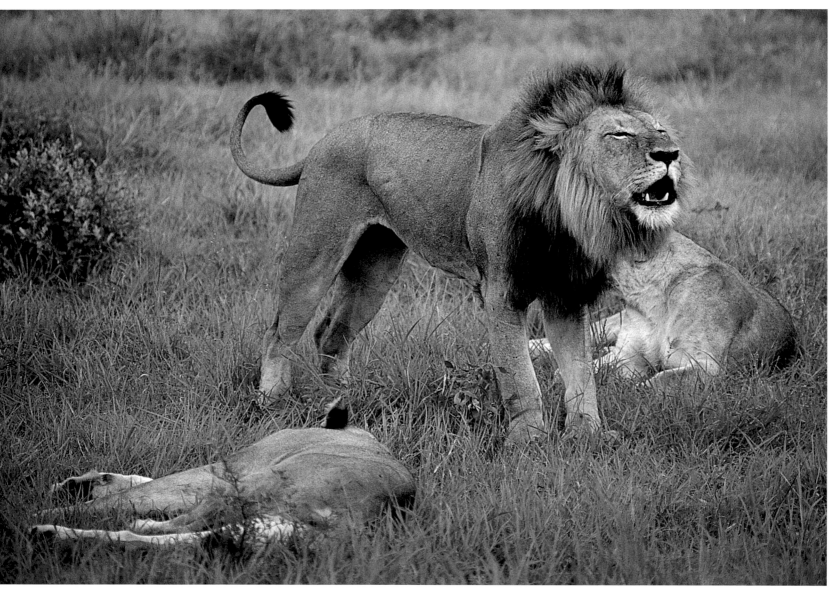

A male lion guards two lionesses in oestrus. During mating, males escalate their rate of roaring
to reinforce their claims of ownership and to ward off possible rivals.

The first challenge faced by most cats is overcoming their solitary tendencies and finding a mate. To achieve this, they employ the very same catalogue of behaviours intended to keep them apart. When a female approaches oestrus, the territorial displays discussed in the previous chapter – scent-marking, calling, scraping and so on – serve to attract members of the opposite sex. The switch occurs at the molecular level. Chemical changes in the female's urine associated with elevated levels of oestrogen transform the message from a warning to a welcome – to the right audience, of course; to other females,

the message presumably remains a warning and, although this has not been tested, probably a particularly explicit one keeping female rivals away. To ensure that males receive the invitation, females approaching oestrus increase their rate of urine-marking and associated come-hither behaviours, in particular calling loudly: the lioness' roar, the leopard's rasp or the black-footed cat's deep caterwaul. On detecting the messages, males in return increase their own rates of marking and calling, announcing their presence to the female while also warning off potential competitors seeking the same prize.

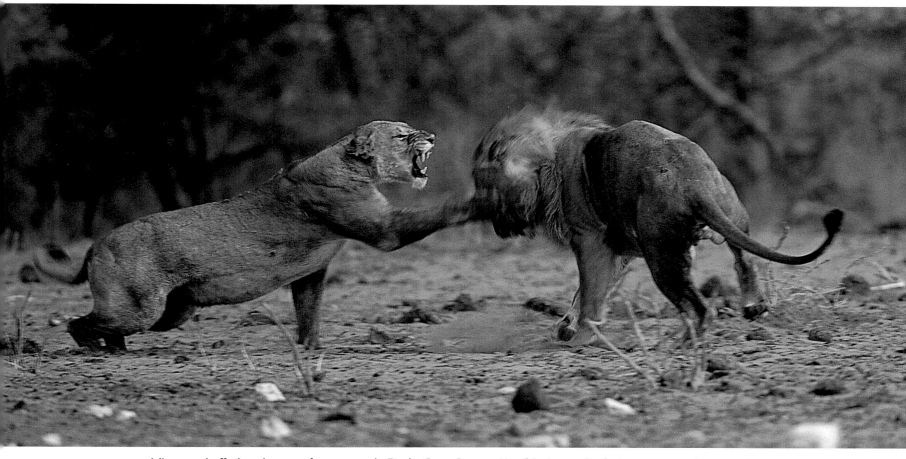

A lioness rebuffs the advances of a young male, Etosha Game Reserve, Namibia. Aggression between prospective mates is common, particularly those unfamiliar to each other, but it almost never results in anything more than superficial injuries.

The system clearly works efficiently. For those species that have been observed in the wild, it seldom takes more than 24 hours for a receptive female to be joined by a male. Even so, mating rarely occurs right away. Female cats of many solitary species begin advertising their availability up to three days before they are willing to accept a male. This period is known as pro-oestrus, and it ensures that pairs have sufficient time to find each other before the female's oestrus (when the female is ready to mate and during which time she ovulates) has passed. It also provides time to establish familiarity with each other. Between such well-armed lovers, meeting for the first time can be a dangerous process. Often the early stages of the consort period are marked by outbursts of nervous aggression from both sexes as they overcome their asocial and potentially lethal predispositions. These spats are almost never serious though, and typically subside after a day or two. In the case of pairs that already know each other from prior meetings, they may not occur at all.

The pro-oestrous period might also be a mechanism whereby females encourage competition among males. By advertising her availability in advance, a female increases the likelihood that multiple males will turn up to compete for her attentions. Indeed, oestrous

> *Between such well-armed lovers, meeting for the first time can be a dangerous process.*

females attended by two or three males have been recorded in a number of cat species, among them leopards, caracals and wildcats. The behaviour is also known among lions and cheetahs, though in these species, attending males are almost always coalition partners, not unfamiliar rivals. Among lion coalitions, competition between males is usually negligible. Typically, the first male on the scene enjoys access to an available lioness, and his coalition partners stand down with little or no aggression. Doubtless, the arrangement works in part because lionesses in a pride usually come into oestrus at the same time, providing many mating opportunities; but even when that does not occur, familiar males rarely fight over females. In the case of cheetahs, mating is rarely observed (there are just five published accounts from the wild), but competition among coalition males appears to be equally mild. Two Serengeti brothers observed competing for a female tried to push each other off her with their heads.

Among solitary cats, there are few observations of direct competition between rival males over oestrous females. In theory, the female in heat represents an extremely valuable resource worth fighting for, but battle is either a rare event or there are simply too few

observations for us to know. Competing males among leopards and all the smaller felids probably resolve most issues of ownership by largely demonstrative displays of ritualised feline aggression: standing sideways with back arched and hackles raised, accompanied by a stiff-legged walk, bared teeth and flattened ears showing, in most species, white or light-coloured warning patches. Such encounters must occasionally escalate into full-blown fights, but this is probably further tempered by the 'rule of possession', as in lions. I once saw a female leopard mate with three different males over three days. The first two males on the scene were both in attendance from the start, and one simply waited for 36 hours at a distance until the first male left. Male number two subsequently gave way to the remaining male on the third day. I did not see the changeovers to determine whether they were peaceful, though clearly there was no serious fighting; none of the males was injured when I saw each of them after the encounter. The same relatively tolerant arrangement has been noted among radio-collared caracals in Israel, where males stayed nearby and awaited their turn, with changeovers taking place around every 48 hours. It is not known whether the same pattern occurs in African caracals.

Mating behaviour: promiscuous females and misled males

As many a safari guide has explained to fascinated tourists, mating itself is both a brief and, for most cats, frequent event. Feline copulation usually takes less than a minute and most matings are over in under 20 seconds. In a series of observations from a pair of Serengeti leopards, copulation lasted on average for three seconds. Caracals apparently hold the record among cats, at least in captivity, where copulation has been timed ranging from 90 seconds to eight minutes; the average duration was around four minutes. There is no clear reason why caracals should have such relatively prolonged matings. Indeed, if observations from other small cats are any indication, brief matings make more sense in that they reduce vulnerability to predation. Given that there are no accounts of wild caracals mating, it remains to be seen whether the record-breaking performances of captive cats reflect what occurs in nature.

Regardless of duration, mating may occur with astonishing frequency, with large cats the most prolific. George Schaller watched a male lion mate with two lionesses 157 times in 55 hours, while a captive pair mated 360 times in eight days.

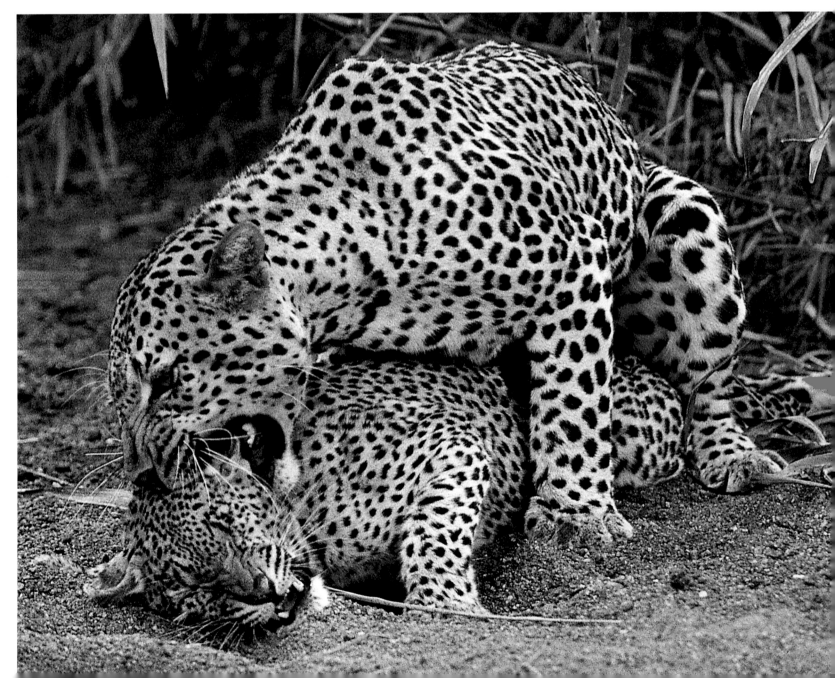

Leopards mate at similarly elevated rates, with up to 70–100 copulations per day. Cheetahs are something of an exception among the larger cats. The few observed mating bouts (including those in captivity) are rare events, separated by long periods of inactivity with only three to 15 copulations taking place per day. The discreet mating behaviour of cheetahs might be a strategy to avoid drawing the attention of predators, less of a concern for leopards and lions which suffer fewer such threats. The same pattern is manifested among smaller cats, which tend to mate less frequently or for shorter periods than their larger relatives. Among those species for which we have good data, black-footed cats represent the most extreme case. Females accept males for a fleeting period of receptivity lasting only five to 10 hours, during which time they mate about a dozen times. Alex Sliwa suggests that the black-footed cat's sparsely vegetated habitat with few refuges and many potential predators creates an incentive for getting mating over as quickly as possible.

Whether mating is discreet and concise or flamboyant and prolonged, the end result is that all female cats mate many times during a single oestrous period compared to numerous other species. But exactly why do cats have so much sex? Part of the reason is probably to induce ovulation. Most cats are thought to ovulate in response to mating (unlike spontaneous ovulators such as human females, who automatically ovulate at regular intervals). The stimulus for a female cat to release eggs is thought to come from backwards-facing barbs on the male's penis – the reason a female often turns violently on the male at the end of each copulation. Biologists think that females require repeated stimulation before ovulation occurs, presumably achieved by repeated copulations in a limited time. For example, domestic cats separated after only one mating conceive only half as often as those allowed to mate four times. Similarly, only about every third mating bout in lionesses results in conception. Interestingly, lionesses and female leopards (and tigresses too) in captivity occasionally ovulate without mating when housed next to other cats, or in response to some other social or physical stimulus, a trait known as reflex ovulation.

Induced ovulation (and perhaps even reflex ovulation, should it occur in wild females) serves to increase the likelihood that mating is successful in solitary species; there is no point wasting an egg if there are no males to be found. But it may also serve to test the quality of males. The female's

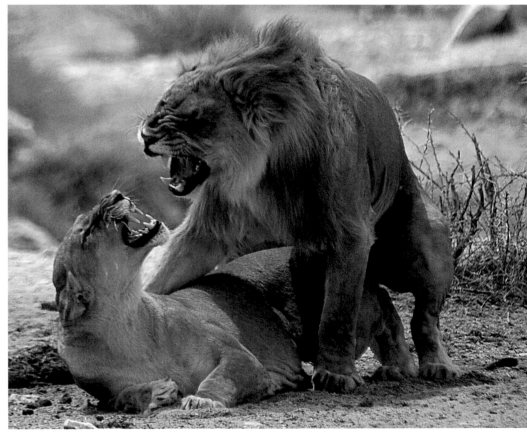

ABOVE: The end of mating is often marked by aggression from both partners. For females, the male's spine-covered penis is thought to be the chief reason, though for both partners it probably also stems from anxiety at being so close to such a potentially dangerous mate.

LEFT: Like all male cats during mating, this male leopard grips the female with a gentle bite to the loose skin of the neck. Known as the 'inhibited nape bite', it is thought to pacify the female, just as kittens are immobilised when carried by the scruff of the neck.

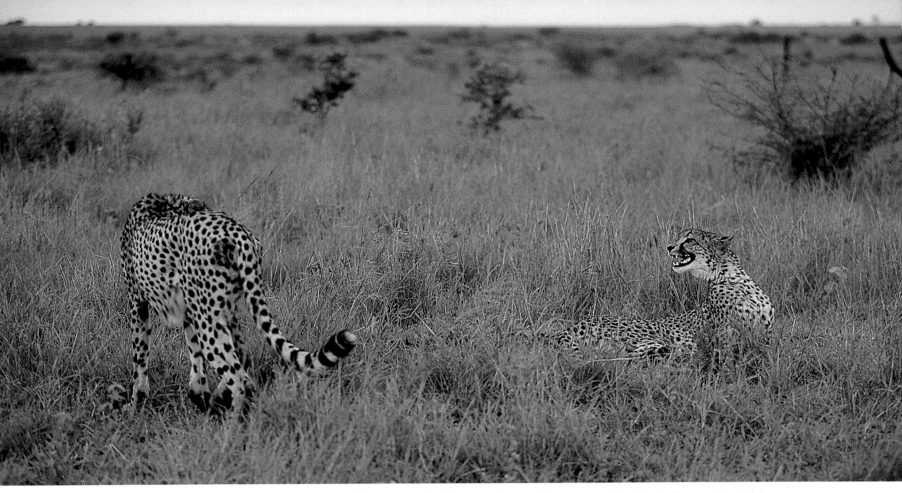

Courtship in cheetahs is always prefaced by prolonged and apparently severe harassment of the female (here, on the right)
by the males. The behaviour is thought to encourage the female's receptivity but the theory remains untested.

requirement for frequent copulation increases the likelihood
that she will mate with numerous males over the course of her
oestrous period. Recall the female leopard I watched pair off
with three separate mates: all those males were territorial,
mature adults which, presumably, were all worthwhile mates
from the female's point of view. Being more or less evenly
matched, they had little reason to fight over her but they may,
unknowingly, have competed for her at another level. It is
thought that the difficulty in inseminating females puts the
genetic quality of competing males on trial by 'sperm competi-
tion', which ensures that only the most active, healthy sperm
reaches the eggs for fertilisation. Some species are believed
even to have a type of non-fertilising sperm that repels or
disables the sperm from rival males, though this has not been
demonstrated for any felids yet.

If the quality of male suitors (or of their sperm) is com-
parable, the sperm of different males can contribute to a litter
– the second advantage to accepting several males. Only lions
have so far been shown to produce litters from multiple sires,
and this appears to be rare; in the only rigorous study
performed to date, 23 of 24 litters of Serengeti cubs were
each sired by a single male. The single litter demonstrating
mixed paternity had greater genetic heterogeneity which, in
theory, would make those cubs more likely to survive a
change in conditions, for example, the outbreak of a novel
disease. Even so, nobody has yet collected sufficient data
to demonstrate the advantage in any felid.

Less ambiguously, female promiscuity almost certainly
reduces the danger of infanticide (see text box 'Infanticide in
cats', opposite page) by confusing the issue of paternity.
Males encountering cubs for the first time most likely cannot
recognise their offspring by smell or some other innate chem-
ical cue, and presumably base their attitude towards them on
their relationship with the mother; having mated with her
probably encourages a male to believe he is the father,
whether or not he actually is. There are no tests of this idea
in wild individuals, although a few captive trials suggest males
accept cubs on the basis of having mated with their mother.

For example, a male lion introduced into a large, natura-
listic enclosure with six related lionesses mated with all the
females over the course of six weeks, even though some were
already pregnant by a previous, unrelated male. The intro-
duced male treated the subsequent crop of cubs as though
they were his. Even females close to birth or already with
young cubs will attempt to win over new males. I once
watched a lioness who was 12 hours away from giving birth
consorting with three intruding males. She doggedly attempt-
ed to mate with all three, trotting invitingly in circles around
them, flicking their faces with her tail and emitting a deep,
purring rumble. But whether the new males were too inexpe-
rienced (they were 30 months old, young to be in their privi-
leged position) or simply unconvinced by her displays, none
mated with her. They killed her newborn litter the
following day.

Infanticide in cats

Intense competition for territory among male cats (see Chapter 3) means that they cannot afford to be stepfathers. Territorial tenure is simply too brief to allow females to raise offspring sired by previous males so, in taking over turf and the females that go with it, new males typically kill all the cubs present. Removing cubs hastens the female's return to oestrus, creating the all-important window in which a new male can make his own genetic contribution. Infanticide is best documented from lions, where incoming males typically kill 100 per cent of unrelated cubs up to the age of nine months. If not killed outright, older cubs and sub-adults, including females too young to breed, are expelled and usually die from starvation. In Serengeti lions, infanticide speeds up the female's return to oestrus by an average of eight months. Intriguingly, though, this is not as fast as when cubs are lost for other reasons. Following a take-over, a lioness' fertility is suppressed (even though she mates normally), on average, for four months longer than when cubs die from other causes. The postponement allows the lioness to assess whether the newcomers will endure; why conceive to them if they are not going to be around to prevent the loss of her next litter?

Among African cats, infanticide is also known among leopards and caracals (eyewitness accounts are unknown in the latter, but five male caracals killed in the Cape contained the remains of kittens in their stomachs), and it is recorded in tigers, pumas, Canada lynxes, ocelots and semi-wild domestic cats living in colonies. Indeed, it is probably practised by all cats in which both sexes are territorial, which is perhaps the reason it has never been recorded in cheetahs. The female cheetah's non-territorial behaviour is thought to rule out the potential benefits of infanticide to males because there is no certainty she will remain nearby after losing a litter. Due to her wide-ranging movements, she is just as likely to conceive to the males of a neighbouring territory or, indeed, any male. So, although male cheetahs finding mothers with cubs occasionally batter the youngsters a little, they apparently have little incentive for infanticide, and otherwise tolerate them.

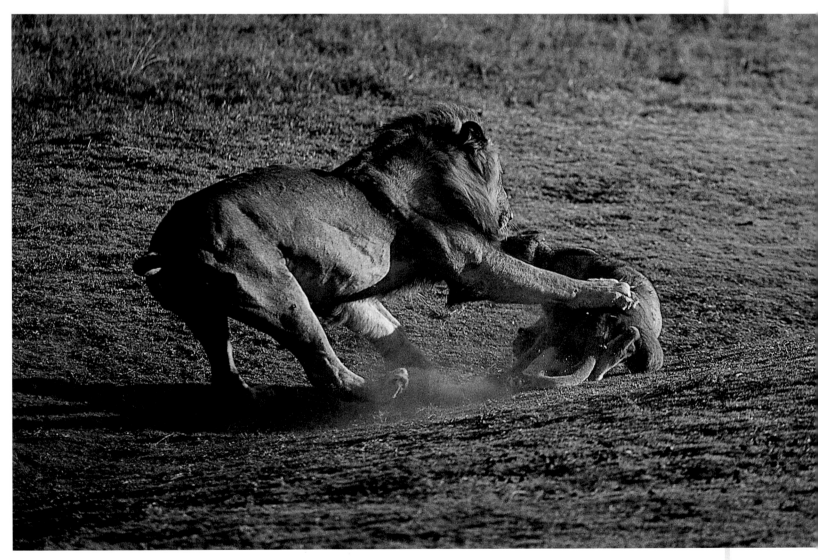

The life and death of cubs

Once pregnant, female cats are essentially on their own again. In all species (except, to some extent, in lions: see text box 'Altruism versus self-interest in lions', page 121), males play no active role in raising cubs, though of course their presence is crucial for maintaining social stability and preventing infanticidal intrusions. With the possible exception of the sand cat, female cats do not construct a den and instead seek out existing sheltered natural features in which to give birth. Just as she knows which places offer the best opportunities for hunting (see Chapter 2), a female cat probably has intimate knowledge of suitable den sites in advance. Typically, a week or two before birth, the expectant mother does the rounds of her territory or home range to inspect potential dens and make her selection. Cheetahs, leopards and lionesses usually locate their dens in dense thickets of vegetation or crevices among rocks and in kopjes. Smaller cats choose similar sites and are also able to exploit tree hollows (the sole record of a golden cat den site was inside a large, hollow log) or burrows made by other species. Sand cats den in the burrows of various foxes, desert hedgehogs and gerbils, enlarging the lair to their satisfaction; and, given their burrowing ability, they perhaps also excavate their own dens from scratch. Black-footed cats use springhare burrows or termitaria hollowed out by aardvarks, while in the Kalahari Desert, female African wildcats, caracals and even leopards use porcupine and aardvark burrows. Saharan cheetahs conceal their cubs in the appropriated burrows of striped hyaenas, black-backed jackals and even spurred tortoises, as well as in caves scattered throughout the desert's mountain massifs.

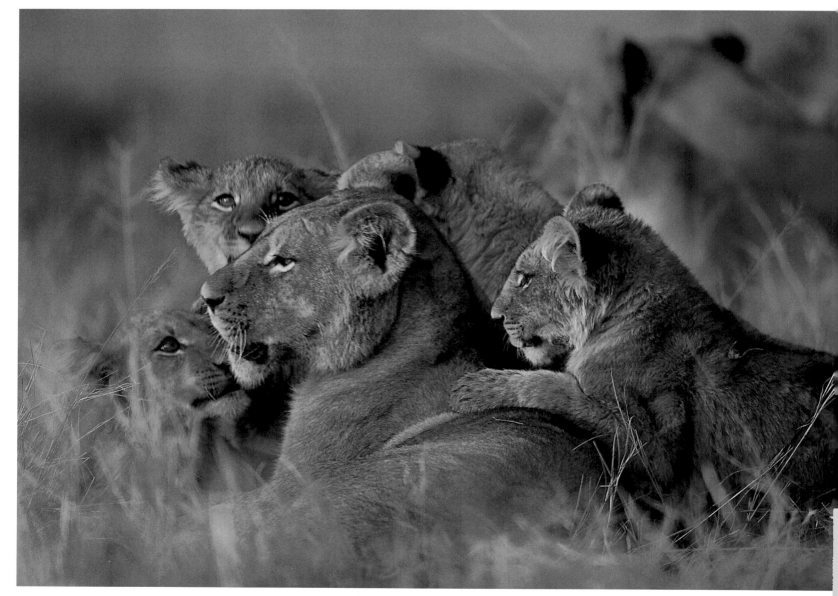

At around two months of age, these young cubs have recently been introduced into the pride by their mother. Once cubs are absorbed into the pride, they are treated communally by the adult lionesses and it is almost impossible to tell which cubs belong to each female.

As with all cats, lion cubs begin their lives knowing only their mother and are completely defenceless when she is away.

All cats give birth alone. Even lionesses abandon the pride to give birth (very rarely accompanied by a close female relative), often moving some distance from the core area of their range to do so. The reasons for the separation are unclear, especially given that lionesses in a pride often give birth around the same time due to their synchronised oestrous cycles. For the first six to eight weeks of their lives, lion cubs are alone and vulnerable whenever the mother leaves to forage, usually by joining up with her pride to hunt before she returns to the den. Lionesses would seem to benefit by having their cubs together, safe under the protective mantle of the pride. Perhaps the competitive, vigorous life in the pride is too dangerous for newborns, especially when older cubs and sub-adults are present; on occasion, very young cubs *are* killed by older cubs, though it is more a result of over-exuberant play than aggression. Yet lionesses could easily avert this threat by forming a crèche of mothers and guarding the cubs from the unwanted attention of unruly relatives (and other dangers) or by simply avoiding the main pride altogether. Indeed, two or three closely related lionesses with cubs sometimes come together for a brief nursery period prior to introducing their youngsters to the pride proper around the age of two months. Even so, as with all cats, lion cubs begin their lives knowing only their mother and are completely defenceless when she is away. Perhaps there is no significant advantage in giving birth on their own, and lionesses are simply expressing a solitary feline tendency deep in their evolutionary heritage.

Once they join the pride, lion cubs benefit from greater protection than that accorded the young of solitary cats, but it sometimes comes with costs. Lionesses share cub-raising duties and, although a female shows a slight preference for suckling her own offspring, all cubs in the pride are suckled communally. If milk is available, young lions continue to suckle until around 12 months, long beyond when their own mother has weaned them (which usually takes place around four months of age and rarely later than six). With older cubs in the pride monopolising milk, very young cubs are occasionally out-competed and starve. Similarly, competition over carcasses is intense, especially during periods when prey is scarce. Lion cubs on the Serengeti plains often die from starvation during the long, dry season when prey and water are hard to find. Under such dire conditions, young cubs cannot compete with older relatives on kills and also fail to keep up with the pride when it is forced to cover long distances to find food (see text box 'Altruism versus self-interest in lions', page 121). By contrast, in the nearby Ngorongoro Crater where prey is resident and generally abundant year-round, cubs rarely die from starvation or abandonment. Comparing the two populations, under 30 per cent of plains cubs survive to 12 months compared to almost 70 per cent in Ngorongoro. Survival to two years of age is about 23 and 58 per cent respectively.

Other cat species under gruelling circumstances are similarly affected. Karen Laurenson's exhaustive research on female cheetahs in the Serengeti showed that the most successful mothers located their dens close to prey and water. A mother that denned 12 kilometres from the nearest concentration of Thomson's gazelles ate a third as much as other mothers due to her having to commute such large distances from her litter to hunt. She was eventually forced to abandon her young cubs.

ABOVE: Captive African golden cat females usually have one or two kittens. If true in wild individuals, small litter size may reflect relatively low predation rates on kittens – the only serious potential threat in golden cat habitat is the leopard.

FOLLOWING SPREAD: Leopard cubs are left alone for long periods when their mother goes to hunt. To reduce their vulnerability to predators, leopard cubs instinctively and expertly climb trees from the age of two months.

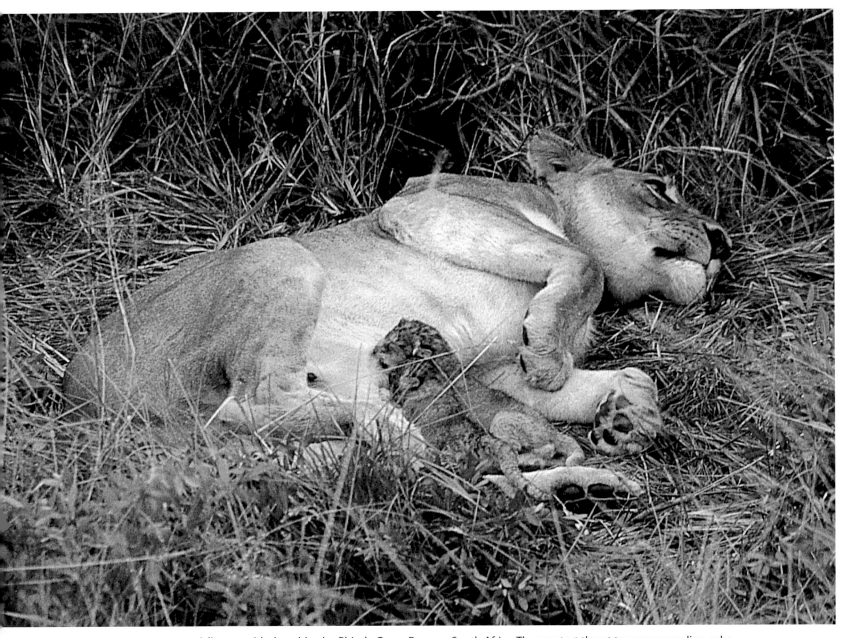

A lioness with day-old cubs, Phinda Game Reserve, South Africa. The greatest threat to very young lion cubs is predation, either by intruding males of their own species or by other large carnivores.

Cub-killers: the threat of predation

Starvation and desertion, however, rarely rank at the top of the list of factors that kill the cubs or kittens of most species. The principal threat to most young cats is predation, often by other members of the cat family. Where lions occur, they are usually responsible for the majority of cub deaths in both cheetahs and leopards. Leopards in turn kill the cubs of cheetahs and, less so, of lions; doubtless they also kill kittens of smaller felids, though there are few observations. Similarly, caracals are thought to be a threat to the kittens of black-footed cats. In most (though not all) cases of intra-familial predation, the killed cubs are left uneaten; the motivation for their killing is presumably to reduce competition for resources rather than for food (see Chapter 5 for details on competition between cats).

Other predators of young cats generally treat them as prey. Spotted hyaenas comprise a significant threat to young cats, and there are numerous records of their killing and eating the cubs of lions, leopards and cheetahs. Other occasional predators include any species large enough to tackle a cub or kitten, usually when the mother is absent. Black-backed jackals are recorded killing young cheetahs, caracals and black-footed cats, and a honey badger in the Kalahari was seen chasing and killing an African wildcat kitten. Large raptors sometimes feature as predators: a secretary bird was seen to kill a very young cheetah momentarily left in the open by its mother; a martial eagle in the Masai Mara was witnessed taking a serval kitten; and the Verreaux's eagle-owl is recorded as a predator of young black-footed cats. In a unique record from Tanzania's Mahale National Park, a male chimpanzee snatched a very young leopard cub from a cave with the mother leopard present (who, other than growling from inside the cave, did not resist the attack). The chimpanzee eventually killed the cub but did not eat it.

Taken together, predation and other sources of mortality mean that more cubs die than survive in most populations. Calculating the mortality rate of juvenile cats is invariably fraught with problems, because they are very rarely seen before they leave the den. For most species, estimates begin only once they have emerged, which inflates the survival rate because losses in the den are unknown. Karen Laurenson addressed this question by radio-tracking 20 female Serengeti cheetahs until they gave birth and counting very young cubs still in the den. Of 125 cubs in 36 litters, 89 did not survive the period in the den; most were found and killed by lions. At four months of age, close to the point at which young cheetahs can out-run most predators, only 12 were still alive. By the time the cohort reached independence at 14–18 months, perhaps seven of the cubs were still alive; the survivors may have numbered as few as five, given that Laurenson was not certain about the fate of two animals. In other words, the survival rate for Serengeti cheetah cubs was no greater than 5.6 per cent and may have been as low as 4 per cent.

This female leopard consumed her cub after it was killed by lions, behaviour also observed in female cheetahs and lionesses.
In such cases, the female's behaviour indicates she does not perceive the carcass as that of her cub – females often call
for their missing youngster while intermittently eating it – and that eating it simply serves the same purpose as any meal.

These extreme figures reflect conditions in the region. The density of predators in the Serengeti is high and the plains offer few refuges against them; den sites such as kopjes, luggas (river valleys) and thickets are thinly spread and also attract lions or spotted hyaenas. Further, once they have emerged, cubs are visible to predators from as far away as two kilometres. Despite its common depiction as sub-optimal cheetah habitat, denser woodland offers a refuge for mothers with cubs; its mixed vegetation affords an abundance of suitable den sites, dens are less likely to be discovered and emerged cubs are less likely to be seen. In the humid woodlands of northern KwaZulu-Natal, almost 70 per cent of cheetah cubs that emerge from the den survive to independence. Although this figure excludes losses in the lair (the most vulnerable period), it is over three times the survival rate of Serengeti cubs *after* emergence; Karen Laurenson's data showed that, at most, only 19 per cent of Serengeti cubs survived once they left the den.

No other study has matched Laurenson's for such a precise estimate of cub mortality in any cat species; but even so, such severe losses are unlikely to apply to most populations of felids. Ninety-five per cent mortality means that a female will lose 19 cubs for every one she manages to raise, a ratio that's probably unsustainable for any cat. In fact, the reason cheetahs persist on the plains at all may be due to overflow from surrounding woodlands where cubs probably enjoy greater rates of survival (a question currently being investigated by researchers). For leopards, Ted Bailey estimated that half of cubs in the Kruger National Park survived to independence. Long-term records from the adjacent private Londolozi Game Reserve suggest higher rates, at least for cubs observed from about the age of eight weeks (therefore excluding some losses taking place earlier in the lair). There, the famous female leopard known simply as 'The Mother' had at least 16 cubs in nine litters between 1979 and 1991. She reared 12 to independence. Importantly, though, Lex Hes, who observed the Londolozi leopards for many years, regards her as a particularly successful mother; he agrees with Bailey's estimate of 50 per cent survival of cubs for females in general. Among the seven smaller species of African cats, estimates of kitten survival remain a guess.

Growing up: learning to be a cat

Life as a young cat is hazardous, but life-threatening events are fairly rare episodes and most of their time is spent resting, feeding and playing. Regardless of species, cubs or kittens usually leave the den and begin accompanying their mother from about the age of six to 10 weeks. Young cheetahs are rarely left alone from that point and move with their mother constantly.

Despite their reputation for being feeble, cheetah cubs are actually very robust, and like all young cats, engage in furiously energetic play sessions in which trees and other high points are favoured focal points.

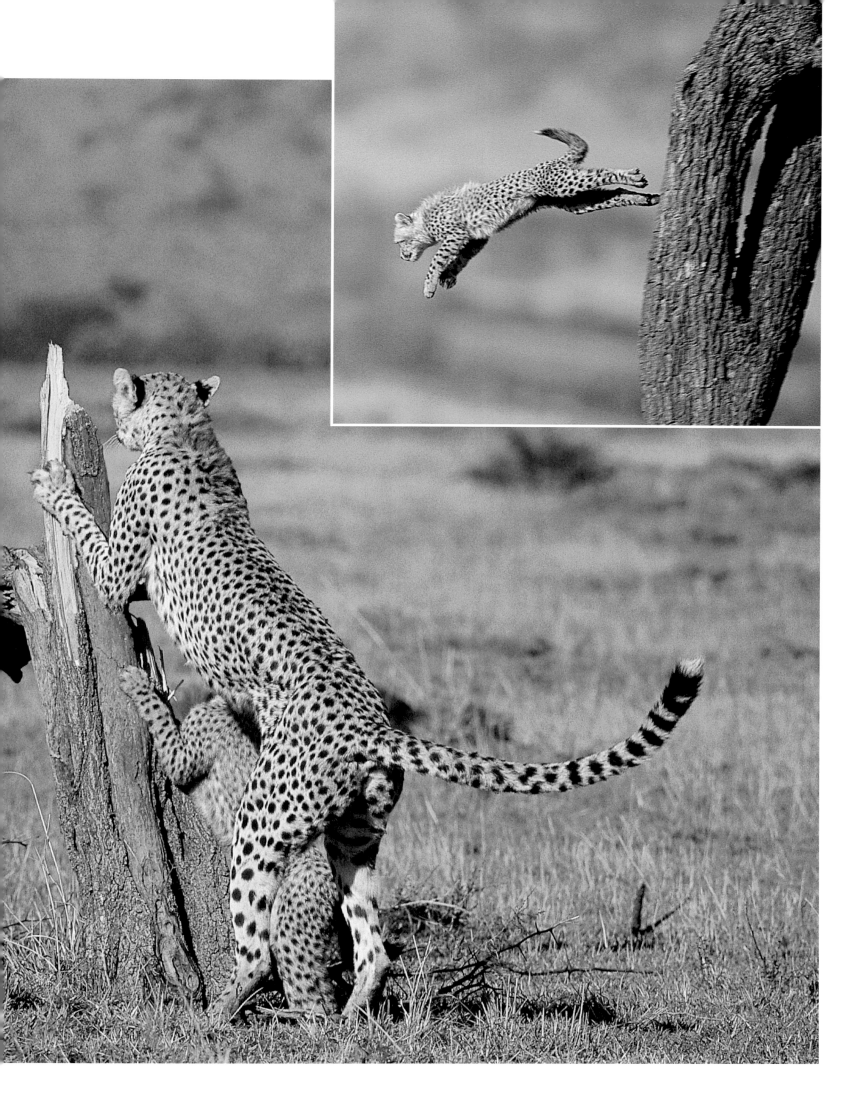

A lion pride scavenges the carcass of an elephant that died of natural causes, northern Botswana. Like most cats (with the exception of cheetahs), lions are not averse to putrefying meat and will remain with such a bounty for days on end. In this case, the pride fed for a week before leaving the remains to crocodiles and spotted hyaenas.

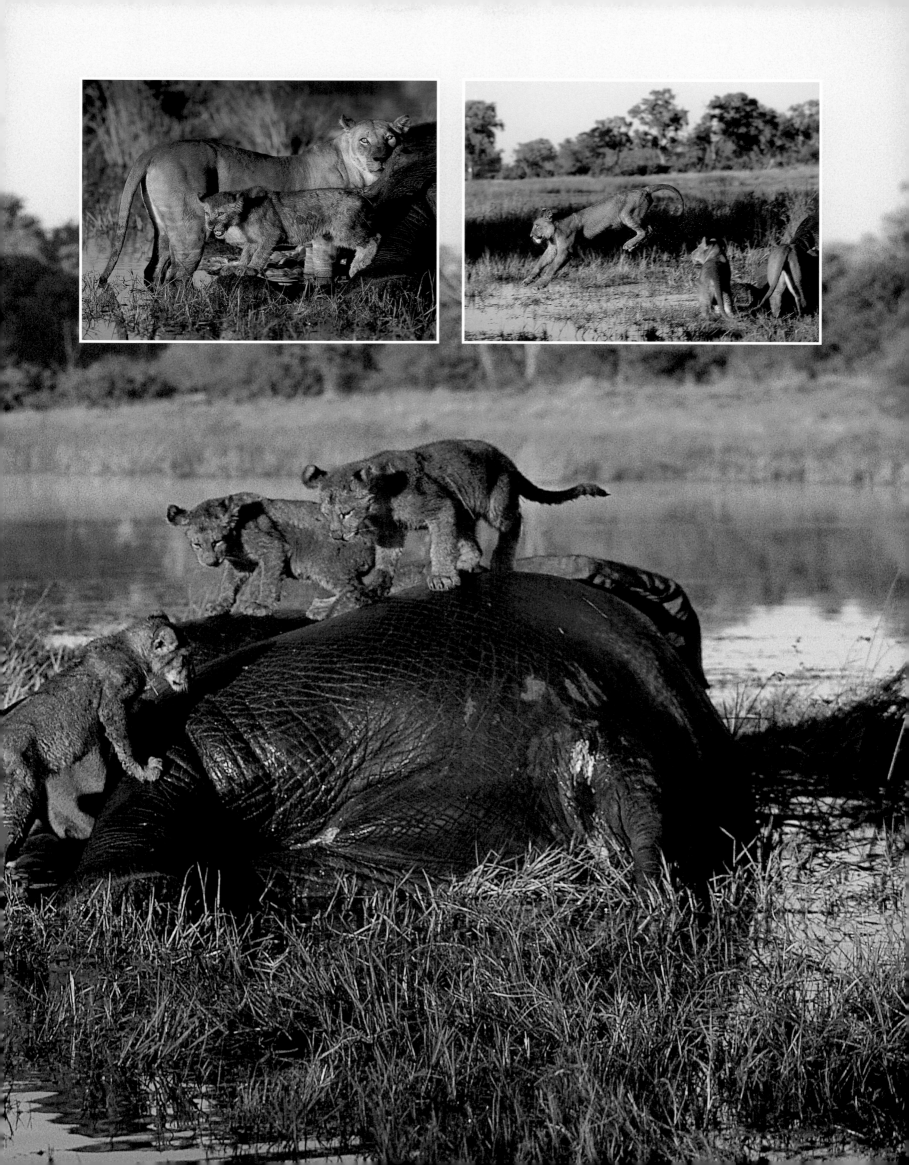

Lion cubs similarly tend to be with their mother or other members of the pride most of the time, though hunting females may leave crèches of young cubs alone until they reach four to five months of age and are better able to keep pace. In leopards and most likely the smaller cat species, even larger cubs are left to their own devices more often. Although cubs often travel with their mother, a female leopard setting out to hunt usually leaves them behind and returns later to escort them to her kill.

In domestic cats, it has been shown that kittens raised with their mother are much more efficient at dealing with mice than those raised without their mother.

intervening to assist clumsy youngsters when the mouse was getting away.

Caro later investigated this phenomenon among cheetahs in the Serengeti. The same experimental set-up – mothers present versus mothers absent – was impossible to replicate in wild cheetahs, but Caro demonstrated how mothers gradually release more live prey for their cubs as they age: from around 10 per cent of her catches when the cubs were four months of age to around 40 per cent at seven months. At the same time, the proportion of prey caught by the mother but killed by her cubs increased over time as they became more proficient in applying a suffocating bite. Although the process has not been as precisely documented for other felids, it is doubtless similar, and many observations exist of lionesses and mother leopards releasing live prey for their cubs.

Travelling with their mother helps equip cubs with the critical skills they will need to survive as adults. As they mature and cover increasingly more ground, young cats are exposed to danger, prey and conspecifics, honing their instinctive responses to each under the relative protection of their mother's presence. In particular, mothers assist their youngsters in learning how to be efficient killers. Mother cats begin releasing live, sometimes disabled, prey in front of their offspring early in their development: from as young as four weeks for domestic kittens in semi-wild colonies, to around four to five months for big cats such as leopards and cheetahs. Tim Caro tested the effects of this predatory training in domestic cats, discovering that kittens raised with their mother were much more efficient at dealing with mice than kittens without their mother. By 12 weeks of age, kittens with mothers had killed five times as many mice as those where the mother was absent. Kittens raised by their mother benefited from maternal encouragement – vocalising reassuringly to draw the kittens' attention and prompting them to investigate the prey – and from mothers

Eventually, the young cat reaches the point where it can hunt on its own. The age at which cats attain independence varies (see Species Profiles, page 18–31), but families ultimately part ways because the reproductive imperative has come full circle. Female cheetahs and leopards (and likely those in other species) may mate and conceive while still accompanied by older cubs, but they invariably leave their adolescent offspring when they are about to give birth to the next generation. It is the culmination of a sometimes protracted process in which the young cat spends increasingly more time on its own until all contact with the mother is finally severed. Newly independent cats face a suite of challenges and dangers and, as discussed in the next section, many will not make it to adulthood.

A female cheetah (far right) oversees her cubs' hunting attempts after releasing a live young springbok. Although this appears cruel to human observers, such opportunities are a crucial part of the training that young cats must undergo to survive as adults.

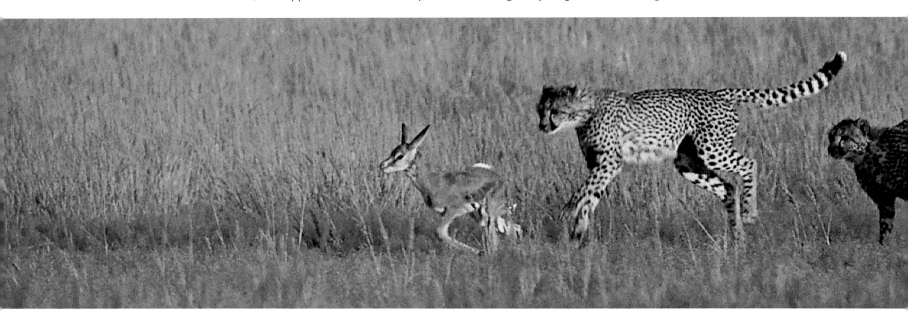

Altruism versus self-interest in lions

Male lions in Ngorongoro Crater (and, indeed, wherever they enjoy reliable foraging) often allow young cubs to feed on carcasses while repelling the rest of the pride. The classic portrayal of males 'always feeding first' is correct in that they monopolise kills when they can, but under most conditions they make an exception for small cubs. Apparently altruistic, the behaviour is inherently selfish because it improves the likelihood of their cubs surviving, thereby enhancing their own genetic 'fitness'. But, of course, such vested interest is the underlying reason for the great majority of behaviours we often interpret as selfless and it usually disintegrates when individual survival is at stake; when prey is particularly scarce, males prevent even young cubs from access to kills. Interestingly, lionesses almost always allow their cubs to feed, no matter how hungry they are themselves. Their energetic investment in producing cubs is greater than that of males, and it takes truly desperate circumstances for a female to forsake her offspring. Because lionesses do not carry cubs to kills nor bring kills to their cubs, the critical threshold is reached when females have to cover prohibitive distances to feed themselves. If cubs cannot keep up, the female has no choice but to abandon them.

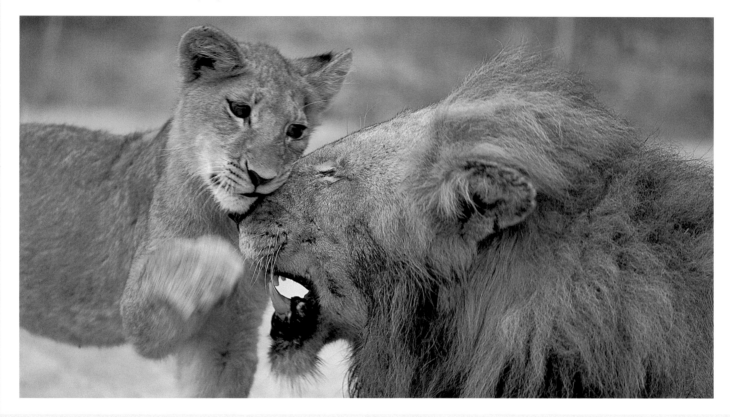

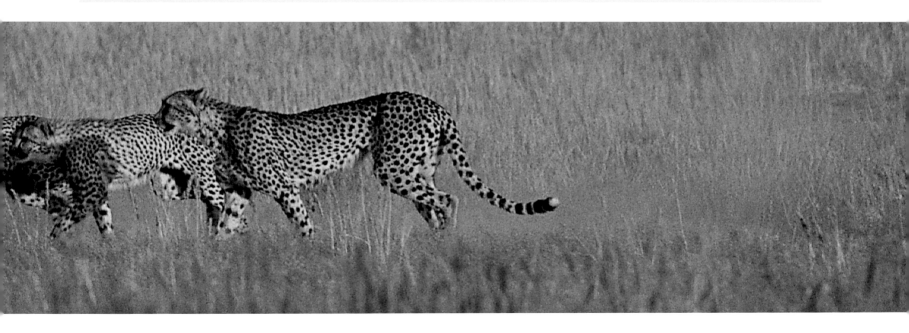

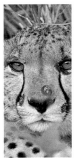

Into adulthood: dispersal and survival

The path to adulthood for young cats is surprisingly poorly understood but, in general, the feline pattern is one of female philopatry and male dispersal: sub-adult females are more likely to stay in or near their mother's (or pride's) range while males move further afield to establish a range. As a general rule, the pattern probably applies to all felids but it has been thoroughly investigated only in lions and cheetahs, and less so in leopards and servals.

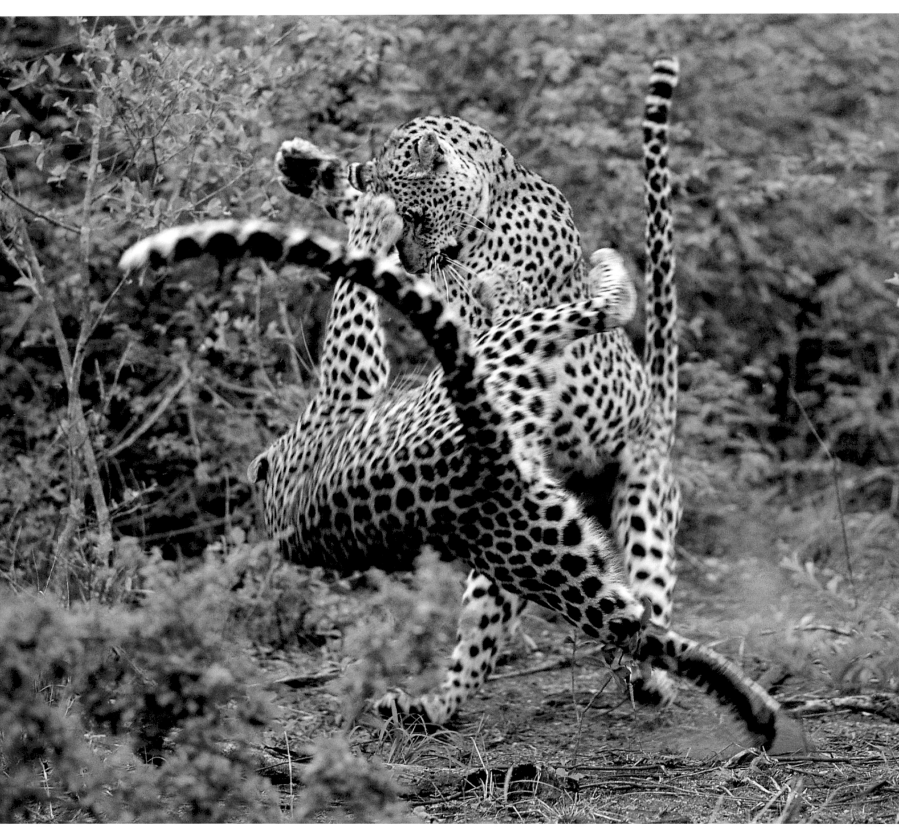

In solitary-living servals and leopards, the adult female usually tolerates her female offspring utilising part of her territory when the youngsters gain independence, though they rarely interact directly with one another. To the mother cat, tolerating a female relative nearby is less hazardous than risking encounters with an unfamiliar newcomer; adhering to the 'dear enemy' principle (see Chapter 3) carries even fewer costs when the neighbour is a relative. It potentially also increases the mother's overall reproductive output (her fitness) by enhancing the survival prospects of her female offspring and elevating the likelihood that they will in turn raise their own cubs. For dispersing adolescent females, inheriting a portion of their mother's territory has considerable advantages during a period when the chances of starving or being killed by other carnivores suddenly escalate. They already know the area intimately and do not need to invest energy in locating and 'mapping' those features that are critical to their survival: areas where prey congregates, the location of hostile neighbours, and the whereabouts of waterholes, rest sites, refuges from predators and so on. Given the limitations of space, it is likely that some young females do not end up

Increasing aggression from the mother and resident males pushes young male leopards and servals from their natal range into a dangerous phase of nomadism.

settling near their mother (and, most probably, their older sisters), but the process is still insufficiently understood in any felid to estimate relative figures.

Males, on the other hand, are always evicted (at least, the limited data available indicate this is so). Increasing aggression from the mother and resident male or males pushes young male leopards and servals from their natal range into a dangerous phase of nomadism. The pattern guards against young males staying put and breeding with their female relatives, but it comes with considerable costs to them. In South Africa's Phinda Game Reserve, sub-adult male leopards are almost three times as likely as females to die during this period; young males die from a combination of natural violence and being forced into marginal areas such as farms where the chances are high that they will be killed by people. Phillip Stander found a similar outcome for two adolescent leopard males he monitored in north-eastern Namibia. Both stayed in their mother's range for 6–8 months after independence before dispersing 25 and 162 kilometres respectively. The first died in his new range after six months while the second was killed for cattle-raiding five months later.

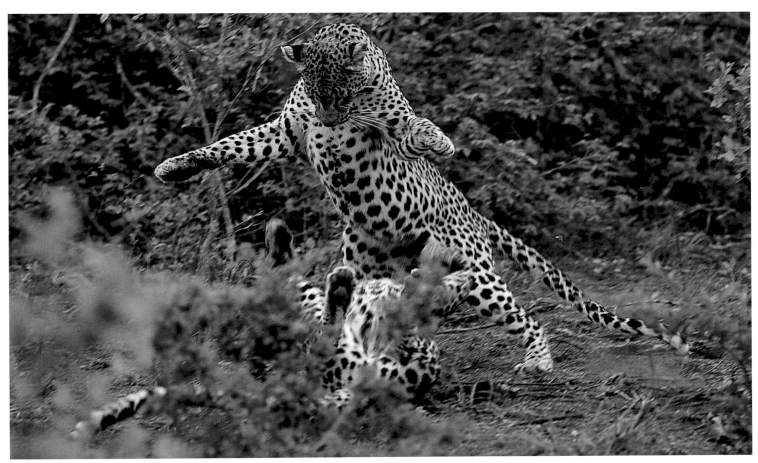

OPPOSITE AND ABOVE: A female leopard confronts her young adult son, a necessary part of his gaining independence. At 24 months, the young male is no longer welcome in his natal home range, and escalating conflict with his mother and especially with adult males will soon force him to disperse.

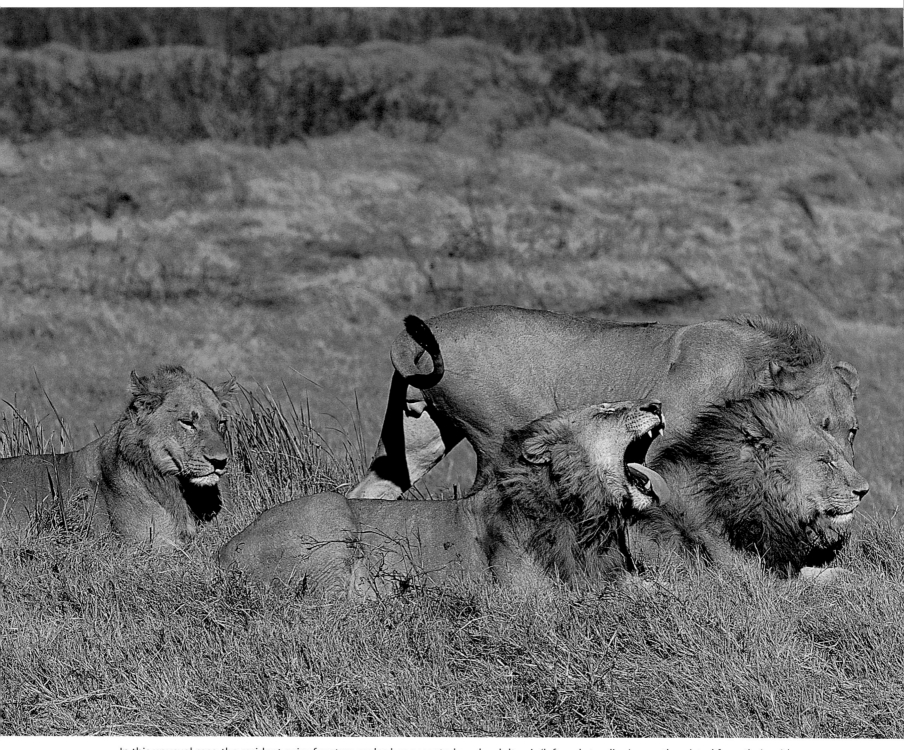

In this unusual case, the resident pair of mature males has accepted a sub-adult pair (left and standing) recently evicted from their pride, Duba Plains, Botswana. Given that larger coalitions have longer territorial tenure, access to more females and sire more surviving cubs than smaller coalitions, the 'pact' might reflect rising pressure on the resident coalition from intruding males.

The pattern of philopatric females and dispersing males also applies to lions. Young lionesses occasionally wander for a period near their natal range but most will eventually end up incorporated in their original pride. In the Serengeti, about two-thirds of female sub-adults are recruited into their mothers' prides while the rest emigrate, either to avoid mating with their fathers and uncles or to evade new males which have taken over the pride. Dispersing females usually establish new prides nearby, but their reproductive success is significantly less than for females that stay put; reproductively, the best strategy for lionesses is to remain with the pride in which they were born.

Male lions, however, always leave. Between the ages of two and four, young males are evicted, either due to increasing aggression from their adult relatives, both males and females, or in response to a take-over by new males. Bereft of their pride, sub-adult males enter a similar nomadic phase as experienced by young male leopards. This is a perilous period during which they risk being killed by territory holders if they

Disease in cats

Investigating disease in cats is problematic because researchers rarely find dead cats. Even so, indications from wild populations suggest that significant loss to disease is a rare event. As in all species, naturally occurring diseases probably cycle continually in cat populations with relatively minor impacts. Most individuals survive exposure with a small percentage of individuals succumbing; those that die are often already compromised and vulnerable from other factors such as injury, starvation or infection. Some pathogens persist in populations with no effect at all, Feline Immunodeficiency Virus (FIV) being a case in point. Despite sometimes hysterical press reports about AIDS in lions, FIV has been present in many wild lion populations for prolonged periods, possibly for thousands or even millions of years, and most adult lions have the virus. Unlike HIV in humans, FIV produces no clinical effects and does not affect the survival of lions. FIV has also been found in African leopards where it is similarly innocuous.

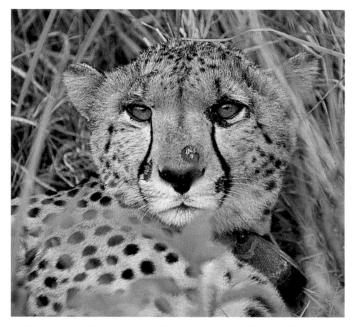

Many cats suffer from occasional outbreaks of 'mange', caused by skin-burrowing mites. Mange is usually innocuous but severe outbreaks sometimes lead to fatal secondary infections.

Exotic disease, usually introduced by people or their domestic animals, has the potential to cause far greater damage. In 1993–1994, an epidemic of canine distemper virus (CDV) raged through the lions in East Africa's Serengeti-Mara ecosystem, killing one third of the population, some 1 000–1 100 animals. The outbreak probably originated in the 30 000 village dogs living on the periphery of the protected area. Lions are particularly vulnerable to novel diseases because of their rich sociality and high densities; constant interaction among lions facilitates transmission. Fortunately, the solitary lifestyle of other cats probably reduces their vulnerability, and the CDV episode apparently did not affect Serengeti leopards or cheetahs. The exotic livestock disease bovine tuberculosis (bTB) may pose a significant threat to lions in the Kruger National Park and there is at least one case of infection in leopards. The long-term implications of bTB on cats in Kruger are still being investigated.

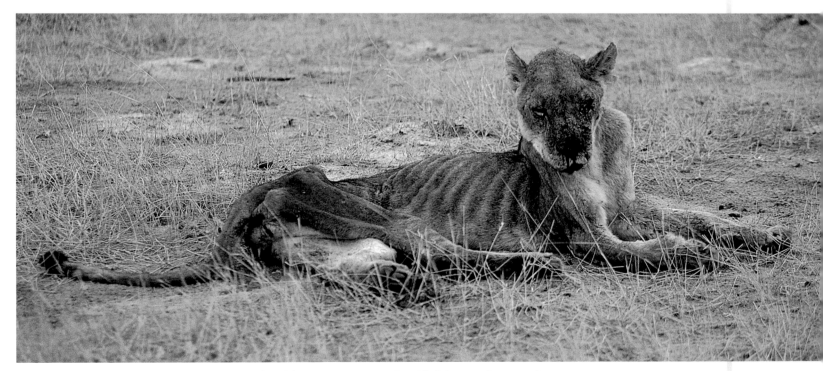

An aged lioness close to the end of her life, Savute, Botswana. Provided they can keep up, the support structure of the pride means that lionesses are more likely to die from advanced old age than infectious disease.

are caught interloping on occupied land. Intriguingly, Paul Funston and Gus Mills found that young males in southern Kruger National Park do not always become drifters, but sometimes form 'lodger groups' close to their natal range. While they must still avoid their former pride or risk a potentially deadly reunion, inhabiting the vicinity of their original home probably confers similar advantages to those enjoyed by non-dispersing females; they already know the best areas to search for prey and are well equipped to avoid other male lions in the region because they are familiar with their rivals' status and movements. Ultimately, 80 per cent of the male lions in the Kruger study established territories close to their original pride range; by comparison, most Tanzanian males established territories at least 120 kilometres from where they were born.

It is still unclear how Kruger males avoid breeding with their female relatives but, when given a choice, it seems that males prefer non-relatives. Long-term observations in the Serengeti show that, instead of being ousted from their prides, some young males voluntarily depart to avoid inbreeding. Maturing coalitions of males have been known to quit prides even when there were no resident males driving them off and when their own pride contained more reproductively available females than the unrelated prides in which they eventually settled. Perhaps a similar choice-based mechanism is at work among the Kruger male lions as they gain territory and access to females, although so far it has not been documented.

Among cheetahs, female philopatry and male dispersal hold true, even allowing for the vast home ranges of the mothers. Newly independent adolescents, females and males, usually stay together in a sib-group that remains temporarily in their mother's range. Grouping in young cheetahs increases their chances of making a kill while still developing their hunting abilities, though they eat no more than corresponding singletons; sib-groups kill larger prey more often, but they have to share the spoils with their siblings. There are, however, further advantages to staying together. The individuals in a sib-group each devote less time to watching for danger and are more relaxed than young females on their own; and groups are less likely than individuals to be harassed by spotted hyaenas or by adult male cheetahs. Even so, the advantages of sociality are not compelling enough for females to remain permanently in the sib-group and they always leave their brothers to adopt a solitary lifestyle as they approach sexual maturity. Just as in lionesses, leopards and servals, they usually inherit some of their mother's range; in the Serengeti, the ranges of young females overlapped those of their mothers' by an average of 62 per cent and their sisters' by 30–90 per cent. Young males older than three rarely stayed in their natal range, probably because of the presence of adult territorial males. Sub-adult males in the Serengeti dispersed at least 18 kilometres from their mother's range while distances recorded in Kenya's Masai-Mara reached 40 kilometres.

If they reach adulthood, cats continue to face threats throughout their lives, but the risk of dying from natural causes declines sharply from the precarious periods of cubhood and dispersal, then rises again as cats grow old (see Species Profiles for longevity figures, pages 18–31). As covered in earlier chapters, some will die in clashes with their own kind over territory or from mortal injuries incurred in hunting mishaps. Starvation and disease (see text box 'Disease in cats', page 125) claim a lesser percentage of adult cats and some will be killed by other carnivores; this complex relationship is covered in the next chapter.

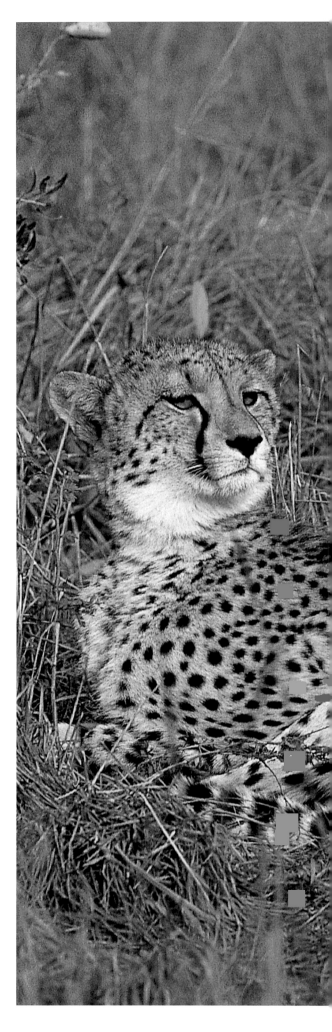

At one year old, these young cheetahs (right and left) will soon be independent. The female cub (left) will ultimately pursue a solitary existence while the male (right) will likely attempt to form a coalition with another single male.

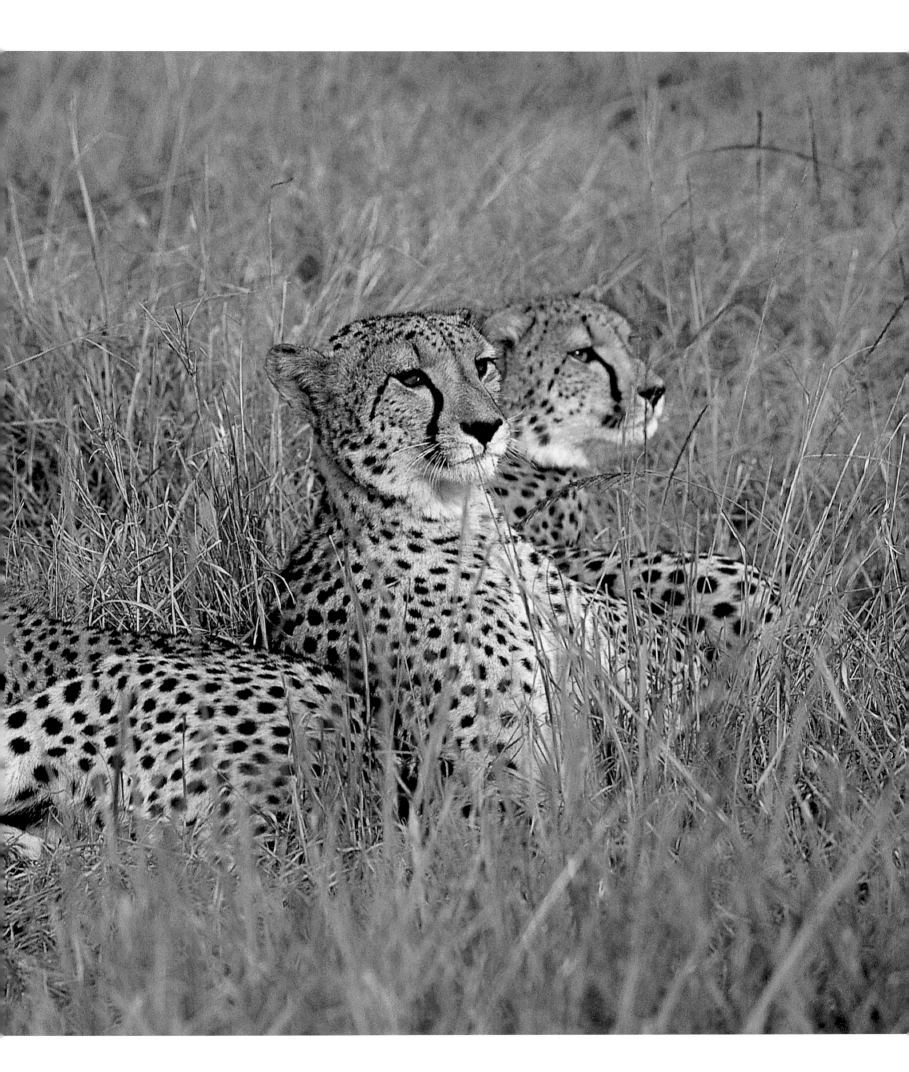

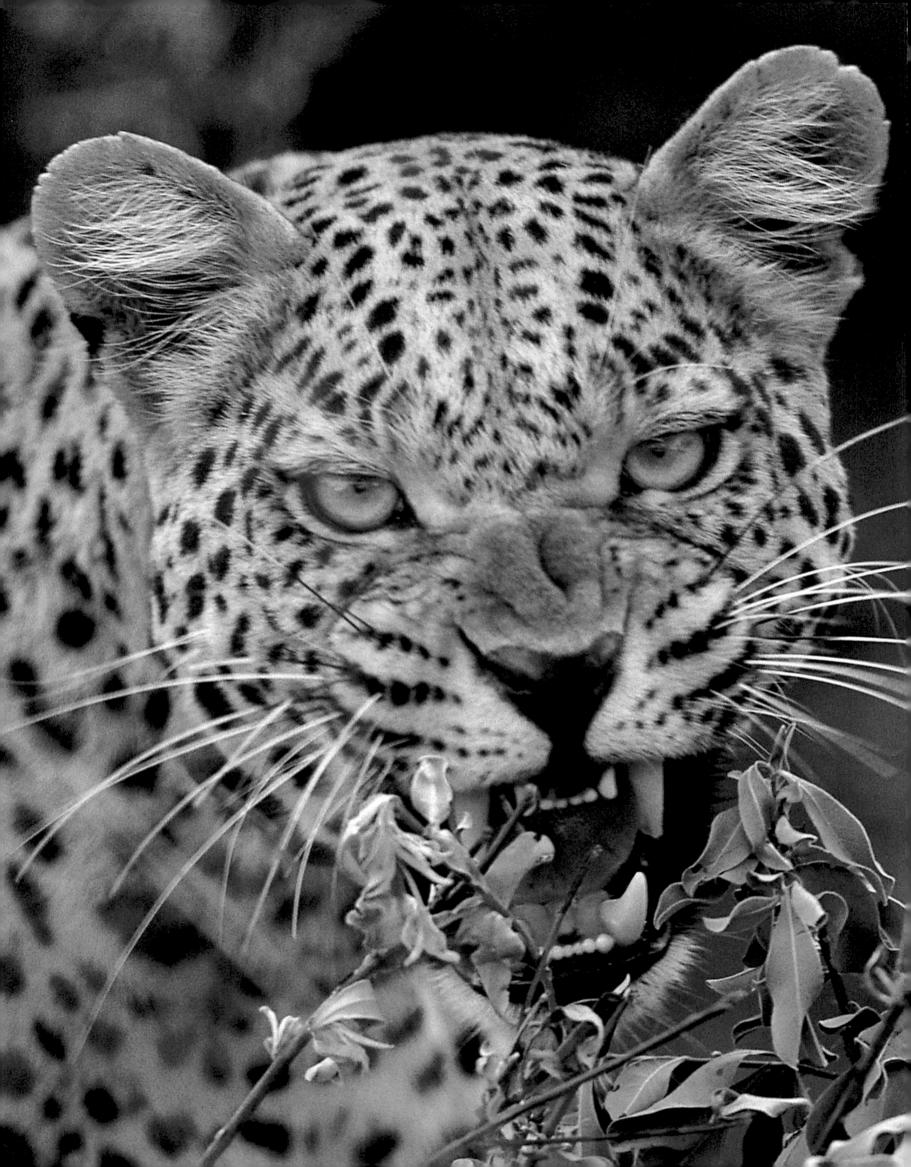

5

COMPETITION, CONFLICT AND COEXISTENCE

relationships
among cats and
other carnivores

Interactions among the cats

Africa is exceptionally rich in carnivores. Excluding the unique carnivores occurring on Madagascar, there are some 80–84 species in Africa (taxonomic uncertainty among some smaller carnivores clouds the issue slightly). This is not the highest continental tally, but nowhere else compares for sheer numbers. Measured in biomass, there are more carnivores per square kilometre in Africa than anywhere else. Mostly, this is due to the rich productivity of the savannas. With bountiful vegetation supporting herbivores of all sizes at high densities, carnivores reach their highest numbers in savanna woodlands, and interactions between carnivores are probably more common there than in any other habitat. In less productive areas, carnivores are less abundant and inter-actions between them are thought to be less common (or perhaps just less easily observed) but the relationships remain similar. Except for the remote interior of the Sahara where only the highly specialised sand cat exists, there are no large, natural areas in Africa where any cat species lives in isolation from others. Confrontations between different felids are typically hostile in a hierarchy that is essentially linear; predictably, larger species dominate smaller ones in their day-to-day encounters.

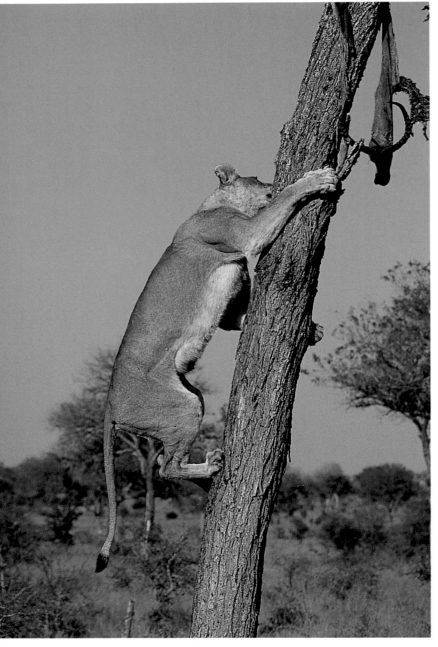
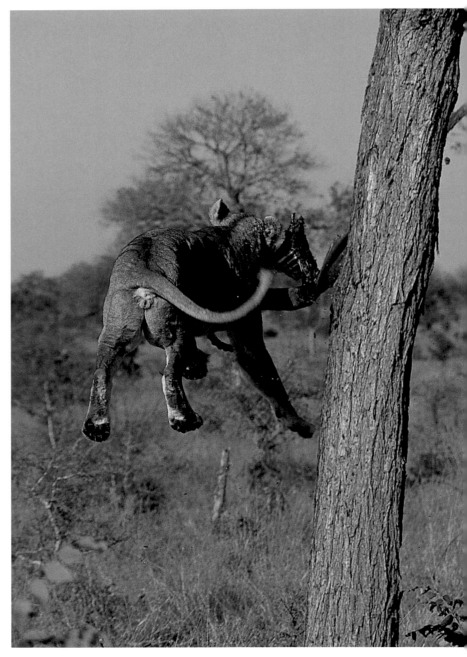

ABOVE AND OPPOSITE: A lioness pilfers the remains of a leopard's kill, Ngala Game Reserve, South Africa. Lions are not nearly as well equipped as leopards for scaling trees, but as illustrated here, they are quite capable climbers. Fortunately for leopards, lions are too heavy to reach the smaller, outer branches where this leopard found refuge.

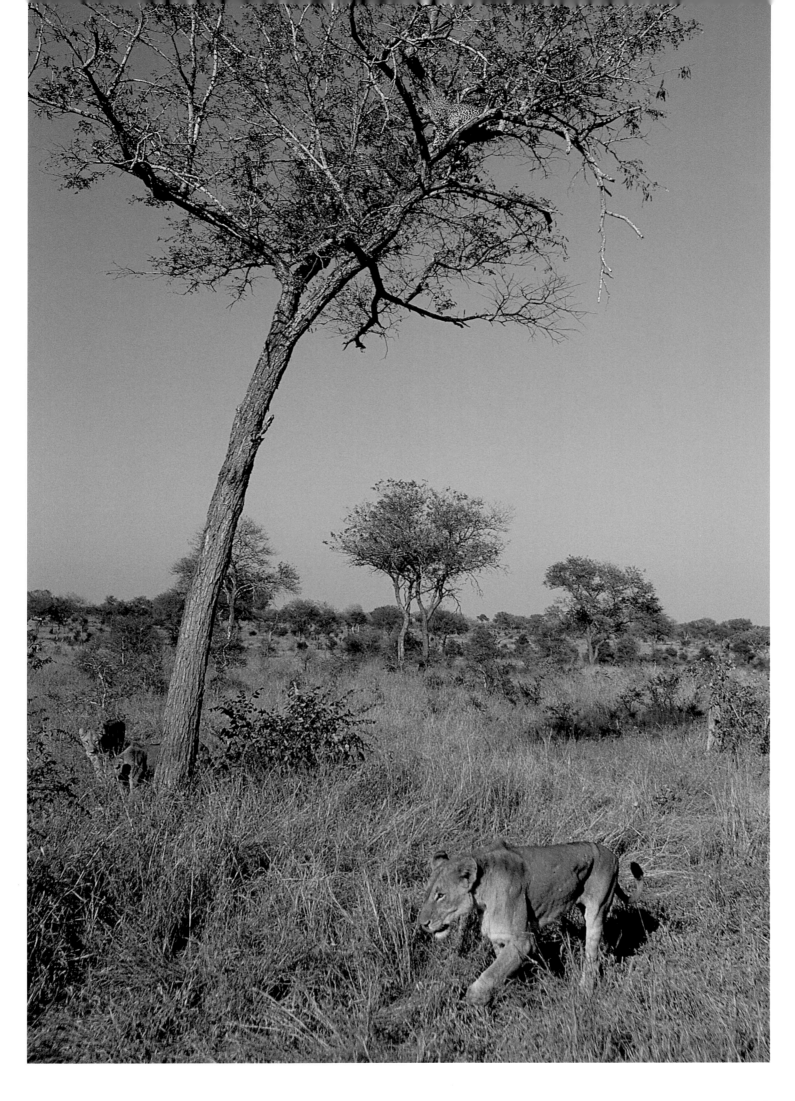

As the largest carnivore on the continent, the lion has little to fear from other cats except for occasional losses of young cubs. George Schaller describes an incident in which a Serengeti lioness left a very young cub at her kill, despite knowing that a leopard was resting in a tree directly over the carcass. As the lioness departed to fetch her other cub, the leopard quickly descended the tree and killed the cub left behind. Such incidents occur from time to time, but the leopard is the only recorded feline predator of lion cubs. While adult cheetahs, caracals and perhaps even servals and African wildcats are plausibly capable of killing young lion cubs left unattended, losses to these species must happen extremely rarely, if at all. With the occasional exception of young cubs, the lion is essentially invulnerable to any feline threat other than that from strange conspecifics (see Chapter 4).

On the other hand, the lion is an important threat to all other cats, irrespective of age. As discussed in the previous chapter, they represent the main source of mortality to cubs in well-studied populations of cheetahs and leopards, but if given a chance, lions readily kill adult cats as well. Vulnerability to lion attacks appears to vary with habitat. In

With the occasional exception of young cubs, the lion is essentially invulnerable to any feline threat other than that from strange conspecifics.

open habitats where cheetah cubs are most at risk, adult cheetahs have the advantage of visibility, space and their remarkable acceleration. Cheetahs can spot danger coming from a distance and have few obstacles to negotiate in fleeing, so it is rare for a healthy adult to be killed by lions in such habitat By contrast, woodland habitats increase the risks for adult cheetahs. Ironically, despite the advantages afforded to mothers that raise their cubs in dense bush (see Chapter 4), *single* females and males are more likely to die here in clashes with other big cats. The cause of the disparity is unclear but is likely due to the mother's heightened vigilance while raising a litter; mothers successfully counter the diminished visibility and fewer escape routes inherent in dense habitat by being more watchful. Females on their own and adult males, both of which, presumably, are less vigilant than mothers, suffer an increased chance of attack. During a five-year study where I monitored the large cats living in the dense acacia woodlands of northern KwaZulu-Natal, attacks by other cats (mainly lions and, secondarily, leopards) were the leading cause of mortality for adult cheetahs.

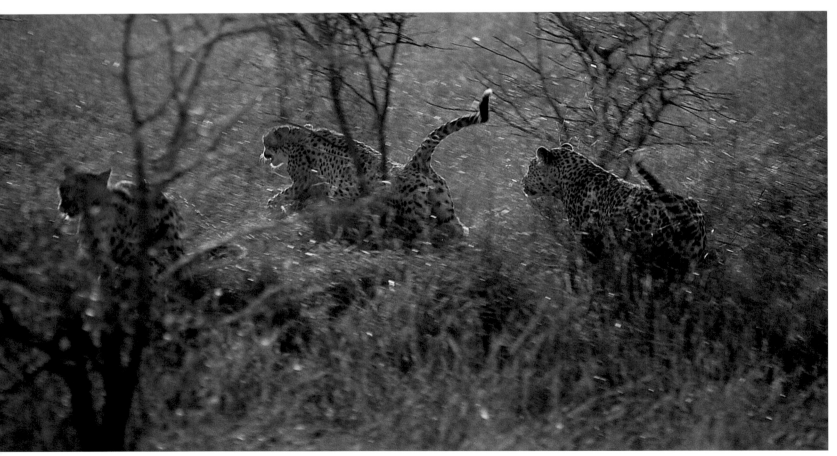

Although similar in size and weight, the leopard's heavier build and greater muscularity means they easily dominate cheetahs; here, a leopard chases two cheetahs in the Sabi Sands Game Reserve, South Africa. On rare occasions, mother cheetahs with young cubs stand their ground against leopards, but typically only enough to provide a diversion for the cubs to reach safety.

Kleptoparasitism

Aside from lethal confrontations, cats also impact one another through kleptoparasitism – securing an easy feed by displacing a sub-dominant species from its kill. Unsurprisingly, the chain of command is rarely anything other than linear: lions chase leopards and cheetahs from their kills, leopards displace cheetahs, and so on. The cheetah is worst affected, though not as severely as often depicted; of 325 kills made by cheetahs at the Phinda Game Reserve, only three were lost to lions and leopards (and only five kills in total were lost when all predators were counted). The widespread availability of cover at Phinda probably reduced losses for cheetahs, but even in open habitats, losses are fairly modest. During Tim Caro's study of male cheetahs on the Serengeti plains, 14 of 110 kills were lost to klepto-parasites, considerably more losses than at Phinda, but the Serengeti cheetahs had usually fed substantially by the time they were driven off; Caro calculated that only around nine per cent of the meat caught by cheetahs was abandoned to thieves. Notably, none of the Serengeti cheetahs' losses was to other cats; all were stolen by the spotted hyaena which, for most African cats, represents a greater competitive nuisance than other felids.

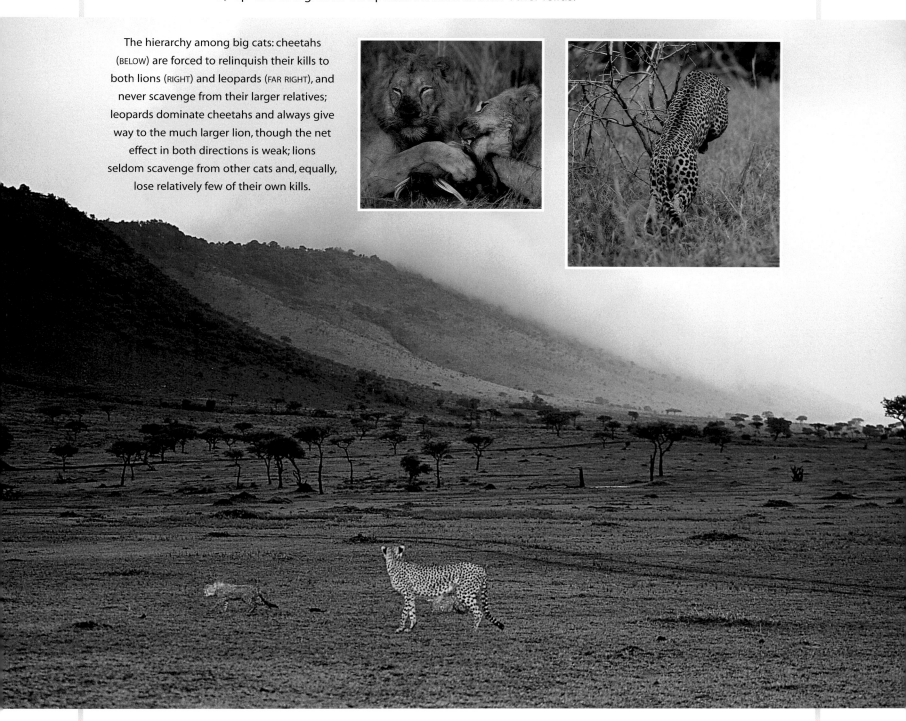

The hierarchy among big cats: cheetahs (BELOW) are forced to relinquish their kills to both lions (RIGHT) and leopards (FAR RIGHT), and never scavenge from their larger relatives; leopards dominate cheetahs and always give way to the much larger lion, though the net effect in both directions is weak; lions seldom scavenge from other cats and, equally, lose relatively few of their own kills.

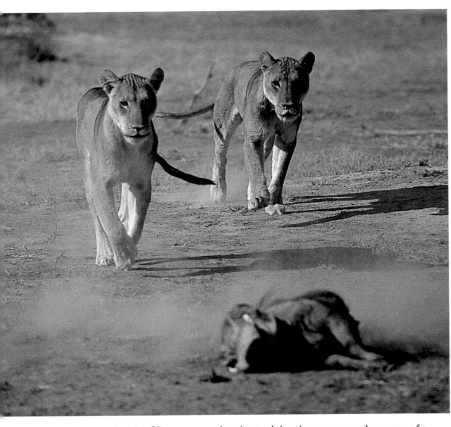

A pair of lionesses rushes in to claim the scavenged carcass of a warthog, northern Botswana. Outweighing the next largest felid species by a factor of two, a single lioness is more than a match for all other species of African cats.

faster than leopards on open ground. I once saw two lionesses come upon a male leopard resting in a large clearing in open terminalia woodland. The three cats simultaneously exploded into action, the leopard bolting for a large umbrella-thorn tree about 35 metres away with the lionesses on his tail. Despite a 10-metre starting advantage over the lionesses, by the time the leopard reached safety, they were less than a metre behind him. Only his extraordinary agility in scaling the tree saved him. In northern Namibia where large trees are more thinly spread, Phillip Stander recorded a female leopard killed by lions after taking refuge in a small tree that did not provide sufficient protection. Similarly, the wildlife photographer and naturalist Jonathan Scott photographed a young male leopard in Kenya killed by lions after being disturbed by tourists; the leopard fled the safety of cover and was caught by the lions on open ground.

Leopards, in turn, are capable of killing all cats (except, of course, lions other than young cubs) and the anti-predator benefits enjoyed by cheetahs in open habitats appear to wane in the face of the leopard's more catholic tastes and exceptional stealth. In arid and open habitats such as the Kalahari Desert and north-eastern Namibia's Bushmanland, leopards occasionally hunt cheetahs for food; carcasses of adult cheetahs are cached in typical leopard fashion and consumed in the same way as their regular prey items. Similarly, cheetahs (as well as caracals and servals) were recorded as prey in the Chipangali region of eastern Zambia shortly after a tsetse fly control programme had denuded the area of antelope prey. In more profitable habitats like the mesic savannas of eastern South Africa, leopards also kill cheetahs and other cats from time to time but seem less inclined to eat them, presumably because they have a greater choice. Their preferred antelope prey is abundant and they do not have to work quite so hard to secure a meal.

Intriguingly, the relationship between habitat and the lion threat swings the other way for leopards. Leopards easily evade lions by climbing the nearest large tree; in dense habitat, the options are legion and adult leopards in good health are rarely caught by lions. In open habitat, however, refuges are fewer and leopards do not have the cheetah's advantage of speed; lions are

Lions are capable of explosive bursts of speed and, over short distances, are able to out-run all other cats except the cheetah.

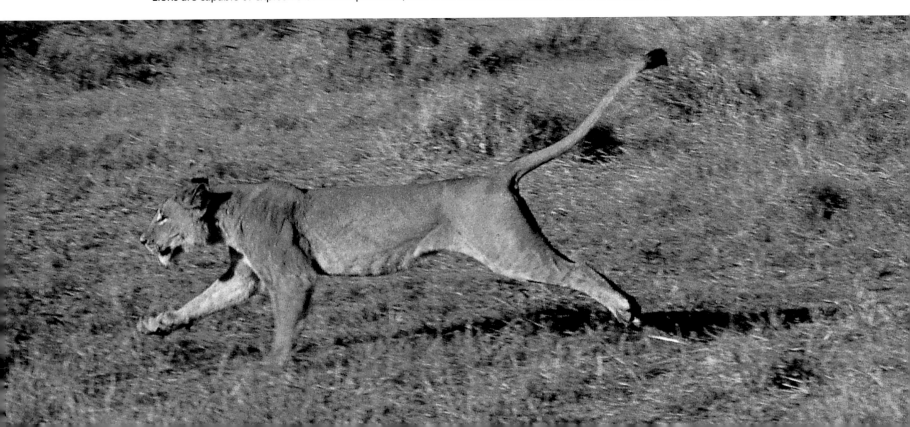

Gaining the advantage: interference competition

It begs the question, why do cats kill one another if not for food? Biologists usually cite three principal reasons: occasionally, they prey upon one another as food; secondly, they consider other cats as potential enemies of their offspring, so killing another cat removes a threat; and finally, they compete for the same resources. It is this last factor – specifically, 'interference competition' – that is widely considered to be the primary cause of conflict between felids, and also gives rise to clashes over carcasses (see text box 'Kleptoparasitism', page 133). Chris Carbonne and John Gittleman calculated that it takes 10 000 kilograms of prey to support 90 kilograms of predator; in other words, it requires about 475 rock hyraxes to support a caracal, 100 impalas to support a female leopard and 67 wildebeest to support a lioness. The relationship holds for carnivore communities around the world and it places a threshold on the total biomass of predators that can be sustained by an ecosystem.

Even so, this does not satisfactorily explain why some cats go to such lengths to kill other members of the family. As the most aggressive culprit, the lion is a puzzling case in point. As we have seen, lions rarely eat leopards or cheetahs they have killed, and lion cubs are seldom killed by other felids. This leaves competition for resources as the lion's motivation, which seems reasonable, though it is unlikely that competition with any other felid affects lion survival or numbers. As discussed earlier, lions rely on large prey that is mostly inaccessible to leopards and cheetahs which, in turn, take smaller prey that comprises a minor proportion of lion diet. Indeed, such partitioning of prey is partly the reason cheetahs and leopards can exist alongside lions. Similarly, even though leopards and cheetahs share a similar diet, leopards subsist on a wider range of prey, and cheetahs naturally occur at low densities, such that any effect on leopards is likely to be negligible.

Interference competition might carry advantages in sub-optimal habitats where the struggle to secure prey is elevated and fewer options result in a greater dietary overlap among cats. Conceivably, the springbok-hunting lions in Etosha National Park would need to cover less ground or be forced to abandon fewer cubs in the search for prey if there were no leopards or cheetahs feeding off the same prey base, though no-one yet has successfully investigated the idea (see the following section for the effect when lions are removed). Elsewhere, perhaps like predators around the world, large cats exert dominion over smaller ones simply because killing is hard-wired, regardless of the quarry. It might also reflect a period in felid evolution when the number of carnivorous competitors was twice that of today (see Chapter 1) and removing other cats carried a direct benefit. Inter-specific aggression may persist today, not because it yields rewards but simply because it carries no significant costs.

In the final analysis, competition among cats likely has more to do with maintaining an advantage, but over evolutionary time rather than from one day to the next. Competition can produce significant effects on the sub-dominant species that may include changes in behaviour, numbers and distribution. Even when such effects are subtle, competition benefits the dominant species by keeping other cats in their evolutionary place. Given unchanging availability of resources, the competitive dominance of the lion ensures that leopards or cheetahs do not evolve larger body size and encroach upon the lion niche. Equally, although manifested very differently, the ability of small-bodied felids to exploit small prey better than large cats are able to, means the opposite does not happen. Although a leopard easily kills a serval, the serval out-competes any leopard as a rodent hunter; the leopard cannot evolve into a rodent specialist while servals (and other small felids) continue to occupy that niche so successfully.

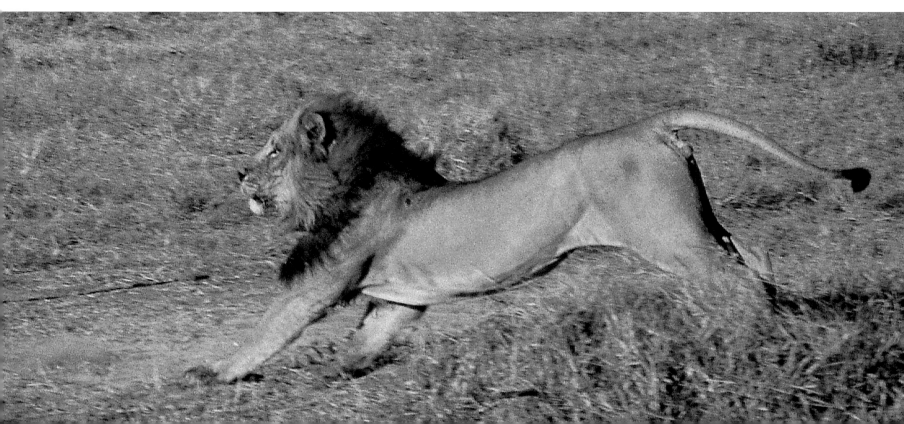

Large Nile crocodiles like this individual are formidable foes and are mostly safe from lions provided they are not caught on land, where lions have the advantage. There are reliable records of lions killing crocodiles as large as three metres.

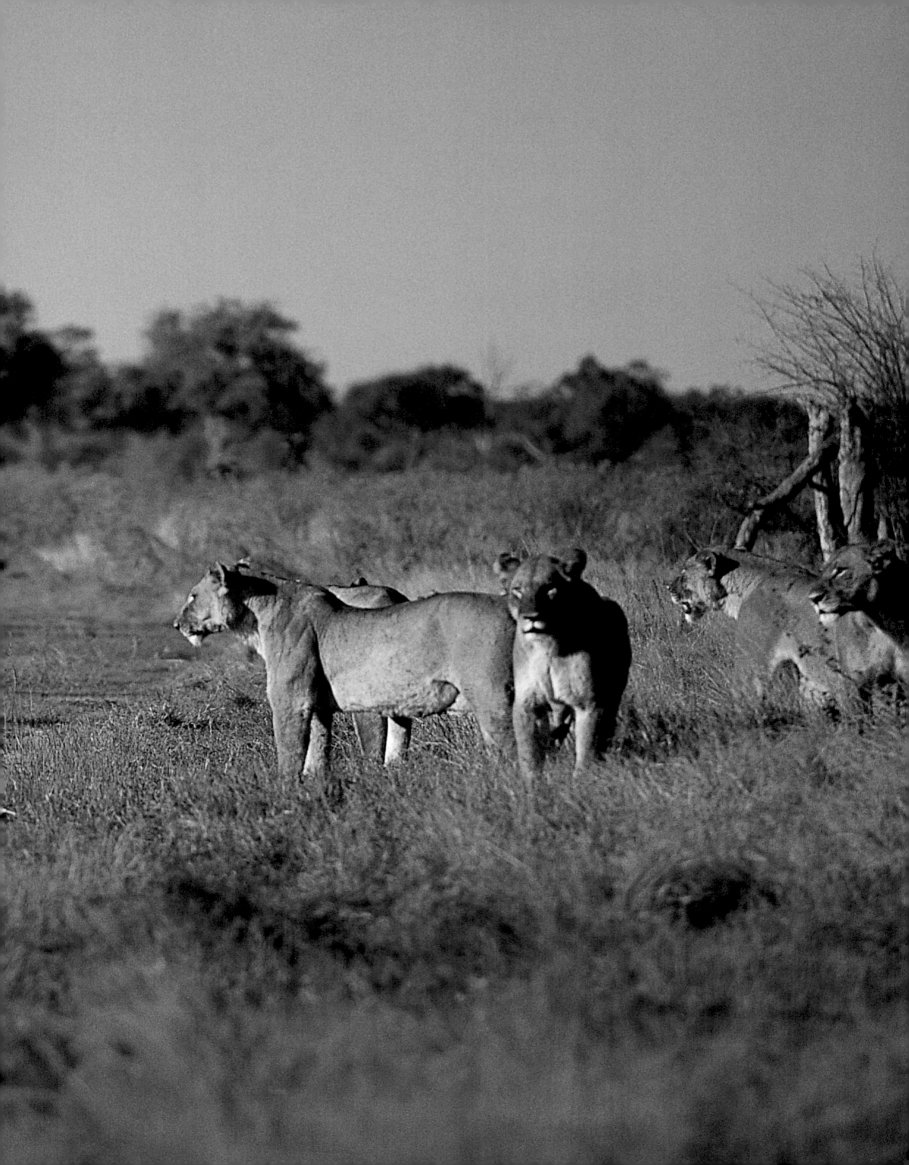

The effect of competition and conflict

How do the complex interactions between cats affect one another in the long term? Every indication is that the loss of cubs or kittens is an extremely stressful event for a mother cat. Yet female cats recover quickly and are able to reproduce again rapidly following the death of a litter (see Chapter 4), so it may constitute no more than a temporary setback for an individual. Similarly, the killing of an individual by another cat may have little effect on a population, or indeed on the species.

On average, the likelihood that this leopard cub will survive its first year is around 50 per cent.
In the more marginal habitat of the Kalahari, survival of cubs is estimated at around only 10 per cent.

As the most arboreal of big cats, the leopard's ability to find refuge in trees is a key factor in its ability to reach high densities where lions and spotted hyaenas are abundant.

For most populations of felids, the effect of interference competition from other cats is probably minor. As biologist Phillip Stander has noted of leopards, the cat's ability to conceal itself and its food means that adults generally suffer little from inter-specific predation and competition. Yet even for the versatile leopard, predation by lions is the primary threat to cubs in areas where the two species coexist (see Chapter 4). How can biologists conclude that interference from lions is having little effect on leopard populations when up to half of their cubs are killed by the larger cat?

Freed of predation by lions, more leopard cubs *would* survive. Imagine Kruger National Park suddenly devoid of lions: leopards would find themselves in an environment without the major killers of their offspring, therefore many more leopard cubs would survive. Perhaps – yet even with lions present, leopards in Kruger reach the highest densities recorded for the species: up to 30 adults and independent sub-adults for every 100 square kilometres in the productive southern region of the park, an area where lion densities are also extremely high. The leopard density in Kruger is probably at capacity; even if lions were absent, leopards could not reach greater numbers. As ecologists would define it, the leopard population is regulated by 'density-dependent' processes; as leopard density climbs, space becomes scarce, conflict increases among leopards and fewer young leopards survive to be absorbed into the population. If density declines (for example, following

drought or a disease episode), a greater percentage of young leopards survive to fill the newly opened spaces until capacity is reached again. Ultimately (as described in Chapter 3), the ceiling is established by the availability of resources, not by how many lions are around or how many leopard cubs they kill.

In other words, even a high level of lion predation on leopard cubs is primarily *compensatory* rather than *additive* to the overall mortality rate. Lions remove a percentage of leopards that cannot be recruited into the population anyway. So, while the absence of lions might elevate cub survival, an inevitable balancing effect would be felt somewhere else in the population; perhaps more sub-adults would die during dispersal, or the territorial tenure of adults would be truncated by a larger sub-adult cohort competing for space. In theory, the effects of lions might be more extreme in small populations of leopards, those in sub-optimal habitat, or in concert with aggravating factors like drought or reduced prey availability; but so far, there are no rigorous studies demonstrating such an effect.

Density-dependent processes probably contribute to the population dynamics of most felids, but this is not to say that interference competition from other cats never has an influence. Indeed, under certain circumstances, the effect may be profound, such as those arising from the exceptionally high losses of cheetah cubs to lions in the Serengeti (see Chapter 4). In contrast to the negligible impact of lions on leopards, their impact on the population dynamics of Serengeti cheetahs is

Cheetahs are nervous feeders, particularly when faced with a lack of cover, as with this family on a Thomson's gazelle kill in Kenya's Masai Mara National Reserve. Exposed like this, cheetahs scan their surroundings constantly for possible threats and sometimes abandon the carcass when the inevitable build-up of vultures increases the chance they will be discovered by lions.

very marked. More than 25 years of continuous monitoring by Sarah Durant, Tim Caro and colleagues has revealed that the lifetime reproductive success of female cheetahs on the plains is significantly related to the presence of lions. Further, as lion numbers rise, cheetahs have a harder time raising cubs. From the late 1960s, lion density in the Serengeti has climbed (probably due to increases in wildebeest numbers following rinderpest control operations) with a corresponding decline in the reproductive success of female cheetahs. Comparing two time periods – 1969–1979, when lion density was low, and 1980–1994, when lions were more numerous – cheetah litters at emergence declined from an average of 2.9 cubs to 2.1 cubs, and average litter size at independence declined from 2.5 to 2.0 cubs. On average, a female raised 2.1 cubs to independence in the 1970s compared to only 1.6 cubs more recently.

Although these declines may seem modest, they are significant enough to push the population across the threshold of viability. Given that the cheetah population always contains fewer adult males than females, and that the survival of only a small number of male cubs is required to replace males that

die, an adult female has to replace only herself for a population to remain stable. In other words, she needs to raise just one female cub in her life (assuming the odd female also raises a male cub) – but that cub must also reproduce to avert a decline. Given the losses occurring after independence and the fact that half of all cubs at independence are male, even successfully bringing 1.6 cubs to independence is not sufficient. As cat biologist Marcella Kelly puts it, the cheetah population on Serengeti's short-grass plains was already 'failing' by 1994, largely due to pressure from lions.

Escaping competition

The effects on cheetahs can be seen elsewhere by examining the outcomes from a different approach – where lions are extinct. In areas where persecution by people has wiped out lions, cheetahs prosper (see text box 'Predator release', opposite page). On Namibian ranches, the average litter size numbers 3.2 cubs at emergence and 2.4 cubs at independence. More dramatically, mortality of Namibian cheetah cubs in the first year is around just 25 per cent (this excludes losses in

the den, but predation on young Namibian cubs is thought to be rare because there are no lions or spotted hyaenas). Ironically, the gains enjoyed by cheetahs in Namibia are threatened by conflict with people (see Chapter 6), but even so, Namibia has the largest contiguous cheetah population anywhere, due, in considerable part, to the absence of lions (and, to a lesser extent, of spotted hyaenas) in most of the country.

'Predator release', or liberation from predators, probably benefits other African cats at times, although, for the most part, it has not been accurately assessed. Paradoxically, it may apply to the least studied felid on the continent, the African golden cat. In most of their range, golden cats co-occur only with the larger leopard, and the overlap in their respective diets can be acute. In the Central African Republic's Dzanga-Sangha Reserve, 92 per cent of prey species are common to both cats, particularly the 4.5 kilogram blue duiker. Furthermore, golden cats are occasionally killed by leopards. Philipp Henschel found golden cat remains in five leopard scats from a sample of 197 collected in Lopé, Gabon.

> *The cheetah population on Serengeti's short-grass plains was already 'failing' by 1994, largely due to pressure from lions.*

The little known about the golden cat suggests it thrives when its larger cousin is removed. In equatorial Africa, Henschel's work has revealed that leopards are easily extirpated from secondary forest, areas that have been logged and subsequently clogged with thick, moist regrowth. Leopards do not tolerate the human activity that creates secondary forest (see Chapter 6), which also ranks as poor habitat for larger leopard prey such as forest duikers. However, secondary forest is prime habitat for small rodents and ground-dwelling birds, the perfect prey for golden cats. The absence of leopards combined with elevated densities of small prey is a likely recipe for a predator release scenario that benefits the golden cat. Although hard data are mostly lacking, the extinction of the leopard in Uganda's Bwindi Impenetrable National Park has promoted the golden cat to the role of top predator and these cats are thought now to be the park's most common felid.

Where it occurs, predator release results primarily from the activities of people. In natural systems, it probably occurs from time to time – for example, the 1994 distemper epidemic

Predator release

Although populations of all species are influenced by a host of factors – one of which may be predation – the removal of a predator or dominant competitor from an ecosystem often produces profound effects in lower order species. Altered activity patterns, changes in foraging or vigilance behaviour and, especially, rapid increases in numbers are indicative of predator release: liberated from its predator, the prey species flourishes. Among carnivores, there is now considerable evidence for mesopredator (meaning 'middle predator') release; when the dominant carnivore is removed, mesopredators benefit from a reduction in predation, kleptoparasitism or competition for prey. Most long-term studies come from the northern hemisphere, for example, the proliferation of coyotes in the United States following the widespread extirpation of wolves; but the pattern doubtless also holds true for African carnivores. Within the cat family, mesopredator release applies to cheetahs in areas lacking lions and spotted hyaenas, and perhaps also benefits African golden cats (RIGHT) where leopards have been extirpated (see main text).

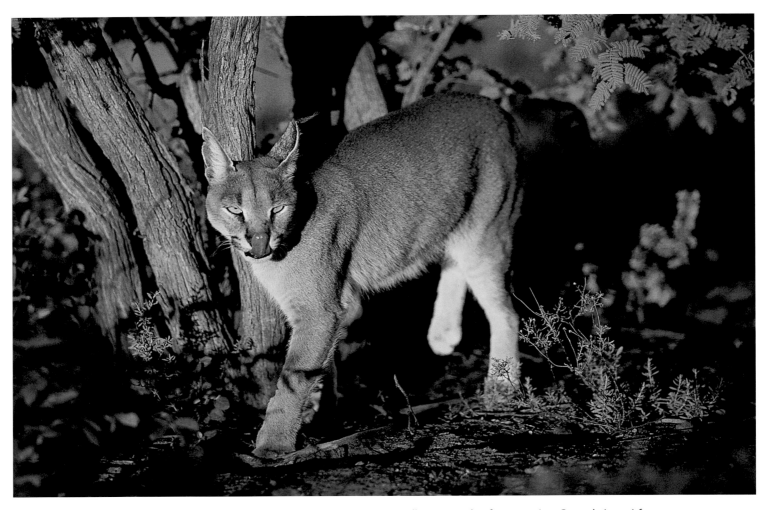

The coexistence of similarly-sized caracals and servals is a compelling example of segregation. Caracals (ABOVE) focus on larger prey in broken, drier habitat and are largely crepuscular and nocturnal; by contrast, servals (BELOW) concentrate on small rodents in well-watered, open habitat and are mostly crepuscular or diurnal.

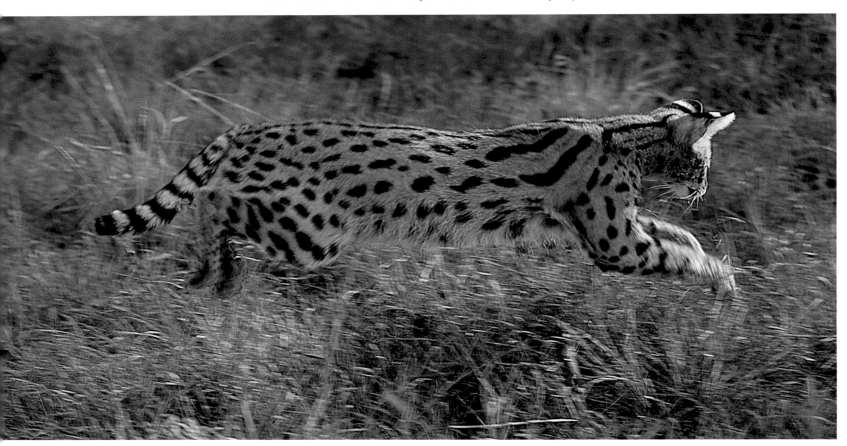

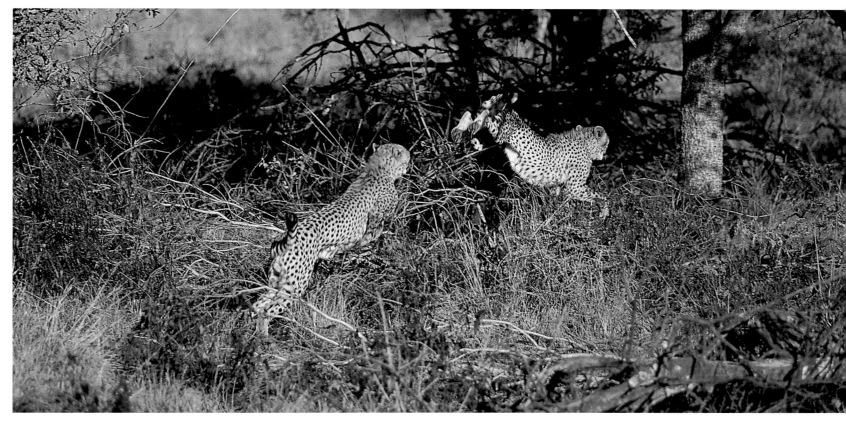

Cheetahs are active mainly during the day, in part to maximise visibility during high-speed chases but also to avoid lions and spotted hyaenas. Females with young cubs are particularly careful about drawing the attention of larger carnivores and often hunt during the hottest part of the day when other predators are inactive.

among Serengeti lions (see Chapter 4) might provide temporary respite for cheetahs – but for the most part, different cats manage to coexist regardless. As we have already seen, the risk of being killed or having a carcass stolen by another cat is actually quite low, chiefly because most cats excel at avoiding conflict with their larger relatives.

They achieve this by the ecological mechanism known as segregation: temporal (in time), spatial (in space) and dietary (in food). In other words, overlapping species reduce conflict by being active at different times, in different places and by eating different prey. Cheetahs hunt during the day, in part because lions are then inactive and unlikely to notice them. Counter-intuitively, cheetahs also avoid prime areas with high densities of prey, because such congregations also attract lions and spotted hyaenas. Leopards occur wherever lions are found and both hunt primarily at night, but leopards select smaller prey and better exploit certain features of the environment than lions – well vegetated areas such as river valleys and thickets, and trees in which they cache kills, neither of which is easily accessible to lions. Similarly-sized servals and caracals are able to coexist because servals specialise in rodents while caracals have a greater reliance on larger mammals; both species

Similarly-sized servals and caracals are able to coexist because servals specialise in rodents while caracals have a greater reliance on larger mammals.

eat both types of prey, but limit direct competition by reducing the overlap. They further reduce competition by selecting different habitats in the same area: radio tracking of caracals concurrently with servals in South Africa's Drakensberg mountains showed only a 20 per cent overlap in the area used by both species, with servals preferring low-lying, well-watered areas and caracals dominating higher rocky, dry ground.

In conclusion, it is important to note that while segregation promotes coexistence, it is the flip side of the same relationship that imposes changes in behaviour, density and distribution that, sometimes, are less than ideal. Cheetahs manage to persist in the Serengeti but are forced to avoid the best areas in order to steer clear of lions, and clearly would be better off without lions. Similarly, golden cats will not disappear from African rainforests because of the presence of leopards but, in the absence of leopards, golden cats might be at an advantage. So even where many species of felids coexist and overt interference competition between them is slight, cats may exert an indirect, subtle but profound influence on one another. These intricate relationships between different felids have existed for millions of years, yet we are only now starting to unravel their complexity.

Relationships with other carnivores

As we would expect, the same complex patterns apply to the interactions of cats with other carnivores. Next to lions, the spotted hyaena is the dominant predator in African ecosystems, and it is a superior competitor, as well as a direct threat, to most cats. Long held to be a cowardly skulker that subsists by scavenging the remains of lion kills, spotted hyaenas are efficient and extremely powerful hunters in their own right. Indeed, by hunting in groups, spotted hyaenas take prey considerably larger than themselves and usually focus on the most abundant large and medium-sized herbivores available: wildebeest, gemsbok and springbok in the southern Kalahari, wildebeest and zebras in the Serengeti, and zebras and impala in Botswana's Chobe National Park. This places them directly at odds with lions which concentrate on precisely the same prey. Competition between the two species is usually manifested in fierce, sometimes fatal, clashes over carcasses, but the relationship is not as one-sided as expected.

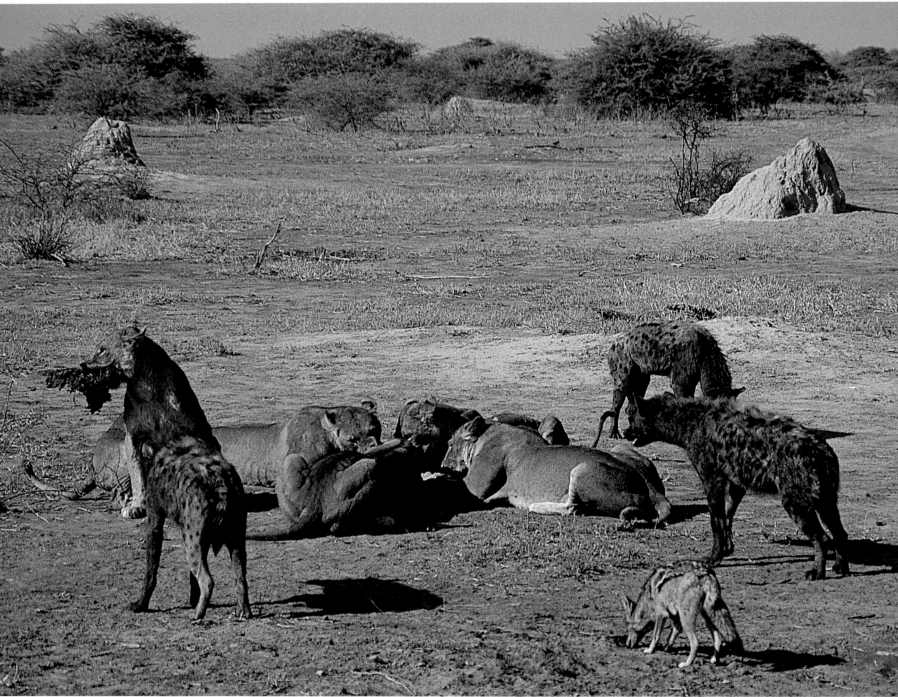

Lionesses finish the remains of a kill as spotted hyaenas and a black-backed jackal wait in attendance, Savute, Botswana; in this case, the hyaenas made the kill – an adult warthog – but the lions usurped it. The hyaena is an adaptable, highly successful predator that reaches high densities in conservation areas but is heavily persecuted on unprotected land.

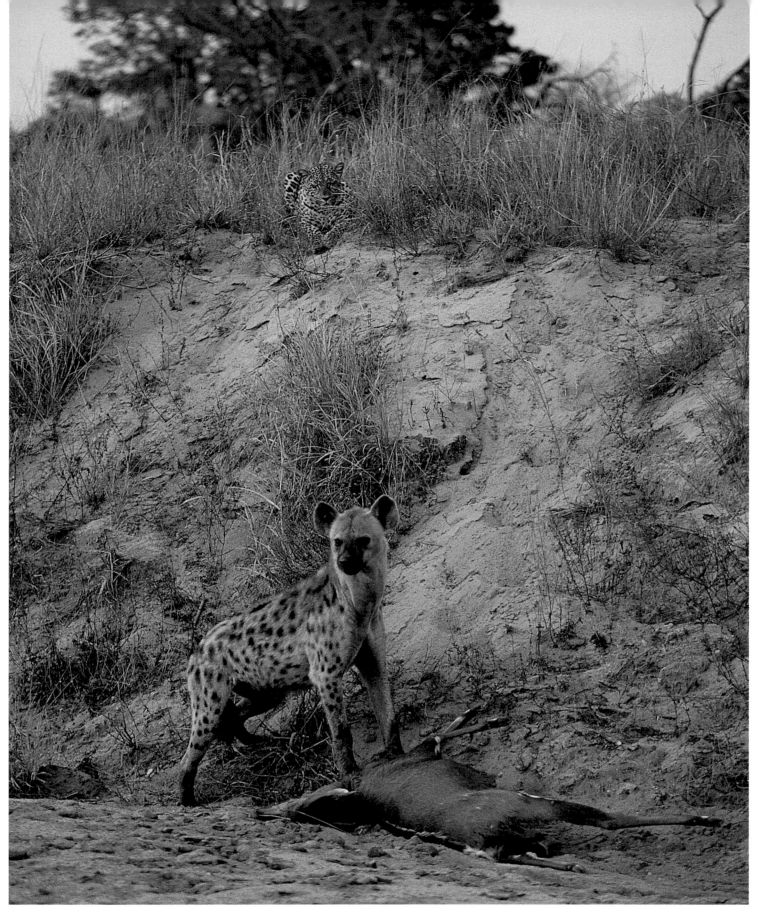

ABOVE: One on one, female leopards are usually subordinate to adult spotted hyaenas. Hyaenas are larger and equipped with a bite force at the carnassials over 40 per cent more powerful, so leopards generally give way, as pictured here – this female leopard relinquished her bushbuck kill rather than fight. Adult male leopards are powerful enough to present more of a competitive challenge and more often stand their ground or, occasionally, kill single hyaenas.

FOLLOWING SPREAD: A female cheetah pauses to wait for her two young cubs, Masai Mara National Reserve, Kenya. As her cubs approach, she gives chase to a potential menace, a black-backed jackal (INSET). Cheetahs, particularly hungry sub-adults, sometimes kill jackals for food but adult cheetahs mostly ignore them except when they are perceived as a threat to their cubs or kills.

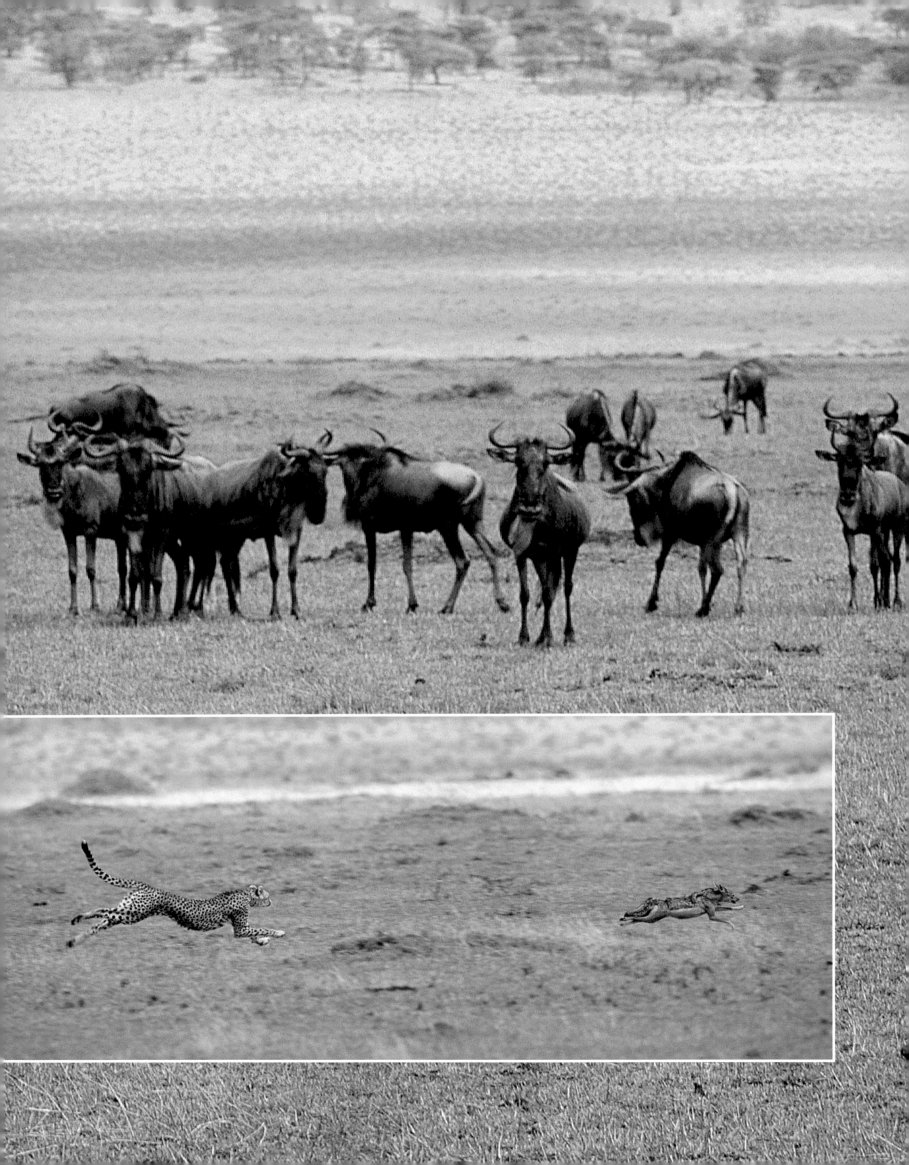

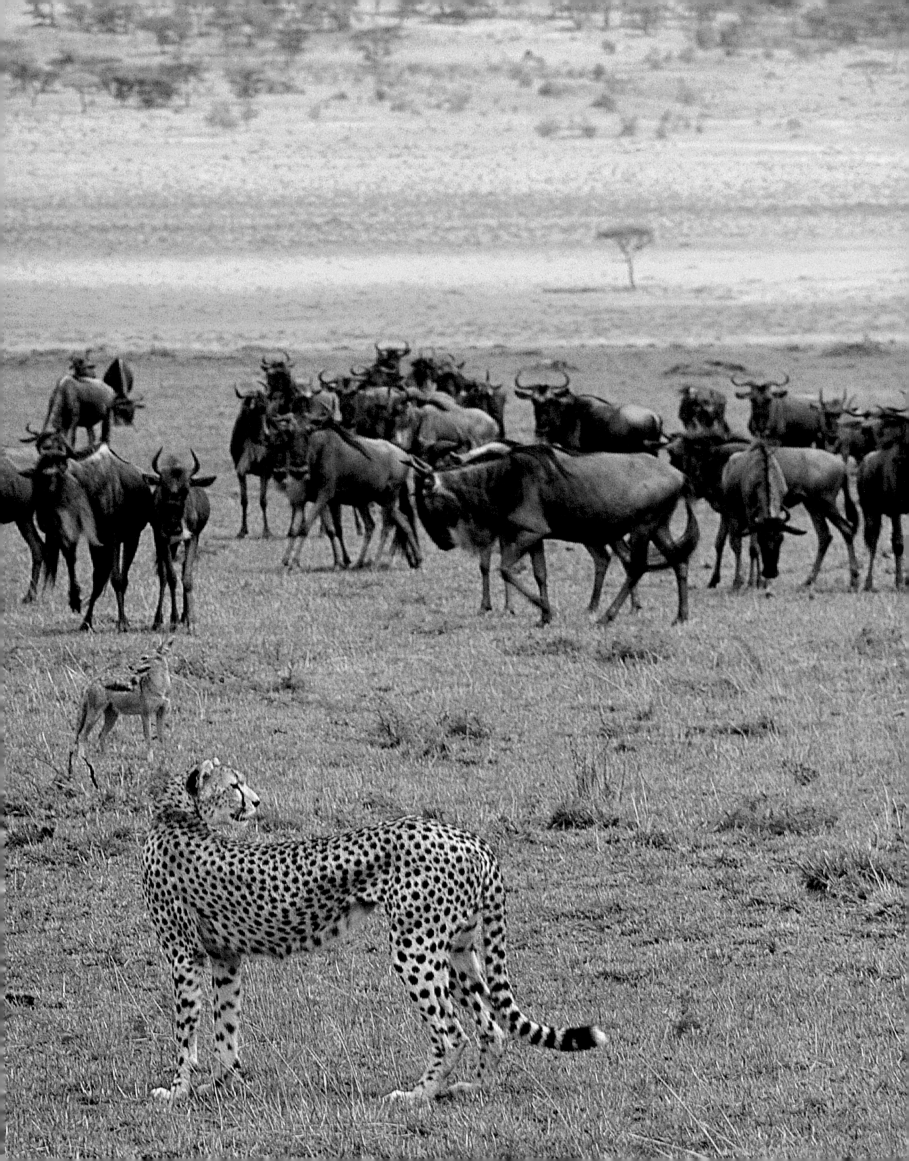

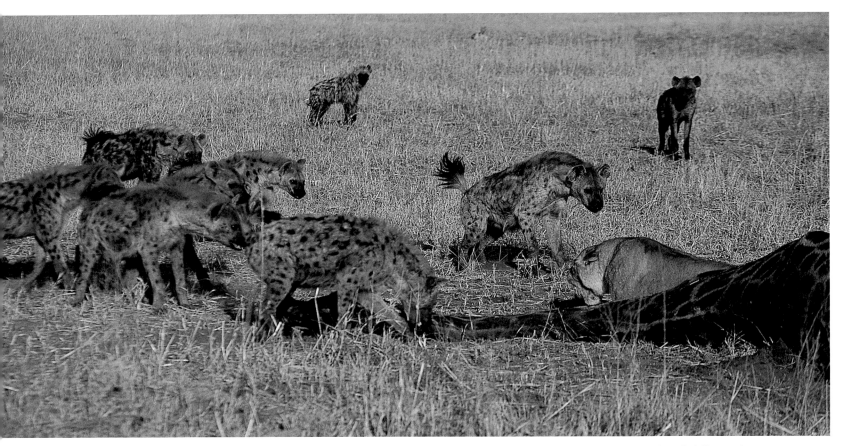

In numbers, the spotted hyaena is a dogged and daring competitor. Even though this lioness could easily kill a single hyaena, she is no match for the concerted harassment of a clan and she eventually yielded to them in this encounter. When male lions are present, hyaenas are far less likely to prevail.

One on one, a lion easily kills even the largest, most aggressive spotted hyaena. However, by living in large groups, hyaenas are able to shift the balance and compete successfully with the much larger cat. The outcome of these clashes is dependent on two factors: the numbers of hyaenas involved and the presence of male lions. Almost regardless of their numbers, spotted hyaenas keep a respectful distance from adult male lions. In the absence of males, hyaenas are much more likely to prevail, but success also depends on the ratio of hyaenas to lions. In the Ngorongoro Crater, it takes an average of seven hyaenas to put one lioness to flight, while in Chobe National Park, the ratio is only four to one. Depending on the numbers a clan can muster, hyaenas may yield to lions one day and triumph the next.

The upshot of this is that lions and hyaenas appear to have little, if any, influence on each other's numbers. Researcher Netty Purchase looked at the densities of both species across 13 protected areas in Africa and found a positive relationship; where there were more lions, there were more hyaenas. Despite their dietary overlap, hyaenas and lions reduce direct competition by targeting different segments of the prey population – juvenile ungulates are more important to hyaenas, whereas lions kill more adults. Further, lions exploit very large quarry mostly beyond the reach of hyaenas (such as adult buffaloes and giraffes), while hyaenas are better equipped than

lions to track migratory prey. Depending on the balance of these factors at a site, lions sometimes outnumber hyaenas while the reverse holds true in another area.

The relationship of the hyaena to other cats is not as well understood, though in general they dominate other felids. As previously discussed, they sometimes kill cheetah cubs, and can drive adults from their kills; their overall effect on cheetahs seems moderate, although they likely exacerbate the problems faced by cheetahs in areas of high lion density. Similarly, they are able to dominate leopards, but single hyaenas are vulnerable to adult males; at least two hyaenas were killed and eaten by a large male leopard during Ted Bailey's study. Further, leopards probably suffer less than cheetahs from hyaena kleptoparasites by hauling their kills up trees (although no-one has actually quantified the degree of loss that leopards sustain anywhere). Hyaenas surely kill the occasional smaller cat or drive them from their kills, but such events are unlikely to occur often enough to make a major impact. Small cats attract less attention, easily flee into trees and make small kills that are quickly consumed; so, for the most part, they are probably not worth more than opportunistic, cursory attention from hyaenas. Aadje Geertsema saw servals stand up to lone hyaenas in Ngorongoro Crater, including one occasion where a young male serval confronted an adult hyaena over the scavenged carcass of a juvenile hippo. Similarly, the wildlife filmmakers Owen

Newman and Amanda Barrett secured a marvellous sequence of a mother caracal standing her ground against three hyaenas threatening her kittens. The hyaenas eventually made off with the caracal's kill (a white stork) but the kittens survived.

In terms of their relationship with cats, African wild dogs occupy a position in the predator hierarchy which is very similar to that of cheetahs. Rosie Woodroffe and colleagues compiled the known causes of death to wild dogs across the five sites in Africa where the species has been most intensively studied, and found that lions comprise the single greatest natural threat to wild dogs, both adults and pups. Predation by lions comprised up to 47 per cent of adult deaths and averaged 10 per cent of mortality across all sites. Pup mortality attributed to lion predation was highest in Kruger National Park (37 per cent), and averaged 20 per cent of all pup mortalities across the five sites. Just as with cheetahs, where there are many lions, there are few wild dogs; and wild dogs go out of their way to avoid lions, even when that means forsaking the best areas. Gus Mills discovered that wild dogs in Kruger avoid areas of high impala densities because the same areas are preferred by lions (and spotted hyaenas, whose effect on wild dogs is similar, but probably more severe than their effect on cheetahs, at least in open habitats). In much the same way that lions are a principal factor in determining the distribution, numbers and behaviour of Serengeti cheetahs, so too do they influence the wild dog. The key difference, perhaps, is that wild dogs are affected throughout their range. Primarily a species of the woodland savannas, the wild dog overlaps extensively with lions and the negative relationship appears to hold true throughout Africa's large conservation areas.

Finally, there is a suite of mesopredators that interact with cats, though their relationships are poorly known. Ethiopian wolves, brown hyaenas, striped hyaenas and three species of jackals (black-backed, side-striped and golden) co-occur with at least one felid species and, except for the wolf (which coexists only with servals), each is killed by or kills cats – but very rarely. Both species of hyaenas and all the jackals benefit from the carcasses left by large cats; so, despite having to keep a respectful distance and, occasionally, getting killed by a large felid, the net result for these species is positive. For cats, the relationship overall is probably neutral. We would expect equally-sized species to compete more intensively and indeed, given a chance, black-backed jackals harass caracals, but at their own risk. Karoo specialist Rob Davies saw two black-backed jackals tree a caracal, which subsequently leapt down and killed one of its tormentors. Some authors have speculated that the intense effort to wipe out black-backed jackals from parts of southern Africa has led to an expanded range and greater numbers of caracals (possibly a case of mesopredator release; see text box 'Predator release', page 141), but the theory remains untested.

Hyaenas weigh about half as much as a lioness and are not nearly as well armed to defend themselves. If caught, this hyaena will probably incur a savage mauling but lone lionesses are unlikely to press home a lethal attack if other hyaenas are present.

6

CATS AND HUMANS

threats, status
and conservation

The human threat

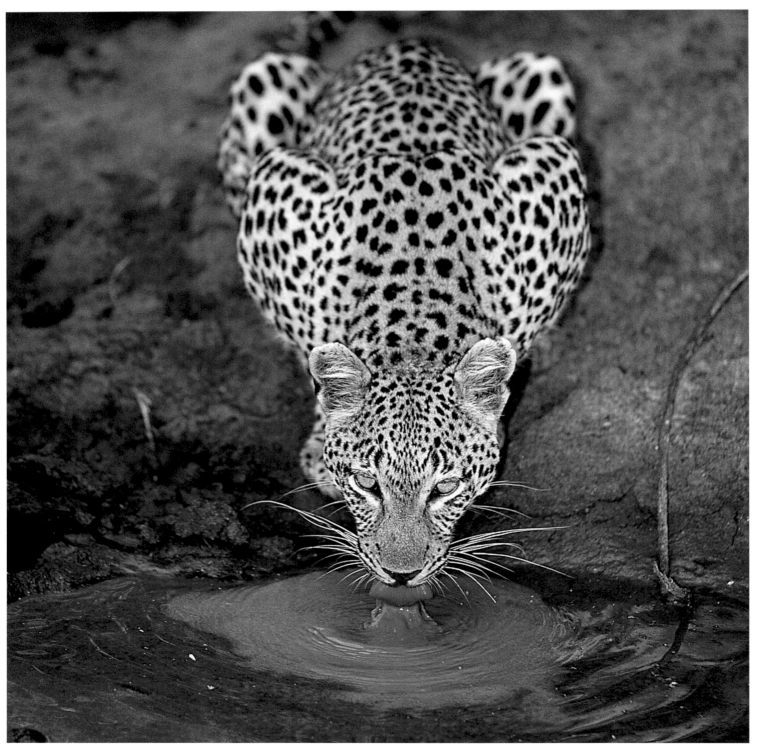

Humans have lived alongside cats in Africa longer than anywhere else on the planet. Modern *Homo sapiens* arose only some 200 000 years ago, but upright, bipedal humans of the genus *Homo* have occupied Africa for at least 2.3–2.5 million years. Just as in *Homo sapiens*, early members of the genus were intelligent and large bodied, and almost certainly lived in complex, extended family groups. At some point early in human evolution, our ancestors also developed the tools and co-ordination to hunt large mammals co-operatively, but even before then, humans and large cats must have encountered one another constantly. For millions of years in Africa, we have occupied the same habitats, stolen one another's kills, competed for the same species as food and even killed one another (see text box 'Man-eating cats', opposite page).

The enduring leopard is the most widespread of big cats with a range that extends from the southern tip of Africa to the Russian Far East and includes most of tropical Asia. Even so, leopards have lost millions of square kilometres of their former range as a result of human activities.

Man-eating cats

Only two African cats, the lion and leopard, kill people (otherwise, it's recorded only for tigers, pumas and, rarely, jaguars). There is no record of wild cheetahs ever killing a human, probably because of their narrow prey preference for antelopes and their defencelessness against larger competitors; humans are both too strange and too dangerous to be considered fair game. In general, this also applies for lions and leopards; all big cats recognise humans as a formidable threat and, given the degree of opportunity, attacks on people are surprisingly uncommon. However, under certain circumstances, lions and leopards do treat people as prey. Often such incidents are provoked or are committed by an injured or otherwise debilitated 'rogue', but man-eating may be adopted by perfectly healthy cats when their natural prey has been eradicated. This was probably the key factor behind the killing spree of the famous man-eaters of Tsavo, two male lions that killed around 28 railway workers (not 135, as usually reported) in southern Kenya in 1898. Rinderpest had wiped out most of their natural prey and, faced with little alternative and ample opportunity, local lions turned to humans for food.

Even today, the same scenario occasionally gives rise to chronic man-eating in which the losses can be quite staggering. In Tanzania, lions kill up to 100 people every year, most in south-eastern Tanzania where intensive subsistence agriculture has depleted wild ungulates. The problem is thought to be equally severe across the border in northern Mozambique. In most of Africa, people living with lions regard them primarily as a threat to livestock (see main text) but pockets of persistent man-eating are probably more common than widely assumed.

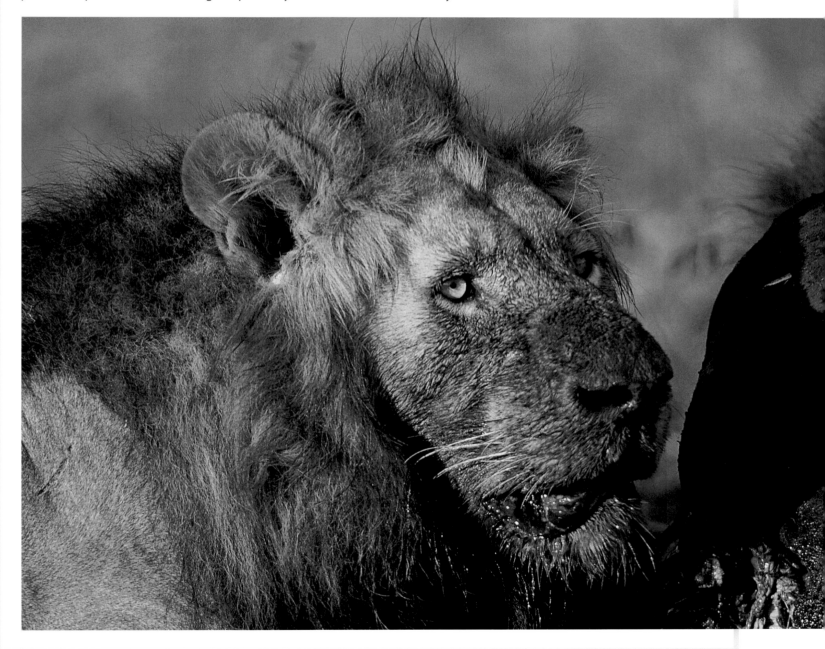

White lions and king cheetahs: conservation or exploitation?

Unusual colour variations arise occasionally in all cat species (melanistic individuals occur relatively often in leopards, golden cats, servals and jungle cats, to list African examples only), but few are as celebrated as white lions and king cheetahs. Both arise from a recessive mutation to a gene that contributes to the colour or pattern of the coat, and both can occur in a litter of normally coloured siblings. Aside from colour, white lions and king cheetahs are no different from other members of their species, yet this has not prevented misguided and unscrupulous efforts to breed them in captivity. Promoted as 'precious rarities', they are valued by some zoos and trophy hunters willing to pay exorbitant prices to exhibit or shoot them. The demand has fuelled deliberate inbreeding to produce more cubs in which the only motive is profit. Despite the claims of most 'breeding programmes', propagating unusual morphs does nothing to conserve their species in the wild. Proposals to reintroduce them are worthless, given that returning captive-bred big cats to the wild usually fails, and that re-stocking can be accomplished safely by translocating wild-caught individuals from elsewhere (see text box 'Reintroducing cats', page 167). The reality is, from a standpoint of conserving the species, breeding white lions and king cheetahs is valueless.

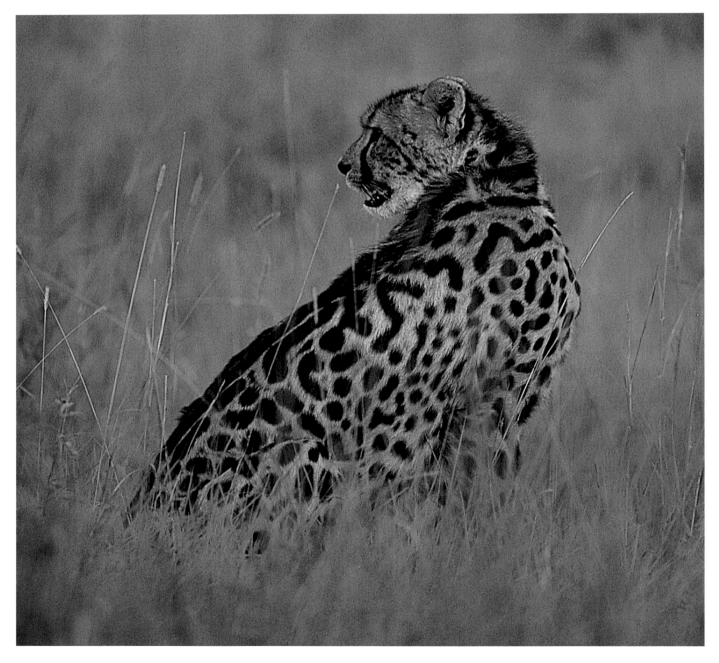

Despite this, our effect on cats (and African wildlife in general) has been inconsequential for the great majority of human evolutionary history. No human species prior to *Homo sapiens* has been sophisticated or numerous enough to cause widespread extinctions and, until recently, even our own species has been constrained by ecological conditions such that we simply could not become too abundant or too influential. The total number of humans on the planet 10 000 years ago (8000 BCE) is thought to have been somewhere between five and 10 million, most of them widely dispersed in small groups of nomadic hunter-gatherers. One thousand years later (around 7000 BCE), intensive agriculture and the domestication of livestock had given rise to the first densely settled areas in the Middle East, yet the world population still could not have exceeded 20 million people, and the largest towns housed only 1 000–2 000 inhabitants.

By 2 000 years ago (0 BCE/AD), the population of the world was about 300 million, the same number of people in the United States in 2005. Large civilisations with sophisticated technology were scattered across the globe and they must have wrought significant effects on their environment. Contrary to a popular Utopian myth, Africa's indigenous peoples developed advanced, sedentary societies that exploited wildlife long before European colonisation took place. It seems that few African cultures hunted big cats as food, but where people intensively hunted their prey species, cat numbers likely suffered. Exacerbating these local declines, recreational hunting of lions and leopards by societies such as the ancient Egyptians resulted in the first signs of range loss among large cats. Lions had already disappeared from parts of the Nile Valley when the Roman Empire began collecting North African cats in the thousands for their gladiatorial games.

Raising the stakes substantially, domestic cattle have been an element of the African landscape for millennia. Intriguingly, recent genetic analyses show that African cattle arose locally from a now extinct species of African wild ox rather than, as long believed, via later introductions from the Middle East and western Asia. The domestication of cattle in Africa is traced to the border region of modern-day Sudan and Egypt some 7 000–9 000 years ago; from there, cattle spread gradually southward into sub-Saharan Africa, changing the landscape forever. Livestock competed with the natural prey (various herbivore species) of cats for the same food, and cats that killed livestock were dispatched. Even today, pastoralists using traditional weapons make short work of stock-raiding lions and leopards.

Even so, the impact wrought by people must have been extremely localised until very recently. At the time of Christ, a

For millions of years in Africa, cats and humans have occupied the same habitats, stolen one another's kills, competed for the same species as food and even killed one another.

resident of even the largest, most complex civilisation in Africa would need travel only a kilometre or two from the city limits to encounter wildlife populations largely unaffected by people. Dense congregations of cattle probably displaced wildlife, but people had still not become so numerous or technologically advanced that their effects were anything other than local. Even by 1750, only an estimated 103 million people lived in Africa – 27 million fewer than the population of modern-day Nigeria. With the exception of localised pockets (albeit, some quite extensive) where humans and their livestock reached high densities, all African cats probably still occurred across the great majority of their respective historical ranges until the time of European colonisation.

Europeans brought with them both an attitude to wildlife and the technology to exploit it that would produce the first widespread, devastating effects on Africa's fauna. In the three-tiered hierarchy of imported European monotheistic religions – God, Man, Nature – wildlife existed entirely to benefit people. Combined with European farming practices, the advent of firearms and the notion of hunting for sport, it did not significantly transform the key threats to cats but it did spawn the uncontrolled proliferation of those hazards. Europeans propagated three main threats to carnivores – habitat loss, hunting of prey and direct persecution – that have been associated with human presence for millennia, but never before with the same intensity and efficacy. Natural habitat was cleared for large-scale intensive agriculture, livestock husbandry and forestry, while prey populations were hunted for meat, sport and ultimately to make way for more domestic herds. In parallel, the persecution of carnivores reached new heights, chiefly in the perceived defence of livestock as well as for sport. For cats, especially the larger species, it began a pattern of local extinctions and range retraction that persists today (see 'The status of cats', page 160). The same relentless trinity of threats caused by man remains the principal reason.

Modern threats: habitat destruction, loss of prey and persecution

Cats cannot survive without suitable habitat. Predictably, the combined loss of habitat and prey has wrought particularly severe effects on large cats with their greater ecological demands. John Seidensticker calls this the 'Large Carnivore Problem'. Large predators require expansive tracts of suitable habitat with ample prey populations, a recipe for wilderness that is increasingly scarce in Africa. But the same forces affect smaller cats and indeed, for those species with narrow habitat

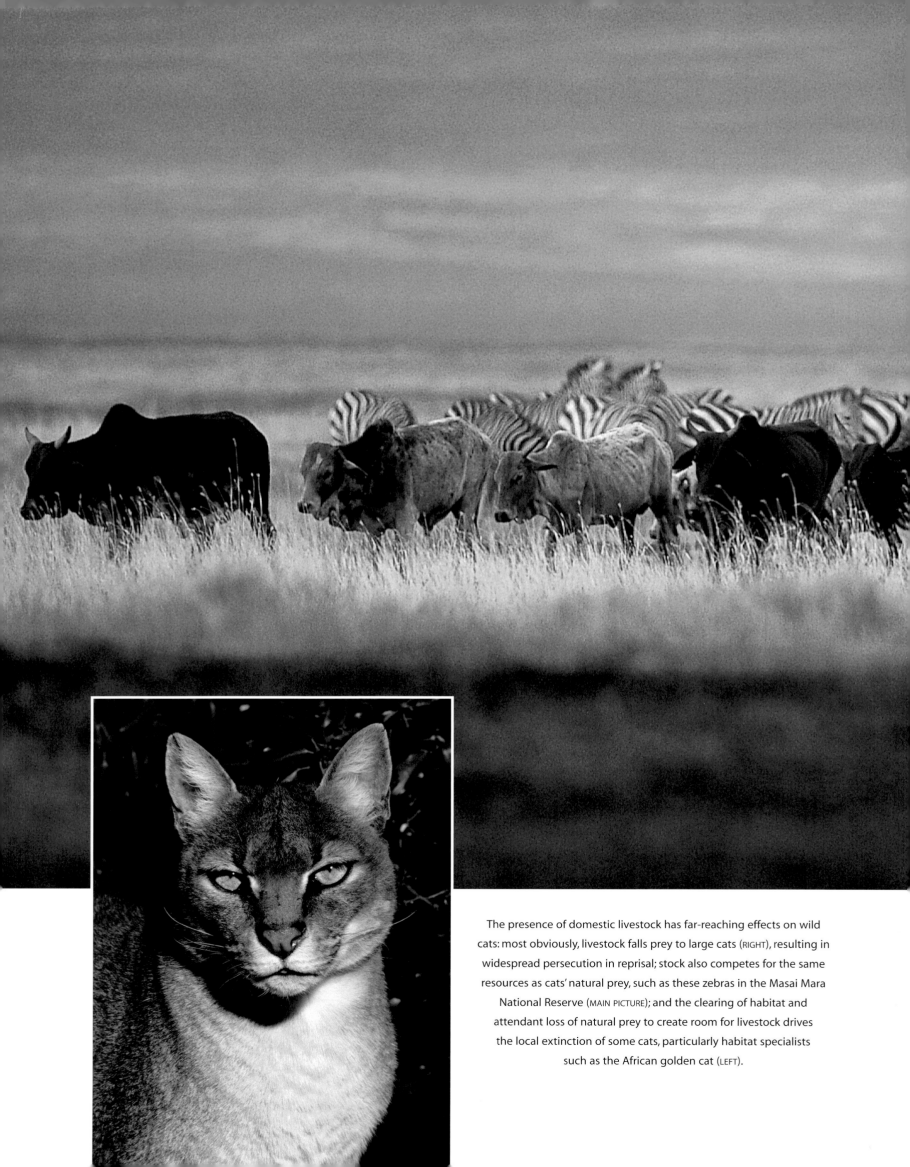

The presence of domestic livestock has far-reaching effects on wild cats: most obviously, livestock falls prey to large cats (RIGHT), resulting in widespread persecution in reprisal; stock also competes for the same resources as cats' natural prey, such as these zebras in the Masai Mara National Reserve (MAIN PICTURE); and the clearing of habitat and attendant loss of natural prey to create room for livestock drives the local extinction of some cats, particularly habitat specialists such as the African golden cat (LEFT).

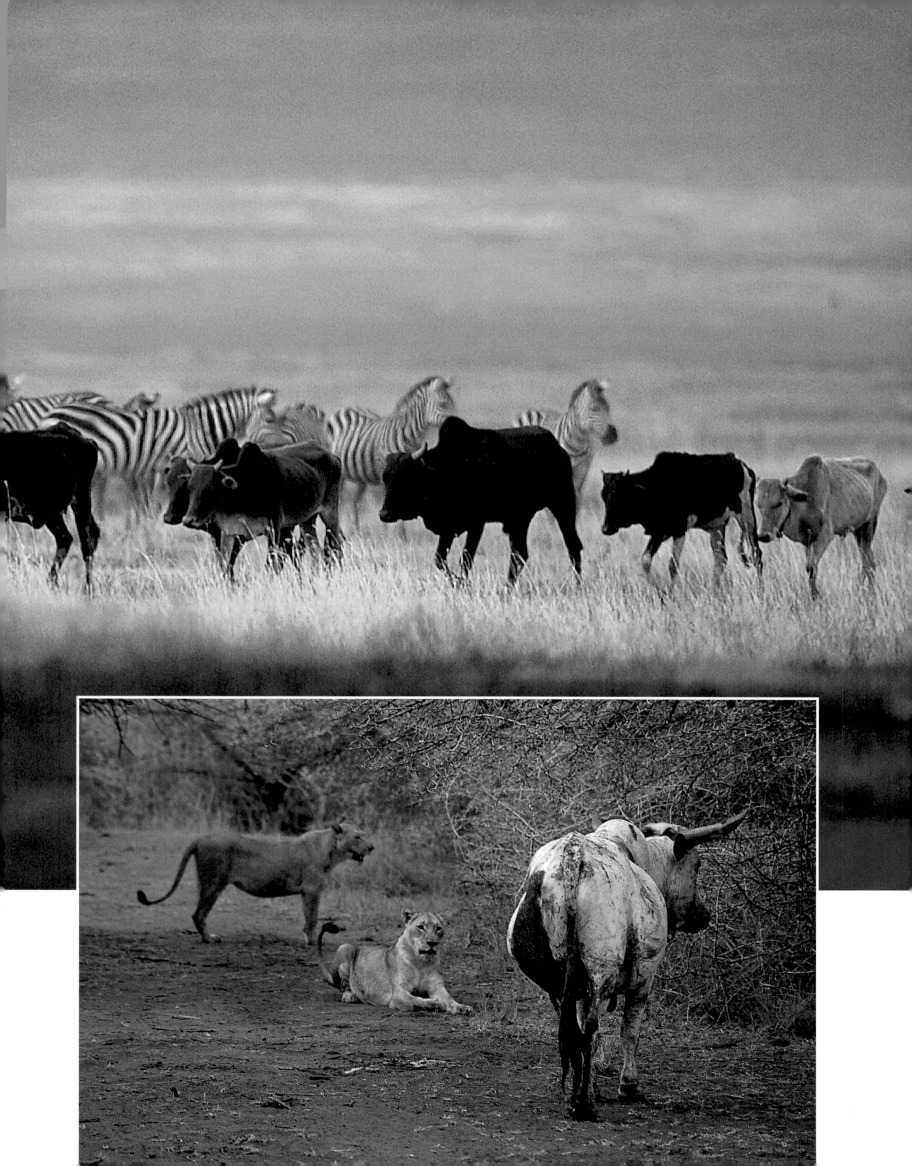

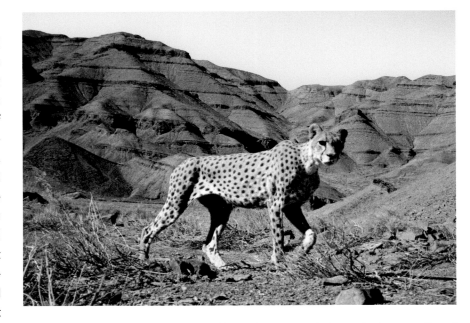

African cats in Asia

Apart from the African golden cat, serval and black-footed cat, all African felids are found also in Eurasia and the Middle East (see Species Profiles for distribution maps, pages 18–31); indeed, some of them probably arose in Asia and subsequently colonised Africa. Leopards, caracals, jungle cats and wildcats (called Asian wildcats, but the same species) are widespread and reasonably common in many areas, although, as in Africa, all have experienced extensive range loss at the edges of their respective Asian distributions. The sand cat is restricted to arid parts of Central Asia and the Middle East where the remoteness of its preferred habitat means that it is probably least affected. Lions and cheetahs have suffered massive range collapse in Asia; up until the 20th Century, both occurred in the Middle East, across Central Asia and into eastern India. Today, the Asian distributions of both species are restricted to a single, though different, country. All Asiatic lions now occur in western India's Gujurat State in the 1 412-square-kilometre Gir Wildlife Sanctuary and National Park, and surrounding areas; their numbers are estimated at around 300. The situation of the Asiatic cheetah (ABOVE) is more dire. Only an estimated 50–60 individuals survive, all in the arid central plateau of Iran. Loss of prey from over-hunting is the principal threat to Iran's cheetahs, though they also suffer significantly from persecution by herders and hunters, as well as from a surprisingly high incidence of being killed on roads.

preferences, the consequences may be grave. Habitat destruction is probably the single greatest threat for African golden cats, servals and jungle cats. Deforestation in West and Central Africa has destroyed large areas of golden cat habitat, resulting in extensive swathes of rainforest converted to savanna; the forest hugging the West African coast is particularly degraded, with pockets of undisturbed stands isolated like islands in a sea of recently converted savanna. Similarly, the wetlands, marshes and riparian habitat required by servals are under extreme pressure in much of Africa, drained or dammed for agriculture, cultivation and development. In Egypt, the same modification of wetlands is thought to be responsible for local extinction of the jungle cat from the more densely inhabited areas of the Nile.

Clearly, preserving suitable natural habitat is key to protecting cats and, surprisingly, it need not necessarily be pristine. Many cat species are quite tolerant of some habitat change – provided their prey base is unaffected. In Gabon, Philipp Henschel discovered that the species most valued by the bush-meat trade – small and medium-sized forest duikers – are precisely the same species preferred by rainforest leopards. In some intact stands of apparently pristine forest where the pressure of bush-meat hunting is intense, leopards have vanished. Almost certainly, competition from people for the same prey – as opposed to direct persecution of leopards

themselves – is the smoking gun. Henschel's observations are not unique. Uganda's Bwindi Impenetrable National Park still shelters mountain gorillas, chimpanzees and elephants but lost its leopards in the 1960s, and they have similarly vanished from the otherwise intact rainforests of southern Cameroon in the last two decades.

In marginal habitat, the eradication of prey has particular significance. Across North Africa and the arid Sahelian savannas bordering the southern Sahara, recreational hunting of desert ungulates is popular, not only among local cultures but also with large, well-equipped hunting parties from the Middle East whose objective is numbers; the more antelopes bagged, the better the outing. Under intense hunting pressure, antelope populations have declined precipitously, driving the already few desert cheetahs towards extinction. The relict Egyptian cheetah population has been extirpated from more favourable areas of the coastal desert and larger oases due to the extermination of gazelles, and now persists only in the remote Qattara Depression of the Egyptian Western Desert, if at all. Assuming extinction has not already occurred, cheetahs are almost certainly doomed in Egypt unless urgent measures are taken to control the hunting of their prey species. Loss of prey is also the principal threat to the last Asiatic cheetahs in Iran (see text box 'African cats in Asia', above).

The third major threat to cats, the direct persecution of cats by people predominantly in conflict over domestic animals, is now so pervasive that biologists use shorthand to discuss it – HWC, standing for 'Human-Wildlife Conflict' (which encompasses conflicts between people and all wildlife, not carnivores exclusively, though they comprise the majority). HWC affects all African cats – even the sand cat is occasionally killed in gin traps set around poultry pens in remote regions of the Sahara – but predictably the effects are most severe on the three large species. Lions, leopards and cheetahs do kill livestock which, naturally, people take measures to curtail.

The lion is particularly affected; large, dangerous and group-living, lions are a genuine and expensive threat to people and their cattle. Working in communal areas adjacent to Waza National Park, Cameroon, Hans Bauer found that annual losses of cattle to lions comprised only about 3.1 per cent of all domestic animal losses to all factors, but represented almost a quarter of financial losses; cattle are valuable and the loss of one causes greater suffering than the loss of many sheep. Leopards and cheetahs generally cause less damage to herders because adult cattle are beyond their reach, but they take calves and small stock. After lions, leopards are the second most costly predator to Ju/Hoan San communities in arid north-eastern Namibia; during one study, they accounted for 100 per cent of dogs killed, 97 per cent of chicken losses and 42 per cent of cattle losses. Also in Namibia, Laurie Marker found that cheetahs were responsible for only three per cent of the livestock losses to predators.

Of course, whether losses are suffered by a subsistence pastoralist family or large-scale commercial ranchers, the percentages are academic. In many areas, predators are not responsible for a majority of losses – livestock die from many factors including disease, poor husbandry, complications during birth, injury and so on – but the 'predator problem' is often the one aggrieved herders or ranchers feel is most easily addressed. It does not take much to kill a cat. Today most herders carry firearms, and predators are opportunistically shot or hunted down with the help of dogs; in Namibia, ranchers are known to shoot cheetahs from the air in microlight aircraft using automatic rifles. Even where firearms are illegal or too expensive, baited cages and gin traps are an effective and economical alternative. Most insidious and destructive of all methods, lacing carcasses with poison has gained rapid and recent currency across much of Africa. The widespread availability of inexpensive, legal poisons such as those used to dip livestock for parasites is an irresistible solution to even the poorest pastoralists. The consequences for cats are acute.

Trade in cats

Distinct from trophy hunting (see 'Protecting the unprotected', page 166) or persecution by livestock herders, the intentional hunting of cats for their fur represented a major threat until very recently. At its climax in the late 1960s, the fashion for spotted cat furs in Europe, Japan and the US saw over 50 000 leopards killed each year in Africa; cheetahs and servals were also harvested in large numbers. Fortunately, public tolerance for cat furs waned during the 1970s and today there is effectively no international commerce in African cat skins for fashion (though in February 2004, the *New York Times* displayed spectacular ignorance in celebrating a revival of cat fur coats in Manhattan).

Even so, hunting cats for skins and other parts remains widespread in Africa. Leopards, African golden cats and caracals are increasingly common as 'luxury' bush meat and fetish items in the markets of West and Central Africa. Throughout northern Africa and the West African Sahel belt, cheetah, leopard and serval parts (especially skins and claws) are sought after, mainly for domestic ceremonial and medicinal purposes, but also by foreigners. In Djibouti, leopard skins are bought mainly by French military personnel who smuggle them to Europe – a single day spent by investigators in tourist shops in 1999 counted 44 skins on display. When local hunting pressure escalates to meet a wider market demand, overharvesting of cats can result in local extinction.

The status of cats: range loss, numbers and trends

It is impossible to estimate accurately the original abundance of any cat species, but by extrapolating where natural habitat occurred a few centuries ago, we have a reasonable idea of the historic distribution of cats in Africa. Combined with historical accounts of occurrence, we know most about the distribution of Africa's three big cats.

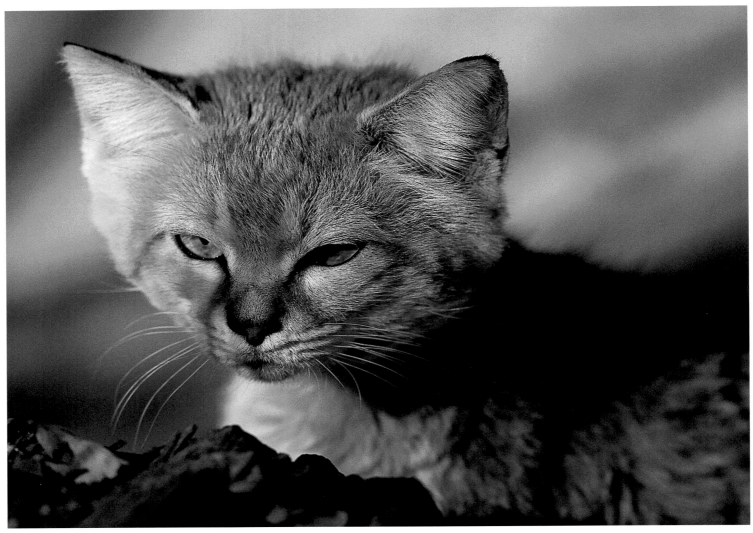

The sand cat's preference for extremely arid, remote regions of the Sahara means that it is probably the African felid least likely to be affected by human activities in the future.

With the exception of a few natural gaps, lions, leopards and cheetahs originally occurred across the entire continent. Lions never penetrated the interior of rainforest nor that of the Sahara, though they naturally occurred at the periphery of both habitat types. Lions survived in the Sahara around Niger's Aïr Mountains until the 1930s, and occupied the ecotone between forest and savanna in Gabon until only a decade ago. Cheetahs are naturally absent from the equatorial rainforests of Central Africa and West Africa's forested coastal belt, while the most versatile of the three species, the leopard, is excluded from only the most arid areas of the Sahara. We know less about the smaller felids but the same habitat reconstructions give us a reasonable idea of their likely original occurrence. The historical range of the caracal and African wildcat essentially mirrored that of leopards, except both are naturally excluded from rainforest (perhaps because the African golden cat has always filled the mesopredator niche there; see 'Escaping competition', page 140). Serval distribution has always been more restricted; they naturally avoid arid areas and forest. Similarly, African golden cats occur only in forested habitat, jungle cats in Africa probably never ranged beyond the Nile Valley and surrounding oases, and the remaining two species, sand cats and black-footed cats, have always been restricted to arid areas.

What is the situation today? Attempts to estimate the change in populations of cats are plagued by very limited data on their numbers today, let alone prior to declines. However,

160 CATS OF AFRICA

we can be confident that lions and leopards historically existed in contiguous populations which, continent-wide, probably numbered in the millions. Occurring naturally at lower densities, cheetahs were never as numerous as leopards or lions, but they probably numbered in the mid- to high hundreds of thousands. Attempting to estimate the original numbers of the smaller felids is essentially meaningless. For the three big cats, a scattering of accurate density estimates from across their range provides a meaningful starting point; we cannot claim the same for the smaller species.

However, we are able to examine the trends in distribution by comparing probable historic range to current occurrence. Justina Ray and I recently mapped the loss of range for the six larger African felids (we excluded the three smallest species because their current range limits are poorly known, and because the larger carnivores have generally suffered most at

At best, all six of the larger African felids are now extinct in close to a quarter of their original range.

the hands of people; and we omitted the mid-sized jungle cat because it exists primarily outside Africa). The results are far from perfect – there are major gaps in the distribution data even for well-known species like lions and cheetahs – but they paint a bleak picture for cats. *At best*, all are now extinct in close to a quarter of their original range. Of the six species, servals are least impacted with about 24 per cent range loss, while leopards and caracals have disappeared from about 37 per cent of their range. African golden cats have lost 44 per cent of their habitat, chiefly to deforestation. The worst affected felids are the cheetah and lion, with an estimated 76.5 and 83 per cent loss in range respectively.

Cats have been most impacted in north-east Africa, north of the Sahara, West Africa and South Africa. Today, lions occur only south of the Sahara, where recent estimates of their numbers range from 16 500–47 100. Only six contiguous

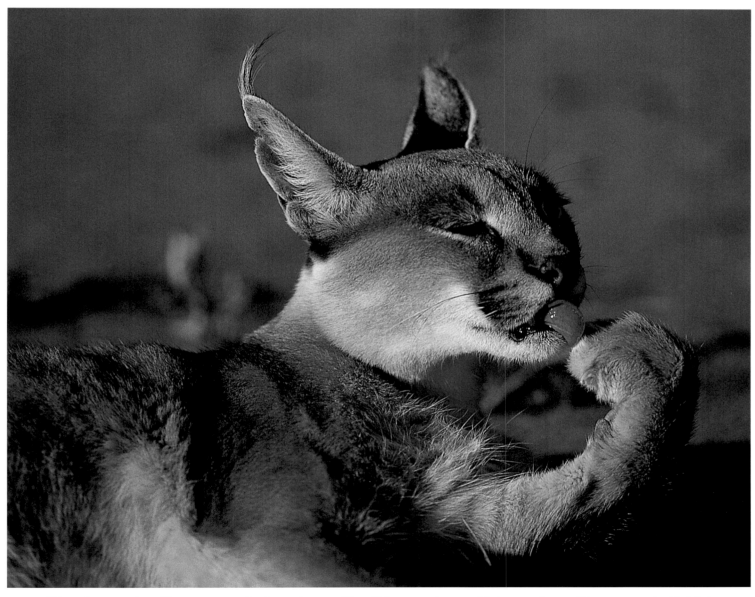

Although extremely resilient to persecution in southern and East Africa, caracals are not faring nearly as well in more marginal habitat. They have disappeared from over a third of their historic range, and the remaining populations in northern and West Africa are in peril.

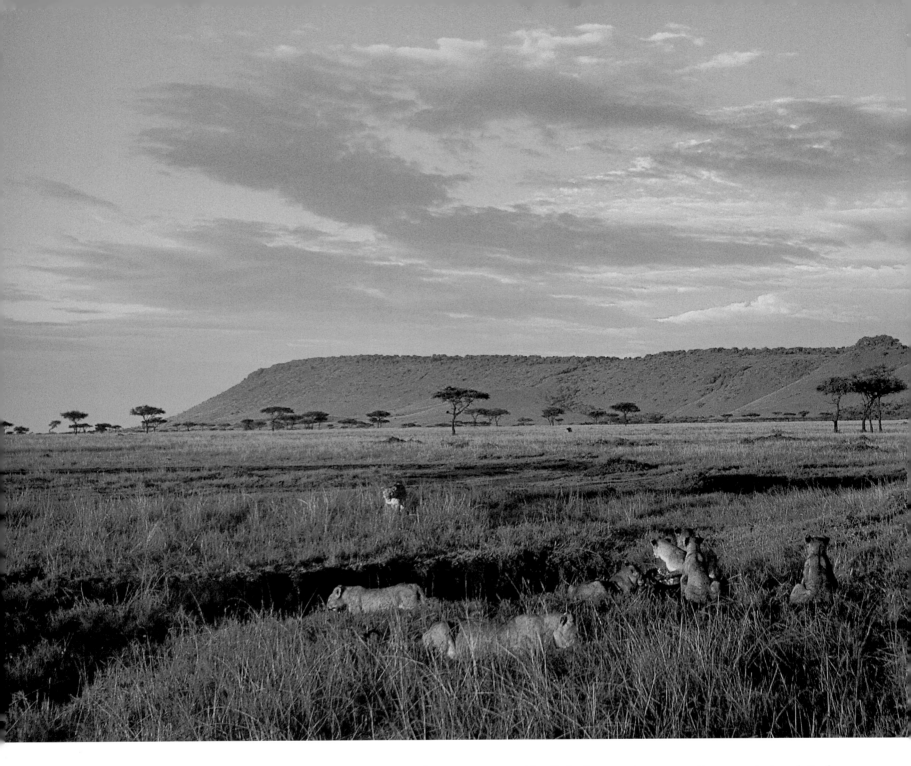

populations, three mainly in Tanzania, are thought to number at least 1 000 individuals: Selous Game Reserve and surrounds, Ruaha-Rungwa ecosystem (Tanzania), the Serengeti-Mara ecosystem (Tanzania-Kenya), the Kafue-Zambezi-Luangwa complex (Zambia), the Okavango region (Botswana) and the Greater Kruger ecosystem (South Africa and Mozambique). In all likelihood, there are fewer than 1 000 lions in all of West and Central Africa. Cheetahs occur over a greater range, but they are also now extinct or relict in North Africa and much of West Africa, and their total numbers are fewer: current estimates total 12 000–15 000 (though, as for lions, the data for most regions are very poor). Of Africa's three big cats, leopards are the most resilient, yet they are reduced to a single relict population in North Africa and have been lost from large parts of West Africa. No Africa-wide estimate of leopard numbers is reliable, but conservatively they number at least 100 000. Even

so, as with all the large cats, an overall aggregate is relatively meaningless. Many populations of cats are too isolated, too small or too beleaguered to be viable.

Suffering from intense pressure for its forested habitat, the golden cat is thought to be naturally rare and is probably the most threatened of the smaller felids in Africa. Similarly, the jungle cat's extremely restricted African range, all of it under pressure from humans, places it in peril though it is widespread in Asia. The African wildcat is widespread, common and not considered threatened in any formal assessment of its status, but hybridisation with domestic cats threatens its survival as a genetically pure form. Occupying the middle ground in terms of status, servals and caracals are still relatively widespread and considered common throughout much of their range; both species are extinct or reduced to low densities in North and West Africa. The status of black-footed cats is poorly known; popula-

Wherever Africa's human population
grows – and no African country
currently has a negative growth
rate – most cats will decline.

1975–2005, compared to just over 1.0 per cent for North America and 0.25 per cent for Europe. Of the 10 countries with the world's fastest growing populations, five are African; of the 12 countries with populations expected at least to triple between 2005 and 2050, 10 are in Africa. Wherever Africa's human population grows – and no African country currently has a negative growth rate – most cats will decline. The Population Division of the United Nations predicts that Africa will have 1.9 billion people by 2050. That figure represents the 'medium' projection; it could be as low as 1.6 billion or as high as 2.2 billion. Regardless, in most of Africa, there will be millions more people requiring more space and resources. The question is, will there be anywhere left for cats?

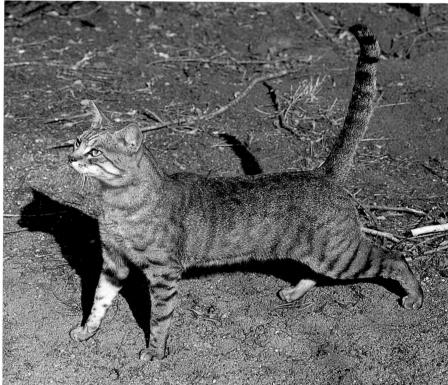

ABOVE: The African wildcat is widespread, common and relatively safe from 'traditional' threats to cats. Ironically, though, hybridisation with domestic cats threatens its survival as a species.

OPPOSITE: Large, viable populations of lions are mostly restricted to the most extensive reserves and surrounding areas. Effective conservation of lions now relies in large part on securing their safety in unprotected areas.

tions are probably relatively secure, though they are unlikely to reach high densities given the constraints imposed by arid habitat, and their limited natural range is vulnerable to human activities, particularly the expansion of agriculture. The sand cat is possibly the only African felid whose population may not decline in the next 50 years. They inhabit remote areas far from serious human influence and, unlike most cats, their habitat is not being degraded. Indeed if desertification in North Africa continues its inexorable spread, they may be the only African cat whose range will increase as a result of human activities.

Except, perhaps, for the sand cat, continued loss of habitat and the concomitant decline of Africa's cats is almost assured. By the middle of 2005, Africa had 14 per cent of the world's human population, around 906 million people. But more to the point, Africa's population is growing faster than any other region's, on average around 2.6 per cent each year between

Conservation: the future of Africa's cats

The 'Large Carnivore Problem' has a simple answer: give them space. Any meaningful effort to conserve felids must begin with setting aside large expanses of wilderness in which cat populations are insulated from the activities of people. Fortunately, Africa boasts a superb network of parks and reserves, with some of the oldest, largest and most biologically diverse protected areas on the planet. Provided that African governments continue to safeguard vast, essentially undisturbed ecosystems, African cats will persist in the wild. But can parks survive? Agriculture, livestock and high densities of people now demarcate a 'hard edge' to many African protected areas, and the human pressure to access the natural resources they protect is intense. That pressure will grow as Africa's population continues to bloom. It may seem inconceivable that the Masai Mara, Serengeti or Kruger National Park could be engulfed by cattle or crops, but to impoverished people living on their boundaries, parks are increasingly viewed as a means of survival.

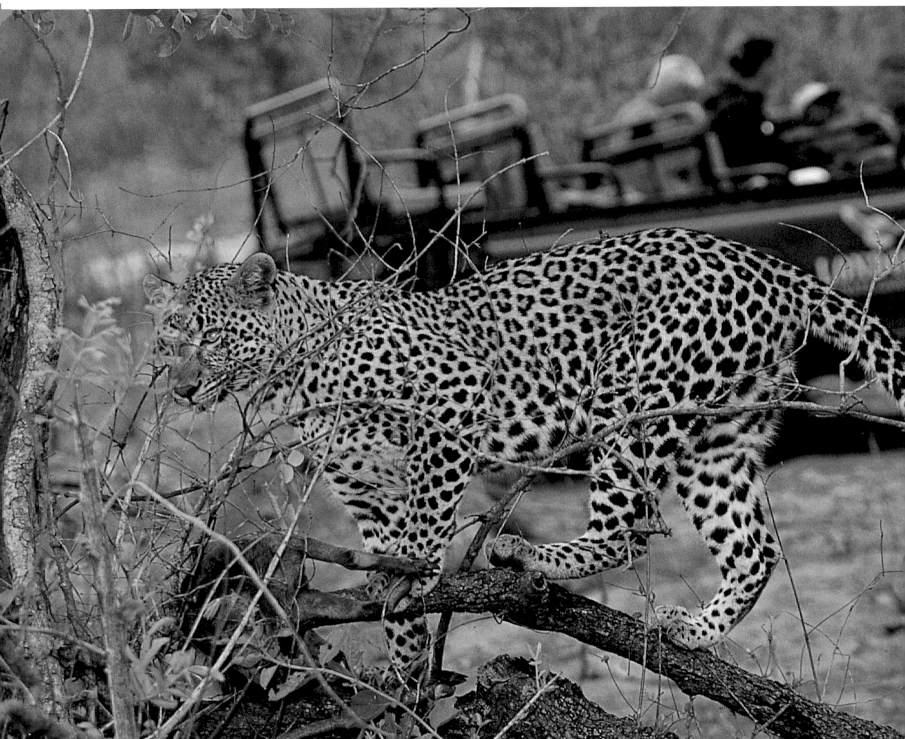

Many conservationists believe that local communities can benefit from protected areas without having to consume them. Their argument is reasonable; if wildlife generates revenue for local people, they will preserve it. Indeed, virtually every national park, reserve and sanctuary on the continent is populated by people who derive their living from the parks as scientists, guides, drivers, lodge staff, game guards and so on. Many more people support themselves on the periphery of parks or in adjacent towns by selling goods and services to the tourist traffic passing through. The complex economies associated with parks are the reason that many of them persist in Africa today. Reducing wildlife to a dollar-value offends many purists, but it may be an extravagance to think that it will be saved otherwise. I believe passionately that we should protect big cats because of their intrinsic value. But I am not a poor subsistence farmer living adjacent to a resource-rich wilderness whose sole contribution to my life is regular raids from cattle-killing predators or crop-raiding herbivores.

Of all places, Africa holds the greatest promise for extraordinary encounters with wild cats, but only where decades of protection have enabled them to overcome their natural inclination to avoid people and their activity. The perpetuation of large protected areas and the tourism they support is a crucial factor in the conservation of African cats.

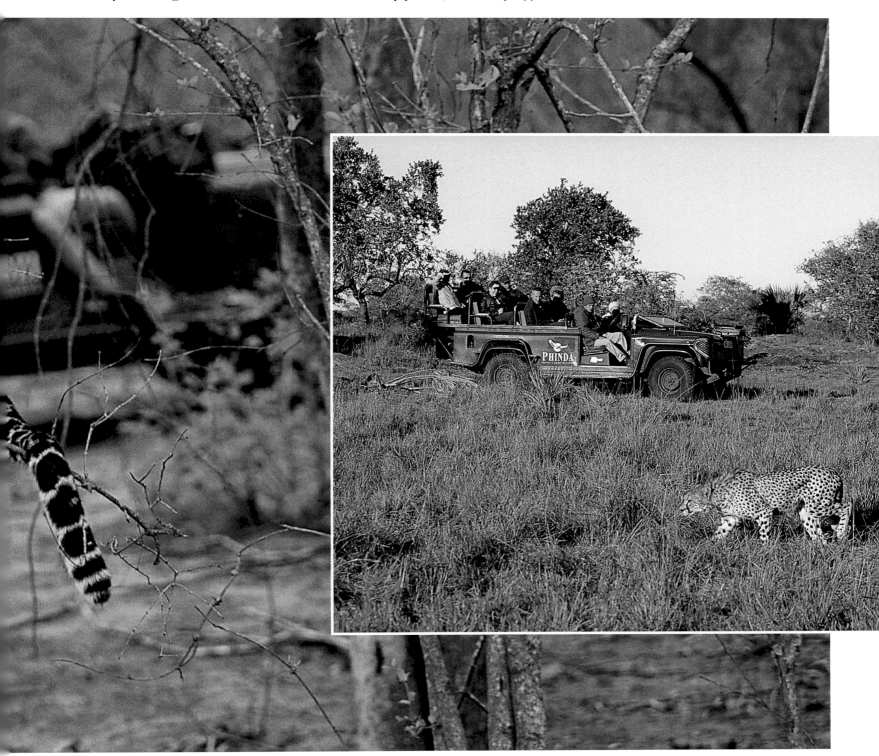

The end of the hunt. Though considered inhumane by many observers, the revenue generated from trophy hunting ensures the preservation of significant tracts of wilderness in Africa.

Even if wildlife-seeking visitors continue coming to Africa in sufficient numbers, can we assume that protected areas are safe? In many East and southern African countries where open woodland savannas and high wildlife densities furnish spectacular experiences, tourism ranks among their most valuable industries. Indeed, some African states – Gabon, Mozambique and South Africa, for example – are continuing to protect more land today even as their human populations grow. With one of the newest and most comprehensive systems of protected areas anywhere in forested Africa, Gabon is now developing a tourism industry modeled on the decades-old one perfected by its neighbours to the east. It does not matter much that a sighting of a wild cat in the rainforest is an exceedingly rare event; a trickle of paying tourists attracted by guaranteed viewing of gorillas, forest elephants, sitatungas and spectacular bird life may represent the birth of an economy that pays to protect the whole rainforest. If, as has happened in parts of savanna Africa, the benefits of tourism flow from the parks to surrounding communities, people may gain the means to limit their harvests of bushmeat from the forest (see p 158) and come to see greater value in parks – and the leopards, African golden cats and other wildlife they protect.

Yet by 2050, many African countries will have populations at least twice as large as today. Gabon, Rwanda and Zambia's populations are predicted to double, Kenya's will grow from 34 million to 83 million and Uganda, with its recovering wildlife populations and growing tourism industry, will explode from 28 million to a staggering 127 million. In some of these countries, it is difficult to imagine that the intense demands of such enlarged populations can be addressed by parks and their associated economies. For countries already with more people and less wildlife, the prospect for tourism as a mechanism to protect wildlife is grim. By 2050, Ethiopia's system of protected areas will need to justify its existence to a population of 170 million people (from 77 million in 2005).

Even in the worst scenario, some protected areas *will* survive and, provided they are large enough, so too will cats and other large carnivores. But even where parks have been overwhelmingly successful (success, it is hoped, that countries such as Gabon will ultimately enjoy), we can no longer afford to assume that setting aside reserves is sufficient. Apart from the growing threats to their survival, many reserves are already too small or too isolated to protect viable populations of cats. Even large, very well-protected populations are not invulnerable, exemplified by the distemper outbreak in Serengeti lions (Chapter 4, p 125). To tackle the conservation of Africa's cats successfully, conservationists are increasingly shifting their focus to the areas where they are most imperiled today – outside the parks.

Protecting the unprotected: cats, people and coexistence

Many African countries still have huge areas where cats live outside the protective custody of national parks and reserves. These areas have the potential to sustain large numbers of cats well into the future. However, in most cases, they are also home to many people, and cats in unprotected areas are already subject to greater pressure than protected populations. As discussed earlier, the greatest threat to cats in unprotected areas is Human-Wildlife Conflict, and the key to conserving these cats is finding ways to ease it.

Sometimes, the solutions are simple. A wealth of evidence demonstrates that pastoralists with few predator problems adopt basic precautions compared with their neighbours. Not surprisingly, good husbandry translates into fewer losses; successful herders accompany herds as they graze during the day, and corral their stock and post dogs at night to warn of approaching predators. Above all else, communities that tolerate wild herbivores on their land boast dramatically fewer losses than areas where there is little natural prey for cats. Of course, cats will seize any opportunity to make an easy kill of domestic stock, but in

In some areas, and for some communities, providing a financial incentive to tolerate cats may be the only way to conserve them.

places where natural alternatives are still abundant, and especially when herders and their dogs stay with the herds, they largely don't. It should come as no surprise that these methods succeed. Africans have honed their ability to coexist with large carnivores over tens of thousands of years, longer than anywhere else on earth. While never conflict-free – cats will always prey on stock, and people will always kill cats in retribution – people and predators continue to occupy the same landscape in relative peace wherever traditional practices are upheld.

Today, new techniques and technology enhance people's ability to avoid conflict. Slightly more sophisticated approaches include limiting the birth periods for stock to the dry season when vegetation is less dense, increasing visibility for herders so predators have a harder time approaching herds without being spotted. Electrified fencing is extremely effective in deterring nocturnal raids on bomas; as Laurence Frank has shown in the Laikipia region of central Kenya, even equipping bomas with a simple fortified gate dramatically reduces losses.

Reintroducing cats

Reintroducing big cats into areas they formerly inhabited (usually by capturing wild cats from locally abundant populations and translocating them to a new site), has yielded some notable successes in southern Africa. In some areas where farming is proving marginal, landowners and governments alike are attempting to tap the demand for wildlife tourism (including trophy hunting) by replacing cattle with large cats and their prey. Provided a few basic needs are met, cats are surprisingly amenable to reintroduction, and populations enjoy high survivorship, successful reproduction and rapid re-establishment. In South Africa alone, wild lions have been reintroduced into at least 21 privately and publicly-owned reserves covering a combined land area of over 4 500 square kilometres but, even so, the long-term value of reintroduction as a conservation strategy remains equivocal. All the South African reintroduction sites are small and most are isolated from other populations. With few prospects for natural dispersal and migration, reintroduced cats require intensive management that includes translocations, contraception, sterilisation and, in some cases, hunting. Furthermore, reintroduction is costly and requires very specialised expertise. The South African projects have provided critical insight into ensuring that reintroduction works when it is required, but the priority for the long-term protection of cats rests in conserving them where they still exist.

Elsewhere, the emerging use of large, aggressive breeds of European livestock-guarding dogs holds promise; bonded to the herds as puppies, they confront predators rather than herding their livestock to safety when danger appears (the typical response of African dog breeds which often incites an attack from a hunting cat). Anatolian shepherd dogs are used in Namibia and South Africa where they successfully deter attacks from caracals, cheetahs and, occasionally, more formidable foes – there is a recent record from Namibia in which an Akbash dog defending its herd killed a leopard.

As intuitive, uncomplicated and beneficial as these solutions are, they require effort to accomplish. Most also require an additional investment which, even though none is costly, some communities cannot afford or are simply unwilling to make. Traditional husbandry practices are declining across Africa as younger generations abandon their farms and villages to seek careers in the cities. All too often, those left behind no longer see the sense in tolerating cats. To many pastoralists, the cheapest alternative also requires the least effort; why go to the trouble of keeping dogs or spending long, arduous hours in the bush watching cattle when poison will do the job? It is a fact that, unless people *want* to protect cats, a great many more will be killed wherever there are people and their livestock.

Which brings us full circle, back to commerce. In some areas and for some communities, providing a financial incentive to tolerate cats may be the only way to conserve them. Numerous efforts have been made to compensate farmers for their loss; by paying for livestock killed, the hope is that herders are less likely to kill cats. But compensation programs almost invariably fail. Claims of depredation are difficult and costly to verify, cats are often erroneously or intentionally blamed for losses to other factors and falsification of claims inevitably creeps into the system. Surprisingly perhaps, being paid to tolerate losses may even remove the incentive to avoid them; the rewards for losing stock can sometimes be more profitable than caring for it. Finally, there is little evidence that compensation programs achieve their most important objective; reducing the numbers of cats killed. Even where losses are reimbursed, the cultural and emotional distress of losing livestock to predators remains, and few compensated farmers find the idea of cats eating their cattle more tolerable. The great majority of pastoralists, remunerated or not, still kill predators when the opportunity arises.

Rather than compensation, positive incentives or insurance schemes may provide an answer. Perhaps paying communities for the number of lions on their land will work more effectively to build tolerance than reimbursements for any cattle the lions

Reducing wildlife to a dollar-value offends many purists, but it may be an extravagance to think that it will be saved otherwise.

kill. Similarly, if livestock were insured against losses to cats, sensible herders would adopt better techniques – or perhaps simply maintain the old, effective ones – to reduce their losses. Just as with drivers whose vehicle insurance rates reflect their ability to avoid claims for damage, farmers practising sound husbandry would enjoy fewer losses and lower premiums. In principle, these novel ideas hold considerable promise, though none has yet been put into practise anywhere in Africa with meaningful results for cats.

Workable economic incentives to conserve big cats are few. The challenges facing compensation or insurance programs are unlikely to see resolution on a meaningful scale across Africa and, arguably, the only alternatives are trophy hunting and ecotourism. As described earlier in this chapter, revenue from tourists wishing to see cheetahs, leopards and, above all, lions, continues to insulate many parks and reserves from their conversion to human-dominated landscapes – farms, villages and so on. But how can the same principle be applied to unprotected areas, where there are already many people?

Cats as commodities

In theory, the presence of cats holds considerable potential value to human communities sharing the same landscape. Calculating the worth of a cat is problematic but the accumulated returns from an ecotourism-friendly big cat over its lifetime far exceeds the single pay-off from shooting it. In 1987, Rowan Martin and Tom de Meulenaer estimated that a particular female leopard, famously indifferent to vehicles, in the Londolozi Game Reserve in South Africa, was worth approximately US$50,000 a year; in today's dollars that equates to almost $90,000. To shoot a leopard, the most a trophy hunter pays anywhere in Africa is less than a third of that (in many places it is very considerably less), only a small percentage of which is the trophy fee; the balance being made up of operator fees, accommodation and other incidental costs.

Does the Londolozi model represent the solution? Like many game lodges in Africa, Londolozi required enormous long-term investment before it paid off; opulent lodges, well-maintained roads and highly qualified staff now attract paying clientele willing to spend hundreds of dollars a night on the promise of seeing wildlife in pampered luxury. Few rural communities can marshall such resources, but a handful of them have negotiated productive partnerships with those who can. In 2001, the northern tip of South Africa's Kruger National Park was restored to its traditional owners, the Makuleke, who partnered with a major ecotourism company to build a Londolozi-style lodge on their land and pay for the lucrative

rights to operate it. Local people are trained to work in the lodge and revenue from visitors is channelled back into the community. Phillip Stander argues that tourism need not be lavish to benefit communities and cats. He piloted a program with the Ju/Hoan San people in northeast Namibia in which tourists accompanied the San as they used their superb tracking skills to find and view leopards. In the 17-month trial period, it required only 35 tourists staying for a total of 25 days (in tents in two San villages) to yield almost N$40,000 – around 12 times the value of the livestock the San lost to leopards.

Such 'community conservation' enterprises are growing more common and hold substantial promise, but many areas (community-owned or otherwise) will never be fruitful for watching wildlife; apart from anything else, cats outside of protected areas are usually extremely shy because of the danger that people represent.

For considerable parts of Africa, the only realistic solution is 'consumptive utilisation' – or hunting. As difficult as it is for me to accept that hunting a lion or a leopard can be considered sport, there is no doubt that hunting makes a substantial contribution to protecting African wilderness. Concessions given over to trophy hunting comprise huge areas of many African countries, and the revenue generated by the industry ensures that governments do not consider those areas for alternative uses, like agriculture or cattle. Further, sport hunters often value places and experiences that 'normal' tourists on the safari route will not tolerate. The dense, malaria-ridden scrub that dominates much of the Ruaha-Rungwa ecosystem in southern Tanzania is of no interest to most wildlife-watchers, but it is prized by hunters for its ruggedness, remoteness and isolation. Similarly,

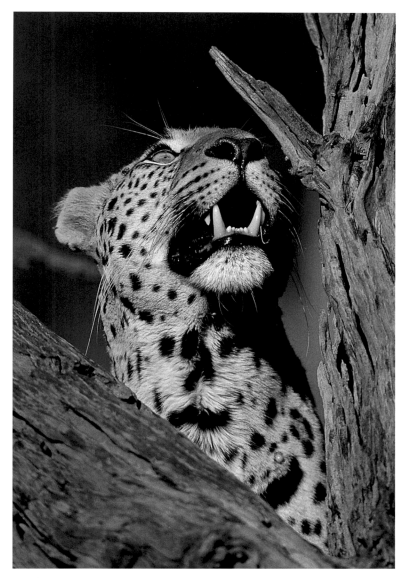

Typified by the adaptable leopard, the resilience of the cat family will confront its greatest test in the coming decades. Without concerted conservation efforts, the outlook for cats in many parts of Africa is bleak.

CITES and quotas

CITES – the Convention in Trade in Endangered Species of Wild Fauna and Flora – is an international agreement between governments that regulates international trade in wildlife. It encompasses the exchange of live animals between zoos as well as trade in their parts and products, including as hunting trophies. CITES works as a democracy; the Parties (signatory countries to the convention; there were 169 in 2005) meet every two years to vote on proposals, including the setting of hunting quotas. Parties seeking to open or increase quotas must demonstrate that harvest levels are sustainable and will not adversely affect the species. In 2002, when Tanzania successfully argued to double its annual quota for leopard hunts to 500, it presented a justification that incorporated the results of radio-tracking research and a detailed analysis of hunting effort. Although the system is imperfect – for example, governments estimating leopard and lion numbers rely essentially on guesswork – CITES oversight means that hunting quotas are generally conservative. More troubling, however, is that quotas rarely consider the *illegal* trade in cats. In one recent example, the skins of at least 58 poached leopards were confiscated in South Africa; at the time, the legal annual quota for hunting was a conservative 75, yet that number was almost doubled in a single raid of illegal skins. Given that illegal trade is so difficult to quantify, few governments include figures in their calculus for hunting quotas. CITES also oversees efforts to regulate illegal international trade in wild cat skins and other parts but, by virtue of the trade's highly illicit nature, far less successfully. (See box on Trade in Cats, p 159.)

whereas Zimbabwe's current social and political turmoil has led to a virtual collapse in wildlife tourism, the country's hunting industry is little affected.

Ironically, hunting may also be a mechanism to protect cats in conflict with livestock. Ranchers in a few southern and East African countries earn a portion of the hunter's fee when a cat is shot on their land. In principle, the financial benefit from the shooting of an occasional big cat encourages a farmer to leave the rest of the population alone because they want to be able to hunt them in the future. The same rationale underlies projects such as Zimbabwe's CAMPFIRE project (Communal Areas Management Programme For Indigenous Resources) which empowers rural communities to manage their wildlife resources and derive economic benefits from trophy hunting (and, less so, from tourism). Of considerable appeal to rural communities, trophy hunting often requires less investment than ecotourism, mainly because far fewer visitors are needed to balance the books.

International hunters pay much higher rates than most safari-goers so, while thousands of tourists each year make sure that Londolozi's $90,000 leopard pays her way, a hunting operation needs only a few successful clients to generate the same return. On many private ranches across Africa, a small hunting camp occupied for a few months of the year creates enough supplementary income to make hunting a worthwhile sideline without incurring the costs of setting up a successful ecotourism business.

In practice though, none of these schemes is a panacea to the challenges of conserving cats. The great majority of trophy hunting in Africa takes place on government land granted by tender to concessionaires. With only a few notable exceptions, the beneficiaries – the government and especially the hunting companies – rarely direct any of the benefits towards neighbouring communities who are still left with the problem of cats killing their livestock.

Even where hunting takes place on private or community land, the benefits to cats are dubious. CAMPFIRE has succeeded where profits are distributed to all members of the community, as intended; but where local corruption thwarts sharing, it has plainly and drastically failed. Equally, the Namibian farmers whose land represents habitat for over 90 per cent of the country's cheetahs probably benefit too infrequently from trophy hunting to stop shooting cheetahs themselves. Finally, even when landowners realise a profit, it does not necessarily translate into tolerating cats. In South Africa, some game-farmers who benefit from leopard hunts continue

to trap and shoot leopards regardless; some landowners simply want to rid their properties of leopards and turn as much short-term profit as they can in the process.

Even if those obstacles are overcome, the trophy hunting industry itself is rife with problems. The incentives for hunting operators are so large – hunters are willing to pay US$25,000 to $30,000 to shoot a lion or leopard – that corruption is widespread. Over-shooting quotas, and hunting young animals and females are persistent problems that, to date, much of the industry seems unwilling to self-regulate. Awarding long-term concessions (15–25 years) to operators, such that they treat the land as their own to manage sustainably, averts many of the worst practices, but African governments increasingly favour shorter concessions in order to increase competition over them. Or, as is legal with long-term concessions in Tanzania, they are sub-leased out by the operator to other companies for shorter periods. To a concessionaire granted only a few years, shooting as much as possible maximises profits in a limited time, regardless of its rampant unsustainability.

Realistically then, do the cats of Africa have a future? I do not believe that any of Africa's felids will disappear from the wild in the next 50 years. However, with the possible exception of the sand cat, all of them will lose more range, decline further in number and surrender some smaller populations – those already surrounded by people, or perhaps, in the most productive regions – to human encroachment. At some point, these losses will reach a threshold at which a species can no longer sustain itself. Science is unable to predict when that point will arrive for any African cat across its range, but it is inevitable for leopards in North Africa, probable for cheetahs in Egypt and may already be too late for lions across West Africa.

Cats display astonishing resilience, managing to persist despite our best efforts to eradicate them. But in the Africa of 2050, most species, especially the 'big three', will survive only where people choose to tolerate them. Such areas will be those where we have succeeded on two fronts – reducing people's conflict with cats and providing the means for people to derive benefit from them, whether by tourism, hunting or some other mechanism. As we have seen, no single approach will provide the complete solution. Indeed, conservationists will need to try, and triumph with, many approaches if we are to ensure that cats remain a part of Africa's extraordinary fauna beyond the next 50 years. If we fail, the continent that has seen humans and cats coexist for the longest time will be a wretched place.

In the Africa of 2050, most species will survive only where people choose to tolerate them. Conservationists will need to triumph with many approaches to ensure that cats remain a part of Africa's extraordinary fauna.

REFERENCES

This book draws extensively on hundreds of scientific papers and reports too numerous to include here. The following section includes key references used in the preparation of the text.

General references

Bailey, TN. 2005. *The African Leopard: Ecology and Behaviour of a Solitary Felid*, 2nd Edition. The Blackburn Press, New Jersey.

Caro, TM. 1994. *Cheetahs of the Serengeti Plains: Group Living in an Asocial Species*. University of Chicago Press, Chicago.

Dragesco-Joffé, A. 1993. *La Vie Sauvage au Sahara* [*Wildlife in the Sahara*; in French]. Delachaux et Niestle, Paris.

Estes, RD. 1991. *The Behavior Guide to African Mammals*. University of California Press, Berkeley.

Ewer, RF. 1986. *The Carnivores*. Cornell University Press, Ithaca, New York.

Hall-Martin, A & Bosman, P. 1997. *Cats of Africa*. Swan Hill Press, London.

Happold, DCD. 1987. *Mammals of Nigeria*. Clarendon Press, Oxford, UK.

Harrison, DL & Bates, JJ. 1991. *The Mammals of Arabia*, 2nd Edition. Harrison Zoological Museum, Kent.

Hunter, L & Hamman, D. 2003. *Cheetah*. Struik Publishers, Cape Town.

Kingdon, J. 1977. *East African Mammals: An Atlas of Evolution in Africa, Volume IIIA, Carnivores*. University of Chicago Press, Chicago.

Kingdon, J. 1997. *The Kingdon Field Guide to Mammals of Africa*. Princeton University Press, Princeton.

Kingdon, JS & Hoffmann, M. (Eds) in press. *The Mammals of Africa, Volume 5. Carnivora, Pholidota, Perissodactyla*. Academic Press, Amsterdam.

Kitchener, Andrew. 1991. *The Natural History of the Wild Cats*. Cornell University Press, Ithaca, New York.

Kowalski, K. and Rzebik-Kowalska, B. 1991. *Mammals of Algeria*. Polish Academy of Sciences, Warsaw, Poland.

Mills, G & Harvey, M. 2001. *African Predators*. Struik Publishers, Cape Town.

Nowak, RM. 2005. *Walker's Carnivores of the World*. Johns Hopkins University Press, Baltimore.

Nowell, K & Jackson, P. 1996. *Wild Cats. Status Survey and Conservation Action Plan*. IUCN, Gland.

Osborn, D. and Helmy, I. 1980. The contemporary land mammals of Egypt (including Sinai). *Fieldiana Zoology* 5:1-579.

Rosevear, DR. 1974. *Carnivores of West Africa*. The British Museum, London.

Schaller, George B. 1972. *The Serengeti Lion: A Study of Predator-Prey Relations*. University of Chicago Press, Chicago.

Seidensticker, J & Lumpkin, S. 2004. *Smithsonian Answer Book: Cats*. Smithsonian Books, Washington.

Skinner, JD & Chimimba, CT. 2005. *The Mammals of the Southern African Subregion*, 3rd edition. Cambridge University Press, Cambridge.

Sunquist, M & Sunquist, F. 2002. *Wild Cats of the World*. University of Chicago Press, Chicago.

Wilson, DE, & Reeder, DAM, (Eds). *Mammal Species of the World: A Taxonomic and Geographic Reference*. 3rd edition. John Hopkins University Press, Baltimore.

Chapter 1: The feline design

Bininda-Emonds, ORP, Gittleman, JL, & Purvis, A. 1999. Building large trees by combining phylogenetic information: A complete phylogeny of the extant Carnivora (Mammalia). *Biological Review* 74: 143-175

Christiansen, P. & Adolfssen JS. 2005. Bite force, canine strength and skull allometry in carnivores (Mammalia, Carnivora). *Journal of Zoology* 266: 133-151.

Holliday, JA & Steppan, SJ. 2004. Evolution of hypercarnivory: The effect of specialization on morphological and taxonomic diversity. *Paleobiology* 30 (1): 108-128.

Huang, GT, Rosowski, JJ, Ravicz, ME and Peake, WT. 2002. Mammalian ear specializations in arid habitats: structural and func-tional evidence from sand cat (*Felis margarita*). *Journal of Comparative Physiology A*. 188: 663-681.

Hughes, A. 1977. The topography of vision in mammals of contrasting lifestyle: comparative optics and retinal organization. Pp. 613-756 *in* F. Crescitelli, ed. *The Visual System in Vertebrates; Handbook of Sensory Physiology*, vol. 7, part 5. Springer-Verlag, Berlin.

Johnson, WE, Eizirik, Pecon-Slattery, EJ, Murphy, WJ, Antunes, A, Teeling, E & O'Brien, SJ. 2006. The Late Miocene radiation of mod-ern Felidae: a genetic assessment. *Science* 311:73-77.

Turner, A. & Anton, M. 1997. *The Big Cats and their Fossil Relatives: Illustrated Guide to their Evolution and Natural History*. Columbia University Press, New York.

Turner, A. & Anton, M. 2004. *Evolving Eden: An Illustrated Guide to the Evolution of the African Large-mammal Fauna*. Columbia University Press, New York

Weissengruber, GE, Forsten-pointner, G, Peters, G, Kübber-Heiss, A, & Fitch, WT. 2002. Hyoid apparatus and pharynx in the lion (*Panthera leo*), jaguar (*Panthera onca*), tiger (*Panthera tigris*), chee-tah (*Acinonyx jubatus*) and domestic cat (*Felis sylvestris f. catus*). *Journal of Anatomy* 201, 195–209.

Wozencraft, WC.,2005. 'Order Carnivora', in Wilson, DE & Reeder, DAM (Eds). *Mammal Species of the World: A Taxonomic and Geographic Reference*. 3rd edition, John Hopkins University Press, Baltimore.

Chapter 2: Predation

Avenant, NL, & Nel, JAJ. 2002. Habitat variation and prey availability and use by caracal *Felis caracal*. *Mammalian Biology* 67: 18–33.

Bodendorfer, T, Hoppe-Dominik, B, Fischer, F & Linsenmair, KE. in press. Prey of the leopard (*Panthera pardus*) and the lion (*Panthera leo*) in the Comoé and Marahoué National Parks, Côte d'Ivoire, West Africa. *Mammalia*

Boy, G. 2003. Phantom feline. *Swara* (April-June); 25–43

Bothma, J du P, & Coertze, J. 2004. Motherhood increases hunting success in Southern Kalahari leopards. *Journal of Mammalogy* 85(4):756–760.

Funston, PJ, Mills, MGL, Biggs, HC, & Richardson, PRK. 1998. Hunting by male lions: Ecological influences and socioecological implications. *Animal Behavior* 56: 1333–1345.

Funston, PJ, Mills, MGL, & Briggs, HC. 2001. Factors affecting the hunting success of male and female lions in Kruger National Park. *Journal of Zoology* 253: 419–431.

Hayward, MW, Henschel, P, O'Brien J, Hofmeyr, M, Balme, G, & Kerley, GIH., in press. Prey preferences of the leopard *Panthera pardus*. *Journal of Zoology*

Jenny, D, & Zuberbühler, K. 2005. Hunting behaviour in West African forest leopards. *African Journal of Ecology* 43: 197–200.

Radloff, FGT, & du Toit, JT. 2004. Large predators and their prey in the southern African savanna: A predator's size determines its prey size range. *Journal of Animal*

Ecology 73: 410–423

Ray, JC, & Sunquist, ME. 2001. Trophic relations in a community of African rainforest carnivores. *Oecologia* 127: 395–408.

Sliwa, A. 1994. Diet and feeding behaviour of the black-footed cat (*Felis nigripes* Burchell, 1824) in the Kimberley Region, South Africa. *Der Zoologische Garten* N.F. 64: 83–96.

Stander, PE. 1992a. Foraging dynamics of lions in a semi-arid environment. *Canadian Journal of Zoology* 70: 8–21.

Stander, PE. 1992b. Cooperative hunting in lions: The role of the individual. *Behavioral Ecology and Sociobiology* 29: 445–454.

Chapter 3. Solitary and sociable

Abbadi, M. 1991. Israel's elusive feline: sand cats. *Israel Land and Nature*, 16: 111–115.

Fuller, TK, Biknevicius, AR & Kat, PW. 1988. Home range of an African wildcat, *Felis silvestris* (Schreber) near Elmenteita, Kenya. *Zeitschrift Saugetierkunde.* 53: 380–381.

Funston, PJ, Mills, MGL, Richardson, PRK, & van Jaarsveld, AS. 2003. Reduced dispersal and opportunistic territory acquisition in male lions (*Panthera leo*). *Journal of Zoology,* 259: 131–142.

Geertsema, AA. 1985. Aspects of the ecology of the serval, *Leptailurus serval*, in the Ngorongoro Crater, Tanzania. *Netherlands Journal of Zoology* 35(4): 527–610.

Grinnell, J, Packer, C, & Pusey, AE. 1995. Cooperation in male lions: kinship, reciprocity or mutualism? *Animal Behavior* 49: 95–105.

Grinnell, J, & McComb, K. 2001. Roaring and social communication in African lions: the limitations imposed by listeners. *Animal Behaviour* 62: 93–98

Marker, LL, & Dickman, AJ. 2005. Notes on the spatial ecology of the caracals (*Felis caracal*), with particular reference to Namibian farmlands. *African Journal of Ecology* 43: 73–76.

McComb, K, Pusey, A, Packer, C, & Grinnell, J. 1993. Female lions can identify potentially infanticidal males from their roars. *Proceedings of the Royal Society of London Series B-Biological Sciences* 252: 59–64.

McComb, K, Packer, C, & Pusey, AE. 1994. Roaring and numerical assessment in contests between groups of female lions, *Panthera leo*. *Animal Behavior*, 47: 379–387.

Mizutani, F, & Jewel, PA. 1998. Home-range and movements of leopards (*Panthera pardus*) on a livestock ranch in Kenya. *Journal of Zoology.* 244. 269–286.

Packer, C, Scheel, D, & Pusey, AE. 1990. Why lions form groups: food is not enough. *American Naturalist* 136: 1–19.

Sliwa, A. 2004. Home range size and social organisation of black-footed cats (*Felis nigripes*). *Mammalian Biology* 69: 96–107.

Stander, PE, Haden, PJ, Kaqece, // & Ghau, //. 1997. The ecology of asociality in Namibian leopards. *Journal of Zoology.* 242: 343–364.

Yamaguchi, N, Cooper, A, Werdelin, L, & Macdonald, DW. 2004. Evolution of the mane and group-living in the lion (*Panthera leo*):

A review. *Journal of Zoology* 263: 329–342.

West, PM, & Packer, C. 2002. Sexual selection, temperature, and the lion's mane. *Science* 297: 1339–1343.

Chapter 4. Populations

Balme GA, & Hunter, LTB 2004. Mortality in a protected leopard population, Phinda Private Game Reserve, South Africa: A population in decline? *Ecological Journal* 6: 1–6.

Gilbert, DA, Packer, C, Pusey, AE, Stephans, JC, & O'Brien, SJ. 1991. Analytical DNA fingerprinting in lions: Parentage, genetic diversity, and kinship. *Journal of Heredity* 82(5): 378–386.

Kelly, MJ, & Durant, SM. 2000. Viability of the Serengeti cheetah population. *Conservation Biology* 14(3): 786–797.

Kelly, MJ, Laurenson, MK, Fitz-Gibbon, CD, Collins, DA, Durant SM, Frame, GW, Bertram, BCR, & Caro, TM. 1998. Demography of the Serengeti cheetah (*Acinonyx jubatus*) population: the first 25 years. *Journal of Zoology* 244: 473–488.

Laurenson, MK. 1994. High juvenile mortality in cheetahs (*Acinonyx jubatus*) and its consequences for maternal care. *Journal of Zoology* 234: 387–408.

Marker, LL, Dickman, AJ, Jeo, RM, Mills, MGL, & Macdonald, DW. 2003. Demography of the Namibian cheetah. *Biological Conservation* 114: 413–125.

Marker, LL, & Dickman, AJ, 2005. Factors affecting leopard (*Panthera pardus*) spatial ecology, with particular reference to Namibian

farmlands. *South African Journal of Wildlife Research* 35(2): 105–115.

Packer, C, Hilborn, R, Mosser, A, Kissui, B, Borner, M, Hopcraft, G, Wilmshurst, J, Mduma, S, & Sinclair, ARE. 2005. Ecological change, group territoriality, and population dynamics in Serengeti lions. *Science* 307: 390–393.

Packer, C, Gilbert, DA, Pusey, AE, & O'Brien, SJ. 1991. A molecular genetic analysis of kinship and cooperation in African lions. *Nature* 351: 562–565.

Packer, C, & Pusey, AE. 1993. Dispersal, kinship, and inbreeding in African lions. Pages 375–391 *in* N. W. Thornhill, editor. *The Natural History of Inbreeding and Outbreeding.* University of Chicago Press, Chicago, USA.

Roelke-Parker, ME, Munson, L, Packer, C, Kock, R, Cleaveland, S, Carpenter, M, Brien, SJ, Pospischil, A, Hofmann-Lehmann, R, Lutz, H, Mwamengele, GLM, Mgasa, MN, Machange, GA, Summers, BA, Appel, MJG. 1996. A canine distemper virus epidemic in Serengeti lions (*Panthera leo*). *Nature* 379: 441–445.

Weibstein, Y, & Mendelsohn, H. 1990. The biology and ecology of the caracal *Felis caracal* in the northern Aravah valley of Israel. *Cat News* 12: 20–22.

Chapter 5. Competition, conflict and coexistence.

Avenant, NL, & Nel, JAJ. 1997. Prey use by four syntopic carnivores in a strandveld ecosystem. *South African Journal of Wildlife Research* 27 (3): 86–93.

Carbone, C, & Gittleman, JL. 2002. A common rule for the scaling of

carnivore density. *Science* 295: 2273-2276.

Cooper, SM. 1991. Optimal hunting group size: the need for lions to defend their kills against loss to spotted hyaenas. *African Journal of Ecology* 29: 130–136.

Durant, SM, 2000. Predator avoidance, breeding experience and reproductive success in endangered cheetahs, *Acinonyx jubatus. Animal Behaviour* 60(1): 121–130

Eaton, RL, 1979. Interference competition among carnivores: a model for the evolution of social behaviour. *Carnivore* 2: 9–16.

Hart, JA, Katembo, M, Punga, K. 1996. Diet, prey selection and ecological relations of leopard and golden cat in the Ituri Forest, Zaire *African Journal of Ecology* 34: 364–379.

Höner, OP, Wachter, B, East, ML, and Hofer, H. 2002. The response of spotted hyaenas to long-term changes in prey populations: functional response and interspecific kleptoparasitism. *Journal of Animal Ecology* 71: 236–246.

Linnell, JDC, & Strand, O. 2000. Interference interactions, coexistence and conservation of mammalian carnivores. *Diversity and Distribution* 6: 169–176.

Palomares, F, & Caro, TM. 1999. Interspecific killing among mammalian carnivores. *The American Naturalist* 153(5): 492–508.

Purchase, GK. 2004 Imperfect harmony, *Africa Geographic* 12 (7): 66–71.

Ray, JC. 2001. Carnivore biogeography and conservation in the African rainforest: A community perspective. pp 214–232 in *African Rainforest Ecology and Conservation. An Interdisciplinary Perspective* by Weber, W, White, LJT, Vedder, A, & Naughton-Treves, L. Yale University Press, London.

Chapter 6. Cats and humans.

Bauer, H, & Van Der Merwe, S. 2004. Inventory of free-ranging lions *Panthera leo* in Africa. *Oryx* 38(1): 26–31.

Henschel, P, & Ray, JC. 2003. *Leopards in African Rainforests: Survey and Monitoring Techniques.* Wildlife Conservation Society, Global Carnivore Program, New York.

Hunter, L, Slotow, R, Van Dyk, G, and Vartan-McCallaum, S. 2004. Reintroducing the African lion in South Africa: short-term success but is it conservation? in *Carnivores 2004: Expanding Partnerships in Carnivore Conservation*, Defenders of Wildlife, 212pp

Martin, RB, and de Meulenaer, T. 1988. *Survey of the status of the leopard (Panthera pardus) in sub-Saharan Africa.* CITES, Lausanne, Switzerland.

Marker-Kraus, L, Kraus, D, Barnett, D, & Hurlbutt, S. 1996. *Cheetah Survival on Namibian Farmlands.* Cheetah Conservation Fund, Windhoek.

Newby, JE, 1990. The slaughter of Sahelian wildlife by Arab royalty. *Oryx* 24: 6–8.

Ogada, MO, Woodroffe, R, Oguge, NO, & Frank, LG. 2003. Limiting depredation by African carnivores: the role of livestock husbandry. *Conservation Biology* 17 (6): 1521– 1530.

Packer, C, Ikanda, D, Kissui, B, & Kushnir, H. 2005. Lion attacks on humans in Tanzania. *Nature* 436, 927–928.

Patterson, BD, Kasiki, SM, Selempo, E, & Kays, RW. 2004. Livestock predation by lions (*Panthera leo*) and other carnivores on ranches neighboring Tsavo National Park, Kenya. *Biological Conservation* 119: 507–516.

Population Divison of the Department of Economic and Social Affairs of the United Nations Secretariat. 2005. World Population Prospects: The 2004 Revision. United Nations, New York.

Ray, JC, Hunter, L, & Zigouris, J. (2005). *Setting Conservation and Research Priorities for Larger African Carnivores.* Working Paper 24: 1–203. Wildlife Conservation Society, New York.

Saleh, MA, Helmy, I, and Giegengack, R. 2001. The Cheetah, *Acinonyx jubatus* (Schreber, 1776) in Egypt (Felidae, Acinonychinae). *Mammalia* 65(2): 177–194.

Stander, PE, Kaqece //au, Nisa |ui, Tsisaba Dabe & Dam Dabe. 1997. Non-consumptive utilisation of leopards: community conservation and ecotourism in practise pp 50—57 in *Lions and Leopards as Game Ranch Animals* by van Heerden, J. (Ed). South African Veterinary Assoc, Onderstepoort.

Woodroffe, R, & Frank, LG. 2005. Lethal control of African lions (*Panthera leo*): Local and regional population impacts. *Animal Conservation* 8: 91–98.

INDEX